Monumental cares

rethinking art's histories

SERIES EDITORS
Amelia G. Jones, Marsha Meskimmon

Rethinking Art's Histories aims to open out art history from its most basic structures by foregrounding work that challenges the conventional periodisation and geographical subfields of traditional art history, and addressing a wide range of visual cultural forms from the early modern period to the present.

These books will acknowledge the impact of recent scholarship on our understanding of the complex temporalities and cartographies that have emerged through centuries of world-wide trade, political colonisation and the diasporic movement of people and ideas across national and continental borders.

To buy or to find out more about the books currently available in this series, please go to: https://manchesteruniversitypress.co.uk/series/rethinking-arts-histories/

Monumental cares

Sites of history and contemporary art

Mechtild Widrich

Manchester University Press

Copyright © Mechtild Widrich 2023

The right of Mechtild Widrich to be identified as the author of this work has been asserted in accordance with the Copyright, Designs and Patents Act 1988.

Published by Manchester University Press
Oxford Road, Manchester M13 9PL

www.manchesteruniversitypress.co.uk

British Library Cataloguing-in-Publication Data
A catalogue record for this book is available from the British Library

ISBN 978 1 5261 6808 5 hardback
ISBN 978 1 526 1 6811 5 paperback

First published 2023

The publisher has no responsibility for the persistence or accuracy of URLs for external or any third-party internet websites referred to in this book, and does not guarantee that any content on such websites is, or will remain, accurate or appropriate.

Typeset
by Cheshire Typesetting Ltd, Cuddington, Cheshire
Printed in Great Britain
by Bell & Bain Ltd, Glasgow

Contents

	List of figures	*page* vi
	Acknowledgements	xi
	Who cares? An introduction	1
1	The sites of history	26
2	Cold War in stone—and plastic	55
3	Materializing art geographies	87
4	Reversing monumentality	114
5	Reflections	146
6	Drawing pain: political art in circulation	175
	Caring about monuments: a conclusion	202
	Selected bibliography	212
	Index	229

Figures

0.1 Protesters hold signs in front of the statue of Confederate General Robert E. Lee on Monument Avenue in Richmond, VA., Saturday, September 16, 2017. Photo: Steve Helber/Associated Press. 2

0.2 Josef Müllner, *Karl Lueger Monument*, Vienna 1913–17/1926 with "shame" painted onto base. COVID-19 test stations in the background. Photo: Mechtild Widrich, March 2022. 3

0.3 Cai Guo-Qiang, *Color Mushroom Cloud*, December 2017, University of Chicago. Photo: Andrei Pop. 6

0.4 Cai Guo-Qiang, *Color Mushroom Cloud, Sketches*, 2017. Courtesy the artist. 7

0.5 Eiko Otake performing *They Did Not Hesitate*, August 7, 2021. Photo: Ming Tian. Courtesy the artist. 8

0.6 Students protesting against nuclear energy and what was seen as its celebration by the University of Chicago, December 2017. Photo: Jean Lachat. Courtesy of the University of Chicago. 8

0.7 Gómez Platero, *World Memorial to the Pandemic*, Montevideo. Rendering, 2021. Courtesy studio Gómez Platero. 18

1.1 "Then and Now Pictures of the Battlefield." Section on the Website of the Gettysburg National Military Park, www.nps.gov/gett/index.htm. Screenshot. 27

1.2 Glass window commemorating Robert E. Lee, in the Washington National Cathedral, installed 1953. Photo: Remember/Wikimedia, public domain. 30

1.3 Miwon Kwon, *One Place after Another*, cover image, © 2002 Massachusetts Institute of Technology, by permission of The MIT Press. 32

1.4 Occupy Central NWFB Bus Message in Mong Kok, Hong Kong, September 29, 2014. Photo: Wing1990hk/Wikimedia, CC BY 3.0. 34

1.5	Alexandra Pirici, *Leaking Territories*, Münster, Germany, 2017. Photo: Mechtild Widrich.	36
1.6	Alexandra Pirici, *If You Don't Want Us, We Want You*, 2011. Photo: Alexandru Patatics. Courtesy the artist.	38
1.7	View from the elevator at the Museum of Contemporary Art, Bucharest. Photo: Mechtild Widrich.	40
1.8	Alexandra Pirici, *If You Don't Want Us, We Want You*, postcard, 2011. Courtesy the artist.	41
1.9	Emilio Rojas, *The Grass is Always Greener and/or Twice Stolen Land*, 2014. A 25-hour durational performance, 7 km, from UBC to Musquem Reserve, tracing the path of the land that was stolen from the Indigenous Nation that the university occupies. Courtesy the artist.	45
2.1	*Monument to the Victims of National Socialism*, Steinplatz, Berlin. Photo: Fred Romero/Wikimedia, CC BY 2.0.	57
2.2	*Monument to the Victims of Stalinism*, Steinplatz, Berlin. Photo: Evergreen68/Wikimedia, CC BY SA 3.0.	57
2.3	Jewish Community Hall, Berlin. Photo: Peter Kuley/Wikimedia, CC BY SA 3.0.	58
2.4	Sign in front of Brandenburger Tor, "Attention! You are now Leaving West Berlin," January 1, 1989. Photo: Monster4711/Wikimedia, CC0 1.0.	63
2.5	Film still from Wolfgang Staudte, *Murderers Among Us*, 1946. ©DEFA-Stiftung/Eugen Klagemann.	64
2.6	mmtt (Ammon and Lottner), *Steinplatz Reloaded*, 2018. Photo: Peter Kuley/Wikimedia, CC BY SA 3.	68
2.7	Cemal Kemal Altun memorial Hardenbergstrasse, Berlin. Photo: OTFW, Berlin/Wikimedia, CC BY SA 3.0.	70
2.8	Results of the Search for the Hashtag "Auschwitz," March 2022. Screenshot.	73
2.9	Frank Meisler, Memorial Kindertransport at Dorothea-Schlegel-Platz, Berlin, 2008. Photo: Miriam Guterland/Wikimedia, CC BY SA 3.0.	75
2.10	Yael Bartana, *The Orphan Carousel—A Monument*, 2021. Photo: Alexander Paul Englert. Courtesy of the Department of Culture of the City of Frankfurt am Main.	77
3.1	Carey Young, *Body Techniques* (after *A Line in Ireland*, Richard Long, 1974), 2007. Digital C-Type Print, 48 × 59¾ in. © Carey Young. Courtesy Paula Cooper Gallery, New York.	88
3.2	Carey Young, *Body Techniques* (after *Lean in*, VALIE EXPORT, 1976), 2007. Digital C-Type Print, 48 × 59¾ in. © Carey Young. Courtesy Paula Cooper Gallery, New York.	90

3.3	Mass Design Group, Memorial Monuments at *The National Memorial for Peace and Justice*, Montgomery, Alabama. Photo: Soniakapadia/Wikimedia, CC BY SA 4.0.	93
3.4	Louise Bourgeois (foreground) and Peter Zumthor, Steilneset Memorial, Vardø, Norway, 2011. Photo: Bjarne Riesto/Wikimedia, CC BY 2.0.	94
3.5	Ai Weiwei, *F.Lotus* in front of Belvedere Palace, Vienna, 2016. Photo: Mechtild Widrich.	98
3.6	Jonas Dahlberg, *July 22 Memorial*, Sørbråten site opposite Utøya. Illustration studio Dahlberg.	100
3.7	Y-blokken, Central Government Buildings (Regjeringskvartalet), Oslo, with decoration *The Fishermen* by Carl Nesjar after sketches by Pablo Picasso. Photo: Helge Høifødt/Wikimedia, CC BY SA 3.0.	103
3.8	Manthey Kula, *National Memorial* at Utøyakaia, commemorating the victims, survivors and rescuers of the terror attack on July 22, 2011. Illustration courtesy Kula and Statsbygg.	104
4.1	Dan Perjovschi, *Historia/Hysteria*, University Square Bucharest, 2007. Photo courtesy Public Space Bucharest.	115
4.2	Lia Perjovschi showing parts of her *Contemporary Art Archive / Center for Art Analysis* to the author in her studio in Sibiu. Photo: Andrei Pop.	117
4.3	Lucian Pintilie, *Reconstituirea*, poster, 1968.	120
4.4	University Square Bucharest with Intercontinental Hotel and National Theatre. Photo: eug.sim/Wikimedia, CC BY 3.0.	121
4.5	Ana Lupaș, *Memorial of Cloth*, Bucharest, 1991. Courtesy the artist.	122
4.6	Meinhard von Gerkan, Joachim Zais, Plan Detail of Submission to the *Bucharest 2000* architectural competition. Courtesy București 2000.	124
4.7	Andrei Pandele, Bucharest during the construction of the *House of the People* (Everyday Life under Ceaușescu) 1982. Courtesy the artist and Est&Ost Gallery.	126
4.8	Palace of Parliament, interior, Bucharest. Tim E. White / Alamy Stock Photos.	127
4.9	Mircea Cantor, *Milky Way*, 2013. Indian ink on paper, 21 × 15 cm. Courtesy the artist.	130
4.10	Ion Grigorescu, *Reportage from Gorj*, 1970/71. Courtesy the artist.	133
4.11	Ion Grigorescu, *Portrait of Ceaușescu*, around 1980 (original destroyed). Courtesy the artist.	134

4.12	Dan Perjovschi, *Horizontal Newspaper*, Sibiu. Photo: Mechtild Widrich, 2018.	136
5.1	Marcel Duchamp, *The Bride Stripped Bare by Her Bachelors, Even (The Large Glass)*, 1915–23, at the Philadelphia Museum of Art. Photo: author. © Association Marcel Duchamp / ADAGP, Paris / Artists Rights Society (ARS), New York 2022.	148
5.2	Hannah Wilke, *Through the Large Glass*, 1978 © 2022 Marsie, Emanuelle, Damon and Andrew Scharlatt, Hannah Wilke Collection & Archive, Los Angeles/Licensed by VAGA at Artists Rights Society (ARS), NY.	149
5.3	Bundesverfassungsgericht Karlsruhe. Photo: Guido Radig/ Wikimedia, CC BY SA 3.0.	151
5.4	Monica Bonvicini, *Don't Miss a Sec'.*, 2004. Two-way mirror glass structure, stainless steel toilet unit, concrete, aluminium, fluorescent lights, milk-glass panels, 250 × 226 × 185 cm. Photo: Jannes Linders. © 2022 Artists Rights Society (ARS), New York / VG Bild-Kunst, Bonn.	152
5.5	VALIE EXPORT, with Sinja Tillner, *Transparent Cube*, 1999–2001. Photo: Rupert Steiner. © VALIE EXPORT.	156
5.6	Dan Graham, *Alteration to a Suburban House*, 1978. Photo: Martino Stierli. © Dan Graham.	158
5.7	Adrian Piper, *Food for the Spirit*, 1971. 14 silver gelatin prints (photographic reprints 1997), 14.95 × 14.56 in (37.7 × 37 cm). Collection of the Museum of Modern Art, New York. © Adrian Piper Research Archive Foundation Berlin.	159
5.8	Ana Mendieta, *Untitled (Glass on Body Imprints)*, 1972. © 2022 The Estate of Ana Mendieta Collection, LLC. Courtesy Galerie Lelong & Co./Licensed by Artists Rights Society (ARS), New York.	160
5.9	Catherine Opie, *Sheats-Goldstein #3 (The Modernist)*, 2016. Pigment print. 40 × 26⅝ in. (101.6 × 67.6 cm). © Catherine Opie. Courtesy Regen Projects, Los Angeles and Lehmann Maupin, New York, Hong Kong, Seoul, and London.	165
5.10	Ai Weiwei, *CoroNation*, 2020. Film, 1 hour 53 minutes. © Ai Weiwei.	166
6.1	A visitor passes by an image that shows Chinese artist Ai Weiwei, lying face down on a beach photographed by Indian photographer Rohit Chawla at the India Today stand at the India Art Fair in New Delhi, India, January 28, 2016. AP Photo/Tsering Topgyal.	176
6.2	Honoré Daumier, *Rue Trasnonain, Le 15 Avril 1834*, lithograph (summer 1834), Art Institute of Chicago.	180

6.3	*La Caricature* on October 2, 1834 with announcement of Daumier's print. Courtesy Bibliothèque nationale de France.	181
6.4	Gustave Courbet, *Alms from a Beggar at Ornans*, 1868, Graphite with stumping, squared, with touches of crayon on cream wove paper. The Clark Art Institute, 1955.1846.	182
6.5	Ai Weiwei, *S.A.C.R.E.D.*, 2011–13, Six-part work composed of (i) S upper (ii) A ccusers (iii) C leansing (iv) R itual (v) E ntropy (vi) D oubt. Six dioramas in fiberglass and iron. 377 × 197 × 148.4 cm each. 48 3/8 × 77½ × 58 3/8 in. (WEIW130002). © Ai Weiwei; Courtesy Lisson Gallery. Photography by Ken Adlard.	190
7.1	Women participating in Doris Salcedo's project, *Fragmentos*, Bogotá, Colombia. Photo: Juan Fernando Castro. Courtesy of Fragmentos, Espacio de Arte y Memoria/Ministry of Culture of Colombia.	203
7.2	Doris Salcedo, *Fragmentos*, Bogotá, Colombia. Photo: Juan Fernando Castro. Courtesy of Fragmentos, Espacio de Arte y Memoria/Ministry of Culture of Colombia.	204
7.3	Students gather near a "comfort-woman" statue by Seo-kyong Kim and Woon-sung Kim, during a rally in front of the Japanese Embassy in Seoul, South Korea, Wednesday, January 11, 2017. AP Photo/Lee Jin-man.	205
7.4	Removal of Cecil John Rhodes statue at the University of Cape Town campus, April 8, 2015. Photo: Roger Sedres/Alamy Stock Photo.	209

Acknowledgements

This book manuscript went through many stages and directions, and was rethought considerably during the many perturbations of the last few years. Several residencies and fellowships supported my thinking during this time: At the Eikones Center for the Theory and History of the Image, University of Basel, I was part of the research module *Cities on the Move* (2013–15) immersed in scholarly discourse on the representation of urbanity and architecture as I started working on this project. The NTU Center for Contemporary Art Singapore (2016) and the University of Chicago Hong Kong Center (2018) allowed me to engage with many scholars and artists and think about activism, art, and the politics of exhibiting. The *Public Space Democracy* (2018–20) and *Agorakademi* (2020–) research groups at the École des Hautes Études en Sciences Sociales were among the most important scholarly forums for me to discuss, listen, and learn from the amazing scholars in our meetings. In London, participating since 2020 (mostly online) as a member of the *Performance and Public Space program and Research Center* at London Metropolitan University brought additional exposure.

At the end of this journey, a guest professorship at the University of Applied Arts Vienna (summer term 2022) and a fellowship at the Notre Dame Institute for Advanced Study (year 2022/23) allowed me to finish everything up and to see what comes next. The Dean's office at the School of the Art Institute of Chicago supported me over the years with funds for travel and the production of this book.

This project evolved over such an eventful period that I cannot list all the engagements and talks, and the colleagues and friends I discussed the matter of this book with; they all have my thanks, but I cannot omit to mention Lucia Allais, Maria Fernanda Ariza, Ute Meta Bauer, Lisa Beisswanger, Amy Bryzgel, Elise Butterfield, Miguel Caballero-Vázquez, Barbara Clausen, Delinda Collier, Romi Crawford, Beatriz Dávila, Sebastian Egenhofer, James Elkins, Ruth Fazakerley, Tatiana Flores, Anthony Gardner, David Getsy, Nilüfer Göle, Rebecca Goodman, Ion Grigorescu, Werner Hanak, Max Hirsh, Sean Keller, Irmi Maunu-Kocian, Elke Krasny, Jennifer D. Lee, Christine

Mehring, Didier Morelli, Galit Noga-Banai, Jorge Otero-Pailos, Suzanne Paquet, Lia and Dan Perjovschi, Paul Petritsch, Wolfram Pichler, Daniel Quiles, Barbara Reisinger, Adair Rounthwaite, Jacek Scarso, Caroline Schopp, Alina Șerban, Shawn Smith, Nora Sternfeld, Martino Stierli, Laura Steward, Eva Struhal, Nora Taylor, Ralph Ubl, Sampson Wong, Wen Yau, Ying Zhou, and the students who took my classes in Chicago and Vienna. Essays related to this work were published at various stages of my work in books and journals, but everything in this book is either new or reworked from the ground up. I thank Alun Richards and Emma Brennan at Manchester University Press for their guidance, Amelia Jones and Marsha Meskimmon for publishing me in their wonderful series once again, and Doreen Kruger for copy-editing this manuscript.

Andrei Pop provided intellectual stimulation, emotional support, and helped me with all aspects of this book. He also made sure I finished it, while helping our son Laurens to outgrow us. This book is dedicated to them.

Who cares? An introduction

The last years have brought momentum to the pressing debate about what to do with unwanted monuments. Most of them are traditional in form, often the generic 'man on a plinth' or 'man on a horse', and convey dominant and one-sided narratives of history. From South Africa, Britain, and the United States to the Caribbean and South America, protests against White Supremacy and colonialism have articulated the need to decolonize not just historical discourse, but also its markers in public space[1] [Fig. 0.1]. Why is it that monuments in particular are so contested and how did monument activism become a global cause? We could point to the speed of information and the connection between various movements on social media and in the news, but this in turn needs explaining: namely why monuments are so prevalent on social media. It is their occupation of space that sparks the attention. As monuments are situated in public or semi-public space, their realization must be negotiated with whoever has the power to decide their use. Traditionally administered by hegemonic groups, often occupying prestige spaces frequented by the well-off or by tourists, monuments seldom showcase hard historical truths, but rather crystallize myth or political morality tales *staged* as the past.[2] The aim of monuments as much as of critical interventions and vandalism against monuments is to change the present and the future. That present and future are often strikingly discontinuous to the past commemorated. That there is often a delay between the event and the commemorative object, or monument, is one indicator that these markers are not simply intended to make space for us to remember what was present: For example, many of the Confederate monuments or Columbus statues currently under discussion or facing removal in the United States were erected in the late nineteenth and early twentieth centuries, as physical anchors to stabilize a recently invented rather than recently lived-through history affirming a white immigrant (settler) nation of European ancestry.[3]

A monument does not equal history, despite the return of such rhetoric, especially on the political right.[4] It can show, however, how history has been publicly constructed. The pompous and currently debated monument to Karl

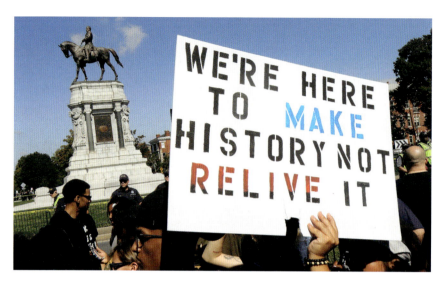

0.1 Protesters hold signs in front of the statue of Confederate General Robert E. Lee on Monument Avenue in Richmond, VA., Saturday, September 16, 2017.

Lueger, the anti-Semitic mayor of late nineteenth-century Vienna, whose populist rhetoric Hitler admired, was initiated by Lueger himself, as part of his massive self-glorification[5] [Fig. 0.2]. Initially planned for the large square in front of City Hall, the location shifted under a Social Democratic mayor hostile to Lueger, finally going up over a decade after his death. In the 1920s, the location was a space of urban renewal, and it is a matter of urban development that this square is now considered solidly part of the the city center. In a paradox of historical self-fullfilment, some politicians now argue that the fact of Lueger being honoured with such a large monument in a prominent location exemplifies his importance. This, in turn, is used to keep the monument in place.[6] What we can learn here is that a monument spatializes a connection to history in the present, whether that history takes the form of historical myth, argument, oral tradition or, rarely enough, fact. In doing so, it connects present concerns both with the past it mediates and an indeterminate future that will witness this particular materialization at a particular site. History in the present is politics, and the discourse in which history is constructed takes part in the creation of the public sphere. Dislocation, destruction, rebranding and reuse do not need to be met with cries of 'cancel culture' or fears of the erasure of history. Such responses are intrinsic to the history of monuments, and always have been.[7] History persists, and the question is rather which forms it will take or keep.

Monument debates in the second decade of the twenty-first century often turn on the question of who is represented by whom. This is understandable and pertinent, pointing to the entanglement of hegemonic power, access to

Who cares? An introduction 3

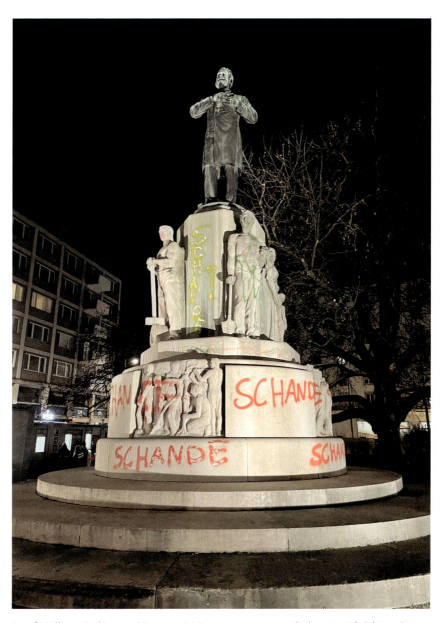

Josef Müllner, *Karl Lueger Monument*, Vienna 1913–17, unveiled 1926, with "shame" painted onto base. COVID-19 test stations in the background.

0.2

public space, and political representation. How important the construction of history is in these condensed symbols that are monuments, memorials, plaques, or commemorative rituals cannot be overstated, and makes monument activism an urgent part of the broader claim to being part of and recognized in society.[8] This means that monuments also function in accordance with the classic aesthetic concern with appearance, contrasted not so much with reality (which as we saw is always complexly and sometimes very loosely related to commemoration) as with invisibility. However, without an audience, monuments communicate, at most, abstract political power: the sheer power to put things in space and keep them there, guarded by law enforcement if necessary. On the other hand, people can take on monumental concerns, if by that term we understand both problems too large to be tackled alone, and the making visible to others of our engagement with such problems. "Especially when those appear who are not supposed to appear, we see as well how the sphere of appearance, and the powers that control its borders and divisions, is presupposed in any discussion of who the people are," Judith Butler observed in a December 2016 interview reflecting on Donald Trump's rise to power.[9] She had in mind protest, not monuments, but the visibility of political aims connects monuments and their audiences, who are sometimes actors in public space. The knitting and wearing of "pussy hats" around the worldwide phenomenon of Women's Marches protesting Trump's inauguration is both such an act of visibility (political-aesthetic appearance) and perhaps the most ambitious distributed monument of recent years.

Monumental concerns

Monumental Cares takes many cues from the current monument debate, but the wordplay of the title hints at a broader aspiration. The life cycle of monuments is not exhausted in their erection, removal, modification, or survival. Without care, objects and sites can disappear, and without care for commemoration and for public discourse, the past will not help us fight for a better future. "Care" is literal, and figurative at the same time: we care for the things we care about.[10] If monuments function at all, they do so by materializing history in ways that connect to people, places, times *and* monuments: and not just by recalling memories tied to one privileged site of past events, any more than by evoking feelings or attitudes connected to one physical material. As we will see, history materialized in this way requires not just sites and their active use by people, but modes of mediation, technical as well as aesthetic, which I will analyze in diverse historical configurations under the rubrics of transparency and realism.

The title *Monumental cares*, then, relates to monuments, but also to events that strike us as monumental, looming, possibly overwhelming, such

as climate crisis, migration, local and global political tensions. Not that these phenomena are equivalent: but we face similar problems in conceiving, discussing, and acting on them. My art-historical contribution in this book is to show how such concerns inform public history and how spatial practices, from monuments and architecture to diverse forms of artistic practices, claim space for such history to be seen. Struggles over the role of monuments in public space taking place around the world are not a distraction, but one such phenomenon reflecting on the others, and on the use of urban space and resources more generally. This means that care encompasses care for our environment, from our places of dwelling to the planet. Nor is care strictly practical or future-oriented. Care extends to objects or sites that allow access to the past, with which our present and future is intertwined.[11]

Activism for or against monuments can itself be seen more capaciously as care applied to society and its members, which translates into specific discussions not just of monumental program, iconography, and ideology, but also and perhaps more urgently, about monumental materials, methods of production and distribution. Let me start with an example: On December 2, 2017, Cai Guo-Qiang detonated a polychrome mushroom cloud on the roof of Regenstein Library at the University of Chicago, some fifty meters from the location of the first controlled nuclear chain reaction seventy-five years earlier. The "pyrotechnic artwork," as the University's news outlets described it, or *Color Mushroom Cloud*, as the artist entitled his preparatory sketches and the ensuing documents, sent an ambiguous message into the autumn sky [Figs. 0.3 and 0.4]. As temporary attraction and towering aerial monument, its dual character could be seen as a concession to the ambivalent outcome of the discovery, a reminder of the pathological hype surrounding the beautiful spectacle of nuclear explosions, or a spectacular gesture affirming the university's priority in nuclear research.[12]

This definite if not obvious ambivalence carries over to the fact that Cai's colorful work is perfect for being photographed.[13] The event lives on in images, which in themselves become tools of commemoration, narrative, or activism. Circulating both bodily and electronically, from author to paper and from cellphone to cellphone, they are neither fully tethered to, nor fully disengaged from, the Southside Chicago site of the explosion. Just so, they allow bodily involvement through imaginative identification with the on-site audience (most evident in the corporeal attachment of smartphones to hands) as well as a historically distanced spectatorship, interested perhaps in the whole sequence of reception of Chicago Pile-1. This reception would include the bronze sculpture commissioned from Henry Moore for the twenty-fifth anniversary (visible in Fig. 0.5) which occupies the pavement around which Cai's audience assembled, or the students lying down during the detonation in a protest-performance organized by India Weston[14] [Fig. 0.6]. It is the layered

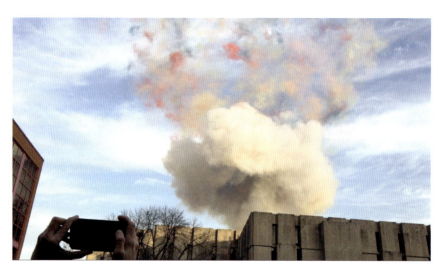

0.3 Cai Guo-Qiang, *Color Mushroom Cloud*, December 2017, University of Chicago.

and intricate interaction of materials, media, activism and commemoration, ultimately, the making public of history in contemporary works of art, but also buildings, urbanistic projects, institutions (in this case a university) that forms the subject of this book. Doing so in a way that is attentive to care and the materialization of history as they play out in space requires thematic and methodological departures from traditional debates about memorial culture and sculpture in public space.[15]

Commemoration, activism, and a rapid ramification of accompanying activities across social networks come together distinctively around Cai's work, but *how* they do so is typical of early twenty-first-century art and political struggle. All these complicating factors are relevant if we want to understand the contemporary life of monuments, how contemporary commemoration works, and how it relates to community activism and demands for representation. That social media has become part of how our bodies in physical space interact with others in virtual space complicates any easy analysis of such works "on the ground," as well as their audiences and reach. It also complicates what we understand as site, and the expressive and practical role it plays in art and activism. The cooperation of work and site in cases like Cai's (and in public art and commemorative objects and events generally), functions in union with the photographic image, indexing software, and the smartphone—both in the moment of creation and later as it is disseminated on social media. Importantly, such mediation takes place always in tandem with, or better said as *one part of* contemporary historical consciousness, rather than usurping its place. Nor is this process fully removed from bodily

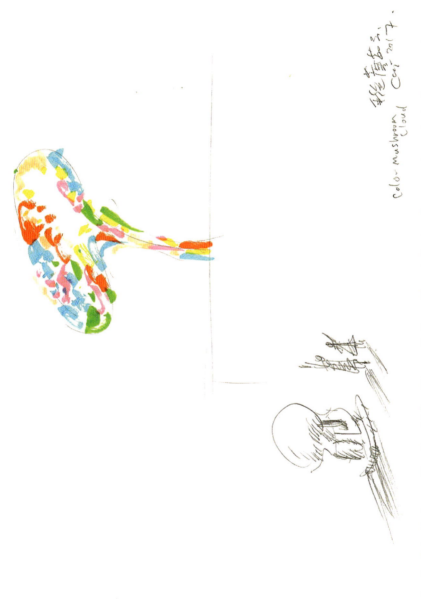

Sketches for *Color Mushroom Cloud* by Cai Guo-Qiang with Henry Moore's Nuclear Energy sculpture in the foreground.

8 Monumental cares

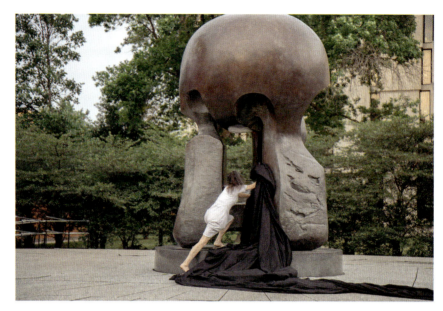

0.5 Eiko Otake performing *They Did Not Hesitate* on August 7, 2021, in interaction with Henry Moore's *Nuclear Energy* sculpture on the campus of the University of Chicago.

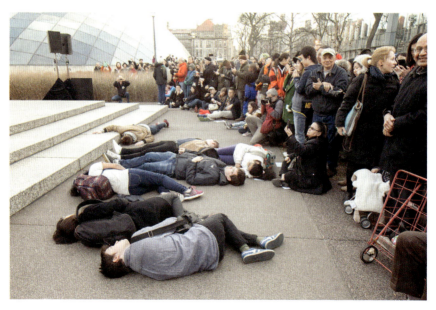

0.6 Students protesting against nuclear energy and what was seen as its celebration by the University of Chicago, December 2017.

involvement with the concrete materialities and sites—the widely felt need to identify the "precise" or "authentic" site of historical events meant to be reenacted or commemorated being one of its indications. It is striking, for instance, that four years after Cai, the Henry Moore plaza at the University of Chicago again served as stage for ambitious, and this time decidedly antinuclear, public art. A collaboration of the School of the Art Institute (SAIC), the nonprofit organization Bulletin of Atomic Scientists and the Linz, Austria-based *Ars Electronica* new media art festival, *Start a Reaction* featured digital and live projects, including an August 2021 dance-performance around, atop and through the Moore statue by Japanese performance artist Eiko Otake, who linked this protest work, *They Did Not Hesitate* (involving an audience of volunteers lying down on the plaza), with a performance she held a month later in Battery Park, New York, serving as an alternative 9/11 memorial[16] [Fig. 0.5]. What we see in this call-and-response is no dematerialization of history, but its variable and complex embodiment around persistent issues of concern, requiring an equally nimble art history to take its pulse.

Material matters

The insistently political themes of many prominent artists—refugees and borders, capitalism and consumption, environmental destruction, activism and agency—don't just reflect present-day anxieties of the educated liberal classes, even if we must admit that they do that too. They are also historical through and through, from the way the problems are posed to the way they are written into the history of art and other discourses, including political activism, with which they seek to establish contact. But art's ways of being historical differs not only from the history taught in schools and commemorated on national holidays but also from the self-reflexive, narratively troped, stylized and subjective history-as-a-discourse that has attracted so much scrutiny in university humanities departments over the past few decades.[17] It is, to put it in a word, *material history* or a history embodied in matter, in objects and modes of making, as well as in the concrete and technological ways these things are reproduced, disseminated, or otherwise mediated to audiences near and far and to a posterity which may radically diverge from its makers and their contemporaries. The concept of materiality, and various theoretical orientations privileging *things* or *objects* or matter, are certainly also concerns of the moment, linking up to various classical philosophical, scientific and literary discourses.[18] Amid this growth of recent interest both in materiality and history within contemporary art, the *combination* has not been much emphasized, and the difficulty, at least for my undertaking, is that the two have also been positioned as exclusive, perhaps because history is seen as explicitly anthropocentric and the new materialism decenters this focus.

The situation is rather different in memory studies, which in recent years have increasingly insisted that memory is "mediated by society, language, and representation: films, photographs, artworks, texts, memorials, monuments, stories."[19] But history, which advances less personal, more public arguments about the past, seems less embodied, perhaps because of our opposition of reason and embodiment.

I don't think we can rest with a disembodied view of history, if we are to understand its materalization in contemporary art. As a scholar writing extensively on performance art and ephemeral, time-based commemorative practices, I need to first explain how I see history's relation to concepts such as material and care, and how this will illuminate the pages ahead. I have always made the case that real ephemeral practices anchor history in various ways, from narratives to remnants, relics, photographs, and video documentation. Photographs, films, and more recent storage technologies are sophisticated material bearers of performance in its *longue durée*, stabilizing past acts and presenting them in certain specific ways to latecoming audiences. This seeming, but only seeming, contradiction between the passing and its inscription was at the heart of my theoretization of performance as enabling a new public art of memory. By becoming monumental, and hence acquiring history, through its documentation, performance came to function much like commemorative objects, which some performance artists went on to design. In that particular context, the "rematerialization" of a public art with pretensions to ephemerality was an empirical fact and not yet an object of critical attention.[20] In retrospect, it is evident that my discussion of the efficacy of speech acts of "taking responsibility" for historical events, characteristic as it is of participatory Holocaust monuments, is also implicitly related to concepts of caring. Both words and deeds can change the social fabric in concrete ways. As speech acts require a social context to have binding force (witnesses, documents, follow-through), they in fact require and make possible a more flexible approach to materiality, beyond the traditional concern with durability, medium specificity, and the static political iconography of various building materials, like marble or bronze. Fortuitously, Giuliana Bruno's 2014 book, *Surface*, has paved the way for an expanded understanding of materiality, one not focusing exclusively on specific materials and their properties, but rather on the way different materials interact and change in being mediated. Outlining a "refashioning of materiality," Bruno asks about the place and role of materiality in "this age of virtuality." One form of such materiality is the screen, a "surface condition [that] has body and depth," approached via "material relations" (as opposed to mere sustantival materials) and "the space of those relations."[21]

This approach is especially suggestive for film and media studies, but it also grants the art historian new terms for thinking beyond the live/mediated

and real/virtual oppositions, connecting monuments, sites, and performances to the outwardly spiraling discourses they participate in. Bruno's approach allows me to look at social media activities and the digital life of monuments without losing sight of the spatiality that is crucial to building bridges to history. As mentioned, one appeal *and* potential drawback of materiality and object-centered theory has been its supposed decentering of human agency, welcome by many who are engaged in the cultural study of the Anthropocene. While I find the attempt to move away from a parochially human-centered view important (particularly today), that benefit must be sharply distinguished from the ignoring of all human agency—I don't think this is even possible, in writing or thinking or acting. Bruno evades such oppositions with a relational approach that combines materialism with affect theory and the study of subjectivity, analyzing "folds of history" in projected images by contemporary artists.[22] In a 2016 questionaire, Bruno clarifies the implications of her stance: "Concern with materiality … does not put an end to human subjectivity, for this is fundamentally a relational matter. Materiality is an active zone of encounter and admixture, a site of mediation and projection, memory and transformation."[23] This relational approach opens up channels of communication between history and the material, both as constructed by human actors (not just artists and historians) and as a site of ongoing historical change.

This approach allows me to position myself at a productive distance from what might be called the historical turn in contemporary art. This turn overlaps considerably with but is not identical with the rise of memory studies and monument-making since the "memory boom" or "industry" of the 1980s and 1990s, which has attracted a perceptive but conflicted theoretical response. In Andreas Huyssen's memorable aphorism, "Historical memory is not what it used to be."[24] He meant that a strong interest in the past ("Present Pasts") had usurped utopian visions for the future, with a contentious unstable contemporary boundary between past and present.[25] In a 2018 interview, Huyssen warned that digital technologies would undermine critical memory:

> So we live under very contradictory conditions: on the one hand there is this hypertrophy of memory in our public sphere […]; on the other hand, there is a structural tendency to forget and to live exclusively in and for the moment. Facebook and Instagram are but two of the platforms that increasingly shape the social experience of time and space, in which algorithms suck distinct temporalities into a timeless now.[26]

While I appreciate the danger of social media creating a "timeless now," this threat is not unique to these particular modes of discourse, and anxieties of this kind met technologies like television, perhaps with equal pertinence.[27] it seems more productive to treat them as part of mediated representation,

reaching into real spaces and beyond them and open to various temporal registers. In a recent, striking account of the historical stakes of contemporary art, Jane Blocker diagnoses a crisis of contemporaneity stemming precisely from this precarious relation to the past, tackling the memory boom and methods that "privilege stable and coherent origin (even as we question how we understand historical agency, cultural interaction, and the causes of historical change)."[28] Blocker is sympathetic to the various studies of the fragmentation, unreliability, and polyvalence of memory and the historical narratives it gives rise to, but fears that the emphasis on memory naturalizes and re-inscribes a naive faith in origins. She urges instead attention to the artfulness of historical uses of memory, its reliance on imagination and aesthetic form to connect frankly fictional or artificial constructions to the real substance of the past. To this end, Blocker revives the concept of the "prosthetic" by which we might make contact with real events in the past (think of historical discourse as a prosthetic limb facilitating a real function).[29] A prosthesis "comes after" the object it replaces and stands for it. That is of course accurate and evocative for a variety of contemporary artworks dealing with the past, as are other concepts with a semiotic and deconstructionist lineage, such as index and trace. However, since the past is *not* just a body or object being replaced or mourned, a question arises about the status and validity of prosthetic substitution, in art and scholarship. The strategy of historical fictions and imaginative association is liable to misuse. Blocker's commitment to politically transformative art and what she calls "truth-telling lie" suggests that there is a difference between good and bad prostheses.[30] If so, it is hard to locate in the metaphor, which insists on the artifice, not ways of evaluating it.[31]

A different picture of the materiality of history arises from Linda Tuhiwai Smith's classic *Decolonizing Methodologies* (1999). Like Blocker, Smith thinks the "modernist" conception of history, with its universalizing progress narratives and othering and objectification of colonial subjects, offers neither true nor helpful models for political emancipation:

> We assume that when "the truth comes out" it will prove that what happened was wrong or illegal and that the system (tribunals, the courts, the government) will set things right. We believe that history is also about justice, that understanding history will enlighten our decisions about the future. *Wrong.* History is also about power. In fact, history is mostly about power. It is the history of the powerful and how they became powerful.[32]

Despite this, Smith does not accept a turn away from historical research, nor does she relativize it as artifice: "At the very least it helps us make sense of reality."[33] Besides revising methods and concepts to better reflect that reality and its needs, Smith urges a necessity to recover Indigenous "language and

epistemological foundations."³⁴ Is this a separate demand—a political one, distinguishable from the project of understanding history? Not according to Smith:

> The idea of contested stories and multiple discourses about the past, by different communities, is closely linked to the politics of everyday contemporary indigenous life … These contested accounts are stored within genealogies, within the landscape, within weavings and carvings, even within the personal names that many people carried. The means by which these histories were stored was through their systems of knowledge. Many of these systems have since been reclassified as oral *traditions* rather than histories.³⁵

The critique voiced here has wide-ranging implications, beyond their pertinence to Indigenous practices of research and the decolonization of art history. The historical modes of knowing enumerated by Smith are *embodied* in social practices (naming) as much as places (landscape) and artifacts. To see how this embodied history can become legible, surfacing in objects and events and the discourse that builds up around them, how this materialized history can *matter* to the most urgent debates to which art and urban activism contribute, we must be flexible in how we think about not just history, but its materialization. This term—tracking as it does in its substantivized verb form the *process* or processes by which history resurfaces, is sedimented, or built up in objects, relationships and practices—is more apposite to pursuing the relative density of history, its links with care and mediation than a rhetorical focus on matter, materiality, and object-orientedness. Studying materialization in contemporary art and monuments *is* doing the history of materials, but also showing how mediation of all kinds allows history to materialize.

The way this works is multidirectional. I take the adjective from an important study I discuss in the next chapter, Michael Rothberg's *Multidirectional Memory: Remembering the Holocaust in the Age of Decolonization*.³⁶ Rothberg starts from the historical fact that the Holocaust was always entangled with theories of decolonization to argue "against the logic of competitive memory" and for a pluralistic practice of memory, in which "memory works productively" to highlight shared concerns, so that, for example, Holocaust commemoration can draw greater attention to the afterlives of slavery and colonialism.³⁷ Rothberg is concerned especially with traumatic histories of genocides and colonization in Germany and Northern Africa, arguing that multidirectional memory can help connect historical struggles rather than one fighting for visibility over the other: "What the histories of the African diaspora in the Caribbean and the Jewish diaspora in Europe share is not any 'positive' experience, but rather the negativity of rupture and the necessity of imaginative work that spans that abyss."³⁸ When I in turn call multidirectional the way space directs our attention to different historical layers, even

layers that accrue after the fact, just as a monument can become relevant in very different future contexts, the affinity with Rothberg's usage is how multi-directionality sees multiple historical references reinforce one another and build connections rather than competing in univocal "memory wars."

Adapting this concept by taking the spatial metaphor of directionality literally allows us to see how object- or event-based artworks are influenced by, and themselves influence, real sites, social mediation, and canonization, finding engagements with history in works ranging from dance to activism, from folk art to performance, reenactment, and actual monuments. Space in all these cases does not simply work figuratively, but it does so as well. Just as Cai's colored explosion is not just *one* material or material history, pointing simultaneously to the Chinese invention of gunpowder and the uneasy colonial history of ballistic weapons, to nuclear test sites in the Southwest and the Pacific and the destruction of Japanese cities during the Second World War, and Chicago's own role in some of these events, our accounts of objects and acts of commemoration must reflect and make sense of densely overlaid historical patterns. There are obviously different valid ways to approach the materialization of history, but do so we must if we hope to give any adequate account of contemporary art at its most ambitious.

The guiding thread connecting these phenomena is the power of monuments to tie strands of the past together to a particular present on a particular site, and to present that complicated interaction of times and (potentially shifting) place to a future that includes them but may itself take on radically distinct physical and discursive guises. The concrete coming together of past, present, and future in monument forms is what opens up real multidirectional spaces. In Henri Lefebvre's aphorism, "the use of the cathedral's *monumental* space necessarily entails its supplying answers to all the questions that assail anyone who crosses the threshhold."[39] Spatial relations are one way to address the multiplicity of people encountering particular histories, though it can hardly be a "one concept fits all" solution. The theory of performativity and its mediation provides a through-line, connecting ephemeral, durable, and distributed practices as well as contemporary artists to histories, social, political, and environmental. Such interactions do not stop in one particular present moment, and a multifaceted public history with all the expected messiness and inconsistensies accrues around its aesthetic materializations.

Monuments, then, will play a key part in my narrative, but so will art that connects to and politicizes history more quietly: through the use of particular materials, via reenactments, reuse and interventions in architecture, and through historically evocative images, in particular images claiming the moral and perceptual clarity associated with an allegedly discredited notion of realism. Before laying out the case studies and concepts of historicity they bring up, it is worth reflecting on the stakes and need for such a study.

In placing several varied strands of recent and not-so-recent art under the lens of materialized history, I have to be careful to resist the claim that history is a common denominator or the dominant trend in art of the present. I teach art history in an art school, and I know that matters are far more complicated: persistent student interests in identity, site, ecology, and, yes, materials (or materiality) do not combine seamlessly, nor do they issue in a blanket concern with history as a topic of or an approach in the art world. But that is all the more reason to dig beneath the surface, and to notice analogous processes at work in artmaking and reception and debates that seem to embroil vast publics, such as those over the continued presence of colonial monuments, or over environmental racism in industrial cities in the United States and beyond. The reason history matters in such forums in public life *and* in contemporary art is that it sheds light on and at the same time permits the questioning and revision of the manifold political, personal, and theoretical comitments people bring to the study of art. *How* histories are manifested, shown to others, made to last, and interpreted, is intrinsic to understanding the world, to say nothing of changing it. Without any monolithic claim of primacy, I do regard the materializations of history as an urgent and insufficiently explored throughline of twenty-first century art.

What the book does

The following chapters bring together my research and public engagement of the last seven years, but they also follow a narrative sequence into modes of thinking that have influenced my work, and questions that arise once we conceive the multidirectionality of history spatially. In particular, while multidirectionality explains much that seems obscure or diffuse in recent projects and debates, insistent questions arise and recur: for instance, what is the valence of site under the pressure of apparently deterritorializing (social) media? Answering such questions will lead to an expanded notion of geographical specificity, but in turn will raise new questions of a media-theoretical nature, in particular about the way photographic reproduction, digital dissemination, and the physical translucency and transparency that is often their operative metaphor act to make visible or occlude history. From here, art theory, and its assumptions about the legibility of historical actions, and the bodies and places that compose them, will have to be interrogated. Finally, bodily presence, at the core of both performance and monumentality and repeatedly challenged and restored in postwar public art, will be investigated as a vehicle of the rematerialization of history in the distinctive contemporary paradigm of reperformance and reenactment. These issues are complicated, and the chapters devoted to them only make a start in untangling them: for which reason, their insights and arguments are

deepened by alternating case studies that approach the preceding questions in fresh detail.

I begin with the historically plural nature of site-specificity (Chapter 1), proposing a multidirectional model of site, not completely free-floating or sublimated into the disembodied sphere of discourse, but responsive to specific audiences and the means used to reach them. My relocating of the discourse around site looks at the current monument debate in the United States, updates Miwon Kwon's study *One Place after Another*, broaches the site-specificity of remote access, and complicates the role of the body and its situated relations to history. This chapter builds up to a multidirectional model of site, which will allow me to then reach back in time to the early Cold War and the first tentative efforts at Holocaust commemoration (Chapter 2) to reconsider the abstract concept of the "citizen" in a particular but highly heterogeneous site of migration and globalization, Berlin after the Second World War, in which "community-based," "for the community's sake" and similar formulas were and remain open questions, not reassuring certainties. I read two memorials of the 1950s in their historical setting to then ask how this particular history might be taught to a contemporary audience of citizens/residents, in particular those who have arrived recently. I proceed to move out into geography (Chapter 3) in an effort to place the isolated sites of art discourse in the world that makes and perceives them. Geography's signature activity of mapping can be made useful to understanding the shifting and malleable arguments applied to real territories by performance artists and monument-makers operating on very different time and spatial scales. Artists themselves have recently engaged in geographical thinking, which, if we follow a dynamic model outlined by Doreen Massey, can bridge past and present, and concerns about migration and resource extraction.

Chapter 4, like Chapter 2, is a case study testing the theories built up in the previous chapter. Looking at art and architecture in Bucharest, I discuss the relevance of history, mediation, and public space in its Eastern European context before and after the fall of state communism in 1989. Examples outside, and then inside, the capitalist framework show how mediation and politics play out differently in differently structured public spheres, even when these are contiguous, but also how the public/private divide itself evolves with the art and architecture reflecting on it. The Cold War comes to an end in this chapter, but haunts the sites and geographies it shaped just as it continues to do in Berlin. To continue the engagement with mediation and its materials, Chapter 5 looks at assumptions about immediacy and clarity of access implicit in our mediated culture. Juxtaposing modernist ideas about transparency, glass, and the photographic lens, it brings together techniques of mediation old and new and relates them to history and spatiality, arguing for a critical transparency. In Chapter 6, the mass-media circulation of political

imagery in Honoré Daumier's celebrated lithograph of the Rue Transnonain massacre is compared to that in Ai Weiwei's notorious photographic reenactment of the dead child Alan Kurdi as classic and contemporary varieties of aesthetic realism. The conclusion points to an ethics of caring—for and about—monuments, of all things, as itself a means of activism, reflection, and engagement with history in the present.

In all chapters, I bring a new understanding of site in various stages of mediation. Social media is only one, if a powerful, means of publicity: online platforms and their relevance in the construction of commonness, identity, and historical precedence need to play a role in this investigation. That said, they do not operate alone, but in concert with local and distributed political, commercial, and critical conditions and imperatives. Throughout, mediation in different artistic registers is connected with the problems of site and geography—ranging from histories of urban development to broader structures extending beyond national boundaries—and to the nature of representation in art. The question of realism, in light of daily revolutions in our use of media, becomes: what reality is at stake in art, and what technologies and strategies mediate it?

I change my frame and scale several times in this book, adopting a multi-directional approach with different foci. For this reason, too, I eschew a strict dichotomy of area specialism and relatively placeless 'global' contemporary art history, discussing issues of more than local significance in the theoretical chapters (1, 3, 5) and grounding them, there as well as in the more concentrated case studies (chapters 2, 4, 6) in recurring (East) European, North American, and Asian sites of political and aesthetic contestation. This specificity is in turn never allowed to ossify into regional exceptionalism, but brought back into contact with transnational debates and the international art world. In the process, I want to show that I am as much directing what we see—hence making history—as allowing the work and its various levels of appearance to direct the investigation. While the individual chapters are fairly self-sufficient, I hope to show how the complexities, and ever-emerging new directions are neither entirely contingent nor prevent us from finding affinities in different regions of the historical fabric. This should not be interpreted as a return to postmodern relativism or skepticism about grand narratives, nor their playful invention. Narrative or not, the present certainly throws up grand problems, or monumental concerns, and these contemporary conditions are quite historically specific and require systemic changes, commitment, and thoughtfulness: in a word, care. This is connected with a renewed interest in aesthetic attitudes that postmodernism had dismissed as naive, particularly nineteenth-century realism with its placement of the individual in historical perspective.

Care won't solve any historical problem by itself, but it is arguably indispensable in connecting art to history. I address artworks whose materials, and

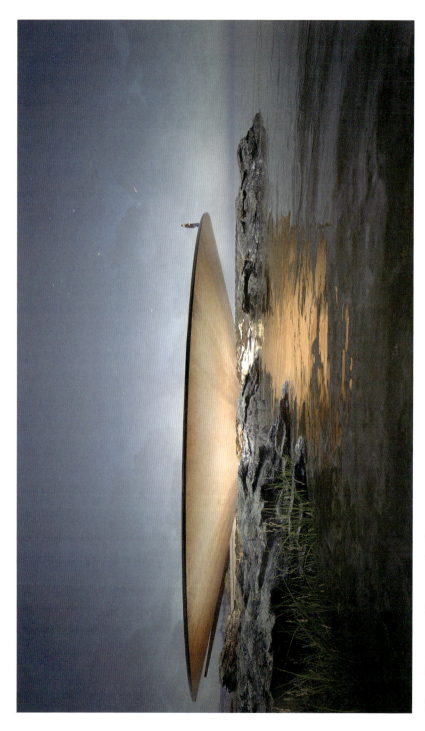

0.7 Gómez Platero, *World Memorial to the Pandemic*, Montevideo, 2021.

ways of involving audiences in states of care, bear a historical burden of representation. In turn, I read the current debates as a historian firmly anchored in the twenty-first century: a geographical reading today must acknowledge concepts of resource extraction which touch on materials used for monuments, or the effects of the Anthropocene forcing populations to leave countries and seek refuge in the North.[40] This has concrete consequences for my art historical endeavor, from the changing audiences in Germany with corresponding challenges for Holocaust education to the pressing need to make public and commemorate the lives lost on the dangerous routes into Europe. Today's audiences often operate at the intersection of material and virtual space (via smartphones), becoming audiences and at the same time producers of encounters with urban environments and history. This in turn influences projects on the ground. Just think about the proposal by Gómez Platero for a *World Memorial to the Pandemic*, a round, shallow minimalist funnel off the Uruguayan coast, to be connected to land by a narrow walkway, the renderings of which floated on social media accounts and online journals in the summer of 2020[41] [Fig. 0.7]. This design felt particularly aloof, even utopian, in its appeal to physical mobility as the world faced quarantines; but artists everywhere strive to integrate digital regimes into their practice, allowing us to see the entanglement of the mediated and the physical. In this as in many of the public artworks and memorial projects that matter today, site, materiality and mediation work together in ways that materialize one of our concepts that is hardest to visualize, history.

Notes

1 See "A Questionnaire on Monuments," *October* 165 (Summer 2018), 3–177. Around the same time, I co-edited, with Jorge Otero-Pailos, a special issue of the journal *Future Anterior*, "Ex Situ. On Moving Monuments" (vol. 15/2, 2018), and in 2020, the Mellon Foundation announced the 250-million-dollar *Monuments Project* to "support efforts to recalibrate the assumed center of our national narratives to include those who have often been denied historical recognition." https://mellon.org/initiatives/monuments/ (accessed January 13, 2020). Their first grant was to *Monument Lab*, a public art and research studio based in Philadelphia founded by Paul Farber and Ken Lum in 2012. See the interview "Paul Farber and Ken Lum on Reimagining Symbols and Systems of Justice," *Artforum* (June 23, 2020), www.artforum.com/interviews/paul-farber-and-ken-lum-on-reimagining-symbols-and-systems-of-justice-83303 (accessed January 13, 2021). A "National Monument Audit" by Monument Lab was published on September 29, 2021. https://monumentlab.com/projects/national-monument-audit (accessed September 29, 2021).
2 Quentin Stevens, Karen Franck, and Ruth Fazakerley, in "Counter-monuments: The Antimonumental and the Dialogic," *The Journal of Architecture*, vol. 23 (2018),

718–39, claim that traditional monuments occupy prominent sites, while counter-monuments occur in mundane places. This is not always the case, but even as a tendency it is important. See also the contributions to Inbal Ben-Asher Gitler, ed., *Monuments and Site-Specific Sculpture in Urban and Rural Space* (Newcastle: Cambridge Scholars Publishing, 2017).

3 See Ansley Heller, "Breaking Down the Symbols: Reading the Events at Charlottesville through a Postcolonial Lens," *Southeastern Geographer*, vol. 58, no. 1 (Spring 2018), 35–38, and of course Kirk Savage, *Standing Soldiers, Kneeling Slaves. Race, War, and Monument in Nineteenth Century America* (Princeton: Princeton University Press, 2nd edn, 2018), which features a new preface. An interesting article about the myth around Columbus is Thomas J. Schlereth, "Columbia, Columbus, and Columbianism," *Journal of American History*, vol. 79, no. 3, Discovering America: A Special Issue (December 1992), 937–68. Erika Doss, *Memoria Mania: Public Feeling in America* (Chicago: University of Chicago Press, 2010), is an important contribution explaining the national(ist) agenda behind official monuments in the twentieth-century United States, and in thinking about alternative models of grieving. On the change in official state commemoration in the US, the authoritative text is probably Harriet F. Senie, *Memorials to Shattered Myths: Vietnam to 9/11* (Oxford/New York: Oxford University Press, 2016).

4 Besides the usual US cases, it is worth considering the 2018 damage to Ilya Repin's 1885 *Ivan the Terrible and his Son Ivan* in Moscow's Tretyakov Gallery; the vandal, who attacked the painting after drinking 100 g of vodka in the museum's café, shouted that Ivan did not kill his son, and in court defended himself on the rationale that the painting was historically false. It is probably no coincidence that new monuments are being constructed *to* Ivan the Terrible (e.g., the 5m tall equestrian bronze unveiled in the city of Oryol in 2016. See "Monument fever takes hold in Russia," *DW*, 14 October 2016, www.dw.com/en/monument-fever-takes-hold-in-russia/a-36047241.

5 On Lueger, see John W. Boyer, *Political Radicalism in the Late Imperial Vienna: Origins of the Christian-Social Movement 1848–1897* (Chicago: University of Chicago Press, 1981); for the current debate, see Oliver Moody, "Karl Lueger: Statue of Hitler's favourite mayor stands tall," *The Times* (November 9, 2021), www.thetimes.co.uk/article/statue-of-hitlers-favourite-mayor-stands-tall-slbkw0h3c (accessed February 8, 2022).

6 I am part of the expert committee drafting the call for a competition (initiated by the city of Vienna) to recontextualize the monument. Austrian artist VALIE EXPORT has taken on the monument many decades ago in the work *Adjunct Dislocations* (Adjungierte *Dislokationen I*, 1973). With one super-8 camera mounted on her back and one on her chest, EXPORT walked from an apartment in Vienna through parts of the inner city and then on to the suburbs. At one point, EXPORT surrounds the Lueger monument with her butt turned towards it.

7 This mutability of monuments has been a classic theme already of Vienna School art history, notably in the work of Alois Riegl, who, after all, was a preservationist. See Alois Riegl, "*The Modern Cult of Monuments*: Its Character and Its Origin" [1903], trans. Kurt W. Forster and Diane Ghirardo, *Oppositions* 25 (1982), 21–51.

Recently, amidst the American monument debate and the rampant destruction of ancient structures in the Middle East, contemporary and ancient phenomena of iconoclasm have been discussed, for example, James Osborne, "Countermonumentality and the Vulnerability of Memory," *Journal of Social Archaeology*, vol. 17, no. 2 (2017), 163–87, which compares the reception of a Confederate monument in Maryland with those of Syrian and Anatolian Iron Age monuments, and Aaron Tugendhaft, *The Idols of ISIS: From Assyria to the Internet* (Chicago: University of Chicago Press, 2020).

8 For the distinction and connection between recognitional and redistributive claims, see Nancy Fraser, *Justice Interruptus: Critical Reflections on the "Postsocialist" Condition* (London: Routledge, 1997), chapter 1.

9 Christian Salmon, "Trump, Fascism, and the Construction of 'the people': An interview with Judith Butler," *Verso Blog*, December 29, 2016, versobooks.com/blogs/3025-trump-fascism-and-the-construction-of-the-people-an-interview-with-judith-butler (accessed February 2, 2017). See also Butler, *Toward A Performative Theory of Assembly* (Cambridge, MA: Harvard University Press, 2015).

10 No allusion to Martin Heidegger's philosophy is intended. The use of the same word for acts of caring and states of mind of worrying is revealing, because our concerns do inform our actions; but the word is incidental.

11 First prominent in feminist discussions, "care ethics" has emerged as a powerful category from psychology to architectural discourse. The most prominent attempt to theorize an ethics of care in relation to gender is Carol Gilligan, *In a Different Voice: Psychological Theory and Women's Development* (Cambridge, MA: Harvard University Press, 1982). The suggestiveness of this classic study is not undermined by its dubious essentialism about the caring nature of women. For contemporary use of the term, see Angelika Fitz and Elke Krasny, eds., *Critical Care: Architecture and Urbanism for a Broken Planet*, exh. cat. Architekturzentrum Wien (Cambridge, MA: MIT Press, 2019), and "On Care as Practice: Conversation with Elke Krasny," *Conversations 7: Architecture as Measure*, Turkish contribution to the Venice Architecture Biennial, 2021, 1–9.

12 The literature on nuclear weapon photography and its aesthetics is vast: see, among others, Rachel Fermi and Esther Samra, *Picturing the Bomb: Photographs from the Secret World of the Manhattan Project* (New York: Abrams, 1995), Bryan C. Taylor, "Nuclear Pictures and Metapictures," *American Literary History*, vol. 9, no. 3 (Autumn 1997), 567–97, Peter Kuran, *How to Photograph an Atomic Bomb* (Blacksburg: VCE, 2006), John O'Brian, *The Bomb in the Wilderness: Photography and the Nuclear Era in Canada* (Vancouver: UBC Press, 2020), and *Flashes of Light, Wall of Fire: Japanese Photographs Documenting the Atomic Bombings of Hiroshima and Nagasaki*, exh. cat. Briscoe Center for American History (Austin: University of Texas Press, 2020). Significant "art books" of nuclear photography include the archival Michael Light, *100 Suns: 1945–1962* (New York: Knopf, 2003) and Peter Goin, *Nuclear Landscapes* (Baltimore: Johns Hopkins University Press, 1991), available at www.onlinenevada.org/nuclear-landscapes-nevada-test-site-peter-goin.

13 Seeing the image in black and white, as in Mechtild Widrich, "Ex Situ, On Moving Monuments," *Future Anterior: Journal of Historic Preservation, History, Theory, and Criticism*, vol. 15, no. 2 (Winter 2018), 132, misses an important dimension, the sheer, startling Technicolor polychromy applied to the familiar mushroom cloud motif.

14 For criticisms of the artwork's alleged celebration of the university's role in nuclear technology, see Luke Fidler, "Harmless Public Art? Cai Guo-Qiang at the University of Chicago," *Chicago Artist Writers*, 10 January 2018, accessible at https://chicagoartistwriters.com/harmless-public-art-cai-guo-qiang-at-the-university-of-chicago/. See also Claire Voon, "Cai Guo-Qiang's Pyrotechnic Mushroom Cloud Commemorates the First Nuclear Reaction," *Hyperallergic* (December 5, 2017), https://hyperallergic.com/414946/cai-guo-qiangs-pyrotechnic-mushroom-cloud-commemorates-the-first-nuclear-reaction/. Voon also interviewed the organizer of the student protest.

15 Which is not to say these debates lose their interest. My first monograph, *Performative Monuments* (Manchester: Manchester University Press, 2014) participated in debates on commemoration and art in public space. Holocaust commemoration remains a key paradigm for thinking about monuments, alongside other, related, monumental cares.

16 According to publicity of the August 7 "culminating event," the performance was frankly anti-nuclear, "Eiko asks: How can we stop celebrating the history of massive killings and technology that made it possible?" www.chicagogallerynews.com/events/start-a-reaction-in-person-event (accessed 28 August 2021). See also www.startareaction.org and https://ars.electronica.art/newdigitaldeal/en/start-a-reaction/. The project is headed by the School of the Art Institute of Chicago's *Institute for Curatorial Research and Practice*, a longer-running collaboration whose first project is *Start a Reaction*. Two art history students at SAIC, who volunteered, describe their experiences in their respective MA theses: Lynette Shin, *A Body in Places: Performative Monumentality in Eiko Otake's Spectral Performance*, School of the Art Institute of Chicago, 2021, and Elise Butterfield, MA thesis forthcoming 2022.

17 It also differs from the generalized historicity of hermeneutics, according to which all human life is a matter of relating to tradition and the presuppositions with which it equips us. See Hans-Georg Gadamer, *Truth and Method* [1960] (New York: Continuum, 1994), chapter 4, and Kristen Gjesdal, *Gadamer and the Legacy of German Idealism* (Cambridge, UK: Cambridge University Press, 2009). This approach understandably tends to downplay materiality.

18 At the risk of leaving much out, a vibrant starting point is Jane Bennett's *Vibrant Matter: A Political Ecology of Things* (Durham: Duke University Press, 2010), which has been criticized for neglecting issues of race and gender, and Timothy Morton, *The Ecological Thought* (Cambridge, MA: Harvard University Press, 2010). There is also "thing theory" in the humanities, of which a cross-section is *Things*, ed. Bill Brown (Chicago: University of Chicago Press, 2004), and various "speculative," or "object-oriented" ontologies, most of which are too ahistorical to concern us here: see, for instance, Graham Harman, "Realism Without Materialism," *SubStance*, vol. 40, no. 2 (2011), 52–72.

19 Dora Apel, *Calling Memory into Place* (New Brunswick: Rutgers University Press, 2020), 3. Aleida Assmann's *Cultural Memory and Western Civilization* (Cambridge, UK: Cambridge University Press, 2011), argues that "the structure and consistency of cultural memory were determined largely by the materiality of its respective media" (398). The book, published by Beck in German in 1999 under the title *Erinnerungsräume* (literally, "memory spaces"), has had less impact than Assmann's studies of Holocaust memory, in part because of its participation in a German discourse on "sediments of time." See Reinhard Koselleck, *Sediments of Time: On Possible Histories*, trans. and ed. Sean Franzel and Stefan-Ludwig Hoffmann (Stanford: Stanford University Press, 2018).

20 *Performative Monuments* was subtitled The *Re-Materialisation of Public Art*, as an allusion to Lucy Lippard's important book the *Six Years: Dematerialization of the Art Object 1966–1972*, published in 1973. As we will see and I have already been arguing, the materialization of *history* can take other forms than the building of monuments.

21 Giuliana Bruno, *Surface: Matters of Aesthetics, Materiality and Media* (Chicago: University of Chicago Press, 2014), 2, 8, 101.

22 Bruno discussed the "folds of history" in several concrete examples, *Surface*, 8, 109, 219.

23 "A Questionnaire on Materialism," *October*, no. 155 (Winter 2016), 14. I certainly understand the skepticism voiced by Julia Bryan-Wilson, who, in the same questionnaire, discusses the implications of ascriptions of human-ness and thing-ness in terms or race. Some writers in the issue raise the concern of the (capitalist) fetishization of things by New Materialism, and relate it to an anxiety over the digitization of our world. For me, on the other hand, seeing images and even language as related to very concrete material practices allows me to fetishize the digital less.

24 Andreas Huyssen, *Present Pasts: Urban Palimpsests and the Politics of Memory* (Stanford: Stanford University Press, 2003), 1. The introduction reflects on essays therein collected, many of which date to the 1990s and their memory debates, though the latest, on 9/11 and its commemoration, appeared in *Grey Room* in Spring 2002.

25 Huyssen is currently working on a book that discusses monument culture in the global South.

26 Patrick Eser, "State of the Art in *Memory Studies*: An Interview with Andreas Huyssen," *Passés Futurs*, no. 3 (June 2018), issue on "Transferencia de memoria," available on *Politika*, www.politika.io/en/notice/state-of-the-art-in-memory-studies-an-interview-with-andreas-huyssen (accessed September 15, 2021).

27 See Neil Postman, *Amusing Ourselves to Death: Public Discourse in the Age of Show Business* (New York: Viking, 1986), and half a century earlier, Walter Lippman, *The Phantom Public* (New York: Harcourt, Brace, 1925).

28 Jane Blocker, *Becoming Past: History in Contemporary Art* (Minneapolis: Minnesota University Press, 2016), 9. Blocker is sympathetic to art-historical and performance studies emphasizing subjective time and its circular, repeating, or discontinuous patterns, notably Rebecca Schneider, *Performing Remains: Art and War in Times of Theatrical Reenactment* (New York: Routledge, 2011), and

Christine Ross, *The Past is the Present; It's the Future Too. The Temporal Turn in Contemporary Art* (London: Bloomsbury, 2012), and less with studies such as Mark Godfrey, "The Artist as Historian," *October*, 120 (Spring 2007), 140–72, and Joan Gibbons, *Contemporary Art and Memory. Images of Recollection and Remembrance* (London: Tauris, 2007) which address art's historical commitments but not a contemporary crisis of history.

29 Blocker, *Becoming Past*, 16–18. In line with the concept's inventor Jacques Derrida, Blocker applies it self-reflexively: "This book is not simply *about* the prosthesis; it *is* prosthetic. Its words stand in the place of speech, its stories prop up events and experiences, its illustrations substitute for actual artworks, and as an object it tries to perform in lieu of the contemporary until such time as we know what the contemporary is (or was)" (16).

30 A different approach to public ethics via "prosthetic memory" ('inauthentic,' e.g. filmic representation) is Alison Landsberg, *Prosthetic Memory: The Transformation of American Remembrance in the Age of Mass Culture* (New York: Columbia University Press, 2004).

31 Blocker, *Becoming Past*, 147: "And if we believe in history at all, then we must concede that because time itself is a form of representation, the truth of past events (or present events, for that matter) might be shown through falsehoods, dissemblance, what I described … as the 'truth-telling lie'." That time is a representation is an insight Blocker derives from neurologist David Eagleman, according to whom our experience of reality is a "tape-delayed broadcast" (10).

32 Linda Tuhiwai Smith, *Decolonizing Methodologies. Research and Indigenous Peoples*, 2nd edn (London: Zed Books, 2012), 35. Emphasis in the original.

33 Ibid., 40.

34 Ibid.

35 Smith, *Decolonizing Methodologies*, 34.

36 Michael Rothberg, *Multidirectional Memory: Remembering the Holocaust in the Age of Decolonization* (Stanford: Stanford University Press, 2009).

37 The quotes are from Rothberg's article, "From Gaza to Warsaw: Mapping Multidirectional Memory," *Criticism*, vol. 53, no. 4 (Fall 2011), 523–48. A recurrent theme is the interweaving of histories of the Jewish and the African diasporas: "What the histories of the African diaspora in the Caribbean and the Jewish diaspora in Europe share is not any "positive" experience, but rather the negativity of rupture and the necessity of imaginative work that spans that abyss." Rothberg, *Multidirectional Memory*, 150–1.

38 Rothberg, *Multidirectional Memory*, 150–1. There are hints of a multidirectional approach in Huyssen, whose "Memory Sites in an Expanded Field," *Presents Past*. chapter 7, called for a "global culture of memory" (95); Apel, in turn, sees memory working in a "comparative, not competitive" perspective (3), without citing Rothberg.

39 Henri Lefebvre, *The Production of Space* [1974], trans. Donald Nicholson-Smith (Oxford: Blackwell, 1991) 220–1, emphasis mine. As Lefebvre's discussion of Antonio Gaudí's Sagrada Familia in Barcelona makes clear (232), this functional richness of monumental space has nothing to do with religious orthodoxy.

40 In a recent discussion with Sarah Nuttall, Achille Mbembe describes the fate of monuments: "there is nothing, no material artifact on this Earth, that cannot be defeated by time. In relation to time, there is no immunity. Time alone is timeless. Everything else, humans and nonhumans included, is doomed to destruction … Our monuments will have been turned into piles of rubble, unrecyclable waste, or dust." "A Questionnaire on Monuments," *October* 165, 112.

41 See Kristine Klein, "Gómez Platero designs World Memorial to the Pandemic for Uruguayan Coast," www.dezeen.com/2020/08/19/gomez-platero-world-memorial-to-the-pandemic-uruguay/, and Meagan Howard, "Remembering a Pandemic: COVID-19 Monuments, Memory Politics, and Memorialization During Crisis," MA thesis, School of the Art Institute of Chicago, 2022.

1 The sites of history

Public art, urban design, and political commemoration have overlapping and distinct goals. But all three spheres advance demands of specificity—of political intervention, aesthetic experience, or historical reference—even when they lay claim to generality or universality. This is why it is hard to discuss mediation in general, particularly the amplified circulation of objects and sites online. In light of our phone- and computer-based access to news, recreation, works of art, and sites of interest, it appears difficult to pin down specificity—tangible or predicted, material or immaterial—to an artwork's content, much less to its literal site. That this is even an issue after decades of postmodern skepticism concerning the positivist connotations of the "authentic," the "real," and the "deictic" might come as a surprise. But, oddly, not only do demands for reality and authenticity continue to be raised by younger generations of artists, audiences, and critics; even in the art discourse of the previous two decades, with its suspicion of the authentic and the real, the loss of these once-compelling markers of unity and coherence was often masked or softened by a notion of site at once reassuring and eclectic. Among all the diverse work it did, the clamoring claims it seemed to fulfill, site has been one privileged way in contemporary art to connect to history, even when history was treated as a fiction. Instead of a linear history, site could be used as a connecting thread for diverse histories, an approach deeply influenced by the development of site-specific art since the 1960s on one hand, and, on the other, the exploration of the relations between commemoration and historically loaded places.[1] Thus, for instance, a twenty-first-century visitor to the National Park Service's website viewing the Gettysburg National Military Park, by clicking on the "Then and Now Pictures" link, can view split photographs of the notorious battle's sites, like Rose Woods and Plum Run, in the classic monochrome prints of Matthew Brady and his peers and their successors on one side of the screen, and the leafy green digital prints of the Park Service on the other [Fig. 1.1]. Occasionally, by an eerie flourish of modern graphical editing, the gray bodies of the dead encroach on the "present" side of the scene as if to literalize the haunting return of the past.[2]

"Then and Now Pictures of the Battlefield." Section on the Website of the Gettysburg National Military Park.

This memory-enforcing aspect of site discourse, amplified by digital media, could come to the help of official memory discourse, with its problematic assumptions of the responsibilities of citizenship, addressing the multiplicity of people encountering particular histories. Newly arrived citizens are not on equal footing with longtime residents, in commemoration as in other domains of life, but the point of a successful project could be how much history is *brought* to places by thoughtful signposting, and how much of the sedimented history is not visible or familiar even to those who regard the place as their home. If monuments and memorials were (and are) always as indicative of the time they are erected as of the event they remember, we need to think not just about a particular significant moment that is the target of commemoration, but also about time strata in commemorative spaces, both successive and simultaneous. Site, as a concept related to such stratification, is a more open access point than the inferred experiences of individuals, which are neither accessible nor always applicable to others: but only if we specify what we mean by the term.

In order to anchor this discussion, and illuminate its importance to the current concern with history in art and commemoration, I first look at the contemporary state of a concept that has dominated, if not monopolized, how "site" is understood in art discourse. This concept, which reached its peak of prestige and interest two decades ago, is site-specificity. If site-specificity is to retain any explanatory force, it will have to account for how techniques of mediation—by no means limited to digitization—create and multiply new kinds of specificity. These documented or documentary specificities often depend on interactions with audiences, whose co-creation generates shifts that can diversify and modify the content of art reception and commemoration as well as the meaning of sites themselves. But to put the matter more starkly, is the concept still important at all? Why not say that, from visiting tourist sites we have seen numerous times before arriving there, to learning about the past and today's artistic responses to it (often while sitting before a screen), specificity is as outdated a factor as authenticity or the irreproducibility of a work of art? For example, by a coincidence of academic travel, I visited Tahrir Square in Cairo a few weeks after the conclusion of the Arab Spring protests, and even though it was no longer the site of transformation it had represented and continues to represent, still my experience of it is probably inextricable from the broadcast images that preceded me.[3]

There is something to this line of thinking, of course, but far from obviating the need for site specificity, it points up some of its contemporary features. Site remains relevant if we want to understand exactly how history is parsed through the vast engines of reproduction, and how historical consciousness relates not only to public space, but the public sphere of deliberation

and debate. To understand site-specificity in this way is also to understand contemporary audiences, and, even more, how history surfaces in particular places at particular times: not just those times (and places) where it was made, but also those where it is remade, rethought, remediated. Thus, in this study, mediation will allow us to approach specificity constructively, rather than as a precious resource being threatened or drained away, as Walter Benjamin described an object's unique 'aura' being drained by photographic mass media.[4] In the era of social media, we need to think beyond a firm presence or absence of specificity: does specificity multiply or settle, and what does it have to offer the public sphere in our mediated society? Given the recent struggles over the visibility of previously marginalized histories, and attempts to reorganize, dismantle, or reinforce monumental presence on the ground, is there a way to figure out how the ever-expanding access off-site plays into actual access to the public sphere? Can we fold these questions and potential answers to them back into a history of cultural heritage, of monuments on the "ground"? And let us not forget that monuments are already a mediation of history.

Relocating site discourse

To begin with, it would be helpful to distinguish what is actually new in contemporary commemoration and the reception of monuments from what appears to be new and revolutionary because its persistence has been obscured, often by nostalgia. In the United States today, an atavistic impulse seems, in the name of preserving history, to shelter Confederate monuments from history: monuments built between twenty-five years and almost a century after the Civil War and often tenuously if in any way connected to the sites they occupy. The United Daughters of the Confederacy gifted the National Cathedral with a stained-glass window commemorating Robert E. Lee as late as 1953, a startling gesture given that the window depicts among other triumphs the 1863 Battle of Chancellorville, one of Lee's victories *against* the U.S. government in Washington[5] [Fig. 1.2]. It is this counterintuitive quality of the donation, and its acceptance, that I want to foreground. Far from being site-specific markers of local loyalties, Confederate monuments like these windows function generically. Like the Bismarck memorials that once dotted Germany's landscape, of which today only a few survive, and which novelist Robert Musil in his famous "Monuments" lecture of 1927 referred to as forming something like an "association" or "union" of monuments (*Verein*, the same linguistic base as the German word for "united" in United States, *Vereingte Staaten*), Confederate statues can be seen as opposed to specificity wherever they are built, asserting the unity of political identification—not unlike a hashtag—rather than diverging local conditions.[6] They may even, as

30 Monumental cares

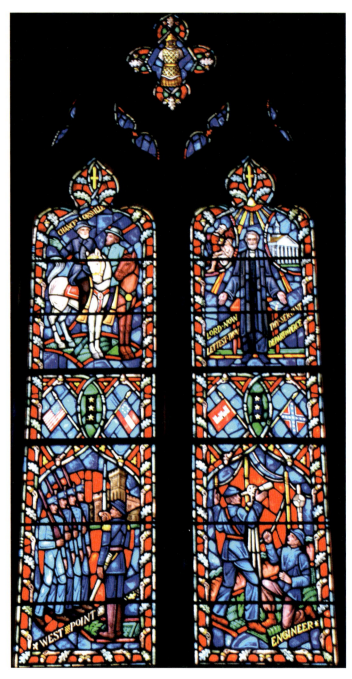

1.2 Glass window commemorating Robert E. Lee, in the Washington National Cathedral, installed 1953, now in storage.

in the case of the National Cathedral, work against their site (Washington as the capital and political center of the United States), and the formal vicinity of the windows to reproductive images—artifacts that transmit light, filtering it and in the process being animated by sunlight—allow us to see them as lucid media tools of historical propaganda for white supremacy.[7]

This alarming possibility, of not just underlining but of effacing a work's link to its site and the history of both, points to the urgent need to rethink the family of notions around site-specificity. The concept emerged nonhierarchically among postwar American artists, but its *theoretical* profile is far more focused: and that is due in great part to one distinguished contribution. Since Miwon Kwon's influential essay of 1997, "One Place after Another," and her 2002 book of the same title, scholarship has settled on an expanded idea of site-specificity in which the discourse *about* a site—not necessarily occurring in the actual place, but connected to it rather as Benedict Anderson's imagined community is connected to the nation-state—became as important as the phenomenological encounter between audience and particular space, familiar since minimalism.[8] The resulting, "discursive" definition of site specificity is capacious indeed:

> Cultural debates, a theoretical concept, a social issue, a political problem, an institutional framework (not necessarily an art institution), a community or seasonal event, a historical condition, even particular formations of desire, are now deemed to function as sites.[9]

Some readers worried that such expansive application of site, "unmoored from any geographical or material terrain," is too broad to do useful work, or that it reduces the materiality of art to a disembodied discourse, a kind of textual essence.[10] Kwon herself does not see this as a serious problem, because she agreed with James Meyer, who had formulated a kindred vision of the "functional site," that what ties together disparate discourses of site is their embodiment in "the body of the artist."[11] This too is ambivalent: there looms a risk of the generic "one place after another" of the title, with curators and artists accumulating frequent flyer miles in an art world whose "myopic narcissism is misrepresented as self-reflexivity."[12] Kwon, at the very end of the book, offers a way out: as long as artists did not try to shore up a lost sense of authentic place with authorial presence, but instead placed "one fragment *next* to another" rather than "*after* another," their vision would invoke the realities of increasingly "de-territorialized" global cities, where consumption and difference had eclipsed production and nationhood.[13]

The resulting "discursive sites," however, seldom included the techniques of mediation linking the bodies of artists with audiences there and elsewhere. Such linkage is however central to any effective site formation. For instance, take only the striking cover image of Kwon's book, identified as *Illegal*

Border Crossing between Austria and Czechoslovakia by Christian Philipp Müller: there is no indication that the artist was accompanied by an assistant taking this and other panoramic snapshots of his hikes, nor a discussion of the fact that, given that the artist possesses a Swiss passport, most of the crossings Müller documented in the *Green Border* series to which this image belongs could have been carried out legally[14] [Fig. 1.3].

Such reservations about the way 'discursive site' specificity was used to endorse certain modes of geopolitical art in the 1990s should not be taken as an outright rejection of the term. Nor will careful attention to the ways in which a project like Müller's was staged deprive it of its real or imaginary sites of political and aesthetic intervention. Instead, what I have been arguing is that such attention to mediation should make our understanding of its site(s) more complex *and* more specific, as it foregrounds the materiality and

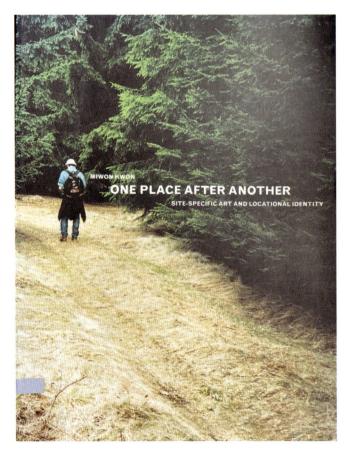

1.3 Cover of Miwon Kwon, *One Place After Another*.

historicity of place, person, and the media used to bring them together. In order not to lose ground, while accommodating newer ways of mediating art, we therefore should see site on a relational model, in which local interactions but also framing and mapping grant access to different versions of the same situations, showcasing some parts and occluding others in accordance with our interests as well as the scale on which we observe them. These framings can come from art and political institutions as well as the artists themselves, or can occur in the reception, a realm in which reproductive media, physical or social, deserve particular attention.

To really understand site in a directional way, we must account for how audiences have changed in the twenty-first century.[15] Above all, we must examine and question the polarity between mediated and unmediated experience, a polarity that has been challenged for at least the last twenty years, interestingly more in memory studies than in art history or theories of public space.[16] That it persists in these fields might have to do with their concerns with (mostly) physical objects for which unmediated experiences in situ are important. From a less narrow point of view, saying that mediated and unmediated experiences and communities intersect is a truism, visible from the literal connection of bodies to devices of distribution to the potential of creating and changing realities online and offline.[17] Even if we disagree about the extent to which it is possible to experience a site remotely, there is little sense any longer in claims of *exclusively* live experience, without any mediating or documenting device or evidence.

The stretched-out sites of public exhibition, then, create their own various, and often overlapping, public spheres. These are partially regulated, either through administration or, in the case of social media, through private censorship or rules of conduct of the software used, self-regulation of the social groups forming therein, the limitations of user-generated metadata (hashtags) and of course, the means of access. At the same time, with social media, the creation of variations and offshoots of official art practice in public space is proliferating, and has the ability to destabilize official commemorative markers, monuments, statues, or stories alike. Thus, 2014 Umbrella Revolution protesters in Hong Kong used images of Japanese pop-cultural icons like Pikachu or Totoro on their posters, along with hashtags like Causeway Bay (a central Hong Kong location notable for its clashes with Chinese authorities), "Dark Corners" (the title of a viral video of police beating a protester) or the numbers 831 (the date of an electoral "reform" imposed by Beijing). The number 689, which is the number of votes won by Hong Kong's token chief executive Leung Chun-ying, features in the meme *689 Bus to Hell* [Fig. 1.4], which certainly lacks the foresight needed for its operation. Without flattening this rich ecology of political and cultural allusion, there is an important sense in which everything from local lore to globally distributed popular culture is

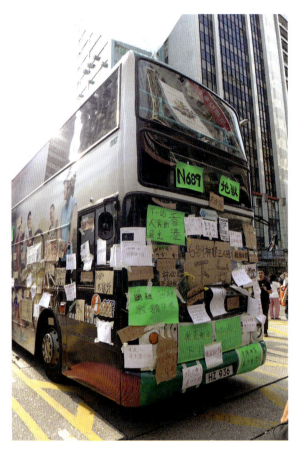

1.4 Occupy Central NWFB Bus Message in Mong Kok, Hong Kong, September 29, 2014.

accessible to both producers and consumers on social media, where the two roles and their assumed active/passive dichotomy are blurred. Likewise, no clear distinction can be drawn between real and mediated references and sites of resistance, only an intricate and familiar process of shuttling between the physical and the digital public sphere.[18]

The phrase "site-specificity," if thrown about too casually, in fact risks obscuring such operations, unless we apply a multidirectional model attentive to how real and digital sites overlap and connect in subtle, capillary ways. In building such a model, with site pointing out and pulling together at the same time, opening up access to the past in the present (and often enough, for the future), drawing on multiple forms of second-hand memory and on the concreteness of embodied experience, we'll be one step closer to understanding how history is sited in contemporary art and commemoration.

What about the body?

As mentioned, a crucial aspect of the discursive concept of site is the anchoring of various levels of discourse about a place—and, we added, its mediations—around the body or embodied activity of the artist. But this cannot require a naive commitment to the artist's presence at the heart of every site-specific project. The long process by which postwar performance art first challenged and then revived the public monument as an open-ended, collaborative scenario, explored in my book *Performative Monuments*, showed how performers, like sculptural objects and architectural structures, can engage spectators in concrete, but often delegated acts of commemoration. The body *is* significant to the materialization of history, and as such it recurs in later chapters of this book. For now, the challenge is to fit specific bodies into our pluralist vision of site open to the mediation of people, places, and things in reproductive and social media.

A look at two works by Romanian artist Alexandra Pirici will ground this discussion, in geographic and historical but also media-theoretic registers, not least because Pirici was born in 1982 under the final years of authoritarian rule under the general secretary of the Romanian Communist Party Nicolae Ceaușescu, but she came of age in a post-communist digital culture. She is at this point an internationally celebrated artist, who addresses multiple audiences with variable access to and interest in her intellectual formation.[19] She reflects on mediation, social media, and the internet, and their role in historical consciousness as well as on the relationship of the body to sites of history. My discussion of her practice is part of an ongoing engagement with Romanian art and architecture, which I take up again in Chapter 4, since it is paradigmatic of the complex negotiations between persons, public space, and history under an authoritarian regime and in the years after its collapse. Here I introduce Pirici through one of her projects in Germany, to allow for a transnational and international framing of site, much as we began to do with issues of materiality and history in Cai's work. In *Leaking Territories*, a part of Sculpture Projects Münster (2017), the artist choreographed dancers to restage iconic political events, some reproduced from photographic sources, some imagined or reimagined from vague, allusive or fictional sources, notably China Miéville's 2011 science fiction story of oil rigs coming to life and returning to the land to lay their eggs.[20] Pirici worked with gestures, and choreography, but also through what Georgina Guy calls "reported actions": dates, locations, and events that are announced aloud for the audience's benefit during their restaging.[21]

Historical events, not all traumatic, nor all attributed to specific individuals, followed one another, nonchronologically—fighting in Mosul, the Warsaw Ghetto uprising, Neil Armstrong's first steps on the moon. Such a

sequence might seem the opposite of any claim of site specificity, like flipping through a dozen magazines or television channels (or the news on your phone). But they were drawn together thematically as events of global significance by the location: The City Hall (*Rathaus*) of Münster, where the Peace of Westphalia ended the Thirty Years War, shaping international power relations for decades if not centuries.[22] Among the political events represented, with particular gravity given Münster's legacy and strategic West German location, was the death of 18-year-old bricklayer Peter Fechter, one of the first people to be shot while trying to climb over the Berlin Wall from East to West Berlin in August 1962 [Fig. 1.5].

Pirici selected a woman to re-perform the photograph of the young man crouching wounded beside the wall, where he remained unassisted for over an hour while outraged bystanders begged police to intervene. Why? The German audience would have known the incident and the image, and been able to take the change of the protagonist's gender in their stride as an aesthetic decision, a matter of estranging an oft-flashed historical morality tale, rather than being confused about what event was being portrayed. That said, *Sculpture Projects* attracts an international art public, to whom this particular scene is less familiar—while others enacted by Pirici's team might be more so. In either case, the strategy is one of distancing, making more

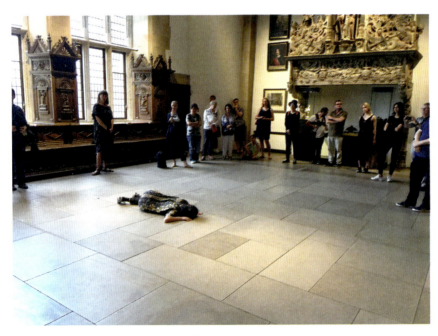

1.5 Alexandra Pirici, *Leaking Territories*, Münster, Germany, 2017.

general, allowing the inevitable shift in time and context to become palpable, but also imposing a historical lens through shifts in tempo, suggesting that reenactment is more connected to commemoration and spatialization of abstract history than to factual recreation.[23] In addition, since Pirici delegated the performance to others, the performance draws no analogy between the artist herself and the image of the martyr, a pitfall in many commemorative reenactments. The effect of distance, of not claiming to relive the actual pain or historical circumstances, was bolstered by the naming of the event by another dancer before it was embodied, almost like a reversed game of charades. The source photographs were not shown, leaving the comparison to the spectators, searching their memory or imagination, or just as likely, looking for the originals on their mobile devices during the performance or after leaving the Rathaus.[24]

The push-and-pull between closeness and distance in Pirici's work is characteristic for both the traditional objects of commemoration and those of contemporary mediation. Events like this can be seen as part of a turn to scarcity opposed to mediation, a performative action to which one had to travel (and stand in line, which I did). Photography was permitted and welcomed, however, and Pirici's work, as is the case with most contemporary performances, circulated on Instagram, Facebook, Twitter, and other social media platforms.[25] Site in this case is hard to grasp in either the discursive or body-centric modalities of the last decades. Specificity here is not just self-referentiality, but used to broaden a historical vista by juxtaposition of the Münster location to other places and publics online. Site-specificity obtains on various reinforcing physical and virtual platforms, with delayed and imaginary interactions that can have as powerful an effect as any other interaction between humans or things.[26] The multidirectionality of the site is inseparable from the multidirectional materiality of the performer's actions and their documentation. This differs from the "next-to-each-other" model Kwon pioneered, at least if we take that literally as a model of exclusively physical proximity. But a multidirectional approach asks us precisely to distinguish between the various directions and currents of specificity, live and mediated, and how they frame our reception. Nor can we afford not to care for public space on the ground, the art institutions built in their respective urban (or rural) settings, and the meaning specific audiences read into them on the basis of their own formation and access to information.

Postcards from cardboard boxes

Indeed, it is only when we look in detail at these various "grounds" that the connections between them come into sharp focus. Another work by

Alexandra Pirici shows what I mean. After having studied dance in post-Communist Romania and in Vienna, Pirici began her artistic practice, which she pursues in live works and films, alone and in choreographed group actions, in her native city of Bucharest. Indeed, the city often seems to be as much her collaborator as the dancer-performer-theorists of the National Dance Center Bucharest (Centrul Național al Dansului București).[27]

In 2011, Pirici and her collaborators confronted Bucharest's most politically charged space, the enormous House of the People.[28] The building was not quite finished at the fall and rapid execution of the Ceaușescus in December 1989. Now called more neutrally the House of the Parliament, but informally still known as the People's House (*Casa Poporului*), it houses both the government and the National Museum of Contemporary Art (MNAC). The still largely vacant building was chosen not very transparently to host the country's first contemporary museum, located in a badly accessible side wing, renovated and equipped with two glass-walled elevators and a rooftop patio, and opened to the public in 2004[29] [Fig. 1.6].

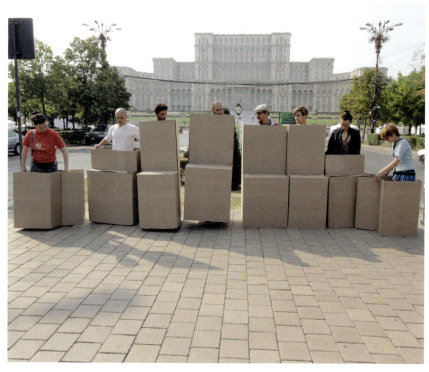

1.6 Alexandra Pirici, *If You Don't Want Us, We Want You*, 2011, intervention in front of the Palace of Parliament, former "House of the People," Bucharest.

I return to the competition and other prospects for repurposing the People's House in Chapter 4, but here it is those parts of the complex that bear on Pirici's performance that interest me. The work forms part of a larger series of appropriations and reevaluations of monumental art and architecture in Bucharest under the title *If You Don't Want Us, We Want You* (2011). Pirici's often comical critique targeted equestrian statues like that of King Carol (first installed in 1939, dismantled by the communists in 1947, and reproduced in 2010) as well as the phallic monument to the 1989 revolution against Ceaușescu installed by the post-communist government in 2005, just a year after MNAC opened, under the bathetic title *Monument to Rebirth* (Memorialul Renașterii, in the middle of Fig. 1.8).

In the rather less widely covered intervention in front of the House of the People, Pirici and her company walked toward a traffic island on the enormous boulevard leading up to it, initially named Boulevard of the Victory of Socialism, holding before them, or more accurately hiding behind, cardboard boxes stacked to resemble the iconic stepped configuration of the Palace looming beyond. This simple but subtle mimesis embodied both the monument and what it leaves out or seeks to overpower—the streamlined simplicity of modernist design. Such a contrast is evoked also in the international-style insertion by Adrian Spirescu, the designer of the glass-walled MNAC renovation of part of the building, promising a transparent confrontation between advanced art and a broad public, a tall order for a nation only slowly emerging from its understandable distrust of state culture [Fig. 1.7]. The dancers behind the cardboard boxes were silent, but occupied the space conspicuously, not unlike the armed guards that patrolled the boulevard, forbidding entry to civilians, through the decade of its construction. Here now in the same space were Pirici and Co., hiding in mock timidity behind variously sized cardboard boxes, or shuffling back and forth in a comically ineffectual effort to approximate the regularity of the façade behind them. This forceful (and funny) mimesis was recorded by a video camera, and Pirici also produced postcards of this and other interventions in *If You Don't Want Us …*. The postcards were later shown (and were available for the taking) inside the Palace itself, in the MNAC [Fig. 1.8]. The museum visitor taking a postcard may well have known—not that it said so anywhere on the cards, unless it is implied in the wordplay of the title—that Pirici's group, the National Dance Center Bucharest (CNDB), was undergoing a crisis around 2011, having been evicted from its space in the National Theatre, then undergoing renovation.[30]

The documentation of the displaced dance troupe was thus turned into touristic souvenirs in an already nostalgic medium, the ephemerality and cheapness of the cardboard boxes mirrored in the postcards that added yet another layer to the historical strata of this deceptively crude performance.

1.7 View from the elevator at the Museum of Contemporary Art, Bucharest.

One of the main characteristics of postcards is their belatedness, carrying memorable experiences—in a mass-produced form—home after the fact, and longer still after the stock photo was taken.[31] At the same time, postcards feature locations or artifacts of general interest and prominence,

Alexandra Pirici, *If You Don't Want Us, We Want You*, postcard, 2011. 1.8

monuments and vistas and tourist traps, playing a role in the (outward) representation of the city as a historically significant entity.[32] To frame a performative intervention in this medium and to allow it to reappear inside this particular museum, whose architectural frame is itself a monument to the dictatorship, is not just a matter of documenting contemporary art. Importantly, as Pirici points out, the postcards were displayed in a temporary library space of the building, The Full Half (*Jumătatea Plină*), which has since been closed by the museum's director.[33] The visibility of the massive ornamental ensemble of the People's House from the rooftop lookout platform, or even more dramatically from within the glass elevator [Fig. 1.7], positions which eloquently reveal, and even embody, the museum's embattled relation to its site, is in a way the real backdrop of Pirici's intervention. "Looking through" the postcard or video to see the performance, itself a stand-in for a monumental accretion that is hard to grasp in one view, is more about changing proportions and perspective than providing transparent institutional critique.[34]

To intervene in this medium, then, is to change the scale of the place, rendering it accessible as an image while at the same time undermining its brute force. At the same time, Pirici's postcard performance, and video, allow the action to be carried into the future, even a future where neither dancers nor postcards have a home—raising issues of urban planning, post-communist economic shifts, and access to public space.[35] At the same time, Pirici allows

viewers, qua owners of the postcard, to take part in the realm of supposed private and individual experiences that we associate with tourism and political memorabilia, playing with notions of home, belonging, and the privileges of collecting.[36] The series title, *If You Don't Want Us, We Want You*, has a bearing not just on the uncertain institutional status of the performers, but on the object of their performance: Pirici and company fought public indifference to contemporary site-specific art with ironic dedication, miming while subverting the love of fatherland monumental architecture continues to exude. Folding personal experience into historical representation, entangling event and mediation, allowing both to become part of the construction of experience in the postcard-souvenir, Pirici's practice is, on the one hand, firmly shaped by our media reality.

There are also, on the other hand, powerful connections to the years prior to 1989, when censorship and repression prevented artists from traveling abroad, and forced them into performing and showing their work in private and semiprivate spaces, niches (in terms of both content and site) that might be overlooked by the regime.[37] This means that site specificity always started from spaces negotiated with and shored up against political authority, and that had to be imagined very flexibly, and often built up belatedly in rumor, reception, and exchange. Thus, a vivid mail art practice and impromptu artist gatherings-cum-performances (most famously, Wanda Mihuleac's *house pARTy* in late-1980s Bucharest) developed by necessity. But more generally, mediation (photographs, some video, many sketches) became a solid part of site-specific practice, less as extensions of the site, or its secondary documentation, than as primary vehicles to construct audiences and, ultimately, a public. Institutions were closely watched, and artists adopted various ways to fold these restrictions into their practice. "The site" was thus primarily one of imagining possible political and social content that audiences could only conceive, not find in person.[38] Images were obviously not trustworthy as witnesses to historical events, as the relation between bodily presence, history, and reproductive media remained slippery through and beyond the end of the regime. In 1989, after protests on the street that had remained invisible on state television, the propagandistic image machine shifted abruptly to the broadcasting of the dictator and his wife being interrogated and shot, framed so tightly that place and context remained undefined—a ghostly shift from the making of history in real space to its construction in mediated space.[39] Almost as spectral is the status of the People's House, which is not just a notorious, instantly recognizable landmark, but one whose very photographic reproduction was banned in the Ceaușescu era. It has been disputed more recently in a copyright infringement case between the Chamber of Deputies and architect Anca Petrescu's daughter Cristina Petrescu, who claimed that her mother as chief architect holds copyright on the building and that royalties would need

to be paid to her estate for any commercial image circulation.[40] The site of Pirici's performance, then, continues to impose: on the ground, on the air, on paper.

Site multiplicity

What these techniques of mediation and repetition in their entanglement with and fending off of political power show us is that for a contemporary understanding of site-specificity in its multilayered relation between location, mediation, and audience, singular terms get in the way. Nor will a mere pluralistic multiplication of sites help much, if it leaves out their interrelation. This is true not just in Bucharest, but wherever personal identity, political culture, and other markers of power and privilege are wrapped up with the sites of artmaking, as they inevitably are. In a discussion with Jennifer Doyle, David Getsy has observed that

> bodily relations immediately and inescapably activate questions about gender and sexuality. Historically, sculpture and performance art have shared this as a fundamental issue. Both rely on the viewer's proprioceptive assessment of their copresence with the sculpture or performer.[41]

Getsy's point is that in coming to experience site-specific work, identities are activated in the space, continuous or disjunctive, between the performer or the object and the audience on site and beyond. This activation is highly political, whatever claim it stakes or challenge it poses to the spectator. On top of this, Pirici, like other artists operating internationally but maintaining close links with their cultural formation, is working with general concepts of scale, bodily subversion, humorous distraction, and the recognizable genre of monumental forms. Rather than multiplying sites, modes of mediation and materiality, a multidirectional approach must be willing to describe their coexistence. Site-specificity, with its modernist overtones of truth to medium (as in "medium-specificity") still too often suggests having to privilege site over mediation, or the reverse. A multidirectional model, which we saw being applied to memory in a global, or at any rate transnational, context, is in turn more suited to understand how the formation of virtual and nonvirtual public spaces, with its multiple forms of mediation (analog and virtual) relate to objects, monuments, and the construction of history. Directionality is a flexible quality, without being vague; as in the case of multidirectional memory, the end result of multidirectional study of sites is not a deterritorial free-for-all of references or audiences, but concerted efforts to bring distinct histories and traditions into dialogue. That said, we should not minimize the challenges in adapting the concept to art history: as a historian specializing in memory studies, Rothberg's multidirectionality seldom addresses concrete sites.[42]

In the ongoing monument debate, the materiality of monuments, their urban settings, and their publics are essential points of contact and orientation in what has now become a global activism on the left and right.

In adapting the multidirectional approach to site, I am arguing that it does not just permit, but requires, attention to the concrete ways it functions, how we come to the site and who else has access, from occupying the traffic island before the People's House in Bucharest to performing various politically charged photographic documents in a space that witnessed the ratification of the Peace of Westphalia. At the same time, attending to this kind of layered directionality will allow us to understand how physical and virtual sites are entangled in our conception of time and space, materializing history on the ground, online, in reception and scholarship. This is important not just for the sake of terminological clarity, but to grapple with inclusions and exclusions, restrictions and opportunities, bodily representation and its material alternatives, from crowdsource to cardboard—in short, to see the forces that shape or frame the ever-changing borders of the public spheres engaged by ambitious public art.

There is more, however, than methodological virtue in a multidirectional approach to site specificity (and multiplicity). We can see its practical point by noting that artists themselves have grown aware of the potential of multiple mediation, thinking of site far more subtly and powerfully than as a kind of raw source of experience. Artists interested in how history affects bodies, language, and the built and growing environment, especially, have adapted intersectional approaches, broadening the concept of sites into environments and the struggles over them. The multidisciplinary practice of Mexican-born Emilio Rojas activates human-nature relations in all their dizzying convolutions, allowing us to reconsider concepts often kept apart, ranging from interactions with monuments, food and food activism, environment and queer theory to issues of colonialism, labor and economic inequality. The performance reproduced on this book's cover, *He Who Writes History Has No Memory* (2017/18), captures some of this range, featuring as it does Rojas nestled in the lap of Chicago's Lincoln monument in a moving and politically incisive retelling of the first scene of Charlie Chaplin's *City Lights*. The interplay of body and site in his work will help us recapitulate the chapter's concerns, while showing how they are being transformed by the work of artists in the present.

I want to discuss a work performed when Rojas was living and working in Vancouver, reflecting on the US–Canadian border as well as the endless borders separating the citizens of these modern states from the Indigenous peoples they displaced. In *The Grass is Always Greener and/or Twice Stolen Land* (2014) [Fig. 1.9], the stolen land is likely that of the Coast Salish people who once inhabited the Northwest Coast from what is now British Columbia

Emilio Rojas, *The Grass is Always Greener and/or Twice Stolen Land*, 2014. A 25-hour durational performance, 7 km, from UBC to Musqueum Reserve, tracing the path of the land that was stolen from the Indigenous Nation that the university occupies.

through most of Washington State, down to the Oregon River. More specifically, the Musqueam (xʷməθkʷəy̓əm) First Nation inhabited and still inhabits the territory of present-day Vancouver by the mouth of the Fraser River, ten minutes away by car from the University of British Columbia (UBC), separated from it only by road and a stretch of forested coastline (the University Lands Ecological Reserve, which bounds the UBC Farm and the Botanical Garden).

Rojas's performance began in the recently built Audain Arts Centre, with four strips of commercial sod "stolen" from the university's grounds, leaving exposed a patch of bare topsoil. Barefoot and wearing all white, he knelt to roll up each strip of grass and efficiently unroll it at the other end of the series of strips. The whole installation, thus become a moving carpet, inched forward out of the modernist gallery space and into the streets of Vancouver. Over a grueling 25-hour period, filmed up close and in wide angle to embrace the terrain and passing traffic, the green rectangles of turf and Rojas's suit lose their contrasting colors, becoming one muddy mess. The precarious voyage seems held together only by the performer's determination to execute the project and—in some sort of collaboration—by the dense network of grass roots holding the repeatedly rolled and unrolled strips of earth together. At the beginning, the glass architecture of the gallery matched the immaculate fabric and the standardized neatness of the grass—with each individual grass stalk the same length, each modular rectangle conforming to modernist principles of utilitarian green space—and thus bore some resemblance to conceptual art around 1970, for example, Hans Haacke's *Grass Grows* (1967), which treated lawn and grass as abstract, if embodied, information systems.

This association dissolves over time, with earth seeping into cloth, and an increasing need for the performer's body to support the increasingly fragile material. The procession finally descends some rocks down into the creek just outside the Musqueam Community Center, where Rojas concludes the performance with a deep bow, submerging his head and shoulders into the muddy water. The result is a witty and moving juxtaposition of industrial agriculture and embattled Indigenous cultural and economic practices (the Musqueam continue to live from their lands and waters), and certainly in contrast to the apparently casual, leisurely investigation of Müller's *Green Border*.[43] Was the serpentine progress of the sod also a recollection of the two-headed snake (sʔi:ɬqəy̓), which, according to Musqueam lore (sx̌ʷəy̓em̓), crushed all living things on its way into the Fraser River, leaving the creek as its trail, and, out of its droppings, created the plants (məθkʷəy̓) that gave the place and the people their name, Musqueam?[44] It would not be atypical of Rojas to craft his carefully documented performance (the muddy suit displayed as a relic alongside the video) so as to delve into overlapping layers of meaning, contemporary and traditional, Indigenous and Canadian, showing

how colonial hierarchies get embedded in our use of the plant world, and the territorial claims this makes possible. For my argument about how bodies come to sites, how they situate themselves and others in places and histories, and how materiality is indispensable to this process, the sod turning to dirt and in turn dirtying the white clothes of the artist is particularly eloquent. Materiality here touches the body itself, rather than remaining a formalist chimera; the physical site, or sequence of sites from campus down the road to the reservation, has as much agency in granting access to its history as the artist and his intricate plans. At the same time, Rojas's body and practice are themselves complex products—physical, intellectual, political— of the border and borders internal and external, official and unspoken, enforced and transgressed. Borders play into Rojas's thinking, and being, ever since his grandmother's decision to give birth to her California-based children across the border in Mexico so they would not be drafted in U.S. wars.[45] The preoccupation with distinguishing humans *from* nature is set in motion and irritated by Rojas's use of his own body, entangled like its environment(s) in various histories. I hope the close look at this performance shows how multidirectional site specificity is repaid by insight into art and its monumental cares.

The next step in understanding the materialization of history, in Chapter 2, takes us from the dynamics of how sites of contemporary public art or commemoration can be mediated to a case study showing how this plays out over a longer time interval. This will make possible, in Chapter 3, a confrontation with perhaps the prime reason we need to think about sites multidirectionally: the global geographical consciousness that makes possible artistic practice fusing activism, mourning, and commemoration.

Notes

1 On the latter, see Françoise Choay, *The Invention of the Historic Monument* (Cambridge, UK: Cambridge University Press, 2001), building on Pierre Nora, ed., *Rethinking France: Les Lieux de Mémoire* [1983], 4 vols. (Chicago: University of Chicago Press, 2001).
2 www.nps.gov/gett/learn/photosmultimedia/then-and-now.htm. Not all the "before" pictures date to the American Civil War: some are pointedly commemorative, being taken on the 50th and 75th anniversaries of the Battle of Gettysburg, in 1913 and 1938 respectively.
3 My thanks to Anneka Lenssen, formerly professor of art history at the American University in Cairo, at whose invitation I visited Cairo in early December 2012. On Tahrir Square's rapid evolution in the early 2010s, see Mohamed Elshahed, "City of Revolution: On the Politics of Participation and Municipal Management in Cairo," in *Participation in Art and Architecture*, ed. Martino Stierli and Mechtild Widrich (New York and London: Bloomsbury 2022), 127–50.

4 Walter Benjamin, "Kleine Geschichte der Photographie," *Gesammelte Schriften*, ed. Rolf Tiedemann and Hermann Schweppenhäuser, vol. 4 (Frankfurt: Suhrkamp, 1977), 368–85.

5 They have since been removed and stored: see Mariann Edgar Budde, Randolph Marshall Hollerith, and John Donoghue, "Announcement on the Future of the Lee-Jackson Windows," September 6, 2017, https://cathedral.org/press-room/announcement-future-lee-jackson-windows/. The Washington National Cathedral website also preserves the leaflet of the September 6, 2017 Deconsecration Service, complete with hymns and a homily noting that in 1953 "the most segregated time of Christian America was on Sunday morning." http://cathedral.org/wp-content/uploads/2017/09/L-J-Service-Leaflet.pdf, On September 24, 2021, it was announced that Kerry James Marshall was commissioned to design new windows, and poet Elizabeth Alexander to write a new work to be inscribed in stone next to the windows. See Peggy McGlone, "Washington National Cathedral to replace Confederate-themed stained glass with new windows by celebrated artist Kerry James Marshall," *The Washington Post*, September 24, 2021, www.washingtonpost.com/entertainment/national-cathedral-confederate-windows-marshall/2021/09/22/5756a47c-1bbe-11ec-bcb8-0cb135811007.story.html (accessed September 29, 2021). On the United Daughters of the Confederacy (UDC) and their active agenda of monument-building, see Adam H. Domby, *The False Cause: Fraud, Fabrication, and White Supremacy in Confederate Memory* (Charlottesville and London: University of Virginia Press, 2020); Karen L. Cox, *No Common Ground: Confederate Monuments and the Ongoing Fight for Racial Justice* (Chapel Hill: University of North Carolina Press, 2021), 74 and passim; and Cox, *Dixie's Daughters* (Gainesville: University Press of Florida, 2003, rev. ed. 2019). The UDC, founded in 1894, are really a twentieth-century phenomenon, but evolved from "ladies' memorial associations," on which see Caroline E Janney, *Burying the Dead but Not the Past: Ladies' Memorial Associations and the Lost Cause* (Chapel Hill: University of North Carolina Press, 2008). Disturbingly, Confederate activists were at the forefront of women's suffrage in the South: see Kelly Houston Jones, "Race, Gender, and the Struggle for Suffrage in Arkansas," *Arkansas Historical Quarterly*, vol. 79, no. 3 (Autumn 2020), 177–92.

6 Robert Musil, "Denkmale," in *Gesammelte Werke,* vol. 7 (Reinbek bei Hamburg: Rowohlt, 1997), 506–9. The published essay, printed in Switzerland in 1936, contained some judicious omissions, notably Musil's enthusiasm for the Prussian *Siegesallee* in Berlin, but not for the Bismarck memorials.

7 The UDC might deny this. Writing in February 2022, the statement greeting visitors on their website insists: "The United Daughters of the Confederacy totally denounces any individual or group that promotes racial divisiveness or white supremacy. And we call on these people to cease using Confederate symbols for their abhorrent and reprehensible purposes. We are saddened that some people find anything connected with the Confederacy to be offensive." https://hqudc.org. Of course the need for such a disclaimer speaks volumes.

8 Miwon Kwon, "One Place after Another: Notes on Site Specificity," *October* 80 (Spring 1997), 85–110; *One Place After Another: Site-Specific Art and Locational*

Identity (Cambridge, MA: MIT Press, 2002). On site and nationhood, see Benedict Anderson, *Imagined Communities: Reflections on the Origin and Spread of Nationalism* (London and New York: Verso, 1983, rev. ed. 2006), esp. the first part of chapter 11 (on "Memory and Forgetting"), entitled "Space New and Old" (187–92).

9 Kwon, "One Place," 93 (*One Place,* 29). Kwon sees this as a historical progression: from fairly unspecific interest in the space around specific objects typical of 1960s art, through the political concern with place in institutional critique, to a conservative recapture of site specificity as "authorial intent" in the debate over *Tilted Arc,* and its growing relevance to ecology, migration, and the notion of the nomad. Kwon recognizes the importance of mediation, particularly early in chapter 2 (*One Place*, 33) but is more interested in the procedural changes toward "administration" (as theorized by Benjamin Buchloh), and a critique of the reemerging author mystique (51ff).

10 Thus T.J. Demos in his review, "Rethinking Site-Specificity," *Art Journal,* vol. 62, no. 2 (Summer 2003), 98. Demos suggests we take site "discourse" in the manner of Michel Foucault as a regulatory practice. A fairly constructive effort to build on Kwon's view comes from a literary critic, who thinks site specificity involves the mutual "deforming" of aesthetic practice and practice outside the art world: see Lytle Shaw, *Fieldworks: From Place to Site in Postwar Poetics* (Tuscaloosa: University of Alabama Press, 2012), esp. chapter 9, "Docents of Discourse."

11 Kwon, "One Place" 103, quoting James Meyer, "The Functional Site," in *Platzwechsel*, exh. cat. (Zürich: Kunsthalle Zürich, 1995), 35. Meyer's article is reprinted in *Documents*, no. 7 (Fall 1996), 20–9, and in Erika Suderburg, ed., *Space, Site, Intervention: Situating Installation Art* (Minneapolis: Minnesota University Press, 2000), 22–37, where it is followed by Kwon's text.

12 Kwon, "One Place," 104.

13 Ibid., 110. Kwon links this urbanistic vision with Saskia Sassen, *The Global City: New York, London, Tokyo* (Princeton: Princeton University Press, 1992), cited at "One Place," 102.

14 Müller's work was presented in the Austrian Pavilion of the 1993 Venice Biennial. This must be kept in mind in evaluating claims like Meyer's, from whom Kwon probably took the example, that Müller was "simulating illegal immigrants' trials" (Meyer, "Functional Site," in *Space, Site, Intervention*, 28). See Peter Weibel, ed., *Stellvertreter/Representatives/Representanti: Andrea Fraser, Christian Philipp Müller, Gerwald Rockenschaub: Österreichs Beitrag zur 45. Biennale von Venedig 1993* (Vienna: Bundesministerium für Unterricht und Kunst, 1993) and Müller's own reflections at http://christianphilippmueller.net/index/works/Green-Border (accessed October 2, 2021). Alexander Alberro, "Unraveling the Seamless Totality: Christian Philipp Müller and the Reevaluation of Established Equations," *Grey Room* 6 (Winter 2002), 5–25, is probably right in calling this "an immanent rather than activist critique" (12). Alberro thinks "Müller's transgressions were not registered by the border officials," while the artist insists he and his assistant were "arrested and prohibited from reentering the [Czech Republic] for three years." Here we might also mention the *timing* of Müller's project:

shortly after the easing of border restrictions between NATO and Warsaw Pact countries in Europe following the collapse of communist regimes in 1989 and 1990.
15. Exemplary is the study of cross-media popularization by Katie King, *Networked Reenactments: Stories Transdisciplinary Knowledges Tell* (Durham: Duke University Press, 2011), esp. the introduction's alignment of "authorships, audiences, and agencies," and chapter 3, on synergies between television and the web.
16. For the changing discussion of mediation and digital media in memory studies, see the introduction by Samuel Merrill, Emily Keightley, and Priska Daphi, "The Digital Memory Work Practices in Social Movements," in Merrill et al. (eds.), in *Social Movements, Cultural Memory, and Digital Media* (Cham: Springer, 2020), particular 7–9, where the "entanglement" of "diachronic" memory is discussed as a recent focus of memory studies, particularly suited to approach "memory under the contemporary globalized digital conditions" (7). The introduction richly points to additional readings. See also Assmann, *Cultural Memory and Western Civilization*, cited in my introduction.
17. Several new fields related to media studies, notably digital ethnography, focus on the use of social media in the construction of identity, national and political agendas, and mobility. Martin Zebracki and Jason Luger, "Digital Geographies of Public Art: New Global Politics" in *Progress in Human Geography* 43, no. 5 (2018), 890–909, is a good overview of the field. See also Aroussiak Gabrielian and Alison B. Hirsch, "Prosthethic Landscapes: Place and Placelessness in the Digitalization of Memorials," in *Future Anterior*, vol. 15, no. 2 (Winter 2018), 113–31.
18. At issue was not just the small margin (689 is the bare minimum required by the law, making it unlikely that someone would get just *that* number of votes) but also the larger scandal that only 1,200 citizens, representing various constituencies and professions, vote for the chief executive. This number, 689, became a ubiquitous nickname for Leung after the 2012 election. See the anonymous blog article, "Why are HK protesters rallying around the number 689?" *Guardian*, October 1, 2014, available at www.theguardian.com/world/shortcuts/2014/oct/01/hong-kong-protestor-689-democracy-cy-leung-electoral-system (accessed January 17, 2017). The other prominent number, 831, became shorthand for the election reform debates, preempted by the ruling handed down by the National People's Congress on August 31, 2014 (hence 8–31), according to which Hong Kong political candidates would be pre-screened by the central government. For discussion, I would like to thank the participants in the conference "The Future of Engaged Art" at the University of Chicago Hong Kong Center, which I co-organized together with Andrei Pop in January 2018 as part of a research residency in collaboration with the University of Hong Kong.
19. She is also ferociously cosmopolitan, confronting global audiences with obscure East European folk or regaling a Bucharest audience in 2014 with a solo *a capella* rendition of Beyoncé's choreography and song from her then-new music video *Drunk in Love*. See Xandra Popescu, "Talking About My Generation," *Revista Arta*, 28 April 2015, at http://revistaarta.ro/en/talking-about-my-generation-2/ (accessed October 1, 2021).

20 China Miéville, "Covehithe," *Guardian*, 22 April 2011, at www.theguardian.com/books/2011/apr/22/china-mieville-covehithe-short-story (accessed July 19, 2019).

21 Georgina Guy, "From Visible Object to Reported Action: The Performance of Verbal Images in Visual Art Museums," *Theatre Journal*, vol. 69, no. 3 (2017), 339–59, this quote at 340. Guy discusses Pirici's work *Public Collection*, performed at Tate Modern in 2016. An interesting take on Pirici is Sven Lütticken, "Gestural Study," *Grey Room* 74 (Winter 2019), 86–111. In the context of his hypothesis that performance is not "exempt from commodification … [but rather] the *vanguard* of commodification" (87), Lütticken holds out hope for the liberatory potential of the abstracted gesture, which he takes Pirici to have perfected, among digital economies of scale.

22 In fact, because of the entrenched nature of the parties to the Thirty Years War, two treaties were signed in parallel in the neighboring cities of Münster (Catholic controlled) and Osnabrück (Protestant), the *Instrumentum Pacis Monastiriensis* and *Instrumentum Pacis Osnabrugensis*. See Derek Croxton, "The Peace of Westphalia of 1648 and the Origins of Sovereignty," *International History Review*, vol. 21, no. 3 (1999), 569–91.

23 On the range available between minutely accurate and poetically evocative restaging, see Iona B. Jucan, Jussi Parikka, and Rebecca Schneider, *Remain* (Minneapolis: University of Minnesota Press, 2019), and Schneider's *Performing Remains* (London: Routledge, 2011).

24 The last part of the work consisted of the audience shouting "search terms" at the performers, who wittily answered in improvised "Wikipedia Style," pulling knowledge from memory and creating connections to other events and terms. Lütticken writes: "Even as the audience shared a space with the performers, the piece emphasized that presence is never pure presence when physical space is always also the geodesic space of data networks, when the exhibition or performance space is also a triangulated space of signals" ("Gestural Study," 101).

25 Cf. Anne Imhof's *Faust* in the German Pavilion of the 2017 Venice Biennial, which—in the openly invited "shooting" by the audience of the performance and the staged confrontation between dancers and audience—recalled the dystopian use of media found in the television series *Black Mirror*. In an interesting essay, Claire Bishop argues that we are at a crossroads in terms of audience and social media, that there is not yet an established behavior, and that attention (a term she prefers over "experience") is both individual and social, "directed outward and online" (38). Claire Bishop, "Black Box, White Cube, Gray Zone," *TDR*, vol. 62, no. 2 (Summer 2018), 22–42.

26 David Harvey, in "Space as a key word," in *Spaces of Global Capitalism: A Theory of Uneven Geographical Development* (Verso, 2005/19, 117–48), reflects on challenges to defining space and its historical associations. He distinguishes "absolute, relative, and relational" notions of space, which he feels should be used in concert, depending on angle and focus; the relational allows for political subjectivities, but the absolute and relative models allow Harvey to insist on a (Marxist) meta-system, and he claims that all three play a dialectical part in his work.

27 There is little scholarly writing on CNDB: see the text by playwright and critic Mihaela Michailov, "Evacuate the Area: Zero Space," in *European Dance since 1989: Comunitas and the Other*, ed. Joanna Szymajda (New York: Routledge / Warsaw: Institute of Music and Dance, 2014), 67–74, and, for the wider context, Andrea Hensel, "Independent Theatre in the Post-Socialist Countries of Eastern Europe," in *Independent Theatre in Contemporary Europe: Structures—Aesthetics—Cultural Policy*, ed. Manfred Brauneck and ITI Germany (Bielefeld: Transcript, 2017), 188–272.

28 The building was designed by Romanian architect Anca Petrescu, discussed in more detail in Chapter 4.

29 MNAC, spearheaded by curator Ruxandra Balaci, succeeded and replaced the Contemporary Department of the national art museum, Muzeul Național de Artă al României (MNAR). Prior to the renovation of the E4 wing of the House of the People, MNAC exhibitions were hosted in the Muzeu Kalinderu in the center of Bucharest (2002–4). Anthony Gardner has theorized the operation of MNAC in *Politically Unbecoming: Postsocialist Art Against Democracy* (Cambridge, MA: MIT Press, 2015), chapter 5. It is suggestive that CNDB was also founded in 2004.

30 See Michailov, "Evacuate the Area," which ends with the plaintive question: "Can we dance nowhere?" (74). As of 2022, the group still performs in various venues, but has not been able to return to the National Theatre (TNB), which reopened in 2013 after being rebuilt from scratch. They have acquired an administrative space in the National Center of Cinematography, and a performance space in Sala Stere Popescu.

31 On the historical and geographic diversity of this medium, see David Prochaska and Jordana Mendelson, eds., *Postcards: Ephemeral Histories of Modernity* (University Park: Penn State University Press, 2010).

32 Peter Greenaway, in his 1987 film *The Belly of an Architect*, puts an apt rationale into the mouth of his protagonist, played by Brian Dennehy, when he is asked why he pilfers Roman postcards from souvenir shops for his own eccentric purposes: he replies that postcards are part of a city's advertising of itself, hence fair game.

33 Email communication with the author, July 27, 2018.

34 The latter was to some extent undertaken by Christoph Büchel and Gianni Motti in their 2004–2005 MNAC project *Under Destruction #1*. See Gardner, *Politically Unbecoming*, 225–32.

35 On the conditions of media art in Romania before 1989, see Horea Avram, "On the Threshold. Conformism, Dissent, and (De)Synchronizations in Romanian Media Art in the 1960s and 70s," in *New Europe College Yearbook 2017–18*, ed. Irina Vainovski-Mihai (Stefan Odobleja Program, Bucharest), 25–50.

36 I analyze the collecting impulse in another political configuration in "Collecting 'History in the Making': The Privatization of Propaganda in National Socialist Cigarette Cards," in *Contemporary Collecting: Objects, Practices, and the Fate of Things*, ed. Kevin Moist and David Banash (Lanham, Toronto, and Plymouth, UK: Scarecrow Press, 2013), 151–172.

37 Caterina Preda argues that instead of dissident art we need to think of "alternative" art in Communist Romania, and that abstraction has been a way to defy

the country's demand for (official) political art since the 1970s. *Art and Politics Under Modern Dictatorships: A Comparison of Chile and Romania* (New York: Palgrave Macmillan, 2017). See also Amy Bryzgel, *Performance Art In Eastern Europe Since 1960* (Manchester: Manchester University Press, 2017), 241–5; Klara Kemp-Welch, *Networking the Bloc: Experimental Art in Eastern Europe 1965–1981* (Cambridge, MA: MIT Press, 2018), chapter 3; Ileana Pintilie, "Questioning the East. Artistic Practice and social context on the Edge," in Katalin Cseh-Varga and Adam Czirak, *Performance Art in the Second Public Sphere. Event-Based Art in Late Socialist Europe* (London and New York: Routledge, 2018), 66f, and more broadly Kornelia Röder, *Topologie und Funktionsweise des Netzwerks der Mail Art. Seine spezifische Bedeutung für Osteuropa von 1960 bis 1989* (Bremen: Salon Verlag, 2008).

38 This imaginative use of media makes contact, of course, with other East European artists: see, e.g., Matthew Jesse Jackson, *The Experimental Group: Ilya Kabakov, Moscow Conceptualism, Soviet Avant-Gardes* (Chicago: University of Chicago Press, 2010), particularly chapter 4, "The Rituals of Nonlife."

39 This broadcast has in turn fascinated artists; it has been repeatedly restaged by Milo Rau and IIPM ("International Institute of Political Murder") as "The Last Days of the Ceaușescus," starting at the Festival d'Avignon in 2009.

40 The suit was in fact brought by Camera Deputaților against Cristina Petrescu to dissolve her 2008 copyright claim on the building; on March 23, 2016, the Bucharest Tribunal (*Tribunalul București*) rejected the suit, endorsing Petrescu's copyright. See Clara Vacaru, "Instanța a decis. Imaginea Casei Poporului aparține moștenitorilor arhitectei Anca Petrescu," *Libertatea*, March 24, 2016, at www.libertatea.ro/stiri/1491159-1491159 (accessed February 20, 2021). At stake were the memorabilia, including postcards, sold by the Chamber of Deputies. Because Romania has limited "freedom of panorama," that is, the right to reproduce objects in public space, Pirici's postcard is borderline: reproduction is forbidden "in case the work is the principal subject and is used commercially" ("în afara cazurilor în care imaginea operei este subiectul principal al unei astfel de reproduceri, distribuiri sau comunicări și dacă este utilizată în scopuri comerciale"). See the text of the law, "Legea nr.8 din 14 martie 1996 privind dreptul de autor și drepturi conexe," http://legislatie.just.ro/Public/DetaliiDocument/7816 (accessed February 20, 2021).

41 "Queer Formalisms: Jennifer Doyle and David Getsy in Conversation," *Art Journal*, vol. 72, no. 4 (2014), 61. See also David Getsy, "Acts of Stillness: Statues, Performativity, and Passive Resistance," *Criticism*, vol. 56, no. 1 (Winter 2014), 1–20, which argues for the affinity between these two arts in how they place bodies in public space.

42 In that respect, it leaves similar room for improvement as the "discursive" or "functional" models of site. Rothberg sees his approach as a corrective to polemical use of memory to advance identitarian claims excluding other histories and sites of memory. Apel, without reference to Rothberg, makes a complementary attempt to connect a non-competitive model of memory to specific places, generally speaking the sites of memorials.

43 I am cognizant that Müller too wanted to highlight issues of border control, domination, and hierarchy. But given that his and Rojas's performances both feature mediated lone male bodies interacting with greenery (and photographed by an unseen assistant), it is remarkable just how differently they project the mechanisms of political power and involvement in their respective sites.

44 On Musqueam territory and urbanism, see Howard Grant, Leona Sparrow, Larissa Grant, and Jemma Scoble, "Planning since Time Immemorial: Musqueam Perspectives," in *Planning on the Edge: Vancouver and the Challenges of Reconciliation, Social Justice, and Sustainable Development*, ed. Penny Gurstein and Tom Hutton (Vancouver: UBC Press, 2019), 25–46. In 2016, Musqueam artist Brent Sparrow carved a post telling the story of the two-headed serpent on the campus of UBC, https://news.ubc.ca/2016/04/06/musqueam-post-dedicated-at-ubc-vancouver-campus-today/ (accessed September 30, 2021). On the double-headed serpent, see Wayne Suttles, *Musqueam Reference Grammar* (Vancouver and Toronto: UBC Press, 2004), 568.

45 See Emilio Rojas, "Naturalized Borders (An Open Wound in the Land, An Open Wound in the Body)," in *Where No Wall Remains: Projects on Borders and Performance*, ed. Tania El Khoury and Tom Sellar), special issue of *Theater* (Yale School of Drama/Yale Repertory Theatre, vol. 51, no. 1 (2021), 62–79. Rojas is responding in part to a classic of border writing, Gloria Anzaldúa, *Borderlands/La Frontera: The New Mestiza* (San Francisco: Aunt Lute, 1987). On artistic response to borders, particularly the militarized U.S.-Mexico border, see Kate Bonansinga, *Curating at the Edge: Artists Respond to the U.S./Mexico Border*, with a foreword by Lucy Lippard (Austin: University of Texas Press, 2014), Ila Nicole Sheren, *Portable Borders: Performance Art and Politics on the U.S. Frontera since 1984* (Austin: University of Texas Press, 2015), and *Border Spaces: Visualizing the U.S.-Mexico Frontera*, ed. Katherine G. Morrissey and John-Michael H. Warner (Tucson: University of Arizona Press, 2018).

Cold War in stone—and plastic 2

If the previous chapter argued for an expanded conception of commemorative practice to take into account the complex site-directedness of much recent public art, I now want to show how this change in perception—and reception—can help us parse longer historical arcs, both as interpreters of earlier monuments and as scholars of the present, putting them in dialogue with recent work addressing or occupying the same historically freighted sites. To this end, I look closely at one discrete site within a familiar, even classic memorial landscape, much discussed in the context of Holocaust and Second World War commemoration: the city of Berlin. In the process, we will see how recent multimedia and narratively pluralistic developments in memorial culture transformed the more combative and purportedly unidirectional monuments built in the shadow of the Cold War in their use and reception.

Contrary to nationalist rhetoric before and after fascism, Germany and Austria have long been migration societies, historically in connection with their empires, then as a result of the postwar 'economic miracle' (*Wirtschaftswunder*) requiring the influx of workers from Turkey and other, predominantly Eastern European, countries. Most recently in 2015 and the years since, civil wars in Syria and Afghanistan, and political instability and climate change in the Near East and North Africa forced millions of people to attempt the difficult journey into the European Union. If this has been acknowledged in public discourse and art, it was often in negative terms, as a source of cultural friction and inequality. As the demographics of Western Europe, which has suffered sluggish birth rates for decades, undergo a change long in coming, we are reminded that histories and cultural references are not the given bedrock of a society, but are built up gradually, over decades if not centuries. The discussion around supposed common European values and their decline, once a staple of former National Socialists like Hans Sedlmayr and Arnold Gehlen, broke out anew in distinctly twenty-first-century forms, especially but not exclusively on the right of the intellectual spectrum.[1] My question here is, therefore: how should the history of the Holocaust, for so long considered both unique *and* of universal moral and political significance,

be taught today—that is to say, in a time when eyewitnesses have become rare, totalitarian regimes and human rights abuses proliferate, and many residents of Germany and Austria are recently arrived from the Middle East?[2] Apart from these demographic generational shifts, there are cultural ones: place-making, public discourse, and the relationship between history and the self is seen very differently by those generations who grew up with the internet. I turn to two relatively little-discussed monuments of the 1950s, relics of a shakily emerging democratic memory discourse in the postwar Federal Republic of Germany, to consider the historical difficulty of pluralist commemoration and its assumptions. Particularly, a question postwar commemoration has had to ask itself repeatedly once again needs restatement from scratch: Who is the audience or recipient? I show how the abstract concept of the "citizen" and even the more open one of a "community," and the physical counterpart of site and place they project, have difficulty addressing the challenges of an ever more heterogeneous society of migration and globalization, in which "community-based," "for the community's sake" and similar formulas are open questions, not reassuring certainties.

Written in stone?

My case study, the memorial on Steinplatz in Berlin Charlottenburg, a central location in West Berlin, is both a monument and a relic [Fig. 2.1]. Erected in 1953, its mostly white limestone blocks rise pyramidally, without figuration. A dedicatory plaque covering the central stone reads *Den Opfern des Nationalsozialismus* (To the victims of National Socialism), with the dates "1933–1945" on the bare stone above it and, above that, an inverted triangle, the symbol used on the uniform of concentration camp prisoners. Connected to the top of the triangle and tilted to form a larger triangle, we find the hardly decipherable letters "KZ" (for **K**onzentrationslager, concentration camp).[3] This unusual structure is considered the first memorial in what was to become West Berlin dedicated to the Jews killed under National Socialism. This specific intent of the memorial is not immediately noticeable given the wide address, but there are material connections that are important. The ashlars forming the memorial were reclaimed from the nearby synagogue in Fasanenstrasse, Berlin's largest Jewish house of worship, burned down in the November pogroms of 1938 and further destroyed by aerial bombardment during the war. The last remains of the ruin were ultimately cleared as late as 1957, when the Berlin House of Representatives (*Abgeordnetenhaus*) decided to commission a new, more or less secular Jewish Community House (*Jüdisches Gemeindehaus*) on the site [Fig. 2.2].

The resulting modernist cube, stunningly surfaced in randomly distributed polychrome ceramic tile and fronted by a surviving fragment of the

Cold War in stone—and plastic

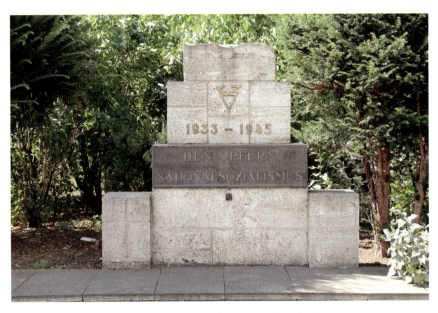

Monument to the Victims of National Socialism, Steinplatz, Berlin.

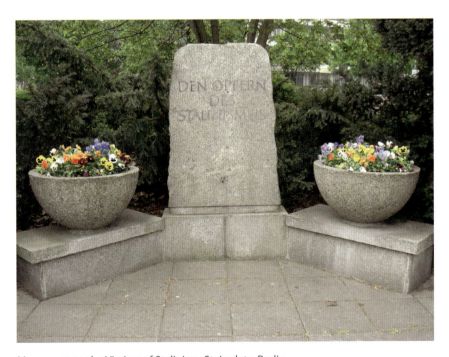

Monument to the Victims of Stalinism, Steinplatz, Berlin.

original 1912 portal, survived a 1969 bombing attempt and served as the headquarters of the Berlin Jewish community until 2009, when the larger Centrum Hebraicum in the New Synagogue in Berlin Mitte (which had played the same role in East Berlin) took over this official role.[4] The Charlottenburg center opened in 1959, a good six years after the private Association of the Persecuted of the Nazi Regime (BVN, Bund der Verfolgten des Naziregimes) claimed the stones for the memorial.[5] We might wonder if the difficulty for visitors to Charlottenburg in deciphering this dedication, even in a graphic design register, is significant.[6] The symbol used to signal its identity is a simple triangle, not the yellow double triangle reminiscent of the Star of David that all Jews older than six years were forced to wear during the Nazi period.[7] Uncertainty over the political implications of the memorial increases once we realize that it faces a counterpart erected on the same square only two years earlier: a memorial "to the victims of Stalinism" (Den Opfern des Stalinismus), consisting of a simple incised block between two planters, initiated by the private Association of Victims of Stalinism (Vereinigung der Opfer des Stalinismus), and its sister organization Community of the Persecuted and Opponents of Communism (Gemeinschaft von Verfolgten und Gegnern des Kommunismus), founded in 1950[8] [Fig. 2.3].

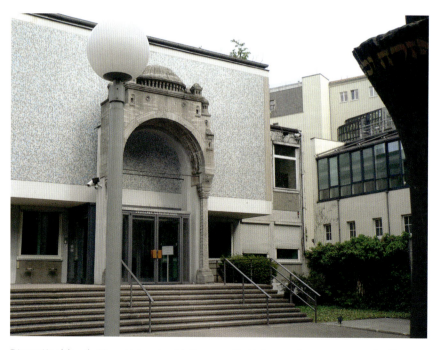

2.3 Dieter Knoblauch, Hans Heise, *Jewish Community Hall*, 1957, Fasanenstrasse, Berlin.

The simultaneous, and certainly competitive comparison or equation of Stalinist and National Socialist terror embodied in the building of parallel memorials attracting visitors to this modest urban park nicely captures the West German atmosphere at the beginning of the 1950s, with its slightly tendentious air of steering between left and right political extremes.[9] Victim monuments were not canonical at the time these two were erected, and would not become so for several decades.[10] But what interests me most is how these stone objects are perceived today. A lot has happened to complicate what was complicated enough in the Adenauer era. Holocaust remembrance has today become uncontroversial in the political establishment, even as anti-Semitic attacks in European cities have risen in frequency and violence. At the time of this writing, right-wing politicians are all too happy to instrumentalize recurrent anti-Semitism to fire up anti-Islamic and anti-migrant sentiment, which neither proves that they themselves are not anti-Semitic, nor that they will not adopt anti-Semitism in the future. As Nora Sternfeld wrote in 2011, the trouble with the political acceptance of Holocaust commemoration is that it "makes it possible to integrate the negative memory of Nazi crimes and the Holocaust in a positive narrative of identification."[11]

Since the 1980s, Holocaust monuments have become increasingly interactive, even performative, in an attempt to engage audiences critically in history, in the best cases not just provoking sadness and mourning, but prompting individuals to take part in a public process of commemoration. Yet only in the last years has it been noted that "the audience" has changed for this family of monuments and memorials. What started as commemoration and work of history for German and—due to persistent attempts to claim victim status— only belatedly for Austrian nationals, became an endeavor of the respective political administrations to show to a global audience, partly reached remotely through news coverage, partly on the ground through tourism *and* multinational communities, that these countries were working diligently through their histories, and might have learned something of lasting value from the experience.[12]

Peter Eisenman's *Memorial to the Murdered Jews of Europe* in Berlin and Rachel Whiteread's *Judenplatz Holocaust Memorial* in Vienna stand at the forefront of this twenty-first-century tendency. With it comes a coherent set of features and concerns: international rather than local design talent; placement in a prominent urban space, often requiring elaborate urbanistic or even archaeological (Vienna) public works; heated local discussions not about the subject of commemoration per se but about the danger of losing tourist foot traffic and parking spots, or complaints by local restaurants that customers would buy less beer (in Vienna) when "confronted" with the history of the Holocaust; and, above all, a vaguely minimalist formal language that allows abstraction, bodily connotations, and also elegance to live side by side.

There is also visible, in two decades' retrospect, a monumental solidity to these two most prestigious projects, standing somewhat at odds with the much-discussed rhetoric of affect and dynamic personal interaction. Not unlike Maya Lin's *Vietnam Veterans Memorial* in Washington D.C., the very formality and permanence of these objects are felt to provide some guarantee of their integrity.[13] To be clear, I am not worried here about the globalization of "star-monuments," their size and expense, but about access to history, and in particular this traumatic history of the twentieth century, in a contemporary migration society. How might first- and second-generation immigrants find their place within the torn, violent history of their new home countries? By looking at massive abstract art? Again, the *writing* or science of history helps us put this in perspective: Michael Rothberg and others have shown that the Holocaust emerged theoretically alongside the critique of colonialism, a worldwide endeavor if there ever was one. Work on diasporic memory, and solidarity between participants in memorial culture, has been ongoing since the turn of the twenty-first century, if not since W.E.B. du Bois's 1949 visit to the ruins of the Warsaw ghetto and his 1952 essay reflecting on that experience, which Rothberg understandably highlights.[14] In light of these developments within memorial culture, and the steeply mounting political challenges it faces, from refugee crises to the mainstreaming of right populism, what if anything can the humble Steinplatz with its little memorial landscape teach us?

In contrast to the heated rhetoric concerning memory and identity today, the 1950s commemorated recent history in a strikingly subdued manner. One may speak with the Mitscherlichs of an "inability to mourn," or give other, less psychoanalytic diagnoses of postwar German culture.[15] But that is not exactly what one sees on the Steinplatz: rather, both memorials are disarmingly simple, physically and spatially. The anti-Stalinist one is in fact a plain stone, while the memorial to the victims of National Socialism consists of several layers of material that amount to a visually undemanding abstract sculpture, recalling the funeral architectural conventions of many cultures in its wide base and narrowing top. Both recall gravestones, a perpetual standby of commemoration. The formal abstraction of their design, in an era by no means committed narrowly to abstract art, points to anxieties about *representing* recent terrors of history, in particular the Holocaust. Though it can hardly have issued from the same idiosyncratic Hegelian-Marxist principles, such anxiety brings to mind Adorno's forthright-sounding but in fact ambiguous claim in 1951 that "writing poetry after Auschwitz is barbaric."[16] The cultural phenomenon of the alleged sublime unrepresentability of genocide, with its inverse effect of raising the moral and political profile of postwar abstract painting and sculpture, has attracted the attention of art historians interested in how non-figurative art was drafted to address the Holocaust and politics more broadly.[17]

More curious still is how quickly Cold War politics took hold of the process of Holocaust commemoration. Stalin died in March 1953. In West Germany starting around that time, a hesitant acknowledgement of the victims of National Socialism could serve as warning against Stalinism. What surfaces here, still latently or implicitly, would become the core argument of the German *Historikerstreit* (Historians' Dispute) of the 1980s, when historian Ernst Nolte denied the Holocaust's particularity by framing relativizing comparisons to Stalinist terror; without denying Nazi atrocities, the message was that they were neither unique, nor unjustified, given what Germans were up against. This incited an acrimonious exchange that played out in German newspapers and political circles well past Reunification.[18] That debate, as wrong-headed and quasi-fascist as were some of its arguments, has provoked unexpected echoes in recent years. If the specific argument put forward by Nolte, that the Holocaust was a *reaction* both to how the Soviets dealt with enemies of the state and to the fear that German Jews would side against Germany in a coming war, was dangerous speculation, like many tendentious polemics in public space, it could only be met by bringing in more context and evidence, not narrowing the focus.[19] Accordingly, the opinion once prevalent on the left that the singularity of the Holocaust prohibits comparative analysis with other genocides has been revised, if only in part.[20] And so the 2020 German translation of Rothberg's *Multidirectional Memory* had sparked a heated debate by spring 2021 in newspapers and news channels that neatly reverses the political loyalties of the earlier *Historikerstreit*. Calls to "Remove the taboo to compare" in the interest of solidarity with other victims of German exceptionalism (Rothberg and his allies), met blanket declarations that "the Holocaust was not a colonial crime," a quasi-performative utterance probably meant less to guard the conceptual integrity of the former term than to discourage discussion of the latter.[21] What interests me here is not how this debate will end (though that is important) but the claim of uniqueness and its relationship to site and duration. Over time, the theory of, research on, and commemoration of the Holocaust has made it a paradigm for historians all over the world working on state-administered killings and historical traumas, from civil wars to colonial genocides.[22] It is to be hoped, but hardly to be believed, that it will not continue to serve as a paradigm for fresh crimes against humanity.

Access to history

Giving access to history sounds like a job for memorials, but of course this proves idealistic upon closer inspection. Let us pause to think about the objects of commemoration for a moment. In many ways, it was a long road to the view many of us share today—that a heterogeneous public sphere is

healthy and needed—a view challenged by conservative authorities (be they national, religious, or neoliberal) whenever it has come to the forefront of debates, and still under fire in today's populist climate, from the call for a German 'mainstream culture' (*Leitkultur*) to the imagined "Greatness" of Trump's United States.[23] In such a polarized public arena, thoughtful curating of sites might be one way to invite this heterogenous public to the table. As noted, I am here thinking mainly of migration societies with roots in different cultural-geographical contexts: but that includes the United States, and growing portions of the world. How can artists and those who commission them share history generously in memorial spaces, instead of setting up competitive frameworks that will only breed new resentments and reprisals?

Let us return to Steinplatz. We have here two memorials initiated by victim groups, and they seem to be in line with a traditional idea of reaching agreement on recent history, which the audience should receive as a straightforward message (totalitarianism is to be condemned), while allowing gatherings to publicly commemorate in their presence. At the same time, of course, these two stone memorials, in their juxtaposition, also show ideological disagreement, if not open conflict, about what to prioritize. The group initiating the Anti-Stalinist monument, the Association of Victims of Stalinism, consisted of persons who had survived prison camps, but it also engaged politically, commissioning memorials, meeting regularly with members of the Berlin Senate and Chancellor Konrad Adenauer, and, perhaps most questionably, demanded an end to denazification procedures for all former political prisoners of the Communist regime.[24] In other words, theirs might be the very dictionary definition of "competitive memory." Stalinist terror, for them, makes Nazi background no obstacle to the victim status of one of their subjects of commemoration.[25] It is not surprising, then, that the monument was convenient to many agendas: it served as the endpoint of a symbolic march led by Willy Brandt to protest the suppression of the Hungarian revolution in 1956, but also became a site of gatherings by right-wing groups in the 1960s and after.[26] The relevance of the memorial and its symbolism to 1980s *Historikerstreit* revisionism about German responsibility for the Holocaust, relativizing or minimizing it in light of the atrocities of Stalinism, is by no means subtle.

Exclusion of one part of history in favor of another—like the rhetoric of "All Lives Matter" in the United States—does not occur in a vacuum. Part of the official tradition of history and public memory is to disregard the possible heterogeneity of citizens (and residents, and visitors, who are often ignored in research on public art), to homogenize public history in the interest of those doing the governing. Even before the construction of the Berlin Wall (1961), however, at the beginning of West German democracy, just after the two parts of Germany had declared their existence as separate nations (in 1949, reunited

in 1990), the difficulty of ignoring conflict became visible, as did the problematic nature of an "exclusion by inclusion" strategy: the effort to bring together people in some kind of unity about historical events, to agree on the meaning of history, construct a common (national) future, and consolidate a complex debate. The split of Germany offered a welcome excuse for both countries' governments (however different their political strategies) to push the Holocaust as a formative moment in German history just out of public discussion. Steinplatz in the West was a marginal space compared to where the debates about current history were being carried out at the time: places near the fault lines of occupation in Berlin Mitte, like the Brandenburg Gate, restored by East German authorities in 1957 without its customary Prussian state emblems, before it ended up in the no man's land around the Berlin Wall[27] [Fig. 2.4].

The political focus in 1950s Berlin, then, rested largely on the conflict between capitalism/democracy on one hand and communism/Russian hegemony on the other. In the *Bundesrepublik* (West Germany) in general, anti-communist policies overshadowed a detailed look at Germany's role in the recent past. With the Second World War as a political and historical caesura establishing a new German political landscape, "Auschwitz" (until the 1980s the metonymic symbol for the Holocaust in all German-speaking countries) did not figure as a concrete historical event, but rather was mystified

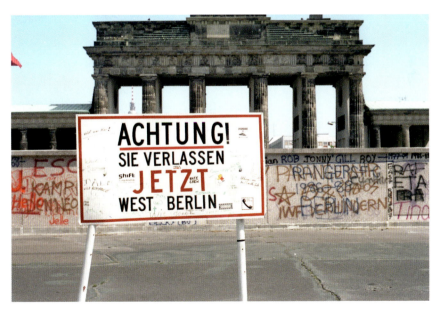

Sign in front of Brandenburger Tor, "Attention! You are now Leaving West Berlin," January 1989.

as the "end" of civilization, even its logical and necessary endpoint.[28] This apocalyptic attitude, popular on the left as well as the right, was accompanied in the politically prevailing center by calls to draw a "closing line" (*Schlusstrich*) across the political spectrum, meaning essentially an amnesty for former National Socialists, and a general resistance against imputing any kind of "collective guilt" to the German people as a whole, once the allies left the country in 1949.[29] Memory scholar Aleida Assmann has diagnosed the absence of public commitment to commemoration as "societal pragmatic of silence," wherein dealings with the past were privatized.[30] In other words, families and individuals were supposed to struggle with these problems in an introspective vein, aided by cathartic and popular works like *The Diary of Anne Frank*, published in Dutch in 1947, and in German translation in 1950. Even in the most outspoken works of art, like the remarkable 1946 film *Die Mörder Sind unter uns* ([Murders Among Us]; directed by Wolfgang Staudte), with its hero haunted by the desire to kill a war criminal, personal drama overshadows the real rubble of Berlin and Potsdam which looms over the shoot[31] [Fig. 2.5].

In East Germany, communist political opposition to National Socialism became the formative myth of the new state, which would culminate in the cynical styling of the Berlin Wall as an "antifascist barrier" (*antifaschistischer*

2.5 Wolfgang Staudte, *Murderers Among Us*, a commercial film shot in Berlin in 1946.

Schutzwall) by the East German government.[32] Accordingly, East German commemorative sculpture revels in the celebration of resistance fighters, affirming the role of the Red Army in freeing the country in 1945.[33] Persecution and resistance were closely aligned in the GDR, and imagination often merged them in official monuments. The individual citizen of the GDR—no matter what his or her alliances had been—could push away the uncomfortable issue of guilt by public rituals such as marching in mandatory anti-fascist parades organized by the *Sozialistische Einheitspartei Deutschlands* (Socialist Unity Party of Germany; SED). Jewish victims, and by extension the East German counterpart of the BVN, the VVN (*Vereinigung der Verfolgten des Naziregimes*) had little place in this narrative of class war, which declared the West German government to be a continuation of Hitler's regime.[34] In other words, far from the quietist stereotype that has dominated recent views of it, the 1950s memorial landscape was riven by conflict. To make this concrete: for nearly a decade (1953 to summer 1961), West *and* East German citizens could conceivably (as unlikely as it was for the average East Berliner) see the two memorials to victims of National Socialism and of Stalinism on a visit to Charlottenburg. These were not the members of distinct cultures, language groups, religious or ethnic collectives: in some cases, they were members of the same family. As with Union and Confederate commemorators in the United States, it is hard to imagine more diametrically divergent stances for remembering the past, pledging one's commitment to a community, or taking responsibility for history.[35] Even assuming the average East German did not share the ideological commitments of the SED (after all, the Berlin Wall was built in large part to stymie defections), the horizon of interpretation, and of possibility, for visitors to Charlottenburg were never one and the same.

Site as identity

Recent memory studies have discussed the conflicts between history, memory, and identity, and also tried to account for the transnationalism of commemoration in our era of migration and social media.[36] Nevertheless, as the example of Charlottenburg suggests, our grasp of the multigenerational and transnational workings of cultural memory can easily grow fuzzy, particularly in the presence of objects which are, after all, representations more than experiences of history. If we want monuments to provide contemporary access to history, we need to focus on space, and see how the location as a site in the present can serve as one anchoring point for a shared experience. How should this look in practice? From talking to educators—teachers and museum professionals—I know that the approach to provoking discussion in a multi-religious audience (itself prompted by mandatory school excursions) involves the introduction of supposedly shared topics such as migration,

marginalization, and prejudice, which leads to the opening of a shared space of interest, after which objects (of personal relevance, or cultural or religious significance) are introduced, allowing for more differentiated discussion of specific histories.[37] One example: the Jewish Museum Frankfurt organizes workshops, run by Manfred Levy, a German Jew, and Türkân Kanbiçak, a Turkish-born German, in vocational schools, which have a high number of first- and second-generation immigrants, many from Islamic countries. Levy and Kanbiçak bring up the concepts of exclusion, identity, migration, and homeland, before asking students to create videos of the locations they call home, which are then presented inside the museum.[38] Real sites play a significant role in this endeavor, but they are mediated through discussions and the relationship to the self. This seems to be one way of thinking through self, place, and object in terms of identity, history, and memory, before turning to German and Jewish history and possible points of contact.

As effective as such efforts might be, the assumption is that various spectators will be drawn together by personal experiences, rather than by any shared aesthetic or political interest. If this works, it would not invalidate Aleida Assmann's diagnosis of a privatized, subjective postwar German memory culture; as with the metamorphoses of historical exceptionalism and comparativism, that diagnosis arises from a particular moment, but can also describe historical patterns that recur. Several generations later, we have arrived at a practical conviction that the personal, in this case experiences occurring in radically different historical circumstances (current histories of migration), need not compete, and indeed may be the only real help a heterogeneous audience has in grasping what is otherwise abstract, ancient history. Of course this is not done in a vacuum, as in the case of a young postwar German (or an Austrian like myself, or an American, I might add) reading Anne Frank and being expected to draw her own conclusions. Educators can draw on a range of documentary and art sources to nuance any crude equation of past and present. I cautiously endorse this approach—but it remains to be seen if it can translate from a controlled museum space, refereed by an education team, to public space and monuments 'in the wild'.

Another translational challenge is our evolving relationship to mediation: social media already play a role in the construction of commonness, identity, and historical precedence, so they must play a role in our investigation.[39] If whatever else a monument does, it claims the space it stands on, where exactly is that space, when even the on-site visitor is likely to share the experience photographically with an off-site public? As I argued in Chapter 1, at this point, we can no longer separate publics in real space from those in virtual space, since audiences more often operate exactly at the intersection of material and virtual space via smartphones, becoming audiences and at the same time producers of encounters with urban environments and history.[40]

If this argument holds water, the ordinary private (non)citizen visiting Charlottenburg today, and posting digital snaps of the Steinplatz, more nearly resembles Willy Brandt in his televised pilgrimage to the site than the average schoolchild in a museum classroom, being asked to think through their own experience and family's memories in relation to some historical event or artifact. Or better yet, the contemporary visitor resembles both, using the memorial site as both a stage for transmission *and* the generator of private, on-the-ground experience.

Reloading history in the age of selfies

Looking at the recent redesign of Steinplatz will make clear what that means in practice. In 2015, a competition was launched by the district government of Charlottenburg to consider Steinplatz under the rubric "Campus meets Steinplatz." Students of the University of the Arts (Universität der Künste), whose building sits just opposite the square, were invited to submit proposals. The winning design opened up access to the square, rethought the landscape design, erased parking spots in favor of pedestrian access, and busied itself particularly with restaging the memorial landscape.[41] Part of this engagement took the form of a three-month installation planned for the opening of the redesigned square in August 2018 by an artist team rather impenetrably named mmtt (Stefka Ammon and Katharina Lottner)[42] [Fig. 2.6]. For *STEINPLATZ reloaded*, mmtt added 24 commemorative sculptures to the three existing memorials—besides the two already discussed, there is a bust of Baron vom Stein (Karl Freiherr vom und zum Stein), the namesake of the square, a Prussian liberal whose early nineteenth-century reform efforts were instrumental to German unification, not to mention the founder of a national-patriotic research project that proved influential internationally, the Monumenta Germaniae Historica.[43] Their aim was to point the public to a multiplicity of historical events and persons, all of them more or less spatially connected to the square. These new commemorative sculptures were presented on pallets and cocooned in plastic wrap, barely revealing vaguely anthropomorphic designs inside, all composed of building waste devoid of intentional formal associations to the events or persons, as the designers explained to me via email. The familiar monuments, like Baron vom Stein, were in turn disguised, in his case with what resembled a helmet or beekeeper's mask.[44]

As "imaginative" history, the temporary memorials remained visual suggestions or premonitions, their context and connection to the site explained via text labels, and the requisite QR codes for further reading on digital devices: twenty-four of many possible connections to the site. The concept was simple, deceptively so. Rather than offer a counternarrative to the Cold

2.6 mmtt (Ammon and Lottner), *Steinplatz Reloaded*, 2018.

War standoff of the 1950s monuments, mmtt's monumental field asked: What are some of the histories deposited in this square? In the most naive terms possible: What happened here? What else? And what else? The artist Charlotte Salomon, who studied at the art university and was murdered at Auschwitz, is among them, as is an art student killed as a resistance fighter, but so are historical concepts relevant to all Berlin and postwar West Germany, like the Marshall Plan, and again specific to the Platz and its neighboring institutions, a memorial to the "first female professors" at the University of the Arts, Rénee Sintenis and Rebecca Horn. The various experiences in what the designers called a "SIMULTAN-INSTALLATION LAB" were to be further intensified through two procedures: dramatic and documentary tours led by actor–tour-guide Eckehard Hoffmann on "five Sundays" and the transcription of the comments of audiences by professionals on "four Saturdays."[45] These transcripts, anonymized and supplemented with photographs, were regarded by the artists as the "experimental material" (*Versuchsanordnung*) generated by the event, to be preserved in Charlottenburg's City Archive.

Despite the awkwardness of some of the quasi-scientific terminology, and the division into dramatic and recorded events, the plurality of concerns and histories addressed or initiated in this temporary project constitutes an

adventurous contemporary way of thinking through commemoration as part of an active representation of a plurality of heterogeneous residents (rather than citizens), whose voices should be heard. It was already obvious from the design concept that these stories and events would not add up to a linear master narrative, but what held them together (and was less of a concern in the memorials of the early 1950s) was the spatial fabric binding these events, and allowing them to coexist in a historical continuum, even to address one another. Instead of a linear history of the kind that still prefaces many museum exhibitions, we have the site as connecting factor of these histories, generously captioned on the ground as well as online. This is an approach influenced by discussions of public art and site-specificity since the 1960s, but also those around the relevance of authentic places in urban history and archaeology, an approach underlined by the provision of tour guides.[46]

This is one bold way of addressing the multiplicity of people encountering particular histories on one site, though it can hardly be a "one concept fits all" solution. For instance, in visiting *STEINPLATZ reloaded*, one wonders whether recent arrivals to Charlottenburg were on an equal footing with long-time residents, to say nothing of art students familiar with the mythology of their school and neighborhood. On the other hand, the very point of the project was how much history is *not* visible or familiar even to those claiming cultural mastery. In that sense, the wealth of commented objects, and their frustrating visual occlusion by plastic wrap, while it can't completely even the playing field, produces an aesthetic confusion that may give different spectators cause to find out more—or not. If monuments and memorials were (and are) always as much indicative of the time and context in which they were erected as the events they commemorate, we need to think not just about a particular significant moment (certainly not a "present" which keeps skipping away from the moment it is invoked), but also about a relay of times, temporal strata or even overlapping memory spheres with their attendant audiences.

That doing so need not blunt the impact of memorials, reducing them to a kind of postmodern-multicultural "something for everyone," can be seen by looking more closely at some of the individual *Reloaded* projects. One of the wrapped statues at Steinplatz was dedicated to Cemal Kemal Altun, a politically active Turkish student who jumped to his death from the sixth floor of the administrative court adjacent to the square after his asylum case had become hopelessly politicized and he was accused of being a terrorist.[47] Altun had been politically active in Turkey and fled to Germany after the military coup of 1980. His death in 1983, in the midst of his deportation trial, spurred protests and eventually, in 1996, the construction of a memorial in front of the courthouse on Hardenbergstraße, movingly if rather conventionally representing his body in mid-fall, inverted and modelled in low relief around a negative space cut into the concrete[48] [Fig. 2.7].

70 | Monumental cares

2.7 Memorial to Turkish student and political refugee Cemal Kemal Altun (death by suicide 1983) by Akbar Behkalam at Hardenbergstrasse, Berlin, 1996.

The inclusion in the park of a nearby victim of the immigration politics of West Germany of course speaks not just to the 1980s, but also the current European refugee situation, and broadens, even if shyly and through a minute gesture, the histories of "Germany" on display in Charlottenburg. The practice of enclosing the monuments, irritating though it be, is especially effective here, where the source object is so dramatic: it makes the viewer viscerally aware of the effort needed to confront these histories, belying the apparent ease of the project's captions, online resources, and art educators.

The shifts in monument-making and curating attempted on the Steinplatz, in their address to the individual, and in the frank expectation of online reinforcement, might help us cope with another, more widespread phenomenon: the potentially narcissistic use of public art as backdrop to the social media lives of visitors. In Berlin, the ubiquity of Peter Eisenman's *Memorial to the Murdered Jews of Europe* in tourist selfies, as well as its popularity with children playing and commercial fashion shoots (one of them, prominently, for the now defunct airline Air Berlin) have brought public outcry, but few if any reasonable proposals for discouraging what many see as misuse.[49] It turns out that one cannot assume that historical understanding and "appropriate" behavior will arise spontaneously to match a high-minded memorial program.[50] In a way, the variety of uses is also a test case for the question of how much context one needs, and how much leeway we really want to give different audiences in the rough and tumble of ongoing public commemoration. I am by no means advocating advertising campaigns on the site, or a neoliberal melee of battling private interests, but for any plausible understanding of visitor activity, we need to take into account that these sites are open to the public, being "visited" again and again not only in person but by users of Instagram, Facebook, and other platforms, with hashtags curated by the individuals posting these images. Vigorous surveillance, far from preserving the thoughtfulness commemoration hopes to achieve, would falsify it under the guise of socially manipulative pseudo-solemnity.

In a recent response to the quandary, provocatively titled "Selfies from Auschwitz," Maria Zalewska starts her discussion by warning against the public shaming culture that reacts aggressively to happily smiling young faces in front of concentration camp barracks, before looking into how cultural institutions, the museum in Auschwitz in particular, handles the social media presence of visitors.[51] This discussion is still emerging, so I can only briefly sketch it. Zalewska neither exculpates all selfie-takers nor condemns all forms of engagement that do not visibly show appropriate gravitas. We need to allow for complexities in all such cases, and also for ordinary human stupidity, which can but need not automatically become hate speech in being propagated online. From conventions we all grew up with (smile for the camera) to the misunderstanding of hastily read visual cues, short descriptions or

hashtags, these images show how even the best pedagogical approach does not guarantee that everyone will "get it." On the other hand, the shamers might be considered activists, or "slacktivists" generating feel-good pseudo-political content online without engagement in the actual public sphere outside their like-minded readership.[52] For my argument, it is more important that visitors to Auschwitz are global, and come for very different kinds of reasons. For better or worse, these images force us to consider canonical sites and monuments anew, less as founts of authenticity than as stimulants to engage with reality, which includes both the obdurate material objectivity of objects in space and the flexible web of interpretations humans spin around them [Fig. 2.8].

A good example of how a moralistic demand for authenticity can turn into something more nuanced may emerge from one of the few genuine works of social media (political) art critically dealing with memorial selfies. In January 2017, Israeli-German artist and author Shahak Shapira posted on his website yolocaust.de ("yolo" being netspeak for "you only live once") twelve particularly egregious images of persons playing, performing, or just photographing themselves atop and around the Eisenman memorial, which he had trawled from the publicly available images on four social media platforms.[53] The portraits were in turn provided in their original color form as well as in black and white, the monumental backdrop digitally replaced by scenes of concentration camp life, "leaving the young selfie-takers unwittingly surrounded by emaciated bodies and corpses."[54] The response was rapid, particularly from news outlets, but according to Shapira he was also contacted by all twelve of his original targets, who were duly contrite. Within the week, he replaced the images on the site with a brief bilingual explanation of his practice, the transcript of the apologetic letter from one particular selfie-taker, and a range of responses he had received, ranging from thoughtful and supportive to all-caps attacks wishing him dead or in a concentration camp.[55] From an incisive but rather flat-footed bit of agitprop, he ended up with a kind of transcript of responses to the memorial and the Holocaust reminiscent of Jochen Gerz's *Monument against Fascism* in Hamburg-Harburg, whose column, inscribed by vandals and commemorators, is central to counter-monument discourse and its hopes to bring together a variety of voices in public space.[56]

There are, then, many ways to attend to the complexities of commemoration today—without losing sight of the fact that it was always intricate. Zalewska, for instance, focuses on the institutional response by the Auschwitz memorial team, and their careful curating of public Instagram photos to allow a respectful engagement from young visitors, but also on how the transnational flow of the images shapes our understanding of the past.

Paradoxically, at a time of national retrenchment, we have to admit that the idea of a coherent society—which was always a myth—has been subtly

2.8 Results for Hashtag #Auschwitz, Instagram, March 2022.

supplanted not just by actual movement of people, but also by the movement of stories, sites, and the possibility to identify with places never visited via "likes," curated stories, memes, visual echoes and other means. But it is not simply a matter of accepting the heterogeneity of the social and allowing tensions or conflict to be part of a functioning democratic public sphere, as suggested by many authors in the last decades, because conflict does not necessarily lead to insight. After all, conspiracy theories and Holocaust denial are incubated in online forums. We need to think once more about how public space and the public sphere are being transformed. The seeming dislocation of sites through social media reminds us that in the contemporary world we cannot claim that sites of common history speak authentically to all residents. We are much too heterogenous for this. What social media also reminds us is that even a site that is new and unfamiliar becomes accessible through individual agency, sometimes even if it seems like narcissistic posturing. Whether individual agency is always the same as foregrounding of the self must remain debatable, in my opinion, but there is no doubt that it aids newly arriving migrants to stay connected to where they came from, and to adapt to, and communicate about, their new surroundings. The sites around them on social media become part of their self-assurance, and social media provides a parallel space in which discussions about politics, life, love, adjustment, and histories take place. I contend that there is a fine line between narcissistic ignorance of the world outside the self and meaningful access between the two. In any case, a better question than how to control or censor visitors, or get them to control or censor themselves, might be how to foreground history in these places and how to use social engagement both in real and virtual spaces already saturated with partisan political manipulation. Doing so would bring together experiences and history (via discussion, social media engagement, or by simply being there) in configurations that reflect not necessarily a linear history of states, but rather the transnationality of much daily life today, and in the past.

I want to end this section with a recent monument project commemorating an event prefiguring the Holocaust, the evacuation of Jewish children (the *Kindertransporte*) to England in the 1930s, which shows just such a skilled multiplication of points of audience contact. Yael Bartana's *Orphan Carousel* in Frankfurt from 2021, works openly with an element of play. The topic is already a challenge, particularly in the evasion of sentimental cliché. What form would be the best fit to remember these young survivors who were brought up by foster families while their parents had to stay behind? How to honor the courageous endeavor of the various organizers, and these children's resilience, without falling into celebratory platitudes? After all, families were torn apart, and many parents did not survive: it is a story of escape and survival, but also trauma.

Maybe it is due to these complexities that few memorials to the Kindertransport exist, and, perhaps surprisingly, more than other forms of recent commemoration, many of those that do resort to the human figure and that traditional material of public sculpture, bronze. In a series of monuments by Frank Meisler erected in the early 2000s along some of their principal routes to safety in England (e.g., railway stations in Danzig, Berlin, Hamburg, Rotterdam, London), small groups of children, some with enormous-looking bronze suitcases, stand or sit composedly, if lonely and a bit wistful[57] [Fig. 2.9]. Old-fashioned apparel and hairstyles indicate the times in which the represented children lived and fled. The care exhibited by the artist for these children, the almost palpable sense that they will manage against the odds, is understandable given the fact that Meisler himself was one of them. But if we shift perspective and want to present these events to a contemporary audience as Germany enters the third decade of the twenty-first century, seventy-five years after the end of the war and eighty years after the transport, which ended the day Poland was invaded, we will notice that few of the survivors can still speak for themselves or identify with their bronze effigies. In this light, we need to move towards an element of experience that allows the

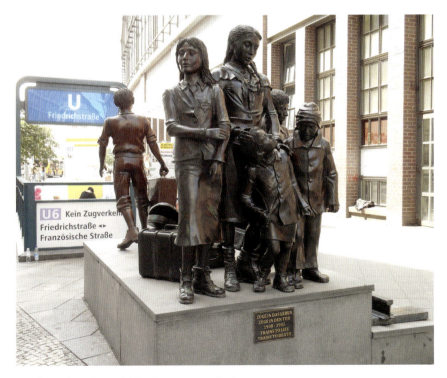

Frank Meisler, Memorial Kindertransport, Berlin, 2008.

audience to engage, to ask questions, to relate. For the question is indeed how to commemorate the stories of these survivors, *their* story, their experience, even their historical existence, while reaching an audience that is diverse and by no means unified in feeling or intellectual formation. Frankfurt is a global city, frequented by citizens, migrants, professional expatriates and tourists, and the design competition was covered by international newspapers and professional architectural journals alike. Even if this society were as homogenous as certain nostalgic, retrospective views make it seem, there emerges with such a project, begun long after the commemorated events, a dynamic tension between those who are remembered, those seeking closure or catharsis for a painful time their family members have experienced, those seeing commemoration as a public sign of reform or education, and those learning about this history for the first time.[58]

Yael Bartana's winning project is, remarkably, neither a figurative depiction of the transported children nor a somber, noncommittal abstraction of their plight. As an object, it is both a monument and a functioning piece of playground design—even if that function, the rotation of the carousel, is reduced in speed [Fig. 2.10]. Through this design feature, the carousel-monument becomes a reenactment, however stylized, of children's experiences of the 1930s. The material taken from its model, a bulky polygonal wooden seat within a metal frame, with rounded metal bars for handles, is certainly solid, but does not read as eternal or even relatively perduring in the sense of traditional public monuments. Form and material thus quietly point to the real time during which the history took place, which avoids turning the event into a general message, however eloquent. But because we can use the carousel, both literally (spinning is possible) and socially (we are allowed, even invited, to use it), it also exists solidly in our present. It is this combination of use and history that allows an individual access to an experience of childhood that opens vistas beyond the corporeal experience towards recollection, imagination, and discursive thought, as mechanisms to help us grasp lived history.

In Bartana's carousel, play is introduced *explicitly* as part of the subject matter, perhaps as something missing or lost: children who left their homes and places of play, who lost their childhood both by being transported and because of the violent anti-Semitism they endured. The loss of play might seem small compared to the loss of human life and of family, but it should not be underestimated. Dutch historian Johan Huizinga in *Homo ludens*, written just before the Second World War, reminds us that play is a prerequisite not only of culture, but of society.[59] For Huizinga, the development of culture is always rooted in playfulness—not to be confused with a lack of sincerity—as can be seen in rituals, religion, arts, conflict, and, we might add, commemoration. In Bartana's project, play is tempered, filtered through this passage of

Cold War in stone—and plastic

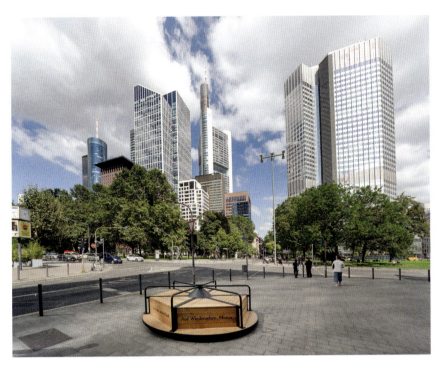

Yael Bartana, *The Orphan Carousel—A Monument*, Frankfurt am Main, 2021 commemorating the organized rescue effort of children relocated to the United Kingdom from Nazi territory before the start of the Second World War.

time and feeling of loss by the slowing down of the carousel, so that it revolves at a constrained pace. In being on the monument and causing it to move, one enacts the role of the children who are not pictured in the memorial, while having an opportunity to reflect on them as the city revolves gradually. It is not that we are expected to embody the experience of these children in any simplistic equation, and indeed we are hardly gazing upon the same city, but the monument makes possible a playful *and* caring attitude towards the conflicting feelings any history of the Kindertransport needs to evoke.

Similarly, the inscriptions "Goodbye, mother," "Goodbye, father," "Until soon, my child," carved into the vertical surfaces of the wooden seat so they are legible to anyone not sitting on the carousel, as well as the more conventional metal plaque inserted into the paving at some distance, point in various directions: the survival of the children, the death of the parents, the pain, the hope, the despair. It does not resolve these contradictions, and it does not tell the audience how to resolve them. This is its strength, because objects, even the best monuments, cannot do anything by themselves. They are not magical solutions to historical problems, and they cannot infallibly show what

happened, nor what the lesson should be. But, if set up thoughtfully, they can invite an interaction between object and those who want to commemorate, explore and record, interact and question, and who can then slowly build up history on their own scale, bringing in relation memory, imagination, and historical facts. They can allow us to see how we relate to history and how they themselves, and we ourselves, change with time.

Notes

1 Thilo Sarrazin, in *Deutschland schafft sich ab. Wie wir unser Land aufs Spiel setzen* (Munich: Deutsche Verlags-Anstalt, 2010), whose title translates to "Germany abolishes itself. How we are putting out country in jeopardy," argues that a combination of declining birth rate and immigration from Muslim countries (who refuse to assimilate) threatens the survival of German society. His book topped the bestseller list in Germany for almost two years. That Sarrazin had been in the SPD (Social Democratic Party) fueled the discussion. Likewise, the most famous German feminist and pro-choice advocate, Alice Schwarzer, founder of the feminist journal *Emma* in 1977, has warned against the Islamization of Europe and advocates a hijab ban in public, including schools. See Alice Schwarzer, "Im Namen einer falschen Toleranz," *Die Zeit* (July 25, 2019); better-informed, Turkish and Syrian-born German critics of Islamism are Necla Kelek and Bassam Tibi.
2 On a "post-witness" era in which few or no survivors remain, see the essays in *Revisiting Holocaust Representation in the Post-Witness Era*, ed. Diana I. Popescu and Tanja Schult (New York: Palgrave Macmillan, 2015).
3 The official description of the monument provided by the district office Charlottenburg-Wilmersdorf describes the stylized letters KZ as "resembling flames." See www.berlin.de/ba-charlottenburg-wilmersdorf/ueber-den-bezirk/freiflaechen/plaetze/artikel.156662.php.
4 See Esther Slevogt, *"Aufgebaut werden durch Dich die Trümmer der Vergangenheit." Das jüdische Gemeindehaus in der Fasanenstrasse* (Berlin: Hentrich & Hentrich, 2009), and more generally Michael Meng, *Shattered Spaces: Encountering Jewish Ruins in Postwar Germany and Poland* (Cambridge, MA: Harvard University Press, 2011), and Brian Ladd, *The Ghosts of Berlin: Confronting German History in the Urban Landscape* (Chicago: University of Chicago Press, 2018). On postwar German use of tile, see Markus Krajewski, *Bauformen des Gewissens. Über Fassaden deutscher Nachkriegsarchitektur* (Stuttgart: Alfred Kröner, 2016).
5 The *Bund der Verfolgten des Naziregimes* (Association of the Persecuted of the Nazi Regime) was founded in 1946. Its magazine *Die Mahnung* ("The Admonition") is still published monthly. The memorial landscape in both parts of Berlin is discussed in Eberhard Elfert, "Denkmalspraxis in Ost- und West-Berlin," in *Erhalten, Zerstören, Verändern? Denkmäler der DDR in Ost-Berlin: Eine dokumentarische Ausstellung* (Berlin: Neue Gesellschaft für Bildende Kunst, 1990). The ruin as monument was popular in the GDR, most notably in the remains of the baroque

Frauenkirche in Dresden, burned down in February 1945, used by the East German state as a monument against war, and finally rebuilt 1995–2005. In the center of West Berlin, the Kaiser-Wilhelm-Gedächtniskirche, a historicist building erected 1891–95 and bombed in 1943, served a similar purpose. See Wolfgang Benz, ed., *Ein Kampf um Deutungshoheit. Politik, Opferinteressen und historische Forschung. Die Auseinandersetzung um die Gedenk- und Begegnungsstätte Leistikowstraße Potsdam* (Berlin: Metropol, 2013). For a discussion of Steinplatz as "selective remembrance"—as opposed to the silence pervasive in the immediate postwar decades in Germany—see Jenny Wüstenberg, *Civil Society and Memory in Postwar Germany* (Cambridge, UK: Cambridge University Press, 2017), 55ff.

6 Eberhard Jäckel, "An alle und jeden erinnern?" *Die Zeit* (April 7, 1989), reprinted in *Mahnmal Mitte. Eine Kontroverse*, ed. Michael Jeismann (Cologne: Dumont, 1999), 58, in discussing the problem of monument dedication with regard to the planned *Memorial to the Murdered Jews* in Berlin, cites the Steinplatz monument critically as an example of a "general," "vegetating" dedication.

7 The Nazi system of prisoner symbols was elaborately modular. There were letters like "F" for French and "D" for Danes and variants for religious adherents like Jehovah's Witnesses, while the triangles were color-coded: those for political prisoners were red, homosexuals pink, and those "unwilling to work" (*arbeitsscheu*) black.

8 Elfert, "Denkmalspraxis in Ost- und West-Berlin," 23.

9 On this period's shift from denazification to economic liberalism, see Norbert Frei, *Adenauer's Germany and the Nazi Past: The Politics of Amnesty and Integration*, trans. Joel Gelb (New York: Columbia University Press, 2002).

10 In the US context, Senie's *Memorials to Shattered Myths* argues that this only happened after the Vietnam War; in Central Europe, monuments to "the fallen" (*Gefallenendenkmal*) presented soldiers as hero-victims, ignoring civilian casualties. On the genre, see Benjamin Ziemann, "Die deutsche Nation und ihr zentraler Erinnerungsort. Das "Nationaldenkmal für die Gefallenen im Weltkriege" und die Idee des "Unbekannten Soldaten" 1914–1935," in *Krieg und Erinnerung: Fallstudien zum 19. und 20. Jahrhundert*, ed. Helmut Berding, Klaus Heller, and Winfried Speitkamp (Göttingen: Vandenhoeck & Ruprecht, 2000), 67–91, and Jay Winter, *Sites of Memory, Sites of Mourning: The Great War in European Cultural History* (Cambridge, UK: Cambridge University Press, 1995), chapter 4.

11 Nora Sternfeld, "Memorial Sites as Contact Zones. Cultures of Memory in a Shared/Divided Present," online publication of the *EICCP. European Institute for Progressive Cultural Policies* (2011), http://eipcp.net/policies/sternfeld/en (accessed February 20, 2021). A revised version of this essay appears in Sternfeld, *Das radikaldemokratische Museum* (Berlin: De Gruyter/Edition Angewandte, 2018), chapter 6.

12 An affecting study of one such overlap is Marc David Baer, "Turk and Jew in Berlin: The First Turkish Migration to Germany and the Shoah," *Comparative Studies in Society and History*, vol. 55, no. 2 (April 2013), 330–55. Europe has to a certain point wrested a negative foundation myth out of the Holocaust, which binds the different nations together through their mutual, simultaneous involvement in

this continent-wide process of violence, even when their histories or the sides on which they fought the war differ. Benjamin Nienass finds a shared ethics of memory across this varied spectrum, centering on the commitment against anti-Semitism. This does impart common values, but also, an attempt to define the "European" on a specific Judeo-Christian model, a tendency with obvious risks of political exclusion. See Benjamin Nienass, "Postnational Relations to the Past: A 'European Ethics of Memory'?" *International Journal of Politics, Culture, and Society*, vol. 26, no. 1 (2013), 41–55.

13 On Lin's Vietnam Veterans Memorial, see the now classic essay by Marita Sturken, "The Wall, the Screen, and the Image: The Vietnam Veterans Memorial," *Representations,* no. 35 (Summer 1991), 118–42, revised as *Tangled Memories: The Vietnam War, the AIDS Epidemic, and the Politics of Remembering* (Berkeley and Los Angeles: University of California Press, 1997), chapter 2; Kirk Savage, *Monument Wars: Washington, DC, the National Mall, and the Transformation of the Memorial Landscape* (Berkeley and Los Angeles: University of California Press, 2009); and Harriet Senie, "The Vietnam Veterans Memorial: A Symbolic Cemetery on the National Mall," chapter 1 of *Memorials to Shattered Myths* (Oxford: Oxford University Press, 2016). On Whiteread, see Simon Wiesenthal, ed., *Projekt: Judenplatz Wien* (Vienna: Zsolnay, 2000), and Widrich, *Performative Monuments*, chapter 2.

14 W.E.B. Du Bois, "The Negro and the Warsaw Ghetto," *Jewish Life*, vol. 6, no. 7 (May 1952), 14–15, discussed at length in Rothberg, *Multidirectional Memory*, chapter 4. See also Nicholas Mirzoeff, ed., *Diaspora and Visual Culture: Representing Africans and Jews* (London: Routledge, 1999); related is Jenny Wüstenberg's notion of transnational memory: see "Locating Transnational Memory," *International Journal of Politics, Culture, and Society*, vol. 32, no. 4 (December 2019), 371–82, and *Agency in Transnational Memory Politics*, ed. Jenny Wüstenberg and Aline Sierp (New York: Berghahn, 2020). On Du Bois as an international thinker, see Adom Getachew, *Worldmaking after Empire: The Rise and Fall of Self-Determination* (Princeton: Princeton University Press, 2020).

15 Alexander and Margarete Mitscherlich, *The Inability to Mourn: Principles of Collective Behavior* [1967], trans. Beverley R. Placzek (New York: Grove, 1975), a book that greatly shaped memory culture in Germany and beyond.

16 Theodor W. Adorno, *Prismen. Kulturkritik und Gesellschaft* (Munich: Deutscher Taschenbuch Verlag, 1963), 26. The whole sentence reads: "Kulturkritik findet sich der letzten Stufe der Dialektik von Kultur und Barbarei gegenüber: nach Auschwitz ein Gedicht zu schreiben, ist barbarisch, und das frisst auch die Erkenntnis an, die ausspricht, warum es unmöglich ward, heute Gedichte zu schreiben." The article was written in 1949 and first published in 1951. Of course, at that time, there was much representation of the Holocaust, foremost the educational films shot by the Allies at the liberation of the camps, which German citizens were forced to watch in cinemas, alongside other means of distributing the images of the camps through reproductive media as part of "re-education." Adorno does not call *this* barbaric, but poems and presumably other art (on Auschwitz? or simply "after"?). Is all postwar poetry barbaric? Adorno secured himself against criticism by adding

that the "knowledge" why poems have become barbaric is also "eroded" (*angefressen*). On this dogma, disputed by poets from Paul Celan to Hans-Magnus Enzensberger, see the essays in Petra Kiedaisch, ed., *Lyrik nach Auschwitz: Adorno und die Dichter* (Stuttgart: Reclam, 1995).

17 See esp. Mark Godfrey, *Abstraction and the Holocaust* (New Haven and London: Yale University Press, 2007).

18 The first shot was Ernst Nolte, "Die Vergangenheit, die nicht vergehen will." *Frankfurter Allgemeine Zeitung* (June 6, 1986). There were many criticisms by historians and public intellectuals, but Nolte's main opponent became Jürgen Habermas, who demanded that younger Germans take responsibility for their parents' actions.

19 There were subtler arguments, with equally unsubtle political motivations: for example, Andreas Hillgruber, *Zweierlei Untergang. Die Zerschlagung des Deutschen Reiches und das Ende des europäischen Judentums* (Berlin: Siedler, 1986), which presented the "crushing" of the German Reich and the "end" of the Jews as parallel and interrelated.

20 See the special issue on "The Future of Remembrance in the 21st Century: Jewish Museums and the Shoah" of the *Vienna Yearbook of Jewish History*, no. 12 (2020), esp. "An altered approach to the Holocaust. Interview with Professor Ido Bruno, Director of the Israel Museum Jerusalem by Danielle Spera," 98–113.

21 The German edition is called *Multidirektionale Erinnerung: Holocaustgedenken im Zeitalter der Dekolonisierung*, trans. Max Henninger (Berlin: Metropol, 2021). See Michael Rothberg and Jürgen Zimmerer, "Enttabuisiert den Vergleich! Die Geschichtsschreibung globalisieren, das Gedenken pluralisieren: Warum sich die deutsche Erinnerungslandschaft verändern muss." *Zeit Online* (March 30, 2021) and the reply, Thomas Schmid, "Der Holocaust war kein Kolonialverbrechen. Eine Erwiderung auf Michael Rothbergs und Jürgen Zimmerers 'Enttabuisiert den Vergleich!'" *Zeit Online* (April 8, 2021), and Rothberg, "Holocaust und Kolonialismus. Historiker müssen vergleichen (February 8, 2022), www.berliner-zeitung.de/kultur-vergnuegen/debatte/zweiter-historikerstreit-michael-rothberg-wissenschaftler-muessen-vergleichen-li.210124 (accessed February 9, 2022). In English and without the paywall, there is also Michael Rothberg, "Holocaust Memory after the Multidirectional Turn," *Berliner Zeitung* (February 21, 2021), www.berliner-zeitung.de/open-source/gegen-opferkonkurrenz-es-gibt-auch-in-deutschland-kein-isoliertes-gedenken-li.141816 (accessed September 8, 2021).

22 See, for example, A. Dirk Moses, ed., *Empire, Colony, Genocide: Conquest, Occupation, and Subaltern Resistance in World History* (New York and Oxford: Berghahn, 2008), and other volumes in the *Studies in War and Genocide* series, ed. Omer Bartov and A. Dirk Moses. Within art history, see Susan Best, *Reparative Aesthetics: Witnessing in Contemporary Art Photography* (London: Bloomsbury, 2016), and Apel, *Calling Memory into Place*.

23 The *Leitkultur* debate was inaugurated in Germany by a Syrian-born German sociologist, Bassam Tibi, in his *Europa ohne Identität, Die Krise der multikulturellen Gesellschaft* (Munich: Bertelsmann, 1998). Trump's authoritarian

rules on public art are embodied in Executive Order 13933 of June 26, 2020, "Protecting American Monuments, Memorials, and Statues and Combating Recent Criminal Violence," *Federal Register*, www.federalregister.gov/documents/2020/07/02/2020-14509/protecting-american-monuments-memorials-and-statues-and-combating-recent-criminal-violence. The Biden administration has since revoked this order: see Executive Order 14029, "Revocation of Certain Presidential Actions and Technical Amendment," *Federal Register*, posted 19 May 2021, www.federalregister.gov/documents/2021/05/19/2021-10691/revocation-of-certain-presidential-actions-and-technical-amendment (both accessed November 30, 2021).

24 See Wüstenberg, *Civil Society and Memory in Postwar Germany*, 49–50. Also see the historical overview of Alexander Richter, "Aus der Geschichte der VOS," in *Vergesst uns nicht—wenn auch die Tage wandern und die Jahre*, ed. Vereinigung der Opfer der Stalinismus (Berlin, VOS, 2000), 253–59. In the 1950s, rumors of CIA and MI6 backing were rampant; more recently, VOS leaders have made anti-Semitic and anti-Islamic statements and been courted by right nationalist organizations. See also the entry on Steinplatz at *Flucht-Exil-Verfolgung*, an initiative founded in 2015 by students in the MA Program in Holocaust Communication and Tolerance of Touro College, Berlin, a private Jewish-American liberal arts college: https://flucht-exil-verfolgung.de/en/ort/steinplatz (accessed November 30, 2021).

25 Cf. Rothberg, *Multidirectional Memory*, introduction, where the term "competitive memory" is introduced to describe and critique the divergent approaches to identity of Walter Benn Michaels and Khalid Muhammad, which according to Rothberg share the assumption that identity, like collective memory, is an exclusive proposition.

26 Dominik Geppert, *The Postwar Challenge: Cultural, Social, and Political Change in Western Europe, 1945–1958* (Oxford: Oxford University Press / Studies of the German Historical Institute, 2003), 358.

27 See the concise article by Bernhard Schneider, "Invented History: Pariser Platz and the Brandenburg Gate," *AA Files*, no. 37 (Autumn 1998), 12–16.

28 Norbert Frei, "Auschwitz und Holocaust. Begriff und Historiographie," in Hanno Loewy, ed., *Holocaust: Die Grenzen des Verstehens. Eine Debatte über die Besetzung der Geschichte* (Reinbek bei Hamburg: Rowohlt, 1992), 101–9. The notion that the Enlightenment necessarily leads to totalitarian terror, as human domination of nature turns inevitably against human subjects, is a running theme in Theodor Adorno and Max Horkheimer, *Dialektik der Aufklärung* (Amsterdam: Querido, 1947, reprinted Frankfurt a.M.: S. Fischer, 1969).

29 See Norbert Frei, "From Policy to Memory: How the Federal Republic of Germany Dealt with the Nazi Legacy," in Jerzy W. Borejsza and Klaus Ziemer, eds., *Totalitarian and Authoritarian Regimes in Europe: Legacies and Lessons from the Twentieth Century* (New York: Berghahn, 2006). Aleida Assmann is the most prominent scholar of German memory culture. For her ideas on national identity, see *Shadows of Trauma: Memory and the Politics of Postwar Identity*, trans. Sarah Clift (New York: Fordham University Press, 2016).

30 Aleida Assmann, "Der blinde Fleck der deutschen Erinnerungsgeschichte," in *Geschichtsvergessenheit—Geschichtsversessenheit*, ed. Aleida Assmann and Ute Frevert (Stuttgart: Deutsche Verlagsanstalt, 1999), 112.
31 The film is well described by J.G. Ballard, who saw it in Britain, where it was widely shown: "the first revisionist German film, powerful but hollow." *Miracles of Life: Shanghai to Shepperton* (New York: Liveright, 2013), 116.
32 For the title and a sense of the prose, see *Rededisposition: Fünf Jahre Antifaschistischer Schutzwall*, ed. SED-Bezirksleitung Berlin, Abt. Agitation/Propaganda, Berlin, 1966, available at www.berliner-mauer.de/5-jahre-anti-faschistischer-schutzwall (accessed August 18, 2020). The larger propaganda story was that West Germany was planning an invasion, stopped at the last moment in 1961 by the building of the wall: see, for example, the reproduction of "argumentation instructions" (*Argumentationsanweisung*) sent by the same propaganda bureau to East German newspaper editors on the fifth anniversary of the "military securing of our state border," in Ann-Marie Göbel, "Krisen-PR im 'Schatten der Mauer': Der 13. August 1961 in der DDR-Zentralorganen," in *Fiktionen für das Volk: DDR-Zeitungen als PR-Instrument*, ed. Anke Fiedler and Michael Meyen (Berlin: Lit Verlag, 2011), 186.
33 Fritz Jacobi, "Trauer als Widerspruch. Leidmetaphern der Kunst in der DDR," in Eugen Blume and Roland März, *Kunst in der DDR: Eine Retrospektive der Nationalgalerie* (Berlin: G + H, 2003), 64f. On East German monument culture, see Anna Saunders, *Memorializing the GDR: Memorials and Memory after 1989* (New York and Oxford: Berghahn, 2019); Kristine Nielsen, "Whatever Happened to Ernst Barlach? East German Political Monuments and the Art of Resistance," in *Totalitarian Art and Modernity*, ed. Mikkel Bolt Rasmussen and Jacob Wamberg (Aarhus: Aarhus University Press, 2010), 147–69; and Nina Ziesemer, *Denkmalbestand im Wandel: Denkmale der DDR nach 1989* (Baden-Baden: Tectum, 2019). Especially suggestive, given the lack of a personality cult among living DDR leaders, is the martyr-cult around Ernst Thälmann, shot on Hitler's orders in Buchenwald in 1944. See, for example, Russell Lemmons, *Hitler's Rival: Ernst Thälmann in Myth and Memory* (Lexington: University Press of Kentucky, 2013).
34 Olaf Groehler, "Der Umgang mit dem Holocaust in der DDR," in Rolf Steininger, ed., *Der Umgang mit dem Holocaust. Europa—USA—Israel* (Vienna, Cologne, Weimar: Böhlau, 1994), 233–45. See also the essays by Groehler, Norbert Frei and others (notably Gudrun Schwarz on the Ravensbrück Memorial) in *Die geteilte Vergangenheit: zum Umgang mit Nationalsozialismus und Widerstand in beiden deutschen Staaten*, ed. Jürgen Danyel (Berlin: Akademie Verlag, 2014).
35 The reality and literary trope of fratricide is aptly handled in Drew Gilpin Faust, *This Republic of Suffering: Death and the American Civil War* (New York: Knopf, 2008). For a concrete case study, see J. Tracey Power, "'Brother against Brother': Alexander and James Campbell's Civil War," *South Carolina Historical Magazine*, vol. 95, no. 2 (April 1994), 130–41. The theme recurs in Germany, and split nations ranging from Korea to Moldova.
36 I have provided references in my discussion on multidirectional memory. But a volume influential for its framing of the issue is *Memory in a Global Age:*

Discourses, Practices and Trajectories, ed. Aleida Assmann and Sebastian Conrad (New York: Palgrave Macmillan, 2010). Other works characteristic of this newly transnational, media-aware approach include Ana Lucia Araujo, *Slavery in the Age of Memory* (London: Bloomsbury, 2020), and Anna Reading, *Gender and Memory in the Global Age* (New York: Palgrave Macmillan, 2016).

37 This sentence sums up ten years' conversations since I joined the Scientific Board of the Jewish Museum, Vienna in 2011, my experience teaching at an art school connected with an encyclopedic art museum (School of the Art Institute/Art Institute of Chicago, where I have taught since 2015), and the insights of university and museum colleagues in the United States, Canada, Europe, and East Asia. It is however ultimately my own synthesis of their ideas.

38 Phone conversation with Werner Hanak, then deputy director of the Jewish Museum Frankfurt, January 25, 2019. One of the outreach programs initiated by Kanbiçak is called "AntiAnti. Museum goes School."

39 This is a developing field, which has not reached even provisional consensus. For the effect of social media on the traditional public sphere, see Marie Shanahan, *Journalism, Online Comments, and the Future of Public Discourse* (New York: Routledge, 2018); in the European political context, *Social Media and European Politics: Rethinking Power and Legitimacy in the Digital Era*, ed. Mauro Barisione and Asimina Michailidou (London: Palgrave Macmillan, 2017). In art history, some new avenues come from outside the field: see, example, the work of literary scholar Rochelle Gold, "Reparative Social Media: Resonance and Critical Cosmopolitanism in Digital Art," *Criticism*, vol. 59, no. 1 (Winter 2017), 123–47. Part of the difficulty, as anyone consulting the *Encyclopedia of Social Media and Politics*, 3 vols., ed. Kerric Harvey (Los Angeles: Sage, 2014) will notice, is the short shelf life of research on social media, or put another way, their rapid development and branching use.

40 See Martin Zebracki, "A Cybergeography of Public Art Encounter: The Case of *Rubber Duck*," in *Public Art Encounters*, ed. Martin Zebracki and Joni M. Palmer (New York: Routledge, 2018), 198–216 and Zebracki and Luger, "Digital Geographies."

41 Oliver Schruoffeneger and Małgorzata Mientus, Press Release on 14 August 2018, "Eröffnung des Steinplatzes mit Kunstprojekt und Forschungspavillon," Charlottenburg-Wilmersdorf District Headquarters (Bezirksamt), www.berlin.de/ba-charlottenburg-wilmersdorf/aktuelles/pressemitteilungen/2018/pressemitteilung.729319.php (accessed January 17, 2019).

42 Incidentally, the two are not associated with the Universität der Künste: Ammon studied, and has taught, at Kunsthochschule Berlin-Weißensee, and Lottner studied architecture at the Fachhochschule Frankfurt am Main and stage design at the Technische Universität Berlin. Ammon's online vita suggests mmtt's activities ended in 2018 with the successful Steinplatz entry; besides that, they were notably placed third in a 2016 competition for a Nelson Mandela Memorial for the city of Nürnberg. See www.stefka-ammon.de/vita/ (accessed September 7, 2021). mmtt had proposed a semitranslucent "sculptural space" of safety glass around a planting, titled *Mandela's Garden*.

43 The bust was added in 1987, a present of the Deutscher Städtetag (Association of German Cities) on the 750th anniversary of Berlin; a replica of the same bust, gifted to East Berlin, is now in Berlin's City Hall (*Rathaus*).
44 Email from Stefka Ammon to the author, October 13, 2020.
45 Stefka Ammon and Katharina Lottner, Project Website, Steinplatz Reloaded, www.steinplatz-reloaded.com (accessed January 17, 2019), unfortunately not accessible as of August 19, 2020; the project is still however hosted on Stefka Ammon's website, www.stefka-ammon.de/steinplatz/, and the brochure is found at www.berlin-city-west.de/sites/default/files/Downloads/Flyer_STEINPLATZ%20reloaded_mmtt.pdf. In January 2020, a publication appeared, Stefka Ammon and Katharina Lottner, eds., *STEINPLATZ reloaded: Dokumentation und Recherche* (Berlin: EECLECTIC, 2020). Fittingly for an organization devoted to "digital publishing for visual culture," this is an e-book first and foremost, though a paperback edition was also printed.
46 On this shift, see Choay, *The Invention of the Historic Monument*, chapter 5, "The Invention of the Urban Heritage."
47 The case continued and he was granted asylum, symbolically, six months after his death. See the European Commission of Human Rights, *Cemal Kemal Altun Against Federal Republic of Germany, Application No. 10308/83: Report of the Commission* (adopted on 7 March 1984). See also the discussion of the Altun monument as lending itself to a variety of "*contexts* of identity" rather than a unitary one in Henry W. Pickford, *The Sense of Semblance: Philosophical Analyses of Holocaust Art* (New York: Fordham University Press, 2013), 80–2.
48 The permanent memorial sculpture erected in front of the administrative building in 1996 is designed by Akbar Behkalam, an Iranian-German artist who studied in Istanbul. See Helmut Kaspar, *Marmor, Stein und Bronze. Berliner Denkmalgeschichten* (Berlin: Edition Berlin, 2003), 214–16.
49 The discussion over "misuse," which dates back to the prehistory of the monument, took a photographic turn before the ascendancy of smartphones and the selfies they enabled: a Berlin newspaper article, somewhat ironically called "The monument lives," on the occasion of the ten-year anniversary, is headed by a striking photograph by Mike Wolff, showing a young woman photographing her friend, who grins into the (digital) camera while propping her body above the ground between two stelae. See Lothar Heinke, "Das Mahnmal lebt." *Der Tagesspiegel*, May 4, 2010, www.tagesspiegel.de/berlin/fuenfjaehriges-jubilaeum-das-mahnmal-lebt/1813574.html. Nearly two decades earlier, James E. Young photographed smiling Hungarians posing in groups with the menorah-shaped Holocaust memorial designed by Agamemnon Makrisy and Istvan Janaky in 1964 for Mauthausen. See *The Texture of Memory: Holocaust Memorials and Meaning* (New Haven and London: Yale University Press, 1993), 94.
50 Elke Krasny has recently, for a different context, argued that "The silence of the dead appeals to ethics in the choice of means of commemorative culture. In remembrance, the silence of the dead must be heard, must remain audible" (96). Krasny, "Of the Silence of the Dead," *Vienna Yearbook of Jewish History*, no. 12 (2020), Special issue, "The Future of Remembrance in the 21st Century," 88–97. This silence is, of course, difficult to achieve.

51 Maria Zalewska, "Selfies from Auschwitz. Rethinking the Relationship Between Spaces of Memory and Places of Commemoration in the Digital Age. In *Studies in Russian, Eurasian and Central European New Media*, no. 18 (2018), www.digitalicons.org/issue18/selfies-from-auschwitz-rethinking-the-relationship/ (accessed November 30, 2021).

52 See Evgeny Morozov, *The New Delusion: The Dark Side of Internet Freedom* (New York: Public Affairs, 2011).

53 The platforms, according to Shapira, were Facebook, Instagram, Tinder, and Grindr—an interesting selection for photographs involving the *Memorial to the Murdered Jews of Europe*, since the latter two are dating/sex apps.

54 The commentary (mentioning also Breanna Mitchell, an American who became notorious in 2014 for posting to Twitter a "Selfie in the Auschwitz Concentration Camp") is from Joel Gunter, "'Yolocaust': How Should You Behave at a Holocaust Memorial?" *BBC News*, 20 January 2017, www.bbc.com/news/world-europe-38675835 (accessed November 30, 2021). Gunter quotes Eisenman to the effect that it is vain to try to police visitor habits or social media use.

55 This is the presumably final state of the website, http://yolocaust.de, signed Shahak Shapira, 2017.

56 On this monument, see James E. Young, *At Memory's Edge* (New Haven and London: Yale University Press, 2000), chapters 5 and 7, and Widrich, *Performative Monuments*, chapter 4.

57 Another series of bronze sculpture commemorating the Kindertransport is by Flor Kent, who even worked with life casts for her figurative bronze sculpture of a girl in Liverpool Street Station in London (2003), but added a glass case in which objects belonging to rescued children are exhibited. Frank Meisler's London sculpture in fact replaced Kent's, but her statue was put up again nearby in 2011. Another of Kent's sculptures is at Westbahnhof in Vienna, depicting a boy sitting on a suitcase; another one in Prague shows Nicholas Winton, who saved hundreds of children from Czechoslovakia, with two children.

58 Jürgen Habermas elaborated on the responsibility of Germans born after 1945 in the essay, "Vom öffentlichen Gebrauch der Historie," in Jürgen Habermas, *Kleine politische Schriften*, vol. 4 (Frankfurt am Main, 1987), 137–48. His reasoning remains a model for how latecomers might approach a painful historical event, though he does not, at this juncture, consider new residents, or Germans-to-be.

59 Johan Huizinga, *Homo Ludens: A Study of the Play-Element of Culture* (London, 1949; Dutch original 1938). Commemoration comes in especially in the chapter on "Play and war". As the preface and the title of a 1937 London lecture makes clear, Huizinga intended to call his text a study of "the play element of culture," not "in" culture, since he regarded culture as play through and through, rather than having extraneous play elements thrown in. See Andrew Murray, "The Play Element of Culture," December 4, 2019, *The Warburg Institute Blog*, www.warburg.blogs.sas.ac.uk/2019/12/04/the-play-element-of-culture/ (accessed December 27, 2020).

Materializing art geographies 3

As the previous chapters suggest, one way to understand how history is confronted in public art, memorials and urbanistic projects today is to follow the conceptualization of site not just down to the ground, but also "upward" through the various channels of mediation, familial and local as well as global and distributed. This in turn confronts us not just with questions of the authentic and the replicated, the digital and the real, but with the wider geographic framework in which every site participates. As this chapter shows, to come to terms with the historicity of a site, and of the art responding to it, is to construct what we might call a contemporary art geography.[1] Geography, with its signature activity of mapping, is a discipline useful to understanding the shifting and malleable constructions that comprise real territory and its constitutive sites, their reimagination and representation in various media, moving across time and spatial scales. Tracking some characteristic geographical variables, from socio-economic circumstances to the presence of natural resources and their depletion, and especially their visible and functional configuration in space, will allow us to look at the resurfacing of history in environments that at first sight might seem far removed from the reach of activism and commemoration.

A line in the desert

A project by British artist Carey Young shows how the extramural ambitions of 1970s performance in urban or rural settings can be applied to today's global reality. Against a dusty sky, cranes and high-rises loom in the distance [Fig. 3.1]. In the middle ground, amid clumps of desert grass, a short-haired woman in a gray pantsuit walks atop a heap of what looks like discarded concrete paving. Her arms point outward and her eyes are trained on her feet, as if she is working to maintain balance atop the rubble. Her poise brings to our attention a geometric element intersecting her body perpendicularly just below the shoulders: a vast white wall enclosing the city. The title of the photograph makes explicit an art-historical allusion: *Body Techniques*

3.1 Carey Young, *Body Techniques* (after *A Line in Ireland*, Richard Long, 1974), 2007.

(after A Line in Ireland, Richard Long, 1974). It is one of Young's 2007 set of eight *Body Techniques*, responding to canonical performances by Long, Mierle Laderman Ukeles, Bruce Nauman, VALIE EXPORT (two), Dennis Oppenheim, Ulrich Rückreim, and Kirsten Justesen.[2] Performing in airports and building sites around Dubai and Sharjah, Young always cites her art-historical source, never her exact physical location.[3] The title therefore often has a location embedded in the parenthesis, comically jarring in this case ("Ireland"). Urban expansion, resource use, individual agency and historical consciousness are muddled together and pulled apart in performances for the camera, on sites vaguely recognizable but *not* pinned down to provide political or cultural context.

It is fair to ask whether this work unmasks the globalizing process or is just another of its manifestations.[4] Despite its art-historical pedigree, *Body Techniques* is not so much about appropriation as about repetition and the drawing of distinctions between and within gestures, as we are made aware of historical difference through these performances' new sitings. For instance, Long's *Line in Ireland* organized a rocky landscape, and perhaps,

more problematically, the pictorial cliché of a wind-swept island, then in the throes of sectarian violence, around the modernist device of a straight edge.[5] Young does not attempt to recreate Long's distinctive design, physically or photographically. Instead, she navigates her "recreation" literally, by having herself photographed walking on concrete debris too sloppily poured out of a construction truck to read credibly as the work of her hands: but also, perhaps, through the monumental line far behind her, which is horizontal, in stark contrast to Long's vertically framed, and somewhat romantic, line of hand-moved rocks. It might be too much to claim Young has disenchanted Long's rather touristic land art practice; but her performance brings humanly impacted detail (and the performer's person) to the sublimity of early land art.[6]

The very title of the series recalls one of its sources, EXPORT's *Body Configurations*, shot over a decade from 1972, to 1982 with the artist sometimes before, sometimes behind the camera. Young's *Body Techniques (after Lean In, VALIE EXPORT, 1976)* in fact recreates one of the latter more closely than she did in the case of Long's photograph: only instead of the imperious architecture of Vienna's first district, against which EXPORT's model Susanne Widl stretched back, Young slumps forward against a massive step, while enormous white modular panels block off the building site behind her[7] [Fig. 3.2]. The colliding geographies made explicit by the title and use of color film stock complicate the interpretation of human action in a landscape, only residually legible as the adversarial or anarchic acrobatic gesture attempted in the original. EXPORT used this particular sequence of *Body Configurations* herself in her 1977 feature film *Invisible Adversaries* (*Unsichtbare Gegner*), a body-snatcher-themed thriller in which internal and external perception, feminist self-definition, and the role of media, consumption, and official architecture play their part in the construction of a patriarchal state system paralyzing individual agency.[8] *Lean In* was a good choice for a still in that film because of its tense double suggestion of passively contortion in the face of power and active resistance to it.

In the case of EXPORT, historicist nineteenth-century Vienna as filmed in the 1970s and 1980s stood for a continuation of authoritative culture, relating the stones of the late-Imperial Ringstrasse to Fascism and postwar social conformity. EXPORT used space and the camera to illuminate how the architectural environment not only conserves this milieu in its massive forms, but also how these in turn shape our subjectivity—through an exaggerated behavior of bodily mimesis of architecture. Is all this now retained and extended into a discussion of global economy, labor, and their visible effects on the environment? To the extent that it succeeds in doing so, Young's work is not a nostalgic recreation of the postwar avant-garde; it allows for the tension between that which is familiar (bodily gesture) and jolting difference in

3.2 Carey Young, *Body Techniques* (after *Lean in*, VALIE EXPORT, 1976), 2007.

meaning (corporate architecture in the desert, with its stark environmental impact): a very general message, mapping familiar forms onto a discourse we read first and foremost as 'global'.

Against the grain of such legibility, we might wonder why the specificity of the places Young visits is so easily effaced by that of familiar artworks, and what preconditioning we are overlooking to the work being so readily intelligible to an art public. It is no doubt tempting, and to some extent justified, to regard the site of this and the other *Body Techniques* as compromised: some variant of the nonsite, junkspace, Irit Rogoff's "unhomed" or Kwon's serial "one place after another," to say nothing about technical and popular terminology from environmental activism, such as the "brownfield land" defined legally as comprising contaminated former industrial sites.[9] But whatever critical lens we apply to the site of the performance, or Young's choice of it, it must not obscure the fact that the site and its selection do not operate alone, in a vacuum, but in a network of both real and imagined interactions between past and present sites. The work is a web woven out of temporal and spatial

connections, from EXPORT's feminist and post-humanist investigation in the *Body Configurations*, to images that romanticize nature and human-made systems. Stone and concrete emerge as materials telling us about human fantasies of expansion and place making, about the power to shape the environment, and the imagination of particular, "fitting" and "behaving" bodies in their midst. It is no coincidence that Young considers the professional photographer behind the camera a technician without aesthetic investment in the resulting image, as if the tools used in her experiment had to be neutral, and the print were not also a material artifact, insistent in its objecthood inside gallery spaces all over the world.[10]

Young's series can be read through the networks and audiences constituted by bringing together the various performance histories with present concerns, but there is another narrative that is important, however little Young foregrounds it. That is a tension between human labor as manifested in the vast and extensive construction site, and the seemingly carefree attitude of the artist. The result is an, at times, absurd but by no means trivial clash of artistic and political concerns at the brink of postmodernity and current affairs, with some narratives still emerging: gender inequality, global capital and authoritarian politics, contracted labor, questions of individual freedom and public space, and aggressive human intervention in the planet and what we call its resources. This also anchors Young's series, however unofficially, in questions of ecology, as one of the multidirectional site discourses discussed in Chapters 1 and 2, here applied not to one site over time but disjunctively, through her reconnoitering in pursuit of performance-tourism. Whether the work is constitutive of an ecological consciousness or an anesthetization of the world of resource extraction, a tendency Amanda Boetzkes describes in her book *Plastic Capitalism*, which looks at many forms of artists' fascination with waste and industrial process, remains ambiguous.[11] That is because of the beautifully calibrated sublimity of what we can, but don't have to, read as a space of rampant financial speculation, a possibility subtly underlined by Young's vaguely corporate wardrobe, which, in contrast to Emilio Rojas's purposely stained whites in *Twice Stolen Land* [Fig. 1.9], remains spotless, as if she never broke a sweat despite her desert surroundings. Young's project, from a geographic perspective taking in the successive sites of her performance(s), loses its intentional impression of a surface, glancing engagement with sites to become a complex engagement with history, in which references to the art historical avant-gardes are combined with a critique of, and simultaneous fascination with, urbanization in newly developed urban areas, bumping up against challenges raised by the introduction of the new epochal concept of the *Anthropocene*, an era marked geologically by the rise of modern humans and their manufacture and modification of the landscape in agriculture and

industry, and the various critical alternatives offered to both the concept and the phenomenon.[12]

Reforming (art) geography

If geography permits a broader view of what some internationally active artists are doing in the present, it cannot be a blank check for global business travel, any more than an excuse not to look closely at the sites involved in global placemaking. One way to draw these disparate and potentially divergent strands of Young's and other geographically committed performance together is to consider them through commemoration and monument design: like the performance artists, including EXPORT, who memorialized their actions in public space with consequences for how we read the very spaces they inhabit, Young's line of concrete in the desert is frozen in time, however unstably and ambiguously, whatever the site's shifting use and appearance. Returning to commemorative landscapes, a reflection on memorials as geographical and ideological landscapes requires a broader view than the subject-centered architecture of the "memorial boom" of the 1990s, with its emphasis on memory and feeling, and its (to a certain extent justified) elation at having found forms to represent the traumatically unrepresentable.[13] But neither art nor activism can stop there. Just as the way we understand and remember our past is sensitive to changes in the world and how we treat it, we can say that monuments too are indicators of contemporary states of affairs, both in how they change and persist in relating to a site and a history (or more than one) in stable ways while discourse changes around them. With the growing emphasis on a world *beyond* the memorial, and stretching out beyond the visitor's immediate perception in space as well as in time, a corresponding shift in the stakes of commemoration has, almost imperceptibly, taken place.[14] *Processes* rather than *events* have come to assume more prominence in today's memorial projects, and their environmental footprint, from energy consumption, expenditure of labor and materials to construct and even maintain monuments (think of water use!), have become parameters of debate. In a very literal sense, contemporary monuments have come to handle contemporary, or contemporaneous themes and problems in ways that complicate the monument's orientation to the past.[15]

 This change should not be greeted uncritically, as there are few or *no* contemporary problems that do not have an involved history, to say nothing of significant historical landmarks threatened with invisibility and which need to be remembered. Indeed, the two options are not mutually exclusive— apparently isolated past events reveal their contemporaneity often enough *through* commemoration. The most ambitious grand-scale memorial project in the United States since Michael Arad's National September 11 Memorial

Materializing art geographies 93

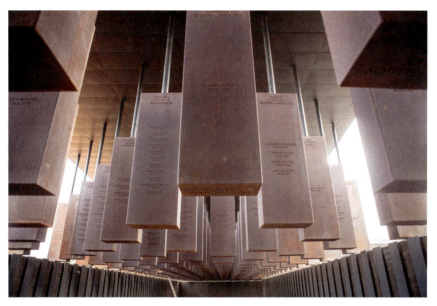

Mass Design Group, Memorial Monuments at *The National Memorial for Peace and Justice*, Montgomery, Alabama. 3.3

and Museum, the *National Memorial for Peace and Justice*, informally known as the National Lynching Memorial, opened in 2018 by the Equal Justice Initiative in Montgomery, Alabama, is certainly responding to contemporary and unfortunately ongoing instances of racial violence as much as to the murdered Black Americans whose names are inscribed upon its 805 hanging steel monoliths[16] [Fig. 3.3]. But it would be a mistake to identify the subject of commemoration thoroughly with its contemporary causes. The world in which those crimes took place remains all too present in the ongoing history of racial violence: but it was not a world in which this monument could even be imagined, much less built. *That*, as much as the continuity of violence, is the sense such monuments bring to our uncertain present and future.

Just as exemplary in this sense, though apparently more remote in time and space, is the Steilneset Memorial by Peter Zumthor and Louise Bourgeois in Norway (2011), commemorating the victims of the witch trials of the seventeenth century and, in the process, of Norway's Indigenous Lapp inhabitants, who were disproportionately the target of religious persecution. Here too we confront issues extending beyond the remote northeastern town of Vardø, where the elegant semiabstract memorial architecture, with its mirrored flames set in a modernist glass hall (Bourgeois's contribution) and complex wooden palisade (Zumthor's) faintly recall the violence of burning at the stake [Fig. 3.4]. Misogyny and colonial domination are issues as urgent now as

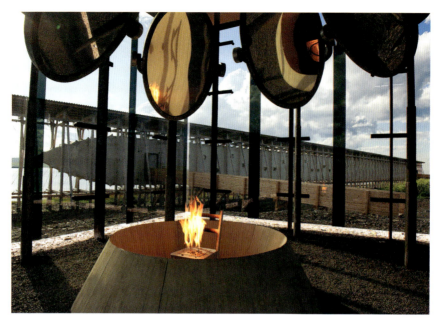

3.4 Louise Bourgeois (foreground) and Peter Zumthor, Steilneset Memorial, Vardø, Norway, commemorating the trial and execution in 1621 of 91 people for witchcraft.

in the days of the Vardø witch trials, though of course differently manifested and, crucially, articulable in public discourse and art.[17] The monument, then, walks a fine line between illuminating how these modes of oppression have persisted *and* changed, especially given the risk of a kind of poetic nature-spa ambience in its beautifully framed Arctic surroundings. A geographic shift in commemoration need not, indeed it categorically may not, neglect the past in addressing the lives and concerns of those doing the commemorating; or vice versa.

Many factors demand attention if we are to explain this shift toward a present-oriented, processual commemoration, some of them acting steadily over the whole of the postwar period: the building up and erosion of the social welfare state, the emergence of the genre of public art, in its corporate, community-based, activist, and other contending variants, and finally, and most emphatically in the last decade or two of political turmoil, the efforts to democratize the use of public space and make it more relevant to broader publics in the present, particularly those not represented by state interests. It sounds like a tall order for geography to ground these volatile developments in public art, but in a sense, that's what it has always aimed to do—at least at its best. We must ask whether this objective is compatible with thinking about the global networks through which art is disseminated, and especially with

political and ecological challenges to entrenched Western ways of conceiving geography as a set of techniques through which land is managed and divided by those who control it.

If we are to appreciate geography's value for commemoration, we must say something more about how it relates to time, both as experienced and as represented: in short, to history. Let me then interpose a capsule history of the discipline, which will help us disentangle and coordinate site, geography, territory, and their histories. Classical geography encompasses both political boundaries and geology, and changes according to the choices made by the map makers about what markers and anchors to foreground in the representation of the map, as well as concerns with land management, ownership, and stewardship that arose and grew in urgency through the last and present century.[18] In contrast, art geography is a perhaps less familiar designation, with a checkered history of its own, much of it played out in European art history departments in the late nineteenth and early twentieth centuries, apart from the development of political geography, and, eventually, from the parallel and uneasily coexisting formalist and contextualist methods that dominated art history in postwar Europe and the anglophone world respectively. Growing out of an Enlightenment preoccupation with climate as determinant of human (racial) diversity in J.J. Winckelmann, Immanuel Kant and their romantic successors, *Kunstgeographie* came to play a major role in German and Austrian art history in the first half of the twentieth century, before tumbling into nationalist or racial explanations for differences in style in the 1930s.[19]

Academic geography, in an expansionist mood during the early stages of the Cold War, did not appeal to a wary art-historical community decisively shaped by émigré scholars; on the other hand, the new critical geography, inspired by French Marxist urbanism as much as by cultural studies as they developed in Britain's new universities, bypassed even much of the "New Art History" as it opened up the seemingly petrified ideas of mapping and demography, which often had close ties to administrative authority and claims to territory.[20] Since the 1970s, writers identified within this ferment with a movement known as "Radical Geography" set themselves in contrast to a positivist or broadly social-scientific understanding of the field. They first aimed at reconsidering geography in relation to society as spaces, territories, and sites as political agendas and their manifestation, but soon also came to discuss the relevance of spatial conceptions to theorizing society. British feminist geographer Doreen Massey summed up and challenged the field around that time by defining space as a construction of interactions between humans, which is inherently already connected to political power struggles, with relational and ever-changing identities.[21] Massey saw places as processes rather than fixed entities, their multiple identities related to the histories of

those being in or moving through these places, which allowed for complex coexistence of the material world with conceptual sites, and—this needs more explaining—time.[22]

Particularly relevant to the contemporary art geography of monuments is the shift that Massey identified in the 1980s in how Radical Geography understood its own contribution:

> And so, to the aphorism of the 1970s—that space is socially constructed—was added in the 1980s the other side of the coin: that the social is spatially constructed too, and that makes a difference ... But if spatial organization makes a difference to how society works and how it changes, then far from being the realm of stasis, space and the spatial are also implicated (contra Laclau) in the production of history, and thus potentially in politics.[23]

For our purposes, the specific debates within Marxism are less significant than the irruption of history through the codependence of space and time. Massey criticized approaches that see "space as instantaneous connection between things at one moment," and consequently as the static product of social forces: "For of course the temporal movement is also spatial; the moving elements have spatial relations to each other."[24] For my project, this means that the histories surfacing in the artworks should be integrated into a spatio-temporal web of relations, without losing any of the concreteness of site specificity. This is a choice with direct practical consequences. The apparent disregard or failure to thematize passage of time is precisely what made Carey Young's performances ambiguous in their confrontation with global real estate speculation and environmental degradation.

The stakes of access to urban space featured in Kwon's analysis of discursive sites, and in the art-historical studies of statelessness and gentrification by Irit Rogoff and Rosalyn Deutsche respectively. They have also informed more recent responses to critical geography by artists and curators of the twenty-first century.[25] But I would like to draw attention to a project that, as it were, bypasses aesthetic concerns to link history directly to the built environment: the work of American urban historian Dolores Hayden, in particular her 1995 book *The Power of Place: Urban Landscapes as Public History*. Turning to Los Angeles for her case studies, the introductory chapters lay out a theory of "urban landscapes" as "storehouses for social memories," examples of how past and present experiences of migration, difference, and marginalization can be shared in public memory, via monuments or the preservation of sites.[26] Hayden did more than just theorize *The Power of Place*—through her nonprofit of the same name, founded in 1982, she produced guidebooks and exhibitions foregrounding lost sites of Black Los Angeles, and other histories since swallowed up by the urban fabric.[27] Hayden's attention to vernacular architecture and design traditions, like her insistence that a theory of place

needs connect to economic and social practices through time, has proven a popular model for urban sociology, expanded in recent years to include both a critique of the history of the seemingly neutral language of geography and geology, and to show intersections with current discussions of the "Anthropocene." Thus, adopting a geological viewpoint, Kathryn Yusoff's manifesto *A Billion Black Anthropocenes or None* argues that a shared focus on territory connects the history of resource extraction to exploitation of humans, most paradigmatically, slavery.[28] Yusoff is radical in her critique of the physical in geographic thinking, which she thinks papers over the violence of colonial extraction under the static guise of matter: "I seek to undermine the *givenness* of geology as an innocent or natural description of the world."[29] It is therefore reasonable to claim that both artists and theorists—of place, urbanism, climate—have become deeply invested in reimagining geographical models to bring out our current understanding of the Anthropocene, or perhaps more accurately the present geopolitical Capitalocene, to use Donna Haraway's term.[30] That the geo-histories of urban space need to be part of our public history, and of art history, is one consequence of this theoretical ferment. Let us attend therefore to the geographical thinking in some recent art, and see how it confronts and pushes the boundaries of aesthetic thinking about site, place, and space.

Global conditions of humanity

Ai Weiwei's recent works can be aptly summed up as contemporary memorials to our current global political condition. Typically, they allude to a cultural history that has been displaced or reimagined from afar, with authenticity preserved through human action and inert physical material, one of the great themes in the counter-memorial boom of the 1990s. Fittingly, the difference between vague political pontification and incisive advocacy in such art often rests on a geographic fulcrum. Thus his notorious 1995 photo-performance *Dropping a Han Dynasty Urn* is, far from a manifesto against history and material specificity, only possible (and thought-provoking) because of the history accruing to the object, both in its intact and destroyed state.[31] In this the most body-centric of his actions do not differ essentially from his aggressive send-up of the tourist photograph in his extended *Perspective* series. This kind of dynamic material specificity extends to the siting of his installations, despite their sheer overwhelming quantity and variety. To gain some purchase on this impressive flux of materials and arguments, I focus on one of his many works dealing with the current displacement and movement of refugees from Syria, Afghanistan, and Africa into Europe, the 2016 installation *F.Lotus* in the garden of the baroque Belvedere Palace in Vienna [Fig. 3.5].

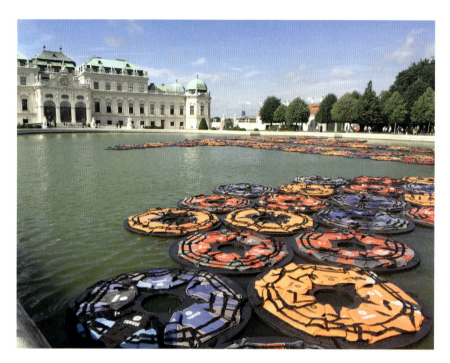

3.5 Ai Weiwei, *F.Lotus* in front of Belvedere Palace, Vienna, 2016.

Consisting of lifejackets collected from the Greek island of Lesbos, cast aside by refugees journeying to Europe in overloaded boats under grueling, often lethal conditions, the work hardly betrays any clues to this painful source of its raw material—at least not on first sight. Groups of five life-vests apiece were arranged in the form of decorative flowers (the lotus being a Buddhist symbol for purity and rebirth).[32] The structures floated in the reflecting pool fronting the main façade of the palace of Prince Eugene of Savoy, a collector of art and a military leader most noted for fighting back the Ottoman Empire from central Europe at the end of the seventeenth and the beginning of the eighteenth century. Formally blending into the *Gesamtkunstwerk* of architecture and garden design, the pool installation was bounded on dry ground by Ai's 2010 installation *Circle of Animals/Zodiac Heads*, thirteen freestanding bronze sculptures replicating a valuable set of avatars of the Chinese horoscope, plundered from the Chinese Old Summer Palace Yuanmingyuan in October 1860, near the end of the Second Opium War, and only partly recovered—a neatly ironic inversion of cultural capital, trading on Vienna and Beijing as former imperial capitals.[33] Thus, the installation is both significant to Vienna and broadly relevant geopolitically, in the present *and* by recalling past moments of military-aesthetic domination, which gave rise to

imperial cultural networks (including such factors as language learning) that continue to shape migration and other forms of movement of people.

Perhaps more striking than the floats, or their synergy with the bronzes and the Belvedere garden and architecture, is the curious fact that seen from above, and hardly if at all perceptible at water level, the 201 five-vest modules (for a total of 1,005 vests) cohered to form a vast florid majuscule F, likely a combination of Ai's customary obscenity with juvenile punning (f.lotus = float us?), and, beyond that, a subtle phenomenological commentary on perception and perspective, the big picture that is hard to experience together with its constituents on the ground.

In light of these several different scales on which *F.Lotus* operated on and cooperated with its surroundings, it seems apt to call it an act of subversive decorum, one that addresses the fragile current state of our world. Ai was hardly unique in making art about the refugee crisis, or even in using the medium of the life-vest: as part of the exhibition *Synesthesia* during the 2017 Venice Bienniale, Turkish designer Argun Dağçınar displayed an impressively bejeweled gold and fur life-vest, a bitterly ironic commentary on the facile but ineffectual sympathy of the well-off and those serving them in the "creative industries."[34] By contrast the force of Ai's work comes not from any satirical charge of indifference to suffering leveled at his audience, but from the transformed literalness of the discarded vests, which when combined with the Belvedere calls into mind its equally literal political implications. The palace complex, as a symbol and product of a multi-ethnic and multi-religious empire appeals to conservative politicians nostalgic for Austria's old power and centrality under the Habsburgs, even while they refuse to take measures that would permit the integration of refugees entering Austria in the present crisis.

More might be said about this intervention's pertinence to local debates, but I want to end by returning to its very matter, and the history it helps us see: the material of *F.Lotus*, unlike the heavy bronze of the *Animal Heads*, is recycled, as the jackets were discarded on the shores of Lesbos after their sea journey. Their shift from used-up utilitarian object to decorative element disrupts the complacent consumption of beauty in the formal garden through the battered roughness of the brightly colored synthetic fabric, and at the same time conscripts ecologically problematic garbage into a new cycle of symbolic value: the value of geopolitical commemoration.[35] *F.Lotus* may be described legitimately as a contemporary monument—not just a monument of the present, but one that reflects on that present, another connection to performance art.[36] To see its network of mutually reinforcing historical references, however, requires adopting a geographic lens, through which some of Ai's more spectacular gestures gain in historical heft. This is the case with some of the most controversial artworks of recent years, even when their

designers maintain a less outspoken public persona, as the next, concluding case study of this chapter shows.

Traumatic sight/site: Oslo's 07/22 memorial

As *F.Lotus* carefully suggests in its deployment of human(itarian) detritus, some of the more ambitious contemporary memorials have come to articulate how the actions humans perceive as historical do not impact merely human consciousness and social structures, but also change the earth as a whole, however incrementally. Issues of economics (monument tourism), of the environment and resource consumption, and of representation (not only national or ethnic, but just as often global and cross-generational) must be kept in mind in evaluating monument designs and debates. This is true even for memorials that seem to be dealing with very specific events in a strictly human register. Jonas Dahlberg's winning proposal for the Norwegian 07/22 memorial to commemorate the victims of the attack by right-wing extremist Anders Behring Breivik on Oslo and a nearby island in 2011 [Fig. 3.6] seems, initially at least, to embrace many of the formal and ideological tropes of the late twentieth century counter-monument.

The proposal consists of three parts: 1) a massive excavation of the landscape opposite the holiday island Utøya, where sixty-nine mostly young

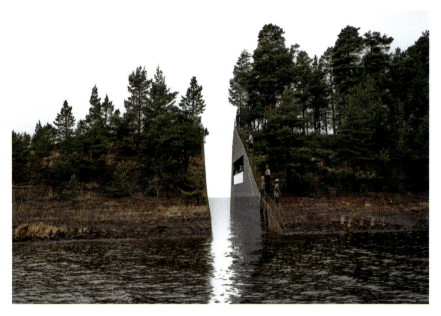

3.6 Jonas Dahlberg, *July 22 Memorial*, proposal, Sørbråten site opposite Utøya.

people connected with the summer camp of the Social Democratic Labor Party were shot in the massacre, 2) a temporary memorial in the government center of Oslo, which was the target of several bombs by the same terrorist, 3) a more permanent memorial in the same location once the fate of the damaged modernist buildings on that site had been decided.

Dahlberg, a Swedish artist, is best known as a maker of films and video installations that question perception and reality through the display of strange architectural settings and desolated cityscapes. His theme is the construction of reality in our minds, and their projection outward on the psychophysical city—an odd choice perhaps for a memorial to a brutal terrorist attack, but, then again, not uncharacteristic of recent memorial culture with its sophisticated emphasis on the psychology of grief and commemoration. The project's execution was first postponed repeatedly, then finally canceled, due to protests of the local population and especially of opposed political factions. Most spectacularly, Dahlberg proposed to disconnect the small land tongue on the mainland opposite the island, from which the site of the massacre could most closely be seen (without being there) by a deep but narrow chasm, a canal preventing visitors from attaining the shore overlooking the island, and thus, from seeing too closely the actual location of the massacre. Instead, an observation space carved from the earth would permit visitors to look on the yawning gap in the peninsula, with names of the victims inscribed on the far side of the cutaway, above water level, but as it were below the original level of the ground.

What prompted this intricate spatial relay? According to the artist, it was a meditation on the initial conditions in which the competition was carried out, something of a tragicomedy of ignorance and misplaced expectations. Recalling the bus ride from Oslo to Utøya organized by the commissioner, KORO (Public Art Norway) for the competition participants, Dahlberg writes:

> As we crested a rise and saw Tyrifjord lake for the first time, someone in the bus thought they saw Utøya. This made everyone in the bus jump out of their seats and peer out the side of the bus where you could see better. But pretty soon someone told us it wasn't Utøya we saw, and we all sat down again right away.

This "passive, almost voyeuristic gaze," Dahlberg continues, made him realize that spectators' inquisitiveness should be turned inward first, not outward to feast on the site (and thus, perhaps, irrationally, the sight) of the mass murder.[37] Keenly aware of the difficulty involved in avoiding monumentalizing Breivik and his deeds, and the dubious ethics of disaster tourism generally, he opted for a choreographed walk, first through the forest, then into the tunnel, with its quasi-romantic obstructed view to the newly created opposite shore of rock, with the names of the victims engraved on the surface

of the outdoor "private room" so as to enable introspection. This wall with the engraved names would then stand, metonymically, not just for the dead and the island but even for the far end of the peninsula, which would have become inaccessible. Symbolically, the cut would have also reduced the size of Norway, making the loss an actual loss of mainland territory. In a way, Dahlberg thus works with, but also against, Pierre Nora's and Françoise Choay's conceptions of *lieux de mémoire* as bearers of dramatic historical meaning, storied in their enduring authenticity. Like some critics of the project, I question the metaphors Dahlberg employed, which seem suggestive but undecided. The wound, as graphic form as well as literal "cut" in the landscape, was first made prominent by Maya Lin's *Vietnam Veterans Memorial*, which respects and in a sense elevates the flat, overwhelming linearity of the National Mall while giving visitors a more sheltered space and gesturing to the pain of the memorial's subjects. In Norway the cut, though it too promised intimacy, was a perpendicular break in the local topography, at which visitors were to stop short, shepherded close together—to say nothing of the impact such ambitious construction would have had on plant and animal life on the forested shoreland.[38] In this uncompromising, brash quality, the cut is more reminiscent of grand gestures like Michael Heizer's *Double Negative* and generally land art around 1970, monumentalizing the human-nature confrontation, despite Dahlberg's insistence that the 3.5m-wide cut would have been minimally invasive, and invisible to all except visitors to the memorial.[39]

Rather than fixate on the controversial land modification, which, right-wing political outrage aside, was likely the deal-breaker in the lengthy effort to come to agreement on some form of Dahlberg's project, it is more interesting to reflect on how Dahlberg wanted to connect the various locations of the attack into a commemorative landscape. This tricky aspect of the commission brings us back to a central topic of critical geography, the way we represent and act on the challenges of resource extraction in the Anthropocene. Dahlberg proposed to use what he excavated for a temporary landscape design with trees and an agora, before a decision was reached concerning how to restore—or dismantle—some of the civic architecture the attack had severely damaged. The government center has its own complicated history when it comes to urban planning and resources, and as Dahlberg's proposal stalled and several structural studies were completed, new, separate competitions were launched for the island and downtown Oslo, alongside a broader discussion about preserving postwar architecture. At issue were the two government buildings damaged by Breivik's fertilizer bomb, both designed by leading postwar Norwegian architect Erling Viksjø, the 1957 Høyblokka ("High Block") and its 1968 neighbor Y-blokka, a low, Y-shaped office space that took up much of the plaza between the High Block and Trefoldighetskirken (Trinity Church) [Fig. 3.7].

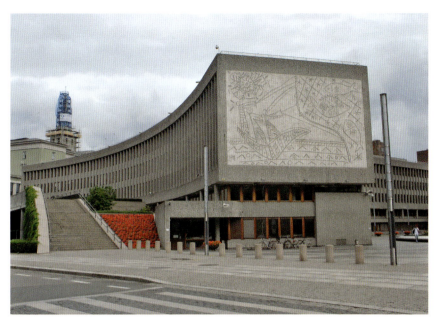

Y-blokken, Central Government Buildings (Regjeringskvartalet), Oslo, with decoration 3.7
The Fishermen by Carl Nesjar after sketches by Pablo Picasso.

By 2014, this space was ripe for redevelopment, with the government agreeing to rehabilitate the High Block and demolish the Y-Block. This too was delayed both by technical challenges and controversy, as architectural students and preservationists sought other uses for the iconic, if problematic postwar building, for various ideological and historical reasons (including the presence of unique Picasso-designed murals, sandblasted into the building walls by Norwegian artist Carl Nesjar), but also because "reusing concrete buildings has become recognized as climate-friendly."[40]

A joint proposal by some eight offices, called Team Urbis, came up with an inviting if conventional mix of midsized office towers, park and open space, the buildings themselves featuring rooftop green space.[41] This ongoing urban transformation and debate is noteworthy, but so is the contrast between the rather routine sustainability gestures of Team Urbis and Dahlberg's proposal to use the excavated earth and stones for the memorial site in the Oslo government center. This reminds us, intentionally or not, that commemoration today is not just about national standing or personal feeling. Such reuse would have opened the site theoretically to what drives history at least as much as political dialogue and narratives of overcoming: economy and the exploitation of resources, and our need for a cautious handling of the world at large, if we want to prevent such

catastrophic scenarios in the future, or others less bloody perhaps but even more irrevocable.

It is not surprising that, in the nearly decade-long debate, punctuated by highly visible international competitions, Dahlberg's efforts to avoid catastrophe tourism (perhaps self-defeating, since any effective design will attract visitors) and a shared longing for marking the "authentic" sites of trauma gave way to other priorities.[42] A turning point for the Utøya site came when AUF, the Workers Youth League, who ran the fateful summer camp, offered their ferry quay as a site for the monument.[43] The quay is the site from which Breivik departed by boat to reach the island, and to which survivors came back swimming, a place "with historical relevance and historical significance," according to AUF spokesperson Jørgen Frydnes.[44] In June 2017 a competition was held for this location, which was won by the Norwegian architecture firm Manthey Kula and landscape architect Bureau Bas Smets, advised by the architect and theorist Mattias Ekman[45] [Fig. 3.8]. What they intend to do is too complex and long-term to be profitably discussed at this juncture, but it is informed through and through by the kind of geographical considerations I have shown becoming prominent in recent public art.

Returning one last time to Dahlberg, it is fair to criticize the original project as too intent on choreographing the symbolism of material

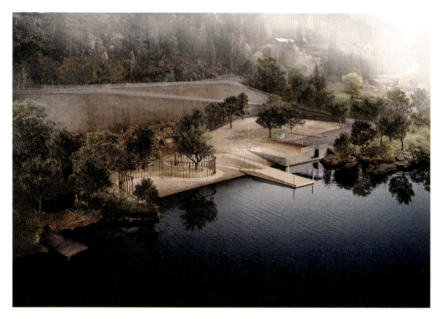

3.8 Manthey Kula, *National Memorial* at Utøyakaia, commemorating the victims, survivors and rescuers of the terror attack on July 22, 2011. Model, executed 2022.

interventions and visitor experience across a set of physical and psychically complicated sites. But for me, the most interesting part of the proposal remains its little-noted emphasis on reuse and recycling. If connected to the artist's more general interest in the instability of the objects of perception, it lends itself to more general theorizing of spatiality and history. Sites are never stable, but also never purely disembodied sites of discourse, operating as they do on many levels simultaneously, from the construction work necessary to modify them to provide pedestrian access to the images circulating of them, before and after their modification. Personal interaction, while still at the center of site-specific art, is being reassessed in widening registers, often merging political activism with representational values and historical depth (or a search for it). To make space for the bigger picture and to conceive history globally, not in the routine sense of globalization or some single world-encompassing system of capitalist domination (a vision, that, for all its value, simplifies things) but taking into consideration earth's ecosystems and geological and physical structures as well as its human residents is, I think, the challenge and promise of much geographically oriented art today. The "siting," the anchoring in our minds and our actual lived experiences, makes visible mappings and territorial tensions on various scales. Be these mappings pedagogical, for profit, or simply modes of survival, they ultimately point to the fact that our lives and the politics and places we inhabit are also directly interconnected with the fate of the earth.

In concluding this chapter, we might ask: Where do the geographic, ecological or geopolitical stakes of recent commemoration leave the compelling and, at least in theory, democratic or pluralist force of the performative monument? This is a large question, but any adequate answer must acknowledge that geography does not diffuse monuments into the mists of abstract power relations so much as place them in space: it is in relation to specific places with their attendant realities of land use, symbolic value and overlapping claims of ownership and access, that memorial speech acts become legible and are carried out by contemporary audiences. The upshot of the protracted work of Dahlberg, Ekman, and others on the Oslo memorial landscape, even more than Ai Weiwei's intervention in the garden of the Belvedere in Vienna, which is in many ways more concise and effective in its sharp focus on the issue and artifacts of migration, brings me to this realization: not that art historians ought to apply the tools of geography, though they certainly help, but that artists and their audiences *already* engage in geographic thinking, debates, and critique.[46] Acknowledging this will hardly bring sudden agreement in long-running debates over public art; but it will help critics, educators, and audiences make sense of the changes in commemorative art already taking place around us.

Notes

1 Geography as an art-critical endeavor has been developed quite differently in Rosalyn Deutsche, *Evictions: Art and Spatial Politics* (Cambridge, MA: MIT Press, 1996); Irit Rogoff, *Terra Infirma: Geography's Visual Culture* (New York: Routledge, 2000); and Thomas DaCosta Kaufmann, *Toward a Geography of Art* (Chicago: University of Chicago Press, 2004), to which I will return. David Harvey's works have also been influential, as has the chapter on "The Formation of the Projective City" in Luc Boltanski and Ève Chiapello, *The New Spirit of Capitalism*, trans. Gregory Elliott (London: Verso, 2005), 103–56. By contrast, art critic Lucy Lippard's efforts to replace "site-specificity" with a more capacious, landscape-friendly "place-specificity" in her book *The Lure of the Local* (New York: New Press, 1997), have been more admired than emulated, though see below for some affinities.

2 It should be clear even from the list that the performances, while familiar, are *not* all by blue-chip artists.

3 First shown at Paula Cooper Gallery in Young's 2007 solo show *If/Then*, it exists as an edition of five with two APs.

4 Of course it might do both! Julia Bryan-Wilson, "Inside Job: Julia Bryan-Wilson on the art of Carey Young," *Artforum*, vol. 49, no. 2 (October 2010), 240–7, criticizes this series for its lack of consideration of Young's Western middle-class position. I mostly agree, but I think it is symptomatic of today's art world, and this by no means detracts from its historicizing of the 1970s avant-garde, which was equally oblivious of its privilege(s).

5 Not that Long displayed any ambition to treat Ireland's specificity—there is *A Line in Peru* two years earlier, *A Line in the Himalayas* a year later, and many cairns, circles, trampled grass lines photographed in Ireland, Scotland, and England from the late 1960s to the late 1970s. But it is specifically *A Line in Ireland* which Young names.

6 This might seem to make the work recall Robert Smithson's industrial nonsites, which however were notable not least for any absence of the body of the artist—who penetrated places like Passaic in the manner of a *flâneur*, eager to see and record the photographic damage, juxtaposed with his provocative reflections, without being himself seen. By contrast, the original works Young cites, with the exception of Long's, prominently feature the body of the artist.

7 Young admits to no longer being certain about the site of every image in the series, many of which were not indicated on city maps. The posture of *Lean In* recalls another EXPORT photo, *Heldenplatz* (1982). Viewers post-2013 may also detect a textual reference to the corporate feminism of the self-help bestseller *Lean In* (2013), obviously unintended by Young in 2007. Incidentally, in the other *Body Techniques* print based on EXPORT, *Encirclement*, Young ingeniously wears a bright red suit to match EXPORT's red hand-coloring of her print.

8 See Widrich, *Performative Monuments*, 73–80, and for more detail, "Stein und Diagramm: Fragen der Materialität in VALIE EXPORTs Körperkonfigurationen," *für Geschlechterforschung und Visuelle Kultur*, no. 57 (October 2014), 51–62.

On performance and site, see Nick Kaye, *Site-Specific Art: Performance, Place and Documentation* (London and New York: Routledge, 2000), who reads art by Robert Morris, Robert Smithson, Meredith Monk, and others, through theorists of place such as Michel de Certeau and Henri Lefebvre. More recently, Bertie Ferdman, *Off-Site: Contemporary Performance Beyond Site-Specific* (Carbondale: Southern Illinois University Press, 2018), proposes the term "off-site" for contemporary performance practice; on British efforts in particular, see Mark Pearson, *Site-Specific Performance* (New York: Palgrave Macmillan, 2010), and on theater, the essays collected in Anna Birch and Joanne Tompkins, eds., *Site-Specific Theatre: Politics, Place and Practice* (New York: Palgrave Macmillan, 2012). In art history, the question is often conflated with the debate about presence, with live performance assumed to be site-specific, unlike mediation. For a critique of this tendency, see Widrich, *Performative Monuments*, chapter 3. See also Didier Morelli, "Form Follows Action. Performance In/Against the City, New York and Los Angeles (1970–85)," PhD dissertation, Northwestern University, 2021.

9 See Marc Augé, *Non-Places: Introduction to an Anthropology of Supermodernity*, trans. John Howe (London and New York: Verso, 1995), and Rem Koolhaas, "Junkspace," *October* 102, Special Issue on Obsolescence (Spring 2002), 175–90, reprinted with new commentary in Rem Koolhaas/Hal Foster, *Junkspace with Running Room* (New York: New York Review of Books, 2016), which carries on its cover a concise slogan: "*If* space-junk *is the human debris that litters the universe,* junk-space *is the residue mankind leaves on the planet.*" On Rogoff's "unhomed geography," drawing both on Freud's *unheimlich* (uncanny) and the ideas of statelessness, see *Terra Infirma*, 4–7, 71. On "brownfields" as a reality and a metaphor, see Yu-Ting Tang and C. Paul Nathanail, "Sticks and Stones: The Impact of the Definitions of the Brownfield in Policies on Socio-Economic Sustainability," *Sustainability*, vol. 4, no. 5 (2012), 840–62. See also "Defining Brownfields: Scope and Nature," in *Sustainable Brownfield Regeneration: CABERNET Network Report* (Nottingham: University of Nottingham, 2006), 23–33, which makes the point that the term (introduced in the United States in 1992) is widely but inconsistently used, particularly by lawmakers throughout Europe.

10 "I worked with an architectural photographer. I had chosen locations based on weeks of recces driving around the edges of Dubai and Sharjah (most of the locations were too new to be on maps, and Dubai alone was 90 miles long at the time). I composed the shot already using a small digital camera, and had selected the performance works that I wanted to reference and 'recreate' for specific shots. The photographer set up the shots on her medium format camera so that they copied my compositions and guided me to the pose I required for the shot." Email to the author, April 18, 2017. Note that "recces" or "recce," like recon, is not a typo but military slang for reconnaissance.

11 Amanda Boetzkes, *Plastic Capitalism: Contemporary Art and the Drive to Waste* (Cambridge, MA: MIT Press, 2019). Particularly suggestive is her recurring concept of the "wastescape" traversed by dystopian gleaners.

12 On the terminology and its assumptions, as well as alternative denominations like the Capitalocene, see Donna Haraway, *Staying with the Trouble: Making Kin*

in the Chthulucene (Durham: Duke University Press, 2016); T.J. Demos, *Against the Anthropocene: Visual Culture and Environment Today* (Berlin: Sternberg Press, 2017) and *Beyond the World's End* (Durham: Duke University Press, 2020); and Andrew Patrizio, *The Ecological Eye: Assembling an Ecocritical Art History* (Manchester: Manchester University Press, 2018).

13 See Aleida Assmann, *Das neue Unbehagen an der Erinnerungskultur. Eine Intervention* (Beck, München 2013).

14 Perhaps nowhere more prominently than in my own neighborhood in Chicago, where construction of the Obama Presidential Center has met with some opposition in relation to its environmental, urbanistic, and labor aspects. See Deena Zaru, Sabina Ghebremedhin, and Nicole Curtis, "Exclusive: Barack Obama defends location of Obama Center, is 'absolutely confident' it will benefit community," *ABC News*, September 27, 2021, https://abcnews.go.com/Politics/exclusive-barack-obama-defends-location-obama-center-absolutely/story?id=80267219; and Neil Vigdor, "Obama breaks ground on Presidential Center in Chicago after lengthy discord," *New York Times*, September 28, 2021, www.nytimes.com/2021/09/28/us/obama-presidential-center-chicago.html (both accessed October 3, 2021).

15 Also, monuments "to the Future" (Joseph Beuys's 1976 contribution to the Venice Biennial) and "for Historical Change" (Clegg and Guttman, 2004), engaging various relics from the environment, are not a new phenomenon, though as I argue here, they are a growing trend.

16 See the Equal Justice Initiative's report, *Lynching in America: Confronting the Legacy of Racial Terror*, 3rd ed. (Montgomery, Equal Justice Initiative, 2017), esp. 65–75, "Trauma and the Legacy of Lynching," and from an art-historical perspective, Apel, *Calling Memory into Place*, chapter 3, "Why We Need a National Lynching Memorial," and her earlier essay "Memorialization and its Discontents: America's First Lynching Memorial," *Mississippi Quarterly*, vol. 61, no. 1/2 (Winter–Spring 2008), 217–35, about a 2003 memorial in Duluth, Minnesota, whose statuary was based on contemporary posed photographs, since no images of the known early twentieth-century victims are extant.

17 There is an interesting critique of the Steilneset memorial for its failure to include local voices and labor in Janike Kampevold Larsen, "Global Tourism Practices as Living Heritage: Viewing the Norwegian Tourist Route Project," *Future Anterior*, vol. 9, no. 1 (Summer 2012), 67–87, at 82. By contrast, see William L. Fox, "Branding Ice: Contemporary Public Art in the Arctic," in *Future North: The Changing Arctic Landscapes*, ed. Janike Kampevold Larsen and Peter Hemmersam (New York: Routledge, 2018), 165–84, which insists that the monument "is both site- and place-specific" (170), the latter being Lucy Lippard's coinage for an extended encounter between art and land.

18 The (sub)fields of physical, political, and historical geography certainly have had their ups and downs, their moments of collaboration and autonomy. Some good starting points are: Alan R.H. Baker, *Geography and History: Bridging the Divide* (Cambridge, UK: Cambridge University Press, 2003), and the classic manifesto of geographical primacy in explanation, W. Gordon East, *The Geography Behind History* (New York: Norton, 1999 [1942]). A good sense of the range of concerns,

especially in geography's postwar heyday, can be found in an introduction to the field like Rhoads Murphey, *The Scope of Geography* (Chicago: Rand McNally, 1966).

19 On the climate fixation of early race theory and its impact on art theory and history, see David Bindman, *Ape to Apollo: Aesthetics and the Idea of Race in the Eighteenth Century* (London: Reaktion; Ithaca: Cornell University Press, 2002). On nationalism, race theory, and the debates on their significance in art historical explanation, see Matthew Rampley, *The Vienna School of Art History: Empire and the Politics of Scholarship, 1847–1918* (University Park: Penn State University Press, 2013); and Eric Michaud, *The Barbarian Invasions: A Genealogy of the History of Art* (Cambridge, MA: MIT Press, 2019). Kaufmann's *Toward a Geography of Art*, 17–104, offers a detailed genealogy of geographic thinking in the discipline, up to and including visual culture studies; his own brief for a "geography of art" mainly calls for attention to cultural exchange. That is also the focus of much of Thomas DaCosta Kaufmann and Elizabeth Pilliod, eds., *Time and Place: The Geohistory of Art* (Aldershot: Ashgate, 2005). On geography, the concept of the 'globe', and globalization, see Denis Cosgrove, *Apollo's Eye: A Cartographic Genealogy of the Earth in the Western Imagination* (Baltimore: Johns Hopkins University Press, 2003).

20 Besides the work of Lefebvre and Harvey, cited above, a good sense of the spirit of the movement, and its initial focus on postwar Britain, can be gleaned from the collection by Doreen Massey and John Allen, eds., *Geography Matters! A Reader* (Cambridge, UK: Cambridge University Press in association with the Open University, 1984).

21 Doreen Massey, *For Space* (London: Sage, 2005), pt. V, "A relational politics of the spatial." Cf.: "If space is a product of practices, trajectories, interrelations, if we make space through interactions at all levels, from the (so-called) local to the (so-called) global then those spatial identities such as places, regions, nations, and the local and the global, must be forged in this relational way too, as internally complex, essentially unboundable in any absolute sense, and inevitably historically changing." Doreen Massey, "Geographies of Responsibility," *Geografiska Annaler*, Series B, Human Geography, vol. 86, no. 1 (2004), 5–18, this quote 5.

22 Despite her temporal emphasis, much in the spirit of this discussion, Massey insisted, against time-privileging leftist theorists, that "(contrary to popular opinion) space cannot be annihilated by time". *For Space*, 90–8. In this she is not so far from David Harvey, in his essay "Space as a key word," in *Spaces of Global Capitalism. A Theory of Uneven Geographical Development* (London: Verso, 2006), 117–48. Harvey distinguishes "absolute, relative, and relational" conceptions of space, all of which are needed to make sense of political and cultural developments.

23 Doreen Massey, "Politics and Space/Time," *New Left Review*, First Series, no. 196 (November/December 1992), 65–84, this quote 70, reprinted in *The Doreen Massey Reader*, ed. Brett Christophers, Rebecca Lave, Jamie Peck, and Marion Werner (Newcastle upon Tyne: Agenda Publishing, 2018), 264.

24 Massey, "Politics and Space/Time," 80 (*Doreen Massey Reader*, 274). Massey makes it clear that her view is in harmony with the view of space and time as distinct but essentially interrelated in physics (76–7/270–1).

25 Examples of the latter are Trevor Paglen, "Experimental Geography: From Cultural Production to the Production of Space," in *Critical Landscapes: Art, Space, Politics*, ed. Emily Eliza Scott and Kirsten Swenson (Berkeley and Los Angeles: University of California Press, 2015), 34–42, and some other artworks discussed in the volume; the 2010 exhibition *Uneven Geographies: Art and Globalization* at the Nottingham Contemporary and the ongoing, ambitious archaeology of art in Los Angeles, *Pacific Standard Time: Art in L.A. 1945–1980*.

26 Dolores Hayden, *The Power of Place: Urban Landscapes as Public History* (Cambridge, MA: MIT Press, 1995), 9.

27 See Ned Kaufman, *Place, Race, and Story: Essays on the Past and Future of Historic Preservation* (New York: Routledge, 2009), 258–9, on Hayden's impact on organizations like Arts for Transit and the Public Art Fund. Theoretically, too, Kaufman's useful concept of "storyspace" owes much to Hayden's narrative spatial history.

28 Kathryn Yusoff, *A Billion Black Anthropocenes or None* (Minneapolis: University of Minnesota Press, 2018). See also George Lipsitz, *How Racism Takes Place* (Philadelphia: Temple University Press, 2011).

29 Yusoff, *A Billion Black Anthropocenes or None*, 10. Yusoff's job title in Queen Mary University's School of Geography is "professor of inhuman geography," a suggestive wordplay on the nonhuman and the inhumanity of racial violence. Yusoff works at the intersection of research, art, and curating, as is clear in her edited volume *Bipolar* (London: The Art Catalyst, 2008), which besides essays by Yusoff and Denis Cosgrove features 'archives' of artists, scientists, and activists concerned with the polar regions and climate.

30 See *documenta* 14 (2017) in Kassel and Athens, curated by Adam Szymczyk with a focus on archaeology.

31 See the discussion of Ai's *Dropping* and the 2012 response by the Swiss artist Manuel Salvisberg, *Fragments of History* (who photographed Ai collector Uli Sigg dropping *Coca Cola Vase*, itself a Han dynasty pot painted by Ai), and the dizzying legal and aesthetic issues involved in both photo-performances, in Chin-Chin Yap, "Devastating History," *ArtAsiaPacific*, no. 78 (May/June 2012), http://artasiapacific.com/Magazine/78/DevastatingHistory#.WS8uAKAZK5A.email (accessed November 30, 2021).

32 See Robert Beer, *The Handbook of Tibetan Buddhist Symbols* (Chicago and London: Serindia, 2003), 169–71.

33 On this event and the Second Opium War (also called the *Arrow* War, after an allegedly British ship boarded by Chinese customs officials, which was used as a pretext for the hostilities), see J.Y. Wong, *Deadly Dreams: Opium and the Arrow War (1856–1860) in China* (Cambridge, UK: Cambridge University Press, 2002), 401, 489. The *Animal Heads* were first shown at Grand Army Plaza in New York in 2011: see www.zodiacheads.com (accessed October 5, 2021). Note that the looters of the original artifacts were British and French, not American or Austrian: Ai deals in subtle observations about cultural imperialism, not blanket accusation.

The Viennese press was aware of the symbolism and discussed it frankly: see, for example, "FLotus in Wien: Ai Weiwei verwandelt Belvedere-Becken in Flüchtlingsmahnmal," *Vienna Online / Vienna.at*, July 12, 2016, www.vienna.at/f-lotus-in-wien-ai-weiwei-verwandelt-belvedere-becken-in-fluechtlingsmahnmal/4782428 (accessed October 5, 2021).

34 Shown in the *Venice Design* exhibition in the Palazzo Michiel. As befits a designer, the product's value was on Dağcınar's mind, as the object label suggested: "those who set out wearing life-vests are carrying their most prized possessions—their lives, hopes, cultures and all the values that mankind has accumulated across millennia—that life-vest, worth only $10, is in fact a priceless artifact bearing the memory of our entire civilization."

35 On the reuse of these and other discarded lifejackets, see Elia Petridou, "Refugee life jackets thrown off but not away: connecting materialities in upcycling initiatives," in *Exploring Materiality and Connectivity in Anthropology and Beyond*, ed. Philipp Schorch, Martin Saxer, and Marlen Elders (London: UCL Press, 2020), 228–46.

36 For example, Ai mounted life jackets in Berlin on the pilasters of the Konzerthaus in an untitled installation a few months earlier in 2016, and in 2009 arranged the backpacks of children who died in the 2008 Sichuan earthquake (partly due to negligent school construction) on the façade of the Haus der Kunst in Munich, a work entitled *Remembering*.

37 Jonas Dahlberg, "Notes on a Memorial," in *osloBIENNALEN FIRST EDITION 2019–2024* (Oslo: 07 Media, 2019), 38–43, at 39. The notes constitute the script of Dahlberg's 2018 film *Notes on a Memorial*, shown in the October 2019 inaugural edition of the Oslo Biennial (osloBIENNALEN): the catalogue is available at www.oslobiennalen.no/app/uploads/2019/11/Jonas-Dahlberg-NOTES-ON-A-MEMORIAL-1.pdf (accessed October 5, 2021). See also Sabina Tanović, *Designing Memory: The Architecture of Commemoration in Europe, 1914 to the Present* (Cambridge, UK: Cambridge University Press, 2019), 162–68.

38 In early statements, for example, the interview with Theodor Ringborn, "Jonas Dahlberg discusses his commissioned memorial in Norway," *Artforum*, July 14, 2014, www.artforum.com/interviews/jonas-dahlberg-discusses-his-commissioned-memorial-in-norway-47199, Dahlberg mentioned the group visit but not the mistake about which island was Utøya: instead, he reflected on the intactness of nature in contrast to human trauma, and mused about how one might "wound nature …to the point that it couldn't heal—to do something that would obstruct its inevitable self-restoration, to do something which couldn't be undone." This emphasis was perhaps wisely dropped.

39 According to Dahlberg, resistance first came from right-wing groups, and politicians responded by asking him to make the gap "less visible". He also notes that the rendering, with its perspective over the water alongside the peninsula makes the cut more conspicuous than it would have been to any visitors on land. Skype interview with the author, April 30, 2014, and subsequent email communication. My own early response to the project and debate, reflected in a lecture I gave in Oslo in 2013, at the invitation of the initial competition sponsor, KORO (*Kunst*

i offentlige rom), can be found in "Natur-Gewalt. Über Jonas Dahlbergs Entwurf für das Utøya-Mahnmal in Norwegen," *Texte zur Kunst*, no. 95 (September 2014), 266–9.

40 See the article by Andreas Breivik, "Just a Building," *Kunstkritikk / Nordic Art Review*, 20 February 2020, https://kunstkritikk.com/just-a-building/ (accessed October 6, 2021). Breivik (the critic, *not* the terrorist) points out that the Y-block was frequently criticized since its building for its domination of public space.

41 See the website of the government building commissioner, Statsbygg: www.statsbygg.no/prosjekter-og-eiendommer/nytt-regjeringskvartal, which makes available to the public a wealth of official documents and reports, as well as design sketches and timelines. One striking proposal was Danish firm BIG (Bjarke Ingels Group)'s trio of pyramidal glass skyscrapers, resembling glaciers, around a "topographic urban park." An invitation also went out to the Oslo School of Architecture, which with Columbia University produced a publication, *Tabula Plena: Forms of Urban Preservation*, ed. Bryony Roberts (Zurich: Lars Müller, 2016). This contains a fine architectural history of the site by Roberts, "Introduction to the Government Quarter," 130–5. For a nuanced statement of the urbanistic issues, see also Mattias Ekman, "Mediation and Preservation," 148–56.

42 In 2016, the café on Utøya was enclosed in a modernist glass and wood shrine designed by Erlend Blakstad Haffner, called the Hegnhuset Memorial and Learning Center. Featuring large meeting spaces, an underground learning center, "intact bullet holes" in the old café, the center also traffics in the usual memorial numerology, with 69 structural columns to stand for the dead and "495 smaller outer poles which create a safe, outer fence around the interior." The latter is the number of survivors on the island; 13 victims died in the café. See the architects' text at "Hegnhuset Memorial and Learning Center / Blakstad Haffner Arkitekter," *archdaily*, September 5, 2017, www.archdaily.com/878932/hegnhuset-memorial-and-learning-center-blakstad-haffner-arkitekter (accessed October 6, 2021).

43 The monument landscape around the massacre site is complicated. A good place to start is with Mattias Ekman's essays: "Remembrance and the Destruction of Church Windows," in *Monument and Memory*, ed. Jonna Bornemark, Mattias Martinson, and Jayne Svenungsson (Münster: LIT Verlag, 2014), 43–61 and "The Artwork as Monument after 22 July 2011. Jumana Manna, Pillars from *Høyblokka* and the Cast as Memorial Art," in *The Government Quarter Study: For Those Who Like the Smell of Burning Tires: Jumana Manna*, ed. Line Ulekleiv (Oslo: KORO, 2016), 24–35. Mattias Ekman discussed the unfolding situation in Oslo with me on Zoom on June 5, 2020, and in subsequent emails.

44 Quoted in Charlotte Heath-Kelly, "Memory Loss: Post-terrorist Sites in Norway," *Architectural Review*, no. 1467 (December 2019/January 2020), 16–20, at 18. The article is available at www.architectural-review.com/places/scandinavia/memory-loss-post-terrorist-sites-in-norway. Heath-Kelly regards the bombed city center as *lieu de mémoire*: "Even if a bombed location lacked a symbolic identity previous to attack, like the buildings in Oslo's government quarter, terrorist atrocity can generate … meaning for a structure" (19).

45 The project, commissioned by Statsbygg, is still sparsely documented: one newspaper source that reported the team, including Ekman (my source), is "The Utøya memorial will be designed by a Belgian," *The Brussels Times*, May 26, 2018, www.brusselstimes.com/news/world-all-news/48604/the-utoya-memorial-will-be-designed-by-a-belgian/ (*sic*: the title refers to Smets; accessed October 6, 2021). See also Helge Jordheim's "Mending Shattered Time: 2 July in Norwegian Collective Memory," in Torgeir Rinke Bangstad and Þóra Pétursdóttir, eds., *Heritage Ecologies* (London / New York: Routledge, 2022), chapter 11. *Artforum*, in its "News" feature on June 28, 2017 printed a statement from Dahlberg reacting to the official calling off of his project on June 21, 2017: www.artforum.com/news/norway-abandons-jonas-dahlberg-s-memorial-to-victims-of-utoeya-massacre-69206 (accessed October 6, 2021).

46 Mattias Ekman, "Edifices: Architecture and the Spatial Frameworks of Memory" (PhD dissertation, University of Oslo, 2013), like his essays cited above, tackles some of these complicated entanglements. He regards the Oslo government center as providing Norwegians with a mental site for cultural and political memory, in addition to its role as "a place for individual, familial, or professional remembering" ("Disputed Spatial Frameworks of Memory," *Edifices*, x, 237f, quote 244). Expanding on Maurice Halbwachs's theory of collective memory, he argues that mediation, ranging from TV to press texts, social media, and informal discussions about and after the attack has altered "people's internal spatial frameworks of memory" more than any direct perception of the site.

4 Reversing monumentality

At this halfway point of the book, we have seen that the materialization of history is intimately connected with the ways the sites of public art and memorials engage the body and mediation (Chapter 1), that a site can be seen as a "thick" layering of subsequent strata of history with changing demands (Chapter 2), and that geographically expansive networks of social media, photographic documentation, and audience movement need to be taken into critical consideration, in part because they already figure integrally in recent art and commemoration (Chapter 3). The kinds of complexity (of site, audience, culture, material, and mediation) are mutually compatible, and almost always present within an urban matrix where power relations are spatialized over time.

I therefore propose now to look at how urban art geography might help us concretely to grasp the relationship between urban history, monumental buildings, and history resurfaces in particularly contentious political circumstances. This chapter turns to the capital of communist and post-communist Romania, Bucharest, in recent years *as well as* in the decade of unmatched destruction prior to the fall of Ceaușescu, when official monumental discourse, aesthetic and political, literally transformed the environment of the city's dwellers. How they responded, physically and psychically, and not least of all artistically, in efforts to reverse or counteract Ceaușescu's Bucharest will be my guide in this chapter. A more patiently urbanistic attitude to artworks and sites pays off here, where history is layered so densely and jumbled so disorientingly. In the process, the question of art geography, and the way acts, artists, and the built environment contribute to the understanding of political pasts and futures, will be answered in a way bearing on the further case studies in this book, and, I believe, more generally.

Hysterical history?

One way to introduce the entanglement of site and history under Socialist conditions is with a piece of performance art by Dan Perjovschi which,

somewhat archly, equates history with hysteria [Fig. 4.1]. At stake in *Istoria/Isteria* is a kind of re-performance of one decisive and traumatic event in contemporary Romania's earliest history, roughly half a year after the fall of Communism. In June 1990, the recently and supposedly democratically elected government under Ion Iliescu bussed miners into Bucharest from the Jiu Valley, some 300 km to the west (the capital of which, Târgu Jiu, is the home of Constantin Brancusi's famous ensemble, including the *Endless Column*). Infiltrated by former Securitate (secret police) officers, the miners brutalized anti-government protesters, mostly students and liberal intellectuals, who protested the ruling National Salvation Front, comprised mostly of former communists.[1] Iliescu, himself part of the central committee under Ceaușescu, and voted into office in 1990 with a whopping 85% of the vote, was cleared of charges for inciting the violence, but indicted again in April 2018 on charges of crimes against humanity.[2] In 2007, when the massacre was re-performed as art, there was little reason to believe he would ever be held responsible.

Dan Perjovschi is best known for his graffiti-like interventions on street and gallery walls and on the internet, whose interplay between word and image in the meme he mastered years before the term migrated from genetics to popular culture. We will have occasion to examine this outspoken, witty

Dan Perjovschi, *Historia/Hysteria*, University Square Bucharest, 2007. 4.1

work later in this chapter, but what is most salient here is how *different* his approach is in *Monument* (*Historia/Hysteria 2*).[3] In this uncharacteristically quiet work, he does not resort to his usual acid wit, nor attempt a quasi-professional "war reenactment" crowd piece in the manner of Jeremy Deller's *Battle of Orgreave*. Instead he reduces the June 1990 event (one of three clashes involving miners that year) to its symbolic backbone, arguably much as his scrawled cartoons do to complex political predicaments, though again, with an unsettling absence of commentary. Two single persons, described in the exhibition program as living statuary, "stand for" the confrontation in University Square: they stood literally, three hours a day, representing, respectively, a miner recognizable solely by his clothing, headgear, and baton, and a student, in this particular photograph the artist Alexandra Pirici, wearing a name tag identifying her as a *golan*, the Romanian for hoodlum or hooligan, which is what Iliescu notoriously called the pro-democracy protesters. Other performers relieved them, but the miner and golan were consistently juxtaposed, the latter slumping occasionally in the corner between pavement and wall in a posture of defeat, if not of violent brutalization.

While the work's content is local lore, traumatic especially for the generation that witnessed it, it was performed in September 2007 as part of an extended exhibition entitled *Public Art Bucharest / Spațiul Public București* (note the shift between English and Romanian from art to space!) co-curated by Marius Babias, a Romanian expatriate well known in Germany for his engagement with art in public space and as director of the *Neue Gesellschaft für Bildende Kunst* in Berlin.[4] The festival-like framing event began as early as April 20, but the week following its official opening ceremony in mid-September must have been one of heightened aesthetic awareness. Other spatial performances took place that weekend including Daniel Knorr's *Trams and Institutions* (*Tramvaie și instituții*) which invited residents to travel on four ordinary public transport vehicles painted to represent the army, police, Red Cross and the Romanian Orthodox Church.[5] More striking still was Lia Perjovschi's ongoing *Contemporary Art Archive / Center for Art Analysis 1985–2007*, hosted by the University of the Arts, a twenty-minute walk from the site of the University Square performance and opening just an hour and a half later on Saturday September 15, 2007. An open archive and studio for the documentation of Romanian avant-garde art and thinking since the late days of Communism, and closing a week later at 7 p.m., an hour before the conclusion of *Historia/Hysteria*, Lia Perjovschi's institutional performance functions as an eloquent if asymmetrical counterpart of semiprivate/semipublic artistic response to the traumatic public events reenacted by her spouse and his collaborators [Fig. 4.2]. This archival performance, whose ongoing development I was fortunate to be able to see in the Perjovschi home/studio in Sibiu a decade later, is in many respects an act of protest not only against public

Lia Perjovschi showing parts of her *Contemporary Art Archive / Center for Art Analysis* to the author in her studio in Sibiu.

4.2

violence, but official indifference and lack of support for artistic experimentation in Romania and beyond. One might have walked from the opening of Dan Perjovschi's *Monument* to that of Lia Perjovschi's *Archive*, then another few blocks to Victory Square (*Piața Victoriei*) or the city's main train station (*Gara de Nord*) to catch one of Knorr's "Army" or "Church" trams, which took their maiden voyage at 7 p.m. that evening.[6]

With or without an acute awareness of the other public art projects taking place around it, then, the *Monument* was both an artwork in public space and part of a larger effort by young artists to rethink Romanian institutions, most of which, like the trams' titular subjects, had only undergone modification, not revolutionary change, in the decades since Communism. The historical event that *Historia/Hysteria* reenacts has itself entered Romanian history under a double guise, being called the Mineriad or Golaniad in accordance with which political tendency the speaker favors (the *-ad* ending signifying epic conflict, as in the *Iliad*). This verbal jousting, and the polemic excess exerted by Iliescu's government in justifying the violence it orchestrated, certainly has something to do with the work's title. In Perjovschi's performance, nothing much happened beside these two symbolic figures embodied by living beings confronting one another, sometimes facing, sometimes side

by side, sometimes crouching face to the wall in a vulnerable posture. The site functioned as both a stage for and the subject matter of this interface. At the same time, the performance functions also as a photo-performance, since it must hardly have been noticeable to pedestrians not interested in the art festival: after all, many locals and tourists cross University Square, one of the busiest public places in Bucharest, which contains no official memorial of the protests or violence.[7]

It is obvious that the work does not attempt the repetition or accurate reconstruction, even on a reduced scale. It does two other things though. First, it stands like a signpost to remind viewers—live or belated—that this vibrant public place was once a zone of conflict. In that sense, the quieter it is, the more effectively it amplifies the site and draws attention to what is no longer visible. Second, it positions itself in a long history of the complicated relationship between traumatic historical events and their photographic documentation, or, to put it more broadly still, the question how media like photography, film, or video can restore such events to public memory or occlude them. One reason we can read the meaning of this particular work so lucidly in the photographs, besides the simple but by no means insignificant fact that the participants acted minimally, is that these photos, being devoid of complicated action, open onto the charged site of University Square, which is legible to the Romanian public beyond the time and place of the action being documented (and not just the Romanian public, as I will show). It is this concrete material basis of the work, an architectural setting that is only casually, incidentally, visible, that anchors its political exploration of the history of the space.

To see how so much meaning, urbanistic, historical, and political, can be packed into a deceptively uneventful—or even purposely anticlimactic—performance or portfolio of performance photographs, it will help to take another look at just how performance reaches people through its documents. A performative gesture, as I argued in *Performative Monuments*, can become socially binding only if the appropriate circumstances are given for participants to follow through on, even if the occasion is an artistic performance or artifact with no seeming demand for further uptake or response.[8] To do so, performance works with certain conventions we can read, even if it stretches and changes them on the go, so that this performative force can travel into documentation, photographs and video, and allow a historical depth and a space for imagination and (historical) fiction that was underestimated by performance scholars more concerned with avant-garde shock and confrontation. With the enormous change in the way images have been used in the last few years, and the growing fragility of public space, due as much to comprehensive surveillance by authoritarian governments as to new restrictions on assembly and the public use of space during the COVID-19 pandemic,

I want to take a closer look at these assumptions as they apply to historically ambitious art like *Historia/Hysteria*.

Perjovschi's and his collaborators' stylized performances, with very little pretense to physically emulate their historical referents, are at the same time attuned to the political and aesthetic potential of the repeated "making-it-so."[9] This has been a theme in Romanian art at least since Lucian Pintilie's 1968 film *Reenactment* (in Romanian, *Reconstituirea*, literally *The Reconstitution* or *Reconstruction*) [Fig. 4.3]. That film, which explores the comic, absurd, and finally tragic consequences of the state-ordered reenactment of a brawl, opens with repeated takes of a film clapperboard cuing in a young man being pushed face-down in the mud, getting up and asking, off-screen, "why did you hit me, man, why did you hit me?"[10] The film, suppressed after only two weeks in cinema, is often taken to be a veiled attack on the Communist regime, as it is an open attack on wider presumptions of documentary transparency, but it is also a reflection on the incendiary force of reality. The reenacting of the brawl by its original participants, far from evacuating all reality, or serving to teach them and their audiences an ideological lesson as the authorities intend, produces unforeseen consequences, including the loss of life, which gave the film its political bite.[11] Bringing the past back to life, be it immediate or more distant, is never a simple operation. An imagined, or better said, conceptual, realism, which I argue for in Chapter 6, is at work in this tradition; whether a feature film emulating a police documentary or photographs of two historic opponents at a standstill, we relate these aesthetic decisions to a history of censorship, and a climate in which any form of attracting attention can be dangerous. The gap between event and reenactment allows a history to emerge that reaches beyond the commemorated event.

Back on the ground, it is hard to imagine any Romanian forgetting the political valence of University Square, which, a year before the 1990 protests, had seen intense unrest that, spreading to the sites of government, brought down Nicolae and Elena Ceaușescu before the end of 1989, in the wake of intense fighting. The square, which has existed since the early modern era and achieved its modern identity in the 1850s with the foundation of the University of Bucharest, underwent significant transformations in the liberal-capitalist 1930s, when the university got its present beaux-arts façade, and the 1960s, when the sausage stands and kiosks were cleared away, pedestrian crossings moved underground, and the enormous structures of the National Theatre (reflected in the window in the photograph of the performance) and the Intercontinental Hotel were erected. The InterConti, as the local diminutive would have it, with its concave crescent façade, is a distinctive piece of Romanian modernist architecture, gesturing at a West European brutalism that had few echoes in postwar Romania. Even more telling is how

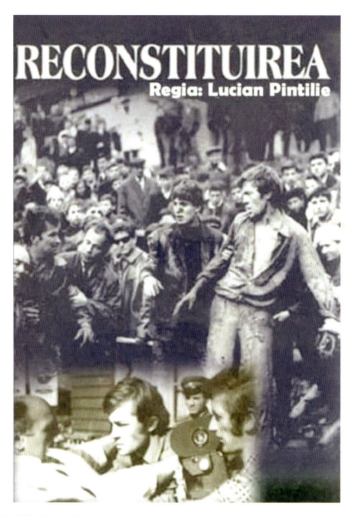

4.3 Lucian Pintilie, *Reconstituirea*, 1968.

it came to be built. The proposal and a 6-million dollar loan for its erection came from a private US firm, but the Romanian government owned the hotel.[12] Know-how and equipment (air conditioners, elevators) came from the American partners: at the time of construction, Intercontinental was part of the Pan Am consortium[13] [Fig. 4.4]. The project is indicative of Romania's favored nation status, reflecting Cold War politics of détente and Ceaușescu's projection of a Moscow-critical image which drew Western investors and subsidies.[14] The balconies of this hotel, frequented by foreign diplomats and reporters, and by Party functionaries, indeed bore witness to most of the media images of protest and fighting on the Square in 1989 and 1990. Is it a

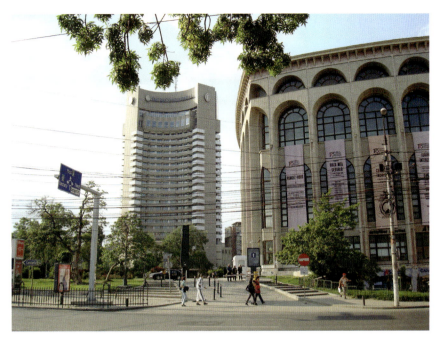

University Square Bucharest with Intercontinental Hotel and former National Theatre. 4.4

coincidence that from its elevated vantage point a photograph was taken of what can be seen as the very first Romanian counter-monument?

The impressive, labyrinth-like *Rag Monument* (*Monument de cârpe*) by Transylvanian textile artist and sculptor Ana Lupaş was installed before the University in 1991, just a year after the mineriad and less than two since the revolutionary protests of 1989[15] [Fig. 4.5]. Lupaş's intervention, itself a revisiting of an earlier collaborative work entitled *Humid Installation*, lasted a few weeks and is nearly the diametrical opposite of the InterConti in size, durability, and public recognizability.[16] The cloth, dark and unyielding, impregnated with asphalt, did not sway dynamically in the wind as in earlier iterations, but hung heavily, suggestive of mourning, but also, perhaps, of the anarchic possibilities change and destruction brought to Bucharest, and to the country. The monument was there briefly and survives in this spot only photographically. The InterConti is still there, if no longer the dominant force it once was in this prominent city square (the new National Theatre, which displaced that seen in the *Historia/Hysteria* photos, and with it, the National Center for Dance among other groups, arguably take that honor). But they both hover, as if tutelary presences of Romanian political culture and unrest, the visibility of capital and the relative invisibility of art, in the wings of the everyday drama enacted in *Historia/Hysteria*.

122 Monumental cares

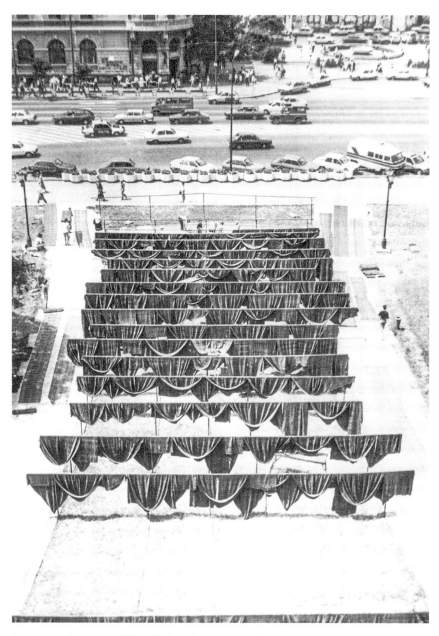

4.5 Ana Lupaș, *Memorial of Cloth*, University Square, Bucharest, 1991.

Bucharest 2000 and its aftermath

The interface of body, site, material, and the public sphere explored in *Historia/Hysteria* (as the title itself makes clear) through history is not limited to post-communist Romanian art. What emerges, besides a plea to reexamine hardened lines and narratives in (post-) communist (art) history, is a need for reexamination of the site as *historical* material in its urban and, where appropriate, rural, contexts. I argue that it is difficult to understand Perjovschi's stance on University Square, or for that matter, the site's valence in contemporary Romanian art, and the Romanian capital that is Bucharest, without at the same time attending to the traumatic transformation of the city in the decade prior to the revolution: chief among them, a public site of power that could be described almost as the diametrical opposite of University Square, one that Dan Perjovschi, among other artists who came of age before 1989, refuses to visit or exhibit in or otherwise engage with.

To take up the valence of performance *in* and *of* the city in Bucharest after communism, then, we will need to make a detour to a site we have already encountered, the so-called *House of the People*. Officially named the House of the Parliament today, Europe's largest structure, with its façade of 276 meters, houses the national government (Senate and Chamber of Deputies), the Constitutional Court, and, alongside a number of other bureaucracies, including the Romanian tax agency (Direcția Națională de Probațiune), the National Museum of Contemporary Art (*Muzeul Național de Arta Contemporană*, MNAC).[17] Built of reinforced concrete and clad, inside and out, with vast amounts of Romanian stone—red Rușchița marble from the West of the country for the interior, yellowish-white Viștea limestone from deposits near Cluj for the exterior columns—the palace both dwarfs and seems radically alien to the glass and steel marking the façade of the country's contemporary art museum, discussed briefly in Chapter 1. Its controversial 2004 opening has been interpreted both as a challenge and a capitulation to the aesthetic and political imperatives of the Ceaușescu era.[18] The considerable fanfare around the reuse and the museum's opening was preceded by, and may well have been intended in part to distract attention from, the international competition to decide the fate of the building and its urban setting, initiated by the Romanian Union of Architects in 1996.[19]

The unexecuted winning project of the German team under Meinhard von Gerkan (the designer most notably of Berlin's Tegel Airport, with its distinctive hexagonal terminal, and many large public buildings around the globe, notably in China), attempted both a simplification of the palace exterior and a grid of carefully calibrated new buildings in the area, which were to eliminate the dead space isolating and feeding the symbolic power of the colossus [Fig. 4.6]. Such a projected diffusion of power of a monumental building,

124 Monumental cares

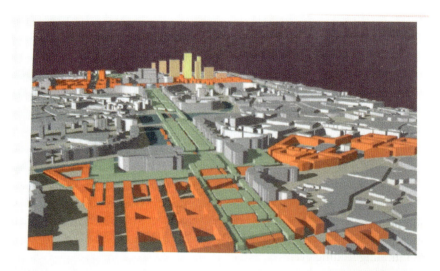

4.6 Meinhard von Gerkan, Joachim Zais, Plan Detail of Submission to the *Bucharest 2000* architectural competition.

which takes its formal and ideological cues from other totalitarian communist regimes, remains an interesting option for modifying a structure that is physically intractable. Somewhat related to concepts of the counter-monument prominent at the turn of this century, the urbanistic power-game that was *Bucharest 2000* also addressed scale: that of human actors in relation to the enormous building, and of making tangible the scale of the building itself,

which seems almost inconceivable while one walks towards or away from its enormous façade.[20] All of the finalist projects engaged in some form of taming, modulation, or drawing off the force of the building, whether by variations on the "park city" or the profusion of new high-rises to overshadow the gargantuan structure. In fact, to "lessen the aggression cause by the 1980–89 urban operation" was one of the competition's official objectives.[21] Gerkan's proposal, strikingly for the winning project of such a high-profile public competition, especially in an intellectual culture new to open calls (it should however be noted that the jury was one of the most formidable gatherings of architects and critics of the late twentieth century), *retained* both the building and its singularity but strove to integrate it into a zoned but by no means minutely planned and executed version of the city center. Since the competition never pretended to have the funds or political means to bring about its intended effect, but hoped to serve as a kind of feedback loop of publicity and funding leading eventually to a rebuilding of the center, we may regard Gerkan's and the other projects as theoretical thought experiments in countering the problematic monumentality of the House of the People.

Does the building, which remains a symbol of totalitarianism while serving as the seat of art and government of a more or less neoliberal EU state, tell us anything about the topics we began the book with, notably multidirectional use of sites in commemoration, and the role of tradition and materials in unearthing history? To really come to grips with the palace, we must recognize the peculiarly international matrix of its initial construction. The style and the extent of the intrusion into urban structure it embodies are partly a product of Ceaușescu's fascination with North Korea. The Kumsusan Palace of the Sun in Pyongyang, which served as the residence and eventually the mausoleum of Kim Il Sung, though not finished until 1976, was already under construction, or at least projected, when Ceaușescu visited North Korea in the summer of 1971.[22]

Kim appealed to Ceaușescu both for his espousal of a myth of national self-reliance, and for the intensification of the personality cult of the leader, which was a part of Romanian practice already in the days of Gheorghe Gheorgiu-Dej, the first Communist leader of Romania, though it had become a controversial strategy in Eastern Europe in the decades after Stalin's death.[23] For the House of the People, fully one quarter of the old city center, not just residences but public buildings and even the very hilly structure of the southwest part of Bucharest, was leveled in the early through late 1980s to make place for the footprint of the building and the broad boulevard leading to it, as well as a whole district of residential and office blocks radiating around it. A devastating March 1977 earthquake had already blurred the boundaries of destruction by nature and by urban planning, leading to several tendentious choices to destroy rather than restore damaged buildings: it was as if the

earthquake showed the leader what he could do on a larger scale.[24] The palace building itself was entrusted to young Romanian architect Anca Petrescu, and construction started in 1984. The liquidation of the old, picturesque, topographically highest neighborhood in the city, Uranus, and the adjacent Antim and Rahova quarters, removed a significant proportion of historical homes, commercial spaces and houses of worship, most prominently Mănăstirea Văcărești, an early seventeenth-century monastery central to the Romanian Orthodox Church, which Ceaușescu briefly toyed with turning into an UN-funded "Theological Institute" before finally tearing it down in the winter of 1986–87.

The demand for materials caused widespread shortages of stone, wood, and, ultimately, food, as the construction site operated day and night for several years with 10,000 laborers forced to relocate to Bucharest from all over the country. Photography on the building site was forbidden, and Andrei Pandele, a young architect and photographer drafted for a year to design interior detailing like marble staircases and wall moldings, recalls developing prints of photographs taken on and around the building site in the privacy of his parents' house, knowing that if seized they could bring him up to five years in prison[25] [Fig. 4.7]. The execution of the building thus shrouded in secrecy was in many ways startlingly discontinuous: proportions varied, bathrooms and other amenities were unevenly spread over the endless corridors, and the lowest, non-party rank of designers had no access to the site, patrons, or even to

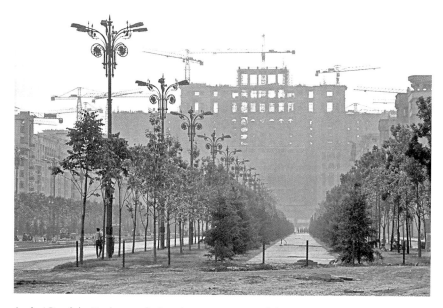

4.7 Andrei Pandele, Bucharest during the construction of the *House of the People*, 1982.

Reversing monumentality **127**

each other's work: Pandele recounts drafting individual rooms without any idea what lay to the left, right, up, or down or the design choices undertaken there. Nevertheless, a kind of consistency was achieved, as for instance when more practical granite staircases were rejected in favor of white marble, to satisfy Ceaușescu's fixation on "white with gold and red in every situation"[26] [Fig. 4.8].

How could such a space lend itself to reclamation by contemporary art in the twenty-first century? Rather modestly, given the stark contrast to the bulk and showy natural materials of the massive building, Adrian Spirescu, the designer of the glass-walled renovated wing of the building dedicated to the MNAC, describes his work as a conversation and revaluation[27] [see Fig. 1.7]. Some others have judged the fairly subtle international-style glass towers framing the museum façade (itself a mere facet of the enormous polygonal floor plan of the People's House) as a statement of resistant modernism against this neoclassical throwback on a monstrous scale. Most notably, Romanian architectural historian Augustin Ioan, in stark contrast with his overall withering critique of Petrescu's colossal structure, views the insertion of the two glass elevators on either side of the entrance as having deftly "muted part of the building's toxic significance."[28] Of course, there is more to the architectural modification than these glass towers—notably, a pleasant roof terrace in Nordic-looking wood planks, juxtaposed with the plain glass of the towers and the glazed glass of the upper gallery spaces; the interior takes

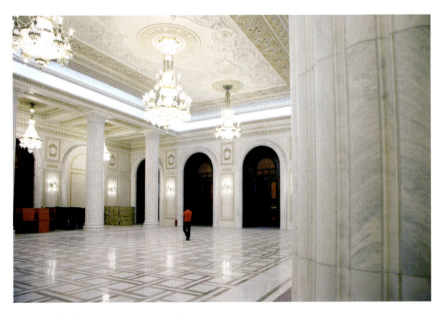

Palace of Parliament, interior, Bucharest. **4.8**

an even lighter touch, inserting occasional round portholes and maximizing visibility through choices like a glass-walled railing around the upper floor of the mezzanine galleries. Still, the symbolic heft of the structure is centered not in these blandly approachable aspects of the interior and exhibition design, but in what they share with the more polemical façade—a pretension to reform through encasement in transparent glass.

The operation has been described more sensationally in the press as an exorcism.[29] Oxford art historian Anthony Gardner picked up on this terminology, and its criticism by artists, in his critical history of MNAC, both in terms of its architecture and its initial global aspirations of exhibitions and curators: one of the board members was Nicolas Bourriaud. This cosmopolitan curatorial program, overlaid on a perhaps prematurely declared successful reckoning with the past, gave rise according to Gardner to a kind of "Bilbao effect" of spectacular tourism, together with the attempt to sweep problematic politics under a "carpet of internationalist rhetoric."[30] From the beginning, public opinion was sharply divided, with artists, critics, and journalists declaring themselves for and against the intervention, but in any case seeing the "grafting" of a symbol of liberal democracy onto one of dictatorship a "challenging" undertaking.[31] Already in 2008, Polish art historian and public intellectual Piotr Piotrowski wrote a biting commentary on the museum's program, which he stated, "look[s] like the result of the museum curators' tourism itinerary," a condition "contradictory to one of the basic characteristics of the museum, namely its local nature."[32] Piotrowski concedes that the cosmopolitan bent "tells us much about the local even if it does not want to," and also that MNAC is well-positioned to become a "forum for political debate on the contemporary condition of the world, whether defined as global, post-colonial, or post-communist."[33] This cautious optimism in fact captures the mood around the museum's opening with the self-consciously exaggerated title of the inaugural 2004 exhibition *Romanian Artists (and not only) love Ceaușescu's Palace?!*, and director-curator Ruxandra Balaci's breathless rhetoric of "decontamination" and "ultracontemporary provocation" in the massive, 300(+)-page *MNAC 2004* exhibition catalogue.[34]

In fact, the design by Petrescu is already riven by inconsistency, and we can see obvious tensions between a skyline that looms like a Stalinist wedding cake and the claim supposedly advanced by its original spokespersons that the palace originates in, and reflects, aesthetic canons of the Romanian baroque Brâncovenesc style (from Constantin Brâncoveanu, Wallachian ruler around 1700).[35] One detail is fascinating in this connection: in one of his studies, Augustin Ioan observes that architect Anca Petrescu claimed to have "saved" the friezes of an eighteenth-century monastery that was torn down as ornamental decoration inside the House of the People—not the originals, but a reproduction of their form.[36] Ioan himself, in his 1992

documentary film *Architecture and Power* (*Arhitectura și puterea*), discusses the decoration in terms of kitsch, pointing out both the extensive internal gilding (5 kg of gold in the "Romania Hall" alone), and the way details taken from local vernacular architecture were used as decontextualized, vulgarly oversized ornament.[37]

However accurate technically, the idea that there is a particularly nativist style buried within what to us looks like influences from Stalinist and Maoist pseudo-classical architecture is yet another clue that the "Romanian" in material, design, or function was a concept as variable as the regime would have it. Indeed, the national implications of the People's House extend into the fantastic, if we agree with Pandele that, in addition to all that it was officially, the People's House, with its coordinated rebuilding of the Dâmbovița riverbed through the city center, made of Bucharest "kind of a port on the Black Sea."[38]

An exhibition poster by conceptual artist Mircea Cantor from his 2013–14 MNAC installation *Q.E.D.* nicely captures this absurdist meeting of the cosmic and the rural in a black ink drawing of the People's House surrounded by a herd of 365 cows, with "life cycle" arrows in the sky around it labelled "The Milky Way" (*Calea lactee* in Romanian), as if the palace is at the center of a galactic drama of political visibility [Fig. 4.9]. This geographical vision, as implausible as it is sweeping, was imposed on Romania's capital during the 1980s, as if materializing it there, amid the ruins of pre-modern Bucharest, would cement the transformation of the country along the same lines. Unfortunately for the People's House, the political context in which it was finished was one that its architect and patrons could not possibly have expected.

Resisting as re-siting

The scale of the urban destruction and the bleak density of what took its place make the People's House, and its expansive site, a tricky thing to exorcise. Spirescu's modernist glass and metal cannot do the job, or can do it only partially, and with problematic levels of self-congratulation, for reasons both specific to Bucharest and generally connected to loss of faith in a sweeping one-size-fits-all modernist rhetoric of transparency: a theme I explore in Chapter 5. Can irony and humble materials do better? As we saw in Chapter 1, Alexandra Pirici and her collaborators set aside any grand polemics in their performance *If You Don't Want Us, We Want You* [Fig. 1.8], deciding to counter the building in an "arte povera"-style mimicry using handheld cardboard boxes, serving simultaneously as shelter, disguise, stage set, and architectural model.

The MNAC is located on the side of the People's Palace diametrically opposed to the façade where the company performed. Looking closely through its glass structure, inside the elevator, at the ornamentation of

4.9 Mircea Cantor, *Milky Way*, 2013, 21 × 15 cm. Indian ink on paper.

Petrescu's building is a strange, meditative experience. Much like the site-directed performance, and its mediation, the experience is more one of changing proportions and the making strange of the materials used and the circumstances that have made this site the center of experimental art activities, than a matter of confirming claims to transparency and successful overcoming of the past in contemporary Romanian politics or art.[39]

Contrary to reports of younger artists pragmatically embracing MNAC with no remainder of political ill ease, Pirici's art, like most of the interesting responses to the site, is ambivalent towards the museum and its gargantuan architectural setting.[40] This is continuous with if not identical to the stance of previous generations, like Dan and Lia Perjovschi, who neither exhibit in nor visit the MNAC, and are critical of the institution for practical reasons of due process, accessibility and accountability, as well as for subtler and more insidious historical reasons, notably the curatorial and audience temptation inherent in it to "take hee-hee selfies with Ceaușescu."[41] The English-language neologism ("hi-hi-hi selfiuri" in Romanian) returns us to the problematic of mediation, transparency, and audience access I have already discussed in connection with contemporary commemoration. It does not imply any distrust of current technology on Perjovschi's part—in the same article he argues that the most effective rehabilitation of Romanian pop experimentalist and propaganda artist Ion Bitzan is his daughter Irina Bitzan's regular posting of work from his archive to Facebook.[42] What is at stake rather in the 'selfie critique' is the uses to which the potent combination of historically compromised site, the spatial rhetoric of transparency, and (self-)mediation on and with the site in question are put. Not only is the presence or absence of their bodies in that politically charged space important to the Perjovschis, but also its dissemination and the tendency of the two to coalesce, evading the kind of hard thinking about space and who has a right to enter it and help determine its character: a thinking that artist-critics as different as Pirici, Pandele, and Perjovschi have undertaken.[43] They make art out of a deep-seated skepticism: dubious waves of political legitimacy, sheer physical gigantism, and the absent public are made visible simultaneously in the ruinous material accumulation of the site. With or without the looming structure, this space is, in a sense, more interesting to artists the less it functions as a part of the urban fabric.

More elusive and hard to grasp are the vast transformations of the city that preceded its current state. In 1977, Ion Grigorescu filmed the first stages of the demolition, very differently than Pandele would with his still camera in the following decade. The painter, who over the course of the 1970s was starting to explore private performance before the camera as a way to escape the restraints of official discourse, here turned outward in a furtive manner, his camera passing on blurry, shaky footage betraying the anxious presence

of a system on all levels of life. The film is called *My Beloved Bucharest* (Romanian *În Bucureștiul iubit*, literally "In the beloved Bucharest"), and already in taking in the title we are on slippery ground, not knowing where autobiographical nostalgia and affection ends and political satire begins. The medium, 8 mm film, was used even in Eastern Europe for home movies, and thus signifies the private sphere, though only a lucky few had this means to document their mementos.[44] The technology of private recording and viewing thus had to stand in—via a network of friends allowed to witness the result, to become its reticent audience—for a hollowed-out public sphere that might actually debate what to do with the city in the wake of the earthquake damage.

Grigorescu, born in 1945, grew up more or less synchronously with the communist period and was an established hyperrealist painter who featured quite a bit in the country's only art journal, *Arta*, which especially favored his awkward line-ups of peasants in folk costume, painted in a blurred-snapshot manner not unlike Gerhard Richter's[45] [Fig. 4.10]. He is better known today for secretive, claustrophobic, body-centered performances he did alone for the camera: 1977, the year of the Bucharest film also saw him record *Boxing*, in which the nude, emaciated artist loses a bout with a doppelgänger filmed through double exposure, and the following year brought the 8 mm film *Dialog cu Președintele Ceaușescu* (Dialogue with President Ceaușescu), superimposing himself qua Grigorescu with himself wearing suit, tie, and Ceaușescu mask, and peppering the conversation with images of the president from newspapers and television news bulletins.[46] These works were not shown and are often seen in opposition to his supposedly tamer public output, but they share a common and quite political interest in the understanding of outside discourses or forces defining identity and experience and making creative use of actually available spaces to create a public, however disjointed or belated.[47] This tendency was widespread among his generation of artists, and in the West it lends itself to simple correlations with dissidence and veiled protest.[48] But in fact it is something more complex; here the invisibility of power, and of artistic intervention against it, encourages us again to think in terms of site-directedness rather than specificity. Mediation opens up these ambiguous works to a future in which they will be seen, and indeed interpreted in a number of subtle ways, rather than flattening out live performance.[49]

There is then, from the very context which artists had to navigate, already necessarily a reflection on reception, audiences and their intentions, as well as the positions of potential viewers—wanted and unwanted, like the apparatus of the *Securitate*, the secret police, with its unknown informers.

Apart from trying to avoid trouble, then, there is in much Romanian art of the period a keen interest in how interpretation and reception would

4.10 Ion Grigorescu, *Reportage from Gorj*, 1970/71.

shape the content of a particular piece, and a high level of experimentation with various means of distribution. The bulldozers overlaid with written political slogans about building communism together in Grigorescu's *Beloved Bucharest*, like the ghostly trio of Ceaușescus looming over an architectural model in a portrait made around 1980, which the artist, as he says, destroyed later, because [it] "was intended as a gift for a demand from the Communist Party 1979, and refused; I thought it is dangerous to keep such an image"[50] [Fig. 4.11]. Maybe the portrait was able to function in its time and place insofar as it could address *another* time and place where the disparity between ideology and event, between the leader's photographically multiplied visage and the archaic Christian iconography of the *Deus trifons*, familiar in Romanian church art, would become legible as if for the first time.[51] This work has, like his Super 8 films, a split, complicated mode of address. An effort to place these

4.11 Ion Grigorescu, *Portrait of Ceaușescu*, around 1980 (original destroyed).

works too rigidly in their time, as if they only function therein, underestimates their monumental, commemorative function.

The writing on the wall

We are in a position to return to the loaded site from which this chapter started out, looking at it and outward from it as well. Today, University Square, whatever else it is, bears official witness not to the mineriad/golaniad in any of its iterations, but to the revolutionary demonstration—and violent reprisal—that brought down the Ceaușescu regime on 21 and 22 December 1989. Street signs with the new name of the square—21 December 1989 Square—and a plaque tell us about this history, but at the time of the 1990 protests and Lupaș's temporary monument, the walls around the square were tagged with the names of the those who had died or were wounded, and with the Chinese and Romanian inscription for Tiananmen Square. These are political slogans, not artworks, scrawled in a hurry and almost entirely gone now, overshadowed by the more colorful, larger tags typical of any modern European city.[52]

It may not be too much of a stretch to see in this rough and ready reinterpretation of public space one source of Lupaș's cloth memorial, and of Dan Perjovschi's discursive wall-writing. His "horizontal newspapers," particularly the ongoing wall painting in Sibiu, Romania, where he lives, are alive with visual and linguistic jokes, often bilingual in Romanian and English, and a kind of prolific political tragicomedy that rails against its own powerlessness. The wall abuts Sibiu's National Theater, a busy enough sidewalk for pedestrians, and it may be well to consider it a collaboration with that institution, since it has allowed Perjovschi to use the wall since 2010[53] [Fig. 4.12]. But it is still a side wall of a public building in a provincial town, the backdrop to a bus station where people await their ride and hurry about their business, as they do elsewhere. The graffiti, with its deceptively naive stick people who turn uncannily into letters who turn into planets or bombs or peace signs, has after several years taken on the texture of a dense weave of signs, almost as if a number of artists were playing call and response, though Perjovschi has noted that local graffiti artists have in fact left him the wall to himself. In their deceptive artlessness, the individual glyphs recall the chalk scribbles of the Prague resistance in August 1968, but with a new, despairing subtext of "who cares?" and "who is watching or reading?"[54] The cutting irony of juxtaposing 1968-style scribbles with the smartphone activism of the 2010s has become, if anything, more eloquent since the pandemic shut down most possibilities for public gathering and shared uptake. In 2018, when I last saw it, the wall hardly attracted the attention of passers-by more concerned with the bus, their children, and their phones; out of the skein of signs in black and white

4.12 Dan Perjovschi, *Horizontal Newspaper*, Sibiu.

paint individual symbols emerge and coalesce, often undergoing transformation in binary groups: a peace sign inverted becomes a tree, a few crosses labeled "tragedy" become a whole field of crosses ("statistic") a figure holding a Molotov cocktail ('68) comes to wield a smartphone ('18). Perjovschi has since taken this project online, while also moving a gallery show meant to open in Cluj online for a collaborative *Virus Diary*.[55] Political and cultural trauma is channeled in unexpected ways in the horizontal newspaper, surviving in analog and digital photography and a public sphere shuttling between them, where aggressive availability and interactivity is as much an obstacle as an enabler of debate.

Works like these, I have been arguing, need not didactically document the history of embattled spaces, like University Square, or embattled concepts, like the Romanian public sphere: but then again, we should not think of the site as latent, mute, awaiting site-specific art to activate it. Historically significant sites almost by definition remain unstable and dynamic, which is one reason why the histories they bear so often fall into obscurity. If artworks succeed in reviving sites, it is not always by occupying them assertively, but by pointing them out to viewers who may be near or far away, in space and time. Once we accept that, I think we will agree that media from analog photography to its digital iterations do not stand in opposition, nor are they any more stable, or less stable, than the site and its physical materials (ranging from rags to platforms storing photographic data), nor any less amenable to artistic intervention. They play their role side by side as equally important players in the tensions that open up a public space—or sphere, or cardboard box—as an art geography. The interface of site and legibility is central not just to understanding Romanian art under and after communism, but in filling in what is missing in the "anything goes" world of discursive site specificity: first and foremost, to grasp the role played by photography and other mediating techniques in directing audiences to a site. The political event without camera, the performance without an audience in front of a lens, the reenactment street spectators might miss because they are hurrying on their own ways: all these channel the power of photographic reproduction, its instability and limitations, to assemble new sites of power and resistance.

Notes

1 For a concise discussion of the University Square clashes, see Florin Abraham, *Romania Since the Second World War: A Political, Social, and Economic History* (London: Bloomsbury, 2017), 233–8. As Abraham points out (233), nationalist clashes between Hungarians and Romanians in Târgu Mureş in March 1990 also spurred anxieties about political violence and even civil war on the eve of the first post-communist Romanian elections.

2 See "Brought to Book in Bucharest: Romania's ex-president, Ion Iliescu, goes to trial," *The Economist*, May 2, 2018, www.economist.com/europe/2018/05/03/romanias-ex-president-ion-iliescu-goes-on-trial (accessed August 9, 2018). As of September 2021, the trial had not reached a conclusive outcome, and is unlikely to have one, given Iliescu's advanced age (in his 90s), procedural challenges, and delays caused by the pandemic.

3 I render the full title in English using the Latin for "history" to retain the Romanian wordplay (*Istoria* and *Isteria* differ by only one letter): the "monument" title, found in the period advertising, is especially suggestive to my argument. The "2" of the subtitle refers to an earlier performance by Perjovschi, which also explains the extended date range, 1996–2007, one sometimes sees associated with the University Square photos.

4 Public Art Bucharest | Spațiul Public București, September 15 to October 15, 2007. Curators were Marius Babias and Sabine Hentsch. Artists included Mircea Cantor, Anetta Mona Chisa / Lucia Tkácová, Nicoleta Esinencu, H.arta, Daniel Knorr, Dan Perjovschi, and Lia Perjovschi. Katharina Koch did a video documentation in German, *Spațiul Public București Public Art Bucharest 2007*, published in Cologne with Walther König. The show traveled to the Neue Berliner Kunstverein, January 24 to February 13, 2009. The actual Perjovschi performance started at 4 p.m. on Saturday September 15 and was performed daily until September 22 from 5 to 8 p.m. It was described as follows: "Dan Perjovschi's project brings back (*readuce*) to the residents' memory a moment from Romania's recent history, the mineriads of the early 90s, recreated in the form of a living statue. *Monument* (*Historia / Hysteria 2*) is interpreted daily for a week in University Plaza, Bucharest." See the announcement posted by Cosmin Nasui in *Modernism: Tabloidul de artă și stil*, September 15, 2007, www.modernism.ro/2007/09/15/spatiul-public-bucuresti-public-art-bucharest-2007/ (accessed February 20, 2022), and the text by project coordinator Raluca Voinea, "Public Space," *Atlas of Transformation* (2011), http://monumenttotransformation.org/atlas-of-transformation/html/p/public-space/public-space-raluca-voinea.html (accessed May 20, 2020), who sees the work as "an appeal against judging based on selective memory."

5 See Vlad Morariu, "Daniel Knorr: Tramvaie și instituții," *Observatorul Cultural*, September 20, 2007, www.observatorcultural.ro/articol/daniel-knorr-tramvaie-si-institutii-2/ (accessed February 20, 2022), which points out that the choice of "kafkaesque" institutions is not arbitrary, the Church having scored as the most trustworthy Romanian institution with 84% approval rating versus 75% for the Romanian army and only 41% for the police (the Red Cross, as an international organization, was not part of any such poll).

6 The timing is significant: it allowed at least the artists, and certainly also more committed audience members, to be in all these places, if not at once. Knorr painted a tram #31 (Piața Victoriei/Gara de Nord) as "Church" and another one entering Victoria Depot (#32 or 45?) "Army"; #27, labelled "Police," runs south of University Square, between Union Square (Piața Uniri and Titan Depot); "Red Cross" if it was tram #16, runs from just south of University Square (Piața Sf. Gheorghe) to Pipera in the northeast. There were obviously also non-modified

trams bearing the same numbers on these routes, the first two quite busy, the latter two joining city center and outskirts.
7 However, non-official plaques, and temporary interventions such as graffiti point to the incident on the square. See Craig Young and Duncan Light, "Multiple and Contested Geographies of Memory: Remembering the 1989 Romanian 'Revolution'," in *Memory, Place, and Identity: Commemoration and Remembrance of War and Conflict*, ed. Daniella Drozdzewski, Sarah De Nardi, and Emma Waterton (New York: Routledge, 2016), 56–73, esp. 65ff. Also interesting is the phenomenology of Oana-Maria Hock, "At Home, in the World, in the Theatre: The Mysterious Geography of University Square, Bucharest," *Performing Arts Journal*, vol. 13, no. 2 (1991), 78–89.
8 See especially Widrich, *Performative Monuments*, chapter 1, and the conclusion.
9 Thus, Voinea, "Public Space," reports that Perjovschi was asked by passers-by why the two were not fighting.
10 "De ce ai dat, mă, de ce ai dat?" "Mă," unsexed, familiar, second-person pronoun, is hard to translate: "yo" might be better than "man," if not for its whiff of neologism. The film ends on the same question, a famous line in Romanian cinema. See the interview with the film's star by Ion Stoleru, "Interviu cu actorul George Mihăiță: 'Cu zâmbetul pe buze am reușit să deschid multe uși'," *Suplimentul de Cultură*, no. 483 (May 18, 2015), http://suplimentuldecultura.ro/10391/interviu-cu-actorul-george-mihaita-cu-zambetul-pe-buze-am-reusit-sa-deschid-multe-usi/ (accessed May 5, 2020).
11 Pintilie's film has seen a flowering of recent discussion, in the wake of the success of post-communist Romanian cinema: see, among others, Katalin Sándor, "Filming the Camera: Reflexivity and Reenactment in *Reconstruction* and *Niki and Flo*," in *The New Romanian Cinema*, ed. Christina Stojanova with Dana Duma (Edinburgh: Edinburgh University Press, 2019), 80–92; Dominique Nasta, *Contemporary Romanian Cinema* (London and New York: Wallflower Press, 2013), 88–95; Laura Filimon, "Popular Cinema in 1960s Romania," in *Cinema, State Socialism, and Society in the Soviet Union and Eastern Europe, 1917–1980*, ed. Sanja Bahun and John Haynes (New York: Routledge, 2014), 94–111; and Anna Batori, *Space in Hungarian and Romanian Cinema* (Cham: Palgrave Macmillan, 2018), chapters 3–4.
12 Elena Dragomir, "Hotel Intercontinental in Bucharest: Competitive Advantage for the Socialist Tourist Industry in Romania," in *Competition in Socialist Society*, ed. Katalin Miklóssy and Melanie Ilic (London and New York: Routledge, 2014), 89–106, this figure quoted at 92.
13 The hotel was erected 1968–70. The architects were Dinu Hariton, Gheorghe Nădrag, Ion Moscu, and Romeo Belea. Pan Am sent an architect and an engineer to Bucharest, who stayed for the whole time of the construction to supervise the work, according to Dragomir, "Hotel Intercontinental," 93.
14 Robert L. Farlow, "Romania: The Politics of Autonomy," *Current History*, vol. 74, no. 436 (1978), 168–86.
15 In its first iteration, *Humid Installation* was first installed in the Grigorescu neighborhood of her hometown, Cluj, in 1966, and later and more iconically just outside the nearby village of Mărgău in 1970. See Mechtild Widrich, "From Rags to

Monuments. Ana Lupaș's Humid Installation," *ARTMargins Online*, November 4, 2021, Special Issue: Contemporary Approaches to Monuments in Central and Eastern Europe, https://artmargins.com/from-rags-to-monuments-ana-lupass-humid-installation/ (accessed February 1, 2022). There, I argue that Lupaș's contribution to monument discourse lies in how it showed traditional peasant labor as art practice at the very moment of its extirpation. Its recurrence post-revolution, in 1991, is certainly pointed, whatever shifts in meaning it underwent.

16 The project, reconceived as a Cloth Monument (more accurately, a "rag" monument given the Romanian word used) in University Square, with the white linen stiffened and darkened with asphalt, and later cast in metal for an installation in Dunkerque, France, solidifies and memorializes its potential drawn from ordinary materials, rituals and chores. According to Marina Lupaș, the artist's sister and manager, "The artist favours here metal because, if the ambition of all humanity in search of memory is to last, it is the longevity of the material that will convey this memory." Marina Lupaș via email in April 2021, citing a 2018 text. See also Maria Alina Asavei, "The Politics of Textiles in the Romanian Contemporary Art Scene," *TEXTILE: Cloth and Culture*, vol. 17, no. 3 (2019), 246–58.

17 By contrast, CERN's Large Hadron Collider, with its circumference of 27 km, is the world's largest *machine*. It is difficult to compare the underground complex directly with the People's House, which Guinness World Records lists (with some reservations naturally) as the world's heaviest building at 700,000 tonnes.

18 See, among others, Erwin Kessler, "MNAC: un kitsch istoric și politic," *Revista* 22, supplement no. 780 (2005), https://nettime.org/Lists-Archives/nettime-ro-0502/msg00126.html (accessed November 30, 2021), and Ruxandra Ana, "Casa Poporului—un melting pot de mentalități vechi și noi. Dialog cu Ruxandra Balaci," *Observatorul Cultural*, no. 355 (January 18, 2007), 12, www.observatorcultural.ro/articol/casa-poporului-un-melting-pot-de-mentalitati-vechi-si-noi-dialog-cu-ruxandra-balaci-2/ (accessed February 20, 2021).

19 The official catalogue of the competition, *București 2000. International Urban Planning Commission*, ed. Illeana Tureanu (Bucharest: Simetria, 1997), shows all entries and is printed in Romanian, French, and English. See also Roann Barris, "Contested Mythologies: The Architectural Deconstruction of a Totalitarian Culture," *Journal of Architectural Education*, vol. 54, no. 4 (May 2001), 229–37. Barris relies on the Western architectural notion of deconstruction, while the organizers of *București 2000* speak of the People's House and the needed urbanism as a "re-integration" in the fabric of Bucharest (21) to "reconstruct urban coherence" (24). See also the interview with Meinhard von Gerkan, "We could not realise one single project," *The Diplomat (Bucharest)*, vol. 2, no. 7 (September 2006), www.thediplomat.ro/features_0906.2.htm (accessed February 20, 2022).

20 Barris, "Contested Mythologies," 233.

21 *București 2000*, 24.

22 These state visits by Nicolae and Elena Ceaușescu continued as late as October 1988. See "Ceaușescu begins official visit to DPRK," *Federal Broadcast Information Service Daily Report: Eastern Europe* (1988), 40, 57. At the festivities, Kim conferred on Ceaușescu an honorary PhD in economics (58). Cf. Vladimir Tismaneanu,

Stalinism for all Seasons: A Political History of Romanian Communism (Berkeley and Los Angeles: University of California Press, 2003), 106, 206. Tismaneanu points out (178) that in this Ceaușescu followed his precursor Dej. Lest it be thought Ceaușescu only ventured eastward, it should be noted that he made state visits with Nixon in Washington in 1970 and 1973, jockeying on both occasions for Favored Nation Status and American support against the Soviets. See Iulian Toader, "Off the Record with Nixon and Ceaușescu," *Wilson Center Sources and Methods Blog*, February 21, 2017, and the original Romanian and US State Department meeting transcripts reproduced therein: www.wilsoncenter.org/blog-post/the-record-nixon-and-ceausescu (accessed November 30, 2021).

23 As Johanna Granville, "Dej-a-Vu: Early Roots of Romania's Independence," *East European Quarterly*, vol. 42, no. 4 (Winter 2008), 365–404, argues, Ceaușescu was in large part following in the footsteps of his Stalinist predecessor in seeking independence from Moscow and tighter economic relations with the West.

24 The 1977 earthquake, felt throughout the Balkans, was at 7.2 not as strong as the 7.7 tremor in 1940; both originated in the seismically active Eastern terminus of the Carpathians in Vrancea County. While the 1977 earthquake killed more than a thousand Bucharestians and destroyed prominent buildings, such as the Dunărea block downtown, the demolition of Uranus, Antim, and Rahova bore no direct relation to the earthquake damage. See Maria de Betania Cavalcanti, "Totalitarian States and their Influence on City Form: The Case of Bucharest," *Journal of Architectural and Planning Research*, vol. 9, no. 4, Theme Issue: Influences on Urban Form (Winter 1992), 275–86.

25 The photos were published much later in the catalogue *Andrei Pandele. Fotografii interzise și imagini personale* (Bucharest: Compania, 2007). In his monograph *Casa Poporului. Un sfârșit în marmură* (Bucharest: Compania, 2009), 60, Pandele recounts being stopped on the street by a police patrol after being denounced as a spy; he bluffed his way out by claiming to be a sports photographer attached to the "House of the Republic" (the going name of the project in 1987). Simina Bădică discusses the success of the first exhibition of Pandele in Bucharest in 2007 in "'Forbidden Images'? Visual Memories of Romanian Communism Before and After 1989," in *Remembering Communism. Private and Public Recollections of Lived Experience in Southeast Europe*, ed. Maria Todorova, Augusta Dimou, and Stefan Troebst (Budapest and New York: Central European University Press, 2014), 201–16. Pandele was also, as she writes, one of the few photographers who "dared to photograph the queue" (207).

26 Pandele, *Casa Poporului*, 56–7.

27 Adrian Spirescu, *Pagini de arhitectură: interferențe și neliniști / Architecture pages: interferences and anxieties*, ed. Cristian Bracacescu (Bucharest: Igloo, 2013), 118ff.

28 Ioan described the modification of the building, in particular the use of modernist glass, as "colonization" of the building, a telling choice of words, I think, and the framing by the elevators as a successful "muting" of the toxic connotations of the building. Augustin Ioan, "Bucharest's National Museum of Contemporary Art in the Big House," *ARTMargins* (April 2008), https://artmargins.com/bucharests-national-museum-of-contemporary-art-in-the-big-house/

(accessed November 30, 2021). See also Augustin Ioan, *Modern Architecture and the Totalitarian Project: A Romanian Case Study* (Bucharest: Institutul Cultural Român, 2009).

29 Most prominently, see Cosmin Costinaș, "Deschiderea MNAC / The Opening of MNAC," *IDEA: artă + societate / arts + society*, no. 19 (Cluj, 2004), 60–7, http://idea.ro/revista/ro/article/XMnMYisAADoA1cAO/deschiderea-mnac (accessed March 7, 2022), a sophisticated meditation in a magazine issue containing an insert by Dan Pervojschi and opening with Romanian translations of the debate on relational aesthetics between Nicolas Bourriaud and Claire Bishop. On Constinaș's piece, see Huth Júliusz, "Neighboring stories—Contemporary institutional debates in Hungary and Romania during the period of transition," *Artportal*, February 8, 2019, https://artportal.hu/magazin/neighboring-stories-contemporary-institutional-debates-in-hungary-and-romania-during-the-period-of-transition/#_ftnref20 (accessed March 7, 2022).

30 Gardner, *Politically Unbecoming*, chapter 5, esp. 197–202.

31 These particular terms, including the English "challenging," come from Ruxandra Ana, "Casa Poporului—un melting pot". Cf. Gardner, *Politically Unbecoming*, 198.

32 Piotr Piotrowski, "New Museums in East Central Europe," in *1968–1989: Political Upheaval and Artistic Change*, ed. Claire Bishop and Marta Dziewanska (Warsaw: Museum of Modern Art, 2008), 149–66, quotes 159–61. Piotrowski found the inaugural exhibition an interesting, ambitious attempt to work through the trauma of the building. The curatorial approach has swerved since 2015, when Călin Dan, a member of the 1990s group subREAL, dedicated to politically critical new media art, began to highlight parts of the Romanian avant-garde.

33 Ibid. Piotrowski, until his recent death, has tirelessly advocated the need to see art from Eastern Europe through its own theoretical framings and not discuss it on the Western model of avant-garde successions. I agree with most of what he argued for, but on the other hand it is also not the case that there is no connection to Western models.

34 Ruxandra Balaci, "Romanian Artists (and not only) Love Ceaușescu's Palace?!," *mnac 2004*, ed. Ruxandra Balaci and Raluca Velisar (Bucharest: MNAC, 2004), 31, 33 (English 40–1). A leading Romanian artist of the older generation, Geta Brătescu (1926–2018), who in 1990 called in writing for the founding of a national contemporary museum, is perhaps closer to the mark in referring to the choice of site as a "serious irony" (62/3).

35 Michael Vachon, "Bucharest: The House of the People," *World Policy Journal*, vol. 10, no. 4 (Winter 1993–94), 59–63.

36 Ioan, *Modern Architecture and the Totalitarian Project*, 142, note 7. This is worthy of a separate essay, but Ioan in his role as architect won a 2002 call for the new Orthodox National Cathedral (*Catedrala Mântuirii Neamului*, literally the Cathedral of National Salvation, also called *Catedrala Națională* or *Catedrala Neamului*), then meant to be situation in Piața Unirii—by 2010, the project was moved to the wasteland behind the People's House, funded by taxpayer money, and adopted a far more conservative design proposed by the firm Vanel Exim. The construction is supposed to be finished in 2025. On Ioan's role and estimate of the

final result, see his interviews with Eugen Istodor, "Catedrala Neamului nu va fi un lăcaș de cult ortodox tradițional," *Hotnews.ro*, May 3, 2018, www.hotnews.ro/stiri-perspektiva-22427211-catedrala-neamului-nu-lacas-cult-ortodox-traditional-cei-tineri-pleaca-dintr-tara-cazuta-interviu-augustin-ioan-profesor-arhitect.htm; Cristian Teodorescu, "Catedrala este un obiect care va arăta vechi, deja bătrînicios, dar care nu este tradițional," *Cațavencii*, February 8, 2017, www.catavencii.ro/augustin-ioan-catedrala-este-un-obiect-care-va-arata-vechi-deja-batrinicios-dar-care-nu-este-traditional/; and the older interview on the original project and its costs, "Catedrala va costa 2.000 euro/mp" *Capital.ro*, October 23, 2002, www.capital.ro/augustin-ioan-catedrala-va-costa-2000-euromp-7764.html (all accessed September 23, 2020).

37 Ioan is not alone in discussing the People's House as kitschy: see Kessler, "MNAC: un kitsch istoric și politic."

38 Andrei Pandele, *Bucureștiul Mutilat* (Bucharest: Humanitas, 2018), 194: "In the dictator's dreams, the People's House was a kind of Black Sea port" (În visurile dictatorului, Casa Poporului era și un fel de port la Marea Neagră).

39 Cf. the hopeful claim in Ioan, "Bucharest's National Museum," that *Spirescu's* glass elevator shafts and upper gallery "frame" Petrescu's classicism. They may well do so, seen from afar, but not too far, where again the totality of Petrescu's great pile "frames" and reduces to insignificance the local intervention that is MNAC.

40 The claim of pragmatism is especially associated with French-Romanian curator and MNAC board member Ami Barak: his "Sex, Lies, and Architecture," *mnac 2004*, 47–8 (English 49–50), opines that international artists who delight in controversy, such as Maurizio Cattelan, Paul McCarthy, or Mike Kelley, would love to work there.

41 Dan Perjovschi, "Critic. Critică. Artist. Artă," *Revista 22* (May 29, 2018), https://revista22.ro/70271469/critic-critic-artist-art.html (accessed August 8, 2018). The Perjovschis' arguments against the museum are supported by Kristine Stiles in *States of Mind: Dan and Lia Perjovschi*, exh. cat. Nasher Museum of Art at Duke University (Durham: Nasher Museum of Art, 2007), 80–5 (a good overview of their art practice), and by Gardner, *Politically Unbecoming*, who also discusses their concept of *dizzydence*, 242–5. See also the Center for Art Analysis (Lia Perjovschi), *Detective Draft* (self-published, 2005), a timeline of press clips and criticism of the museum opening.

42 Perjovschi, "Critic." Irina Bitzan's Ion Bitzan *catalogue raisonnée* in progress is in fact freely accessible at www.ionbitzan.com (a 2017 MNAC retrospective connected to it was one occasion of Perjovschi's remarks). Perjovschi did once pose for a "proto-selfie" (before the concept was current), not with MNAC or Ceaușescu precisely, but with the People's House: one of his four 1995 collages *Post R* (which played with a tourist poster format) juxtaposes the artist's portrait with the building façade, under the rubric "a tiny people with such a big house" (*un popor mic cu o casă atât de mare*). See Stiles, *States of Mind*, 100–2.

43 See Amy Bryzgel, "Against Ephemerality: Performing for the Camera in Central and Eastern Europe," *Journal of Contemporary Central and Eastern Europe*, vol. 27, no. 1 (2019), 7–27.

44. Anders Kreuger, "Ion Grigorescu: My Vocation is Classical, even Bucolic," *Afterall* 41 (Spring/Summer 2016), 22–37: "(using Super 8, the only format available to private individuals in Romania at the time) … the artist is a bystander without much power to do anything but reflect (and reflect on) what he sees" (23).
45. Ileana Pintilie claims that Grigorescu is not so much part of two different spheres, but that his hyperrealistic works should be seen as an avant-garde practice meant to be shown in official contexts. See Pintilie, "Questioning the East," 61, which also discusses *My Beloved Bucharest*. See also Ovidiu Țichindeleanu, "Ion Grigorescu: A Political Reinvention of the Socialist Man," *Afterall* 41 (Spring/Summer 2016), 10–21, and Caterina Preda, "Art and Politics in Postcommunist Romania: Changes and Continuities." *Journal of Arts Management, Law & Society*, vol. 42, no. 3 (July 2012), 116–27. Bob Jarvis, "Creating the Image of Bucharest in art (1850–2017)," *Human Geographies*, vol. 12, no. 1 (2018), discusses Grigorescu and Pandele in the context of the urban transformation.
46. On the 1978 *Dialogue* and Grigorescu's two post-89 returns to the theme, see Ileana Parvu, "Reenactment, Repetition, Return. Ion Grigorescu's Two Dialogues with Ceaușescu," *ARTMargins Online*, published January 26, 2018, https://artmargins.com/reenactment-repetition-return/#ftnlink_artnotes1.17 (accessed November 30, 2021).
47. See also Magda Radu, who considers *My Beloved Bucharest* in light of, among other works, the official portrait of Ceaușescu that Grigorescu was commissioned to paint in 1980, in "Art and Politics: Considering Some of Ion Grigorescu's Films and Photographs," lecture manuscript, www.2020.ro/resources/files/ArtandPolitics.pdf (accessed December 13, 2020). Grigorescu's film has been transferred to 16 mm since. See holdings of the Erste Group, inventory nr. K408, duration 14 minutes, 37 seconds.
48. Few writers now would call Grigorescu a dissident outright, but it is not unusual to find statements like this, from a 2011 one-man exhibition in Sammlung Friedrichshof, Austria, suggesting a kind of dissidence-by-isolation: "Grigorescu is not a political artist who reacted to the extremely repressive communism of the Romanian dictator with activist protest. Instead, he refused all contact with officially recognized art of his country." At http://sammlungfriedrichshof.at/ion-grigorescu/?lang=en (accessed May 30, 2020). Cf. Hubert Klocker, ed, *Ion Grigorescu: Horse/Men Market* (Köln: König, 2012). One might also compare the work of Grigorescu's contemporary Decebal Scriba, *Darul* (*The Gift*), a 1974 performance that involved walking several kilometers in downtown Bucharest holding in his hands a small imaginary box, being photographed, together with unsuspecting passers-by by a friend going in front. See Cristian Nae, "Basements, Attics, Streets and Courtyards: The Reinvention of Marginal Art Spaces in Romania During Socialism," in *Performance Art in the Second Public Sphere*, 84–85.
49. Bryzgel, "Against Ephemerality." Bryzgel argues that "perhaps the most iconic examples of performance for the camera were produced in the totalitarian environment of Ceaușescu's Romania in the 1970s" (p, 12). She discusses Grigorescu's performances in detail, but not this particular film.

50 Email to the author, March 8, 2022.
51 See Radu, "Art and Politics," 6, on the changes to the Ceaușescu portrait, which was reduced to a single figure. Grigorescu, who is openly religious, must have known the peculiar 3-faced iconography, still popular in certain Romanian churches long after its condemnation at Trent; see Nicolae Sabău, "Între Occident și Orient. 'Sfânta Troiță într-un singur trup' și 'Vultus trifrons' în câteva exemple ale picturii religioase transilvănene" ("The Holy Trinity in One Body" and "vultus trifrons," in Several Examples of Religious Painting in Transylvania), *Studia Uniersitatis Babes Bolyai—Historia Artium*, vol. 62, no. 1 (2017), 5–47.
52 A narrow (approx. 2 m across) wall where Strada Biserica Enei turns at a 135° angle, just across from the university fountain retains the inscription *Piața Tien An Men* (Tiananmen Square), above a stone memorial cross.
53 A 2020–21 "Pandemic Edition" of the *Horizontal Newspaper* is described in a press release by Perjovschi's gallery, Gallery on the Move (Tirana), as "courtesy the artist & Radu Stanca Theatre Sibiu." See www.artforum.com/uploads/guide.005/id31438/press_release.pdf (accessed November 30, 2021).
54 In 1998, Perjovschi performed *Live! From the Ground* in Chișinău, the capital of Moldova, crawling on the main boulevard, and yelling "Ground to centre! Come in! Do you hear me!" which, like so many of his cartoon one-liners, "alludes to the peripheral status … of the East in post-communist Europe." In conversation with Amy Bryzgel, Perjovschi is accordingly critical of the post-communist condition in relation to digital technology: "the new invention after communism is to use technology as façade … the laptop and the cellular phone became what Kent cigars and blue jeans had been some years ago. What is the use of the internet if we look at the world from the height of a frog's knee." Bryzgel, *Performance Art in Eastern Europe*, 262.
55 See Georgia Țidorescu, "Virus Diary," *Arta*, September 8, 2020, https://revistaarta.ro/en/virus-diary/, and Dan Perjovschi and Roxana Marcoci, "The Time of the Virus," *MoMA Magazine*, April 1, 2020, www.moma.org/magazine/articles/269 (accessed November 30, 2021). Consistent with his rhetoric, he has documented the project publicly on his Instagram and Facebook accounts. A post to the latter, dated April 18, 2020, may be a dig at the MNAC: a stick figure standing before a tank and pointing to a sketchy pile in the distance declares "Don't militarize the art museum, because it won't go well" (*Nu militarizați muzeul de artă că nu merge bine*).

5 Reflections

If our discussion of the varieties of site specificity through which history is materialized in art and memorial culture led, by one intuitive process of generalization, to geography as a more capacious framework for understanding places and their historical valence, now is the time to turn in the opposite direction and look more closely at the mediation of the geographical site, and the monument or public artwork it supports, which in turn draws attention to it. My previous book, *Performative Monuments*, in contrast to much recent scholarship in performance documentation (which tended to view documentation constructively, as *manufacturing* history or memory), saw reproductive media primarily in a temporal register, extending performance into the future, preserving ephemeral acts, objects, and encounters and confronting them with new audiences, ones often deprived of the original context but bringing to the work contexts of their own.[1] In line with this book's concern with materialization and siting, I here want to look more closely at the *spatial* implications of the transparent screen. Architecture, artworks, and their documentation will allow me to understand mediation in the broadest possible sense: how being viewed, and reproduced, is built into the very means of production of these instances of transparency and the kinds of arguments and experiences they make possible.

Transparency, the screen, and even glass in architecture, have been contested topics in the last decades. For instance, Hal Foster, in his suggestively titled book, *The Art-Architecture Complex* (2013), attacked the combination of old architecture and monumental glass refurbishing as a flattening of architecture into "spectacle."[2] Such conflation of commodity status with glass, which then equals image, is problematic in many respects, not the least of which is its lack of curiosity about the actual mechanisms of mediation and their social and aesthetic effects.[3] I want to affirm, against such a "flattening thesis," that transparency, mediation, and the related image can give rise to interaction as much as a physical object, and be as flexible in its use.

To this end, we must reconsider the aesthetics of transparency, both as they arose in *material* like curtain glass, central to modernist building and

to key moments in modernist pictoriality, and in their implications for what could be known *of* and *through* an artwork—of its content, of its site, of the world around it. We will see that although modernist (and perhaps earlier) ambitions of perfect visibility, fidelity, and authenticity in mediation had to be abandoned or faced a variety of formidable critiques, a cautious, self-critical transparency is still very much alive today, and makes possible a renewed and intense engagement with art-historical realism. Since this is a study of matter and history in contemporary art, the crisis and resurgence of transparency is best explored through its significance to recent practice. Glass, transparency, and the screen function literally but are also apt metaphors for narratives of the apparent fall from reality to appearance, given their well-rehearsed history as a medium of consumption and commodity fetishism. This then leads easily into a critique of reproductive media, new media, with their newest iterations, the social media. Once introduced to the history of this debate, we will be able to see transparency as a versatile set of distinct modes of representation allowing history to resurface: besides possessing historical depth itself, transparency carries with it the ability to draw our attention to spatial interaction within and across it.

Transparent depth

Marcel Duchamp's *The Bride Stripped Bare by Her Bachelors, Even* (*The Large Glass*), 1915–23 [Fig. 5.1], is a strangely conceptual contraption, part painting, part spatial installation, consisting of two glass panes in between which various media were applied or allowed to settle: wire, dust, silvering, paint. Made between 1915 and 1923, and famously cracked during an early transport, the work has attracted much interpretation, from involved iconographic decoding to theories of desire and its frustration, accounts of the man-machine metaphor in avant-garde art at the beginning of the twentieth century, and allusions to the destabilizing of gender relations due to emancipation movements ranging from feminism to the first waves of sexual liberation. Trying to sum up this dissensus and explain it, Rosalind Krauss has described the work's "verism and its mute resistance to interpretation" as a play of eccentric contrasts and attractions.[4] One thing seems certain: there are two rectilinear zones set one atop of the other, separated yet entangled in their spatial illusion, which seems to describe mutual needs, a play between mechanical impulses and chance, woman (above) and man (below), caught in a tension between acting on and holding in desire. Then there is the glass, slicing up the space perpendicular to the viewer's gaze in its permanent installation at the Philadelphia Museum of Art, framed by a low barrier and centered against a window opening to the outside, inviting a response, and framing informal interactions with the audience, as can be seen from the unruly images guests

5.1 Looking through Marcel Duchamp's *Large Glass* at the Philadelphia Museum of Art.

post to social media accounts, in contrast to the pristine monotone background favored by the museum and scholarly publications.

I bring up the *Large Glass* not to propose another reading, but only to note how easily transparency is overlooked even where it is most obviously manifest. To see how transparency can be put to work critically in art and architecture, we cannot forego a brief look at the canonical understanding of transparency in modernism, or, to put it more strongly yet, *as* modernism: or, inversely, modernism as transparency, a radical visibility of aesthetic and social conditions.[5] Many assumptions about reproductive media and how they float across platforms today are, largely unconsciously, resting on a perhaps surprising modernist basis. The *Large Glass* is no manifesto or programmatic statement of modernist transparency, but it is interesting because it puts transparency to work in disorienting fashion.

Despite a good half-century of attempts to connect Duchamp, and his delayed reception, with a postmodern or neo-avant-garde critical distance from modernist concerns, artists have always been closer to the average Pinterest user in their unironic fascination with the work's translucency.[6] Most notably, Hannah Wilke's 1976 performance *Hannah Wilke Through the Large Glass* takes the work both as stage set and a quasi-human opponent—animating it as male counterpart and at the same overpowering it with her "real" body, an alleged authenticity staged for the photograph [Fig. 5.2]: "To strip oneself bare of the veils that society has imposed on humanity is to be the model of one's own ideology. The role model is now both the woman and the artist herself—Hannah Wilke Through the Large Glass."[7] My focus here is less on Wilke's feminist one-upmanship, which she applied also to the work of

Hannah Wilke, performing *Through the Large Glass*, 1978. 5.2

Richard Hamilton and other male modernists, than on the way performance and object in space come together.[8] The oppositions between the built and the animated, felt space and space seen through glass—semi-transparent and visually lucid yet blocking movement—interact, and by implication they do so not just in the performance but also in the artwork the performance engages with. And how, in doing so, they create or rather draw attention to different temporalities, those of the work's making in New York, its continued existence in Philadelphia, and Wilke's momentary intrusion in June 1976.[9] The effect is both one of bringing together and of contrasting, of showing how far apart Duchamp's hieratic notion of female sexuality is from Wilke's kinetic interpretation of both herself and the titular Bride. The distinctive result, one we will see in more detail, is a simultaneous clarification and distancing typical of recent work with (and through) glass. If in previous chapters I discussed the temporal and spatial displacement involved in thinking of site geographically, be it live or recorded, here I turn to the spatial, as well as temporal, displacement made possible by a transparent but impassable barrier ubiquitous in modern life and art—glass as screen. In a trajectory akin to that of Duchamp and his reception, its fluctuating critical fortunes are measured up against the material's renewed use by artists, designers, and theorists for ends not fully congruent either with modernist transparency or postmodern occlusion, but for the critical distance of engaged art practice.[10] What changes in a transparent mediation? Which spatial configurations are put into focus, what historical depth shines through the screen, and how is the audience in turn affected by the possible deceptions and reflections of the medium?

Fracturing modernist visibility

A good place to start, if not a beginning per se, is the classic modernist equation of optical to moral transparency. Walter Benjamin, writing in 1929, declared:

> To live in a glass house is a revolutionary virtue par excellence. It is also an intoxication, a moral exhibitionism, that we badly need. Discretion concerning one's own existence, once an aristocratic virtue, has become more and more an affair of petty-bourgeois parvenus.[11]

I have to wonder if Benjamin is not more perceptive here than his politics, insofar as those politics involve the uncritical acceptance of modernist claims to authenticity. For his approving phrase, "a moral exhibitionism that we badly need," despite its obvious dig at bourgeois hypocrisy, can of course be made to retort on the glass house and its pretensions of honesty—an honesty meant to rub off on the inhabitants who exhibit themselves within it, *as if* unseen but all too self-conscious about their visibility. Benjamin's text also points to another political aspect of glass architecture: even at the beginning of the twentieth century, as can be seen in the expressionist strands of Paul Scheerbart and Bruno Taut's early work, glass carrying with it not just technocratic overtones of perfectibility, but also a mystical ideal of redemption.

Anthony Vidler, in his postmodern defense and historical unearthing of *The Architectural Uncanny*, sums up modernist hopes, both rational and ecstatic, thus: "Transparency, it was thought, would eradicate the domain of myth, suspicion, tyranny, and, above all, the irrational."[12] Against these hopes, Vidler emphasizes the uncanny features of transparency, pointing to glass as a material that physically severs inside from outside, while falling prey to glare and reflections that change with outside conditions, be they diurnal rhythms of night and day, position of the sun and artificial light, or weather patterns. Perhaps most uncanny is the mirroring effect of glass against a dark background, with its sudden estrangements and distortions.[13] Vidler's criticism of the modernist paradigm, Benjamin included, remains pertinent: there is no reason to think that transparency equals enlightenment, though the thought continues to animate postwar building internationally. A dramatic example is the architecture of the constitutional court (*Bundesverfassungsgericht*) in Karlsruhe, Germany, completed in 1969 and consisting of a distributed structure of five pavilions in concrete, steel and glass[14] [Fig. 5.3].

From the point of view of the 1960s Federal Republic of Germany, and through an iconography of humbleness paired with transparency, this project is trying hard to show that in the new Germany laws are made in a democratic, visible manner—in contrast to National Socialist judicial secrecy and absolutism, dressed up with neoclassical pomp.[15] Obviously, glass cannot carry *so* much weight. But Vidler's positive point, as opposed to his well-grounded

The building of the Bundesverfassungsgericht Karlsruhe.

5.3

critique, seems an odd inversion of the modernist faith in the moral effectiveness of materials. Purely physical phenomena of occlusion and obscurity are supposed to perspicuously signal psychic and political problems, and an architecture consciously opaque and transparent at the same time (the point of reference is Rem Koolhaas) is proposed as the right and proper visual expression of the complexity of contemporary social relations.[16] It is almost as if there is an immediacy or *transparency of obscurity* that does just what modernist clarity advertised but failed to achieve: reflecting hidden social and psychic relations in its exterior.

In summing up the implications of glass as it appears to partisans *and* critics of modernist transparency, it is certainly telling that the discussion around architecture and glass is mainly one about behaviors of the participants in events. The nerve of the issue is that visibility implies power, and any asymmetry in how that visibility is distributed—the manorial sweep of the glass villa, the vivarium-like enclosure of Duchamp with its odd captives—implies a power differential, and with it a domain of contestation. Denying or devaluing visibility, as in the proposals connecting glass with the "architectural uncanny," seem less like a solution to this political-aesthetic problem than an admission that it is insoluble. How would this play out in public art? Does the transparent haptic barrier change our notion of presence, being present, and in space? Does it already add an element of showcasing, amplified in new modes of mediation?

Even if the postmodern critique of transparent glass preserves problematic assumptions about the legibility of surfaces, there is more than one way to crack the modernist nut. Consider a glass cube functioning very differently than those by architects Mies van der Rohe or Philip Johnson. Monica Bonvicini's *Don't Miss a Sec'*. [*sic*][17] (2003–4) is a sculpture qua architectural installation containing within it a functioning public toilet, which was installed as part of several exhibitions in Zurich, Cologne, and New York [Fig. 5.4]. Consisting of what is called "two-way" (really one-way) mirror glass panels encasing a metal toilet-and-sink unit, the work allowed visitors inside the public bathroom to look out on the busy street without being seen: passers-by only saw their own reflection. The presumed power of surveillance, allowing the person inside to see without being seen, is balanced if not upset by the discomfort that one sees all this while perched on a toilet, possibly partly disrobed, in the awkward position of irrationally doubting one's own invisibility from the other side. For our very social identity as sentient seeing beings is built to a large extent on the assumption that, if we can see others in an unobstructed fashion, they can see us.[18] Of course this assumption breaks down in most optical technologies, from early modern inventions like telescopes and microscopes to photographic, film, and video surveillance and documentation. But it continues to inhere in the built environment, particularly its light-conductive walls.

The context-dependence of discomfort that attends Bonvicini's work emerges clearly if we compare it to more intimidating scenarios: say, an

5.4 Monica Bonvicini, *Don't Miss a Sec'.*, 2004.

encounter with this kind of mirror glass in a police interrogation room. But while there we would at least suspect we are being watched, the effect of being enclosed on the "seeing" side of the toilet pavilion, with no motive to investigate anyone, leaves one uncertain of invisibility, which ought after all to be assured by the exterior view of the mirror surface experienced before entering. This irrational sense of vulnerability is reinforced by the panoramic effect of the urban architecture as seen from the toilet, as if the chamber had no walls at all, overlaid with one's own faint mirror image as it is cast back to a viewer inside the bathroom. The connection of asymmetrical visibility with power, then, is complicated if not refuted by expectations about the nature of the space from which we are seeing, the freedom of movement it permits, and the kind of observers we are. These themes will prove crucial to recent efforts to reform transparency, as well as to the richness of Bonvicini's deceptively straightforward riff on a modernist commonplace. It can also serve as a metaphor for public art in general, especially the default, and problematic, discourse around public art as inherently "public" and accessible because of its public placement, regardless of the public process (or its absence) which led to that placement, or engagement with different publics.

In a way, Bonvicini's booth is the ultimate Bellevue, but also a high-tech update of the humble pillbox variants on Jeremy Bentham's Panopticon found in clinics and police stations. Complete vision backfires; it disrupts the sense of security linked to such an intimate (though public) place. This feeling of vulnerability for the privileged viewer is of course doubly enforced by the mirrored façade, which, far from offering anonymous shelter, invites passers-by to examine their own reflections and adjust their appearance. The mechanism of visibility and the uncanny here is shown in this work to be less ghostly and irrational than Vidler's paradigm, the fantastic stories of E.T.A. Hoffmann, would lead one to believe. The potential entanglement of private and public inherent in modernist glass architecture is what causes discomfort, more than any dialectic of habitation and abandonment as in Freud's classic analysis of the uncanny, though this of course also emphasized the disorienting use of the utterly familiar ("the homely"), a dynamic here played out fully in the choice of mirror glass.[19] Despite or even because of its banality, Bonvicini's staging of the loss of privacy in public space is ironic and aggressive: her visitors have to "defy their own embarrassment," as she put it, to even enter the installation, much less use it as a public toilet.[20] While the notion of being watched, brought on by being able to watch, is discomfiting for the person inside, it is not at all clear that the object is in any way threatening to pedestrians. The box appears a solid object, not a source of secret looking, and the passers-by reproduced in Bonvicini's catalogues do not seem to suspect that someone is inside, nor to harbor any anxiety about the sleek presence of the box. In a way, the threat to them is only legible to an informed

spectator, especially a latecomer confronting the project documentation: someone who has projected himself or herself into the box. From the outside, it resembles the minimalist sculpture that occupied galleries in the 1960s, inviting visitors to walk around the object and take up an attitude, rather than being able to contemplate its physical presence lucidly and instantaneously without thinking of their own bodies.[21]

That is not to say, however, that this phenomenological reflection on vision and embodiment is *all* Bonvicini's work does, inside or out. "*Don't Miss a Sec.*' is basically a comment on many of Dan Graham's pavilions and on the idea of transparency in modernism—quite cynical," Bonvicini noted shortly after the work's installation, an ironic coupling since Graham is both a sympathetic explorer and a critic of modernist transparency.[22] In the modern-minimalist discourse in which Graham participated while questioning it, the mirrored surface helps its bearer blend into the environment and become less of an obstacle; the supposed impetus to focus on one's own body is largely a product of the neutrality of the object itself.[23] Bonvicini's cube seems ordinary from the outside, in contrast to the simultaneously claustrophobic and exposed effect inside. This makes for an interesting twist on preconceived notions of the public and the private spheres, and how transparency links them: the public sphere becomes the safe zone, while the private is made unsafe by the imagined possibility, however irrational in light of what we know about the object's properties, of an outsider looking in.[24] Implicit knowledge, more than any profound psychic invariant, is responsible for this.

One could, and should, interpret Bonvicini's ironic juxtaposition of Dan Graham and modernism not only in terms of modernist *art*, but of modernist architecture as it entered the urban fabric. For all Graham's subtle critique of suburban modernist modularity, the steel-and-glass pavilions he made over three decades, and which have been a hit on the Biennale circuit, occupy a space closer to event architecture and marketing, for all their author's emphasis on their interaction with spectators seeing themselves through (and mirrored in) them. The trouble lies not so much with Graham's intentions as with the ubiquity of his techniques. Mirrored and plain glass, orthodox in sculpture since the 1960s, is as much a part of the corporate skyline as the curtain wall. The effect of isolating them, of making them conspicuous in the isolation of pavilion-artworks, cannot achieve particularly vivid effects of estrangement, any more than pyramids of iPhones and other contemporary paraphernalia do in the assemblages of Thomas Hirschhorn. And so, apart from a minimalist tradition of objects in space and their interaction with environment and audience, Bonvicini plays on the deceptively placid faces of architecture *and* ostensibly challenging art about architecture. Joan Ockman has analyzed the hegemony of the international style in the postwar United States, under

the rubric of "Normative Architecture," as a historical development from the radical Bauhaus years under Gropius, van der Rohe, and Moholy-Nagy to a triumphant American corporate style that was exported back to Europe. In this transnational transfer, Ockman argues, it became non-political, non-critical, and impersonal, affirming Cold War politics.[25] The glass façade is the major player in this story, representing technological skill and a shift from democratic aspirations to an architecture of domination. Seemingly neutral in its cubic openness, without ornament and without obvious signifiers of hierarchies, this neutrality is a capitalist success story—reflection but no access, while inside, the boss in his corner office can look on the street without looming over it. A gap, social and material, separates this from the ideals of participatory democracy and constitutional access embodied in Karlsruhe. If glass *architecture* can do anything, in Graham or Bonvicini, it does not transparently reflect openness *or* occlusion, but complexly reflects *on* shifts such as this.

Bonvicini has taken up the ideology of the modernist glass façade in another project developed specifically for Zurich. Explicitly citing Gordon Matta-Clark's *Window Blow Out* action of 1976, Bonvicini's *Façade* was intended as an intervention on an existing glass storefront. The glass panels of an office building from the early 1990s were supposed to be replaced by carefully shattered glass panels, evoking both Matta-Clark's action, in which the artist shot into the windows of the Institute of Architecture & Urban Studies (IAUS) in lower Manhattan, and its subject matter, urban poverty and violence, while setting aside his dubious ascription of urban blight to modernist social housing.[26] Bonvicini's shattered glass can be read as an attack on the capitalist monopoly on the glass façade, but also, as she herself says, a return to the "startling crystal" of Bruno Taut with its utopian aspirations, located by early modernism in the apparently harmonious coming together of the natural and the manufactured in crystalline architecture.[27] Here, the sublime effect is achieved by a parallel between nature and industry, but violence is at issue as well, both individual (against property) and structural (against the impoverished). Bonvicini later proposed an alternative version, also for Zurich, in a four-sided glass pavilion that at first sight resembles VALIE EXPORT's *Transparente Raum* (Transparent Cube) in Vienna, an alternative space for women artists enclosed in glass under a rough patch of the Wiener Stadtbahn designed by Otto Wagner[28] [Fig. 5.5]. EXPORT's project, for all its crystalline simplicity, is a loaded proposition indeed, the trumpeted visibility of women's art at odds with the glass house's sense of exposure. However embattled, the contrast with Bonvicini's cube is stark: the latter presents itself as a dystopian place of danger rather than protected visibility, inaccessible, lit at night with bright neon light. Mirroring fears of property devaluation, rioting, and gang violence, Bonvicini's project at the same time elevated the damaged skin of modernism to artistic craft. Or, it would have: the project proved impossible

156 Monumental cares

5.5 VALIE EXPORT, with Sinja Tillner, *Transparent Cube* in Vienna, 1999–2001.

to execute, on technical and logistical grounds; but those would probably not have proven insuperable if not for its pessimistic political implications.

Learning to see through

Is there anything we can conclude from these glass cubes, other than that we should be as suspicious of totalizing narratives about transparency and mirroring as about anything else? That wouldn't be a bad lesson, but I think that, with caution, we can say more. In public space, the functions of glass and mirrors cannot easily be predicted in advance. Depending on lighting and the physical properties of mirroring or transparency, their social effects of stimulating curiosity or discomfiture are highly user- and context-dependent. Functions and expectations intertwine in what we see and what we expect. Ultimately, seeing ourselves projected on buildings and our environment can give us the power to perceive what is behind and around us (including other persons in public space), but also a sense that vision is blocked from us—we cannot see ahead, despite utopian promises to the contrary, modern or otherwise. In any case, given recent interest in the emotional, imaginative, and playful dimensions of the production of knowledge, it seems we cannot rest content with postmodern approaches to glass as obstruction without at the same time giving qualified assent to classic modernist theories of glass as a medium of reflection and at least potential (self-)clarification.[29]

To this end, I want to examine a recent suggestion by Reinhold Martin that, in criticizing the ubiquity of mirrors in corporate architecture, we should not be seduced by a rhetoric of disappearance, mimesis, or dematerialization that comes with the modernist "look into the mirror" but instead "learn first to look *at* the mirror."[30] This formalist attention to the surface rather than, or better said, alongside, what it conveys, recalls philosopher Richard Wollheim's claim that to understand depiction in art, we have to *see* the subject matter *in* the material marks making up the representation, rather than seeing-past it as we do in a *trompe l'œil*.[31] Such attention is consistent with this book's emphasis on the materialization of history *as well as* of mediation. But applied to glass, photography, and site-specific installations, its results might look somewhat different than in Wollheim's engagement with oil painting. Looking at architecture, Martin hopes a bit romantically, will allow us to look "beyond the screen, or really, behind it," escaping the entropy of "postmodernity's self-reflexive feedback loops."[32] Yet in a sense, if we abandon a rhetoric pitting modernism against postmodernism, it will seem that artists have been concerned with this look *at* the mirror, as well as into it, for some time.

We can see this in one of the most prominent artists investigating the mirror effect at the intersection of art and architecture, whom we've already

met in connection with Bonvicini: Dan Graham. His *Alteration to a Suburban House* (1978), a proposal that was never built, models a typical American suburban ranch house [Fig. 5.6]. The façade has been removed and replaced by a glass plate. In the middle of the house, a mirror plane divides the building, reflecting the living room onto the street, while the more private parts of the house (bedrooms, bathrooms) are hidden behind. It is appealing to read this as an indictment of modernism; but it is just as clearly an indictment of American suburban culture, which in its preference for conventional status and pseudo-bucolic comfort at the expense of complex urban experience is in many ways modernism's opposite.

How then to understand transparency in Graham, if it seems to be pitted against the modernist demand for clarity as well as its opposite? The artist had worked with mirrors in many of his canonical performances of the 1970s, perhaps most prominently the action called *Performance, Audience, Mirror* (1975): Graham discussed the actions of the audience members he saw in the mirror, sometimes facing these persons, sometimes facing the mirror that reflected them. The spectators, at least their physical presence within the confines of the performance (sometimes wishfully glossed as their "collaboration") were made part of the piece, and the mirror is a medium that throws doubt on the assurance of pure agency possessed exclusively by the artist,

5.6 Dan Graham, Alteration to a Suburban House, 1978.

or what some avant-gardists regarded as the mythically pure and authentic public.[33] But does it make any difference whether Graham faced his spectators or their reflections, watching him in the mirror? In a context of one-way surveillance, where of two parties facing one another, only one is aware of the other, a mirror makes all the difference. In Graham's case, with the audience following him *and* the mirror in real time, this power differential is not so pronounced. If anything, it is embodied in the fact that he carried out a monologue while the audience sat politely as they do in any theater audience, not in the ontological difference between a "live" and a mirrored audience, even if Graham's intent at the time might have been to "reflect" on the formal difference between the two. Nevertheless, concretely, he addressed the *same* audience in both cases.

As a revisionist and inheritor of modernist conceptions of the artist and material, Graham can afford to be subtle in his use of the mirror. For a feminist endeavor attuned to power differentials in seeing *and* acting, the aspects of the mirror which most interests Graham—its parity, symmetry, and potential for identity between viewer and viewed—are particularly interesting, but not to be taken for granted in their perceptual *or* social effects. Consider Adrian Piper's *Food for the Spirit*, in which she photographed herself in a mirror while fasting, reportedly in response to Kant's *Critique of Pure Reason*, an investigation of the limits of the human mind and its access to the world[34] [Fig. 5.7]. It is implicit in Piper's feminist, philosophically inclined performance that the image of herself nude, photographed in the mirror is not a product of narcissistic or commercial

Adrian Piper, *Food for the Spirit*, 1971. 14 silver gelatin prints (photographic reprints 1997). 14.95 × 14.56 in. (37.7 × 37 cm). Collection of the Museum of Modern Art, New York. © Adrian Piper Research Archive Foundation Berlin.

5.7

exploitation. Instead, the performer's gaze, the mirror's reflection, and the camera's inscription of the self-encounter are allowed to align in one gesture, becoming closely parallel if not identical elements in the work. The effect is not unlike applying to the artist's self (prefiguring the selfie) the triangulation of identity of Dan Graham's audience in the mirror and in the video. Such alignment within the specificity of several transparent mediums can also be seen by comparing Piper's work to a performance for the camera like Ana Medieta's 1972 *Untitled (Glass on Body Imprints)* [Fig. 5.8], which used the artist's body, photographed against transparent plexiglass, to emphasize both the staged character of the resulting photo and the uncannily physical and conceptual distortion of Mendieta's body in its contact with the glass.

Made during Mendieta's study at the University of Iowa, the work seems the opposite of Piper's intense monochrome self-contemplation: the color film, combined with the pressing of lips and nostrils, makes for an efficient

5.8 Ana Mendieta, *Untitled (Glass on Body Imprints)*, 1972.

allegory of how others (white Midwesterners?) saw the artist in racialized terms.[35] Deformation and the breakthrough to visibility achieved through resistant materials would be at the center of Mendieta's well-known *Silueta* series, already in the 1976 *Silueta Works in Iowa*. But if in those works the body in (something recognizable as) nature was the site of transformation, with the photographic documentation serving as the self-effacing vehicle for its preservation and dissemination, in the *Glass on Body Imprints*, the relation of photography, body, and transparent object is more self-conscious. We see Mendieta through a flattening filter that is at once self and other, glass pane and photographic record, the self in contact with, and distinct from or even constrained by the outside world, the plexiglass and the lens creating the distortion while making visible the body and allowing representation at the same time. These aligned transparencies, like those in Piper's work, also connect to history, both the then- (and now-) contemporary social texture of racism, and its lineage in the history of slavery in the Americas. That is a lot to accomplish with little more than bodies, transparent planes, and recording devices, but that just emphasizes how historically dense such materials and technologies are in the hands of reflective artists.

Does the mirror make a crucial difference to this turning around of perception? Some questions would need further exploration: how does one's bedroom mirror differ from the glass wall that reflects one on the street, transparent or opaque? How do reflection and transparency challenge our sense of self and perception, and, in public space, engage us in a game of confusing reflections that suggest control, framing, but also the blending into our environment, including the supra-vision of the world behind us? In what sense is gender an issue in this exchange, and which historical conditions of the environment are being sharpened by the screen, which are diffused? If this sounds like the fallacy of too many questions, we can recall the barrage to which Jacques Derrida subjected his friend, the architect Peter Eisenman:

> What terms do we use to speak about glass? Technical and material terms? Economic terms? The terms of urbanism? The terms of social relations? The terms of transparency and immediacy, of love or of police, of the border that is perhaps erased between the public and the private, etc.?[36]

There are, indeed, what he terms "calls for desire" in the glass and mirror works of Piper and Mendieta, but as much as we will react as individual subjects, shaped by our own experiences, the results will not be more easily anticipated by capitalists and technocrats than by artists, architects, and theorists. What opens before us in these works, and in the renewed discourse around transparency and reflection, is the possibility of seeing screens and transparent surfaces as well as seeing through them to conditions and spaces they make visible, modify, or occlude.

Realism and the lens

What have we learned about the use of glass, transparent or mirroring, from Graham, Piper, Mendieta, and Bonvicini? Negatively, we have seen just how questionable any rigid opposition between modernist transparency and postmodern occlusion is. With it, the opposition also collapses between an allegedly naive and therefore problematic translucency and an allegedly disorienting and therefore sophisticated fragmenting of visibility. All of these artworks, whether the glass in them is translucent, reflective, or both (as in Bonvicini), use it to explore social conditions of seeing rather than to glory in pure effects of phantasmagoric obscurity such as Jeff Wall thought obtain in glass houses at night.[37] Recalling also our opening discussion of Hannah Wilke's use of Duchamp, we can add delay and detachment to the mix: as much as all of these works invite seeing and clarity of conceptualization, they uncouple it from fantasies of immediate and total possession of the object of sight. Borrowing and adapting Wollheim's term, we could call the kind of looking these artists invite a *seeing-through* the medium of glass, and again through glass or other transparent-lens-assisted photographic reproduction, rather than the formalist *seeing-in* that allows us to regard an artwork's subject as built up from meaningless marks on a material support.

Of course, the repurposing of theoretical terms has to be done with care, lest it recoil on the would-be adapter: and in this case, we cannot forget that Wollheim and his followers regard an attitude of seeing-past the surface to the subject as unreflective pictorial behavior, whereas the *seeing-in* not only allows us to understand how these pictures come to be, but can be used to explain pictorial representation without relying in any way on the concept of representation.[38] Whether he is right about this or not, my notion of seeing-through does not stand opposed to the phenomenon of duality or twofoldness he, like Martin, identifies, of an artwork having its own physical properties while representing others. The whole point of seeing through is that in artworks that make crucial use of glass, mirroring, or translucent layers, an awareness of the material and its properties coexists with and in fact makes possible rather than undermining or drawing attention from the subject matter seen through that material.[39]

How does seeing-through help us do more than sum up a tendency in art to use glass and mirroring to investigate persons and their relations in public and private space? Its explanatory value emerges clearly when we return to our insight that glass offers more than capitalist reification or moral candor: in order to see what it does in a particular building or artwork, it must be considered in relation to its environment and not, as theorists on both sides of the modern–postmodern debate so often did, an autonomous aesthetic material.[40] The crucial mediating quality of glass, its tendency to transmit

light *and* make visible objects on the other side of itself, is after all why humans have valued it and worked so hard to manufacture it for thousands of years.[41] Its formal qualities lend themselves to different perceptual and social uses. Wollheim speaks of a human capacity to perceive the representational content and also to "abstract" from it—he calls doing so perception as opposed to simple vision. In this spirit, we can look both at what is behind the glass, the visible space, so to speak, and perceive its interposition—to put glass in relation to our own perception.

Does seeing-through have an explicitly architectural dimension? Over the past decade, I thought so, particularly in connection with my investigation of how history is mediated in building alterations—not so much in Graham's unexecuted intervention in a consciously ahistorical suburban idiom, but in high-stakes renovations of politically and historically loaded buildings, like the transformation of a British colonial courthouse and government center into the National Gallery Singapore.[42] The claims made on behalf of this project—and many other contemporary modifications to historically loaded buildings, particularly controversial ones—range from exorcism to decolonization, and of course draw as much on the function and goings-on inside the building as on any programmatic aspect of the glass façade or enclosure. There is also something experiential about *seeing* the neoclassical columns of the House of the People through the modernist glass—as there is in experiencing the cupola of Singapore's once-British courthouse through glass and branching tree-like metal struts—that seems to both challenge and frame the past in unexpected and potentially critical ways. We can experience and even *capture* experiences of seeing-through in such venues photographically, but of course architecture is never just those experiences or resulting images, and the enclosure is as likely to give rise to triumphalist narratives of overcoming and containing problematic history—especially in the mouths of the authorities who commissioned the projects—as it is to critical encounters with people and objects in space. If no formalist or material-centered "essence" of critical transparency could help architecture to a new avant-garde style, as the glass cube did in high modernism and occlusion in postmodernism, what can we say about the specific configurations that allow seeing-through to function critically in art and design?

I began this chapter by taking glass as both conduit and obstruction, allowing visual permeability but also delay across space *and* time, and along the way we considered the obscuring and revealing uses of reflections, as well as the extension of transparency and mirroring in photographic media.[43] Recalling the analogy between glass and the plane of the photograph, an analogy anticipated by our earlier discussions of history, site-specificity, and social media, and to be explored in more concrete detail in the final chapter, I suggest that these acts of seeing-through function in an aesthetically realist register.

Since the middle of the nineteenth century, technical innovations in imaging and construction have linked aesthetic and ethical claims for transparency: as Émile Zola put it in 1864, in a letter outlining the realist program, the artist sought to construct not so much a particular representation as a tool of representation, what he called *l'écran réaliste*. "The realist screen" was to be a medium between artist and world described as "window glass, very thin, very clear," so clear that it "negates its own existence" and threatens to disappear altogether.[44]

The long-held modernist ideal of a fully self-effacing transparency no longer appeals to designers or visual artists: but there is no reason to throw out with it the hard-won and patiently wrought strategies of aesthetic and social investigation and distanced reflection that continue to define realist art in the present. That art, as we had occasion to see, returns again and again to modernism as to a painful tooth, not to refute it as much as in troubled fascination with its ideal of transparency. Here is a spectacular recent one: in a 22-minute film, composed as a multilayered collage of 800 black and white photographs in the manner of Chris Marker, Catherine Opie has presented an allegory of modernist dreams gone sour and of her own photographic practice. *The Modernist* (first shown 2018 at Regen Projects in Los Angeles, and closing as I write in late August 2020 at the Plug In ICA in Winnipeg), the film takes its title from the widespread, non–art-world habit of referring to modernist houses, especially in Southern California where they are relatively rare and sought-after status symbols, simply as "modernists" [Fig. 5.9]. In this parlance, it is not artists or architects who are modernists, but the accretions of glass and concrete they leave behind—in Los Angeles, mostly as playgrounds for the very rich, but in this case also as set for films such as the Coen brothers *Big Lebowski* (1998; the house is owned by porn producer Jackie Treehorn, played by Ben Gazzara).[45] The unnamed hero of the film, played by Opie's long-time model-collaborator Pig Pen, pins up pictures of modernists and brush fires, until the urge takes them to the very sites of their dreams: we see them, long-haired and nervy, strolling about the concrete ramparts of the Chemosphere, designed by John Lautner in 1960, reflected in the glass walls and swimming pool, pouring something from a canister—we can only guess it's petrol, until a lit match, the sole sound in the film, sets it alight.[46]

Commentators have rightly stressed the wistful longing behind Pig Pen's act of destruction—or is it imaginative defiance, if, as Plug In curator Jenifer Papararo suggests, "the film's oneiric quality forces the viewer to question whether what transpires is an act of destruction or a dream"? Be that as it may, the laconic style reminiscent of Marker's science-fiction film *La Jetée* (1962), which like Opie's is composed of a montage of projected still images, relies, and asks us to rely, on the implicit trust we place in documentary

Reflections **165**

Catherine Opie, *Sheats-Goldstein #3 (The Modernist)*, 2016. **5.9**

5.10 Ai Weiwei, *CoroNation*, 2020. Film, 1 hour 53 minutes.

monochrome photography, not only in what it shows but in what we assume happens between its storyboard-like frames. The modernists look photogenic indeed in this pellucid, evenly toned art photography, devoid of people as they are in the architecture magazines, with the exception of the canister-carrying intruder of course. The modernist here is as much the one directing the conflagration as that undergoing this trial by fire: and what we are shown, and learn, about wealth and misery in Los Angeles, is in some sense right there in the frames, as transparent as the inaccessible interiors Opie was allowed to draft into service in this twenty-first century Benjaminian morality play.[47]

Opie's work has the potential for seeing through modernism, self-consciously and realistically. More radical in its use of media is Ai Weiwei's even more recent feature documentary on the outbreak of the COVID-19 pandemic in Wuhan Province, titled, with his usual breathtaking tasteless wit, *CoroNation* [Fig. 5.10]. The 2020 film looks like contemporary agitprop, and no doubt political and journalistic motives coexist if they don't in fact subordinate aesthetic strategies in its making and final form. But there is an aesthetic in its ramshackle, crowdsourced rhetorical excess. Its seamless integration of drone and smartphone footage, unencumbered by voiceover narration but building up to an allegory of cynicism and despair, corruption and resilience as premeditated as any disaster epic, embraces the possibilities for political art in the most uncooperative domains, powered by cheap recording technology and the author's considerable network of influence. *CoroNation*, downloadable for a fee in the manner of other streaming pandemic entertainment, is starkly opposed in its means of distribution to Opie's art film, accessible in full only to those able to visit one of its gallery iterations. These two works have little in common, but that little is aptly named realism, understood as a material-historical set of strategies and uses of material and media, privileging their transparency to reflect on the world they are trained on as much as on the films' own acts of documenting that world. Their clarity is a hallmark of a realism more interested in helping us see than in convincing us that what we see through the glass lens is reality pure and simple.

Notes

1 See Widrich, *Performative Monuments*, chapter 1, and see the scholarship discussed in note 1 (40–1), which adopts a more fictionalist attitude toward performance documentation, esp. the work of Philip Auslander.
2 Hal Foster, "Crystal Palaces," in *The Art-Architecture Complex* (London: Verso, 2013), 34–51. See also Gevork Hartoonian, *Architecture and Spectacle: A Critique* (Farnham, UK: Ashgate, 2012), which accuses Bernard Tschumi of "turn[ing] the glass facade into a theatrical stage-set" (99).

3 The conflation is famously made in Guy Debord's thirty-fourth aphorism in the 1967 *Society of the Spectacle* [1967]: "The spectacle is *capital* accumulated to the point where it becomes image" (New York: Zone Books, 1994), 24; emphasis in original.
4 Rosalind Krauss, "1918" [2004], in Hal Foster, Rosalind Krauss, Yve-Alain Bois, and Benjamin Buchloh, *Art Since 1900*, 3rd ed. (London: Thames & Hudson, 2016), 172. It is worth noting that Krauss discusses the *Large Glass* "as a photograph," and that its "verism and mute resistance" are supposed to be "a feature of photography."
5 Which is not to prejudge either Duchamp's modernism (in *The Large Glass* anyway), or modernism's relation to transparency: we can take it for granted that this was complex, and at times contentious.
6 See my reading of the 1987 collaboration between Susan Mosakowski and architects Diller + Scofidio, called *The Rotary Notary and His Hot Plate: Delay in* Glass, commissioned by the Philadelphia Museum of Art in Mechtild Widrich, "The Ultimate Erotic Act: On The Performative in Architecture," in *Participation in Art and Architecture*, ed. Martino Stierli and Mechtild Widrich (London: Tauris, 2015), 260–80. The best known "anti-transparent" (though not anti-modernist) reading of vision as libidinal in the *Large Glass* is that of Rosalind Krauss in *The Optical Unconscious* (Cambridge, MA: MIT Press, 1993), 119–25, drawing on the work of Molly Nesbit. See *Their Common Sense* (London: Black Dog, 2000), 180–200 and the more approachable essay predating it and informing Krauss's reading, Molly Nesbit, "Ready-Made Originals," *October* 37 (Summer 1986), 53–64, which presents Duchamp's work as a desperate mimesis of and effort to evade the commodity fetishism of *goods on display in transparent glass vitrines*.
7 Hannah Wilke, "I OBJECT," quoted from Alfred M. Fischer, "Becoming Form and Remaining Human," in *Hannah Wilke: A Retrospective*, ed. Elisabeth Delin Hansen, Kirsten Dybbøl, and Donald Goddard, exh. cat. Nikolaj, Copenhagen Contemporary Art Center, Umeå Konstmuseum, Helsinki City Art Museum (Copenhagen: Bonde's & Dyva, 1998), 48. The text goes on, its clauses separated by dashes.
8 Gratitude goes to Amelia Jones for her work to counteract the negative reactions against Wilke's work as narcissist posing. See Amelia Jones, *Body Art / Performing the Subject*, 1998, in which Jones theorizes a radical, feminist form of narcissism and discusses Wilke's strategic "rhetoric of the pose" (173). Jones has some other interesting articles on Wilke, e.g. "Intra-Venus: Hannah Wilke's and Feminist Narcissism," in *Intra Venus*, exh cat., Ronald Feldman Fine Arts, New York, 1995. See also Amelia Jones, "Meaning, Identity, Embodiment: The Uses of Merleau-Ponty's Phenomenology in Art History," *Art and Thought*, ed. Dana Arnold and Margaret Iversen (Oxford: Blackwell, 2003), 72–90.
9 June 15, 1976: Wilke's performance was part of Austrian director Hans-Christof Stenzel's 84-minute film *Befragung der Freiheitsstatue C'est La Vie Rose* [Interrogation of the Statue of Liberty etc.], a kind of American bicentennial travelogue narrated by Duchamp's alter ego Rrose Sélavy. Wilke shared that film's cameraman, Lothar E. Stickelbrucks and editor, Rosemarie Stenzel-Quast. See the

Electronic Arts Intermix entry: www.eai.org/titles/hannah-wilke-through-the-large-glass (accessed September 1, 2020).

10 Nor, for that matter, with modernist occlusion or postmodern transparency. The history of modern anxieties about clarity and occlusion, at least as old as Rousseau's obsession with those motifs, the subject of Jean Starobinski's classic *Transparency and Obstruction* [1958], trans. Arthur Goldhammer (Chicago: University of Chicago Press, 1988); see also Elizabeth Carlson, "City of Mirrors: Reflection and Visual Construction in 19th Century Paris" (PhD dissertation, University of Minnesota, 2006), which argues in Benjaminian fashion for a multiplicity of disorienting optical identities.

11 Walter Benjamin, "Surrealism: The Last Snapshot of the European Intelligentsia," in *Selected Writings, 1927–1930* (vol. 2, Pt. 1), ed. Michael W. Jennings, Howard Eiland, and Gary Smith (Cambridge, MA: Harvard University Press, 1999), 209. The context is a passage of rather extravagant praise of André Breton's 1928 novel *Nadja*. Cf. Anthony Vidler, "Transparency," in *The Architectural Uncanny: Essays in the Modern Unhomely* (Cambridge, MA: MIT Press, 1992), 218.

12 Vidler, "Transparency," 168. On the long tradition of poetic and philosophical reflection on glass and visibility, see Charles Lock, "Glass Glimpsed: In, On, Through and Beyond," in *Invisibility Studies: Surveillance, Transparency and the Hidden in Contemporary Culture*, eds. Henriette Steiner and Kristin Veel (Oxford: Peter Lang, 2015), 5–24.

13 Vidler, "Transparency," 216–25.

14 See the detailed "Bundesverfassungsgericht in Karlsruhe," *Bauwelt*, vol. 48 (1969), 1714–22. See also Martino Stierli, *Montage and the Metropolis: Architecture, Modernity, and the Representation of Space* (New Haven: Yale University Press, 2018).

15 Theodor Adorno's offhand remark in his *Aesthetic Theory* [1970], trans. Robert Hullot-Kentor (London: Bloomsbury, 2013) that "The more torture went on in the basement, the more insistently they made sure that the roof rested on columns" (68), if not accurate art-historically, certainly reflects the postwar attitude toward fascist architecture that gave rise to the Karlsruhe *Bundesverfassungsgericht*.

16 This may stem from Colin Rowe and Robert Slotzky, who argue for a ("phenomenal") transparency favouring overlap and complexity over modernist ("literal") transparency, in their classic "Transparency: Literal and Phenomenal," first published in *Perspecta*, vol. 8 (1963), 45–54.

17 The *sic* is there to mark that the apostrophe and period are in fact part of the work's title: the work is almost as uncomfortable to write about by name as it is to enter in person, though here the discomfort might be unintended.

18 Recent experimental results that tend to show we recognize other persons before we recognize ourselves in mirrors: see Philippe Rochat and Tricia Striano, "Who's in the Mirror? Self-Other Discrimination in Specular Images by Four- and Nine-Month-Old Infants," *Child Development*, vol. 73, no. 1 (January–February 2002), 35–46. German philosophy has made much of relations of recognition, on the same intuitive basis: see, for example, Edmund Husserl, *Cartesian Meditations* [1929], trans. Dorion Cairns (The Hague: Martinus Nijhoff, 1960), chapter 5, on the simultaneous constitution of ego, alter ego, and objective world.

19 Cf. Richard Sennett's diagnosis of 'isolation in the midst of visibility' amid modernist glass in *The Fall of Public Man* (Cambridge, UK: Cambridge University Press, 1977), 13. But the real rub in Bonvicini is the lack of isolation.
20 Monica Bonvicini interviewed on *BBC World News*, online version, December 3, 2003, http://news.bbc.co.uk/2/hi/entertainment/3257370.stm (accessed April 11, 2014).
21 That is to say, the installation is theatrical in the sense spelled out in Michael Fried, "Art and Objecthood" [1967], in *Essays and Reviews* (Chicago: University of Chicago Press, 1998), 148–72.
22 Massimiliano Gioni and Monica Bonvicini, 'Destroy She Says', *Flash Art*, no. 257 (April 2007), www.flashartonline.com/interno.php?pagina=articolo_det&id_art=32&det=ok&title=MONICA-BONVICINI (accessed April 11, 2014). A 2003 interview yields a wonderful aphorism on the gendered quality of architecture: "I don't think that having men pissing and sweating on construction sites makes them automatically gendered spaces." Angela Rosenberg, "Monica Bonvicini," *Make* (London), no. 92 (2002), 44. Of course, in *Don't Miss a Sec'.*, people of all genders can piss.
23 A good starting point for thinking through Graham's work from an architectural standpoint is Beatriz Colomina, "Double Exposure: Alteration to a Suburban House" [2001], in *Dan Graham*, ed. Alex Kitnick (Cambridge, MA: MIT Press/October Files, 2011), 163–71. Art-historically, Graham, for all his prominence, has not benefited from close monographic study: but see the essays collected in the October Files volume dedicated to him: *Dan Graham*, ed. Benjamin Buchloh (Cambridge, MA: MIT Press, 2011), which includes Colomina's text, and Jeff Wall's eccentric "Dan Graham's *Kammerspiel*."
24 This is not unusual in the history of uncanniness, which as Freud emphasized in German is called the "unhomely" (*unheimlich*), and is conceptually connected also with the "homely" (*heimlich*, which also means secret). See Vidler, "Transparency," 21–7, and for an original account of an interior, meant to be a safe redoubt, coming to be haunted by a mysterious sound, Olga Touloumi, "The 'Uncanny' in Franz Kafka's text *Der Bau*," in *Thresholds*, no. 30: Microcosms, ed. Mechtild Widrich (Summer 2005), 38–41.
25 Joan Ockman, "Toward a Theory of Normative Architecture," in *Architecture of the Everyday*, ed. Steven Harris and Deborah Berke (Princeton: Princeton Architectural Press, 1998), 122–52. See also Reinhold Martin, *The Organizational Complex: Architecture, Media, and Corporate Space* (Cambridge, MA: MIT Press, 2003). Of course, Graham would likely assent to these historical arguments.
26 See Pamela M. Lee, *Object to be Destroyed: The Work of Gordon Matta-Clark* (2001), 116–18. The context was loaded: by breaking the Institute's windows and papering over the boarded-up frames with photographs of broken windows in the Bronx, Matta-Clark allegedly diagnosed the failure modernist urban renewal; the reaction against his act was equally histrionic, with AIUS director Peter Eisenman comparing it to *Kristallnacht*. (Ironically, Eisenman, who was critical of the modernist transparency rhetoric of his teacher Colin Rowe, was succeeded as AIUS director in 1983 by Anthony Vidler). Lee plausibly brushes off such accusations

in favor of a reading of the *Blow Out* as "about" violence; but it is hard to escape the sense that Matta-Clark naively attributes violence to modernist architecture, ignoring many factors at play in impoverished urban environments. For a more realistic appraisal, see Ben Austen, *High-Risers: Cabrini-Green and the Fate of American Public Housing* (New York: Harper, 2018).

27 Monica Bonvicini, "Projekt für Zürich," project paper for Kunst Öffentlichkeit Zürich, 2005. I would like to thank Christoph Schenker, head of the Art Public Zurich projects, for discussing the piece with me.

28 For more on this project, see Widrich, *Performative Monuments*, 85–8, and Mechtild Widrich, "'I'll Be Your Mirror: Transparency, Voyeurism, and Glass Architecture," *Invisibility Studies*, 43–59.

29 Cf. Bruno, *Surface*, 174–6. To be fair, Vidler also sees a critical use of glass, neither modernist nor postmodern, in Koolhaas's proposal for the Paris National Library (BNF), wherein "the architect allows us neither to stop at the surface nor to penetrate it, arresting us in a state of anxiety" (223). This "swerve from the self to the social" still seems to me problematically to posit a master architect dictating psychic states of axiety to a passive spectator.

30 Reinhold Martin, *Utopia's Ghost: Architecture and Postmodernism, Again* (Minneapolis: University of Minnesota Press, 2010), 114. Revising the equation of mirrors and capitalist spectacle in David Harvey and Frederic Jameson, Martin also defines the mirror as "a feedback loop" (106), a very Grahamian metaphor.

31 Richard Wollheim, *Art and Its Objects: An Introduction to Aesthetics* (New York: Harper & Row, 1968), and the late restatement of his thesis, "In Defense of Seeing-In," in *Looking into Pictures: An Interdisciplinary Approach to Pictorial Space*, ed. Heiko Hecht, Robert Schwartz, and Margaret Atherton (Cambridge, MA: MIT Press, 2003), 3–15. There, Wollheim goes so far as refusing to call *trompe l'œil* works representational pictures, "for they do not call for awareness of the marked surface" (5).

32 Martin, *Utopia's Ghost*, 114.

33 Compare the way the audience theories of Brecht and Artaud are evaluated in Herbert Blau, *The Audience* (Baltimore: Johns Hopkins University Press, 1990) and in Jacques Rancière, *The Emancipated Spectator*, trans. Gregory Elliott (London: Verso, 2009), 1–23. Rancière's success in the art world might be connected with the kinship of his defense of critical contemplation to art like Graham's, as opposed to more activist models of audience.

34 On the performance, its documents, and afterlives, see John P. Bowles, *Adrian Piper: Race, Gender, and Embodiment* (Durham: Duke University Press, 2011), chapter 5. It is typical to take Piper's claims of the performance's philosophical origins at face value. For example, Cherise Smith, *Enacting Others: Politics of Identity in Eleanor Antin, Nikki S. Lee, Adrian Piper and Anna Deavere Smith* (Durham: Duke University Press, 2011), 44: 'As a result of spending the summer "doing nothing else but studying and writing a paper on [Immanuel Kant's *Critique of Pure Reason*], doing yoga, and fasting," Piper recalls feeling as though she was "on the verge of abdicating [her] individual self" and of "losing [her] sense of self completely." Bowles (289, note 9) notes that she took a seminar on Kant's *Critique*

at CUNY in spring 1971, and first began studying it in 1969: what matters for our purpose is not the state of mind of the woman photographing herself, but the conceptual narrative under which Piper chose to frame the encounter.

35 Jane Blocker, *Where is Ana Mendieta: Identity, Performativity, and Exile* (Durham: Duke University Press, 1999), 10–12, plausibly compares the *Body on Glass* series with conceptual work like Bruce Nauman's *Pulling Mouth*, since both involve "simple experiment[s] … of limited duration using the human body," but finds that they differ in the "sexed signification of the body," male and self-sufficiently enclosed in Nauman, open and questioning "the ideology of gender" in Mendieta (12). The body's raced characteristics are not discussed, nor in Mendieta's MA thesis project, *Facial Hair Transplant*, where she photographed herself with a beard of curly black hair taken from her (Jewish) friend Morty Sklar. On Sklar, an experimental poet who died in 2019, see the autobiographical notes in *The Ultimate Actualist Convention*, ed. Morty Sklar, Cinda Kornblum, and Dave Morice (New York: The Spirit That Moves Us Press, 2017), 125–31. Sklar recalls that Mendieta, once bearded, "went to Donnelly's Pub [in Iowa City] where she sat at the bar dressed in black pants, vest and sombrero, looking just like a vaquero" (131). The identity performance, perhaps particularly provocative in rural Iowa in the late 1970s, is another point of contact with Piper.

36 Jacques Derrida, "A letter to Peter Eisenman," trans. Hilary P. Hanel, *Assemblage*, no. 12 (August 1990), 6–13, this quote 9. Derrida immediately goes on to quote *another* Benjamin essay, "Erfahrung und Armut" (Experience and Poverty) to the effect that Loos and Corbusier, following Scheerbart, make glass houses because they value their citizens (an observation not demonstrating great grasp of Adolf Loos's thought), and that "things made of glass have no 'aura'. In general, glass is the enemy of secrecy" (9).

37 The photographer Jeff Wall, noted for his choreographed, richly polychrome photographs—many benefiting from a nearly cinematic rhetoric of transparency, reinforced by being displayed in backlit light boxes—attempted just such a non-utopian updating of modernist transparency in an essay departing from Graham's *Alteration*. Wall famously turned to two postwar climaxes of the heroic domesticity that interested Benjamin. Philip Johnson's 1947 Glass House (New Canaan, Connecticut) and Mies van der Rohe's 1945–50 Farnsworth House (Plano, Illinois) are sites of "excessive openness," whose optic "control of nature" forbids the introduction of mirrors. There are no mirrors in these houses apart from the bathrooms, according to Wall, because their relays and multiplications would disturb and render cacophonous the play of reflection and opacity of the glass façades. Jeff Wall, "Dan Graham's Kammerspiel," [1985] in *Real Life Magazine: Selected Writings and Projects, 1979–1994*, ed. Miriam Katzeff, Thomas Lawson, and Susan Morgan (New York: Primary Information, 2006), 194–217; cf. Colomina, "Double Exposure." Interestingly, Wall's approach has become canonical for architects; see the meditations on glass and photographs in Jacques Herzog and Pierre de Meuron, *Treacherous Transparencies: Thoughts and Observations Triggered by a Visit to Farnsworth House* (Barcelona: Actar, 2016). Phyllis Lambert and Sylvia Lavin, *Modern Views: Inspired by the Farnsworth*

House and the Philip Johnson Glass House (New York: Assouline, 2010), collect over ninety responses to the houses by writers and designers, with quite a few Wallish echoes.

38 Wollheim, "In Defense of Seeing-In," 5. Wollheim's critics naturally dispute his claim to have sidestepped issues of representation, recognition, or depiction through an account of seeing-in, however psychologically accurate.

39 There is an affinity here with "transparency" theories of photography such as that of Kendall Walton, "Transparent Pictures: On the Nature of Photographic Realism," *Critical Inquiry*, vol. 11, no. 2 (December 1984), 246–77, again, if transparency is not understood as direct access to truth, but as a transitive relation.

40 I cannot reiterate these lengthy debates here, from Colin Rowe and Robert Slutzky's formalist "Transparency: Literal and Phenomenal," *Perspecta 8* (1963), 45–54, to the metaphor of transparency in political life and the rise of "lifecasting" on social media, on which see the fascinating article by Vincent Kaufmann, "Transparency and Subjectivity: Remembering Jennifer Ringley," in *Transparency, Society, and Subjectivity* (Cham: Palgrave Macmillan, 2018), 307–22. On architecture, Vidler and Martin together make for a balanced overall reading.

41 See the fascinating volume by Julian Henderson, *Ancient Glass: An Interdisciplinary Exploration* (Cambridge, UK: Cambridge University Press, 2013). In art history, see Sarah Dillon, *Seeing Renaissance Glass: Art, Optics, and Glass of Early Modern Italy, 1250–1425* (Berlin: Peter Lang, 2018); contemporary art has approached glass mainly curatorially, as in *Transparencies: Contemporary Art and a History of Glass*, ed. Laura Burkhalter (Des Moines: Des Moines Art Center, 2013).

42 On Singapore, see Mechtild Widrich, "The Naked Museum: Art, Urbanism, and Global Positioning in Singapore," *Art Journal*, vol. 75, no. 2 (Summer 2016), 46–65.

43 We can add video, discussed in Chapter 4 in connection with reperforming and recording: with or without closed-circuit or live interaction between performer and camera, video too can serve as a window or mirror, as we so often use the user-facing cameras on our phones today. For some meditations on how this works, compare Anne Wagner, "Performance, Video, and the Rhetoric of Presence," *October*, no. 91 (Winter 2000), 59–80 and Mechtild Widrich, "Stars and Dilettantes: On the Voice in Video Art," in *Sounding the Subject*, exh. cat. MIT List Visual Arts Center (Cambridge, MA: MIT List Visual Arts Center, 2007), 24–32.

44 Interestingly, the context is a contrast with "l'écran romantique," described as a "powerfully refracting prism that breaks any ray of light and decomposes into a dazzling solar spectrum". Émile Zola, Letter to Antony Valabrègue, Paris, 18 August 1864, in *Correspondance*, ed. B.H. Bakker and Colette Becker, vol. 1 (Montréal and Paris: Les Presses de l'Université de Montréal and Éditions du Centre National de la Recherche Scientifique, 1978), 379.

45 The *Los Angeles Times* review, by Sharon Mizota ("Lautner fans, be warned: Catherine Opie's 'The Modernist' will play like a horror movie," 22 January 2018, www.latimes.com/entertainment/arts/la-et-cm-catherine-opie-review-20180122 2-htmlstory.html (accessed September 8, 2020), playfully warns this constituency in the very title, while pontificating about how "in creating our perfect 'Mad Men' interiors we buy into a nostalgia that comes with racist, sexist, homophobic and

xenophobic baggage." In the Plug In ICA exhibition essay, Jenifer Papararo goes so far as to name notable owners of LA modernists, including Larry Gagosian and Jennifer Aniston: https://plugin.org/wp-content/uploads/2020/08/Opie-Exhibition-Essay.pdf (accessed September 8, 2020).

46 It is tricky to find allusions in the actual film, but suggestive to think Opie may have also had in mind the house's checkered history of violence: its second owner, a Dr. Richard F. Kuhn, was murdered by his 20-year-old lover and an accomplice, apparently for motives of robbery. See William Farr, "Youth Convicted of Slaying and Robbing Doctor," *Los Angeles Times*, 14 January 1977, 51.

47 I mean the "glass house" Benjamin of "Surrealism," which we have seen in this chapter to be so influential in recent transparency theory. But the Benjamin of *Der Ursprung des deutschen Trauerspiels* [1927], trans. John Osborne as *The Origins of German Tragic Drama* (London: NLB, 1977), is also apposite, if we take Opie's mode of animating still photography as related to the fragmentariness Benjamin finds in baroque allegory.

Drawing pain: political art in circulation 6

In Chapter 5 I showed that procedures of focus, clarification, and seeing through for which the metaphor of transparency seemed apt can do new critical work. The connection of transparency—and the historically deeper and even more contentious aesthetics of realism—with site specificity and materialization, though, comes with challenges of its own, not least the reasonable worry that, like other high modernist aesthetic strategies, it enables anonymity and deterritorialization more than a fine-grained attention to sites and their history. Such objections can only be answered by careful attention to detail. In turn, the phenomena discussed in this book gain in sharpness by being seen together, in a broadly comparative and theoretical perspective. In this chapter, I confront a particularly thorny case of "globalized" reception and dissemination of a particularly controversial photographic work of public art, showing that, here too, paradoxically, an excavation of its form as well as content involves us in the *longue durée* of engaged art and publicity, one with a pronouncedly realist emphasis in the pathos of nineteenth-century representations of revolutionary martyrdom. In the process, we will return to performance and the critical realist fiction of transparent access from an art-historical vantage point connecting contemporary practice to the early history of modern art.

The conjunction of the refugee crisis with the controversy raging over it on national and international stages, and a global art audience incorporating and responding to the same tensions can make for volatile reactions, to say the least, when an artist has the temerity to bring them together. It would be an understatement to say that Ai Weiwei's tribute to the Syrian toddler Alan Kurdi, who drowned in the Mediterranean Sea in September 2015, was controversial.[1] Restaging a photograph by Turkish journalist Nilüfer Demir that had itself become an iconic image of the global refugee crisis, the Chinese artist posed lying prostrate on a pebble beach on the Greek island Lesbos[2] [Fig. 6.1]. The black and white image was shot by Indian travel photographer Rohit Chawla in early 2016 for the magazine *India Today*, on the occasion of Ai Weiwei's participation in the India Art Fair.[3] In turn, Chawla's print turned up, framed and with a quote by the artist underneath, at the art fair in

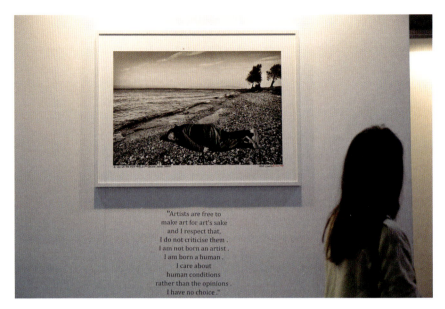

6.1 A visitor passes by an image that shows Chinese artist Ai Weiwei, lying face down on a beach photographed by Indian photographer Rohit Chawla at the India Today stand at the India Art Fair in New Delhi, India, January 28, 2016.

New Delhi, under Ai's name. His statement read: "Artists are free to make art for art's sake and I respect that. I do not criticize them. I am not born an artist. I am born a human. I care about human conditions rather than the opinions. I have no choice."

The photograph debuted at the India Art Fair, which held its preview on January 28 and ran for three days: the wider publication in *India Today*, which appears fortnightly, was dated February 1, 2016, a Monday, meaning that fairgoers had the first chance to see the photograph. Regardless of the intricate dance of publication, the photo (in its online *India Today* form, without any artist statement) went viral on social media immediately, causing outrage that circled primarily around the news of its exhibition at an art fair, leading to varied charges about the artist "capitalizing" on the death of a child, no doubt a reference to the work's presumed salability or proximity to salable works of art at a fair.[4] Here as so often the strident tones of online outrage masked some conceptual confusion, or at least incuriousness. None of these critics suggested explicitly that the photograph was actually offered for sale. There is no question however that the photograph was displayed by the Singapore gallery REDSEA a year later, in an exhibition of Chawla's portraits called *Out of the Box* (January 14 to February 19, 2017), nor that the work was sold eventually—under the photographer's name, not the performer's.[5]

A subtler, more principled discomfort could be felt, irrespective of the commercial details around the work's inception. This was often somewhat inchoately expressed, since it concerned the restaging of a small child's body through what we might call the "signature" body of Ai Weiwei, so large, so recognizable, so full of a certain kind of power and authority.[6] We know from the *India Today* interview, to the extent we can accept what is essentially a puff piece on an artist featured in India's leading art fair, that the tribute was a spontaneous idea of the artist, who had moved part of his operation to Lesbos a few weeks earlier, and who closed a show in Denmark prematurely in protest over the government's decision to seize the valuables of incoming refugees. So it is *not* Ai's political activism, or alleged lack thereof, within his larger practice that is really at stake in the outraged reaction, at least not for the more informed critics.[7]

What then, exactly, is objectionable about Ai's image? The outrage is not comparable to the aesthetic modes of confrontation and outraged public reception of classical avant-garde art by the likes of Manet and Duchamp. Chawla's picture, understood as a work *by* Ai, is at the same time and somewhat paradoxically simply not received as a work of art. To put the matter simply, that is because the very nature of the artwork here—as a performance for the camera and as its art-fair and news-magazine variants—is inseparable from its circulation.[8] Therefore, in what follows I discuss (as "the circulation issue") the discomfort with the appearance of the image in art fairs and on social media, and (as "the reenactment issue") the replacement of the body of the child with that of the artist. The two are interrelated, but worth keeping apart conceptually, one pointing to the changes in photography's reproducibility and use during the last decade, the other to a newly felt need for authenticity in an arena of manipulated images and news stories, but also to challenges inherent in historical reenactment. I will show that rampant circulation on the art market is neither new nor a break with traditions of political image circulation. While I remain skeptical of the use of the reenactment of the body of the child, we will be in a position to comprehend both the divergent responses to Ai's circulated image and his vigorous revival of realist appeals to bodily immediacy across real and fictive transparent screens. To do this requires an examination of a canonical work of political art, Honoré Daumier's *Rue Transnonain*.[9] I will then examine Ai's reenactment under the bifocal lens of realism and commerce, a pair of issues already closely linked in nineteenth-century political art.

Given its prominence in the debate, it is best to begin with the issue of circulation. The objection to Ai's picture, or the gesture it captures, is fueled by our awareness that photographic images, freed from language, are one of the most globally fungible of electronic commodities. Can art use such circulation strategies to convey political discontent incisively, as something more than

a feel-good gesture? The confluence of economic circulation and political activism is a topic of heated debate today.[10] To get beyond the inconclusive play of opinion, it will prove necessary to first look more closely at the work's context of dissemination. The 2016 iteration of the India Art Fair was that institution's eighth, and sixth under this name. The India Art Summit, begun in 2008, first gained international prominence under its new name in 2012. It featured among its obligatory raft of improvements and expansions the *India Today* Art Awards, presented to established and emergent artists, writers and collectors, sponsors and gallerists, the inaugural winner in the latter category being Kolkata's Experimenter Gallery, which also reported strong sales.[11] Concurrently, the *India Today* booth featured, fittingly, photographic portraits of Indian artists by its stable of reporters, including a preponderance of works signed by Chawla—but also by Bandeep Singh, Saibal Das, Fazwn Hussain, and Pramod Pushkarma. Within this group Chawla played an executive role, since besides serving as *India Today*'s "visual director," he was also one of ten judges of the *India Today* Art Awards.[12] The magazine's intended survey of Indian art certainly served a utilitarian purpose with respect to both the fair and the art award: many prominent Indians artists were shown beside their canvases and objects. It is quite striking that such a grouping would be prefaced by the exhibition booth's title wall bearing *only* the Ai Weiwei image (in a slightly larger format), and his statement, the sole artist statement in the lot.

No doubt to the predominantly London- and New York-based art writers denouncing the artist's (and the photographer's) opportunism, the nomination of Ai Weiwei as honorary member of the Indian art world is not very convincing—nor conspicuous, given the image's subsequent deracinated travel on social media. If one assumption seemed to unite the criticisms, it is that a political image cannot be sacral and commercially distributed at once—a fatal confluence of Walter Benjamin's "cult" and "exhibition" values. But that is precisely what historical comparison with one of the paradigm cases of political art will help us to bring into question. The comparison will also illuminate continuities and shifts over the past two centuries, most of all in our mode of reception, which is itself influenced by theoretical and political thought about freedom and constraint. The 'drawn out pain' of the title will turn out to be not just the literal suffering experienced by the subjects of political art (and political domination), but also an aesthetic quality graphically on display, the carrier of "authenticity" in political art, giving the artist permission to speak for others, or at least for their pain. The essentialist return, at least in the United States, of the demand that the artist's own identity be continuous with what is represented, is complicated, and while I understand and to a certain degree share the skepticism against it, it cannot be discussed separately from issues of art market value and the power of reproduction.[13]

The need to justify such political representation of one body through another is urgent, and difficult.

Media attention and reproduction

The image of a man lying at rest on the ground, struck down by the violence of a political system that remains unseen, recalls, formally and thematically, the most famous work of the nineteenth-century French artist Honoré Daumier [Fig. 6.2]: the lithograph *Rue Transnonain, le 15 Avril 1834*, a response to the killing of fourteen innocent citizens in the working-class quarter St. Martin in Paris by the National Guard. Surprisingly, and significantly, this work also entered the public sphere in the form of advertising and fundraising, part of a subscription series of "lithography for freedom of the press," initiated by the owner of *La Caricature*, Charles Philipon. Mailed to some hundred subscribers of *L'Association mensuelle*, this particular print was announced luridly on the front page of *La Caricature* [Fig.6.3] on October 2, 1834: "This lithograph is horrible to see, frightful as the ghastly event which it relates. Here lie an old man slaughtered, a woman murdered, the corpse of a man, which, riddled with wounds, fell on the body of a poor child, which lies under him, with its skull crushed." Perpetrated by members of the National Guard in a house from which shots had supposedly been fired during a strike and upheaval of proletarian workers (which cost a total of over 500 lives), the rue Transnonain massacre became the symbol of "Citizen King" Louis-Philippe's failed political project, both with respect to pacifying the proletariat and reconciling the monarchy with the concerns of the middle class. Though the authorities insisted that the soldiers had been fired on first, and that the bloodshed was thus justified self-defense, they duly compiled a list of the dead, all of them civilians.[14] Daumier's print is less an effort to give the lie to such self-justification, than to literalize the sight of (some of) the victims: affording us a view only the dead, or their killers, could have experienced.

In bringing up Damier's *Rue Transnonain*, I have no intention of using a canonical work of modern art to either legitimate or find wanting a far less reputationally secure contemporary intervention. Nor will I stop at the formal similarities between it and Ai Weiwei's photo, or issues of privacy and public mourning that animate the memorial rationale of both works. Underlying such questions is a more fundamental one: how does the form of a political work, the way it looks and works and conveys its meaning and moral force, relate to the historical conditions of its production, circulation, and reception? Realism as a concept, though it rose to the theoretical prominence roughly twenty years after Daumier's early work, can help us grasp the formal discomfort at work in both lithograph and photograph, and it is no coincidence that just two summers after Ai's Kurdi performance, the 2017

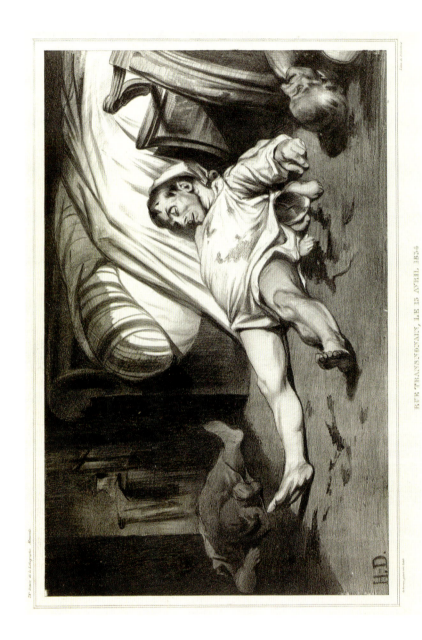

6.2 Honoré Daumier, *Rue Trasnonain, Le 15 Avril 1834*, Lithograph (summer 1834).

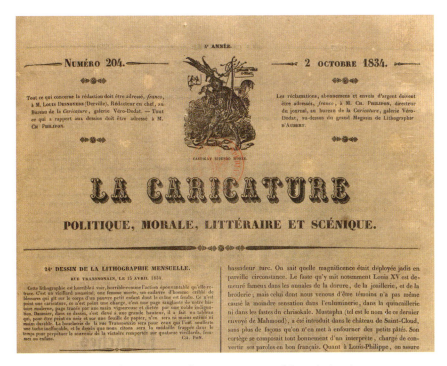

La Caricature on October 2, 1834, with announcement of Daumier's print.

6.3

documenta 14, in particular the exhibition at the Neue Galerie in Kassel, attempted to revive and update realism as a value in contemporary engaged art, starting, suggestively, with a drawing by Gustave Courbet for the painting *Alms from a Beggar at Ornans* (1868)[15] [Fig. 6.4].

Before we consider the potential for aesthetic realism today, let us return to a realism before the realism debates of the 1850s. In Daumier's chalk lithograph, drawn directly on the stone, a sparsely furnished room is presented to the viewer in close-up. The four murdered persons appear to constitute three generations of a family. Apart from the figures there is one sagging bed, and an overturned chair. Its right armrest seems to have broken off, suggesting the violence of the intrusion. Blood, the same color as everything else but unmistakable in the emphatic way it drips and stains bodies and objects, wells from the heads of the three figures in the foreground; the large pillow shared by the family is either submerged in shadow or soaked in blood. An open door in the background, through which washing can be seen hanging, draws the viewer's attention thanks to its light hue and compositional prominence. Though it probably does not lead outside the apartment, the door is the threshold that marks the authorities' overstepping of their domain, their incursion into the private sphere, both literally and symbolically.[16] The incident had

182 Monumental cares

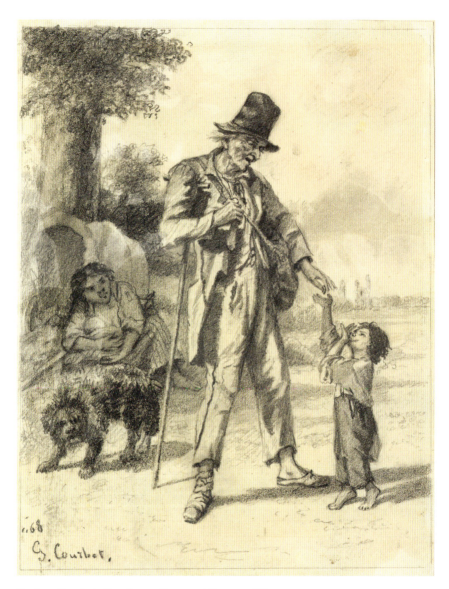

6.4 Gustave Courbet, *Alms from a Beggar at Ornans*, 1868.

already taken place, and the circumstances, comprising individual responsibility for the deaths as well as the whole political background, including the insurgency and the barricade built across rue Transnonain, appear nowhere in the print, unlike several of the less distinguished popular prints around the event. The work is an allegory of the family, whose values have been destroyed by the intrusion of state forces. Formally, this is demonstrated

best through the isolation of each figure, underlined by the violent way their bodies have been forced into physical proximity. The protruding child's head and left arm drive this point home. This kind of "crowded isolation" is felt just as prominently, despite the absence of other bodies, in the cropped photo of Kurdi pressed into the sand, as if the physical texture of reality itself is crushing the vulnerable body.[17] It is, if anything, exaggerated in Ai Weiwei's restaging.

Bed and beach are unusual backdrops for the depiction of the results of state violence and the failure of state humanitarian measures, respectively. Removed from the familiar setting of street, protest, uproar, and collective agency to the quiet of the bedroom and wet sand (pebbles in Ai's case), places of rest and recreation, the violence, though past, becomes palpable again in its incongruity. The cultural conventions of tourism, lending an assumed serenity to the natural setting (we do not see the stressful work of marine rescue) and the shift from the actual death in Turkey to the reenactment on Lesbos, where the refugee crisis also rages, make Ai's gesture more complex, I think, than a historical reenactment, with its often unexamined premium on historical accuracy and the duplication of particulars.[18] Daumier operated similarly in disrupting the autonomy of the private sphere and exploiting the official sanctity of the family for political drama. The success of his print lies in the symbolic transfer of a political struggle from the street to the interior, and the evocation of private sentiment in contrast to a call for political action or political solidarity with the working class. But it lies also in the completion of the political cycle by actively publicizing the intimate drama. The result of such an appeal need not be fleeting: as Gustave Flaubert reminded us in *L'Éducation Sentimental* thirty-five years later, this aggressive disruption of family life not only stayed lodged in public memory, but became a metaphor for the politicization of the French petty bourgeoisie. In the story, Dussardier, a clerk at "MM. Valinçart frères, laces and fancy goods [*dentelles et nouveautés*], rue de Cléry," is a young Republican who befriends the main character, the law student Frédéric, during a riot in the 1840s, and who recalls having been politicized originally by the events of April 1834.[19]

But there is more to private endeavor as political resistance than meets the eye. While Daumier worked on the lithograph, in the summer of 1834, he was likely well-informed about the detailed course of events in April. Apart from newspaper reports in *Le National* and *Le Messager*, and going beyond them in exhaustiveness and rhetorical passion, the most prominent source on the massacre was a booklet consisting mostly of eyewitness reports published by an ambitious young attorney and soon-to-be politician, Alexandre Ledru-Rollin. Ledru-Rollin had been hired by Charles Breffort, the brother of one of the victims (about whom there will be more to say), in response to Louis-Philippe's and the procurer-general's failure to interview any of the witnesses

residing at No. 2 rue Transnonain, and to pursue any legal proceedings.[20] The lawyer published the results of his investigations in July 1834 under the title *Mémoire sur les évenements de la Rue Transnonain: dans les journées des 13 et 14 avril 1834*. The liberal (constitutional-monarchist) paper *Le National* printed selections of his report on July 28, and the *Mémoire* was so popular that it had to be reprinted at least three times that year.[21] The success of this book was financial as well as political, and its factual claims and style of imagery set expectations to which Daumier's print subtly responded.

In light of the early and growing success of Ledru-Rollin's exposé, it must be conceded that money was involved in Daumier's project from the outset, but more interestingly, the commodity aspect of Daumier's print was one of the very reasons for its very existence. His publisher Philipon was the founder and owner of a stable of satirical and oppositional journals, and the print subscriptions were intended to offset expenses for trials and fines. This agenda was openly and proudly announced in *La Caricature* on July 26, 1832: "Twenty seizures, six judgments, three convictions, more than 6,000 francs in fines, thirteen months prison, persecutions, all giving rise to the need for 24,000 francs bail, all this in the span of a year is incontestable proof of the profound hatred of those in power against us."[22] For a subscription of one franc a month, Philipon promised that the prints "would always have a value in excess of the price of the subscription," and compared this steady growth favorably to the whims of the stock exchange.[23] This rhetoric of placement within the emerging art market, appreciation and connoisseurship, did not stand in contrast—at least for Philipon—to the explicit political content of his journals. On the contrary, it allowed him the freedom to act by funding the opposition press. Apart from the distribution of the lithograph through the journal, the print was prominently displayed in the shop window of the editor and graphic dealer Aubert, who was Philipon's brother-in-law, at the gallery Véro-Dodat, close to the Palais Royal.[24] It is reasonable to assume that Daumier, who enjoyed imagining diners so hypnotized by their reading that they would inadvertently pour seltzer water onto their oysters (the subject of one of his 1836 *Charivari* prints, *An absorbing subject/Une lecture entraînante*), would have agreed with Philipon in regarding such display as both potentially profitable and an effective political act.[25]

Stepping back from the specificities of the July Monarchy, this means that in both Ai Weiwei's and Daumier's cases the prints were made public, with alacrity, within the framework of trade and selling. For even if Ai Weiwei's photo was not on sale by the artist in India—in fact according to his gallery, the copyright rests solely with the photographer, not the performer—displaying it at the art fair can be fairly interpreted as part of a marketing strategy.[26] Whether it serves the cause or the artist, and the two are compatible, remains to be seen. It is important to historicize the differences in reception, which

are of course as significant as the similarities, but before doing so, it would be advantageous to consider an ambitious recent attempt to link political agency in art with the mobility of persons and goods.

Profit and the public sphere

In his 2013 book *After Art*, David Joselit makes a spirited case for the circulation of images and the circulation of artifacts *as* social effects. On his account, art functions as currency owing to its circulation and participation in networks—this, and not the contemplation of formally interesting objects, is most pertinent to art's political agency in today's densely interrelated world. The metaphors are those of virtual networks, visualized as shiny, abstract computer graphics commissioned especially for the book, but also those of migration, lifted from the news cycle and the blogosphere. Joselit calls critics insisting on site and its specificity (for example, those demanding restitution of the Parthenon marbles to Athens) "fundamentalists," and opposes them to the "neoliberals" who believe in the liberating force of the art market and, with Joselit, in art as currency.[27] Artifacts, in turn, are personified as agents, and endowed with mock legal statuses: "migrant" objects transmit aesthetic power as they travel the (neoliberal) lanes of commerce, in contrast to "native objects" that stay where they were made, and "documented" objects whose provenance has been researched, and which retain most of their identity whether they themselves travel, stay put, or even cease to exist.

This play on the current rhetoric of migration, connected to global economic inequalities and their effect on sites (territories, homelands, etc.), is both impressive and irritating.[28] Yet there is no denying that it can help us see how questionable certain purportedly left argumentation in art history and criticism is. For instance, writing of *One Million Finnish Passports*, a work of what we might call "political ready-made" sculpture consisting of simulated passports, which was destroyed in 1995 by Finland's border police, Julian Stallabrass accuses artist Alfredo Jaar of taking "the side of the interests of global capital over that of local concerns, for the message of the work was that people's right to resettle must override any national determination, even one democratically arrived at, to protect homogeneity and social cohesion."[29] In an era of mass migration, such a response, insisting on a "democratic" decision for ethnic homogeneity and "cohesion" sounds fundamentalist indeed, if not downright nationalist.[30]

Joselit's rhetoric might not be needed to expose the flaws in such reasoning, but his speculative taxonomy is a rare attempt to do better. If anything, the tripartite classification, fitting so well with our fashionable protest jargon, is too static to handle the real cataclysms that befall objects. This despite the fact that Ai Weiwei is very much a protagonist of Joselit's book, singled

out for doing more than offering a "critique of the power of images—he *exploited* the power of art to transport people and things both spatially and imaginatively."[31] Joselit focuses on *Fairytale*, wherein Ai Weiwei brought 1,001 Chinese tourists and artifacts (chairs) to Kassel for the 2007 *documenta* exhibition and interviewed them (the people, not the chairs). Joselit's vision of migrant images is equally literal: he favors artworks that bring bodies and artifacts into physical motion. But the kind of transmission found in Chawla's photograph, or Daumier's lithograph, I have been arguing, is more complicated and powerful. Are these migrant objects because they were designed to circulate? Documented because their makers and owners had great agency in their dissemination? Native because circulation was their raison d'être? Joselit's scheme is less a done deal than a provocation to look at the actual movements of political art—which *can* and may well *have to* be complex— more closely.

Let us try it out by looking at the fortunes of the Daumier print. Dissemination and the commercial appeal were largely limited to the middle classes, owing to the subscription system Philipon used and the audience who largely funded it.[32] Some of the exemplars reveal a tell-tale crease down the middle, indicating that the print was folded to the dimensions of *La Caricature* and Philipon's other papers. Today, the print would sell for many times the price it fetched in 1834, and its rarity had made it diverge from peer images much earlier, so that by the 1920s one could find the single print for sale at a price comparable to that of an entire collection of caricatures from Philipon's *Charivari*.[33] This is no doubt partly due to censorship: even though the censor seems to have approved publication prior to the subscription going out, the king ordered confiscation of the printing stone and the destruction of all copies that could be recovered. This however was less than the maximum severity exercised at the time, since Philipon was not prosecuted.[34]

Does the scarcity of the print affect its political value? Or is the commodity context a space politically incommensurable with "the street," imagined as a public sphere outside the economic system? Let us recall that the bourgeois public sphere which, according to Jürgen Habermas, came into being as a free exchange of ideas, was throughout its existence connected to concrete business ventures and commercial forms of sociability: coffee-houses and the particular interests of the economically rising bourgeoisie in the eighteenth century, publishers and newspaper companies and, more problematically, since the late nineteenth century, rapidly growing, splitting and consolidating media conglomerates.[35] Of course it wasn't the coffee and other things for sale and consumption that *constituted* the public sphere as politically significant, but letter writing and newspaper reading and writing and the production of books.[36] However, those too were business ventures, or proximate to them. And from a present standpoint, it seems artificial to separate writing and

oral discussion as intellectual activities from the tea, coffee, and other sensual pleasures that made lingering all day in these places of consumption such an appealing mode of life for intellectuals in the past three centuries.[37] The bourgeois public sphere, except perhaps in its ideal image of itself, was never entirely separate from economic motives.

The reason I dwell on café culture is not so much to propose utopian public spheres free of commerce, nor to deny that such are possible. It is rather to think through concretely how the semi-private vehicles (the Aubert shop, the subscriptions) of the Daumier proved an advantage in comparison to public display in an official venue like the Salon, where political art seldom broke through to visibility. Must we consider its dissemination a cooptation of economic exchange for public purposes rather than the other way around? I tend to think so. The print would not exist without the prevailing market, and it needed the market to reach its public. The *Association mensuelle* was crowd funding *avant la lettre*.[38] The opposition, then, consisted in being able to produce and distribute the print through direct mailing. Historical sources suggest that the display of this print in Aubert's shop caused congestion of the streets and long lines as people waited to be let in, and its commercial success added to the embarrassment of Louis-Philippe.[39] How did the police track down owners of the prints? Did they try to get the subscriber list? Hundreds of prints must have reached homes only to reenter the market, too dispersed for the police to round them up. The seeming confinement of the journal and the shop ultimately were the background before which an oppositional public could be formed, supported and made possible by the will of the subscribers to pay for their critical voice. This semi-private ecology of the print as commercial product is therefore the action space of the bourgeoisie—an action space that the violence of the troops threatened in rue Transnonain, as it threatened petit bourgeois and working-class lives. The market in the case almost becomes a counter-system to the official, censored press, and a kind of distributed archive or memorial network, as the lithograph's mobility and relatively large edition guaranteed its survival.[40]

The free space or engaged autonomy for artistic production that many modernist theorists tried to carve out, and which in its romantic-realist form Daumier must have known from Victor Hugo's manifesto for the grotesque and the imperfect in the preface to his drama *Oliver Cromwell* (1827), is always one based on agreement: both the agreement to buy the work, which is social and economic, and that to look at and try to understand it, which is aesthetic.[41] An agreement of this sort, even one that is as fragile as a subscription to buy prints, still provides a certain autonomy to the artist. In looking at how Daumier presented his message, it becomes clear that the working of the market did not limit, but rather amplified, the print's political effect.

Making pain public

The conjunction of private drama, semi-public means of distribution, and network of political implications allows us to return to a question crucial to Ai Weiwei as well as Daumier: what the audience's knowledge concerning the political question being debated contributes to an aesthetic experience. To answer it, we must see that the usual summary observations about Daumier's deceased figures and their identity as a family fall short of the explicitness and articulacy he expected of his reading audience.[42] Keeping in mind the popularity of Ledru-Rollin's *Mémoire*, we can do better. The alert Philipon customer would have been up to date with the names and actions not just of the dead, but of the surviving women (and one man, the theater proprietor Lamy) who testified concerning the massacre. It is possible, then, as French historian Robert Fohr suggests, that "real victims" were intended by the print: the sole married couple, 58-year-old Jean-François Breffort and 52-year-old Annette Besson, wallpaper manufacturers (the official inquest gives Besson's specialty as "papiers de fantaisie") would be the old man at far right and the woman at left, making plausible an association of the middle figure with their son, the 22-year-old painter Louis Breffort.[43] Fohr's suggestion makes sense—the one dead woman (though several were wounded) could only have been Annette Besson, and that Daumier doesn't show her close up may have to do with the fact that soldiers "blew her head to pieces, the fragments sticking against the opposite wall."[44] This in turn should upend our complacent assumption that the central figure is the "husband." Nor is its identification with Louis Breffort unproblematic, since we know from the testimony of his lover Annette Vaché that he spent the night with her, and was shot to death in her apartment upstairs (before he had managed to dress), while his friend Henri Delarivière (or Larivière) was persuaded by Breffort's parents to stay the night in their apartment and thus avoid the danger outside.[45] But things are more complicated still, for the lurid wound suffered by the child in Daumier, "a transversal cut with the bayonet across the forehead, exposing the skull," was in fact suffered by the adult Delarivière.[46] Did Daumier construct a traumatic pastiche, condensing "a series of incidents that took place in rapid succession on several floors"?[47] Such a generalization makes sense, but it does not do full justice to the eloquent specificity of Daumier's storytelling. The scene we see, as if we had stepped through the *écran réaliste* on the night of the carnage, does not correspond to any particular room in the house (containing as it does Breffort *père*, Besson, Breffort *fils* or Delarivière, and a child). But the individual wounds and victims are in every case traceable to those attested.

Perhaps the most dramatic demonstration of this transposition concerns the one figure that Daumier invented: the dead infant. No child was listed among the dead by the authorities or the residents, but the 5-year-old son of

the unfortunate Mr. Hû was shot in the arm as his father, who held him, was killed; only the quick action of Madame Hû saved the boy from suffering the same fate. The child's ruined arm, however, was reduced to "nothing but a stump."[48] The figure drawn by Daumier beneath the massive body of Louis Breffort or Henri Delarivière displays both the unnaturally held arm of the young Hû and the slashed forehead of the latter. We are dealing here, then, with a skilled orchestration of visual charges to match Ledru-Rollin's powerful rhetoric.[49] On the same page of the *Mémoire* that reports the victims, Ledru-Rollin tells of the life and work of the younger Breffort, the one listed in the official inquest as "artiste peintre." He had filled the walls and door of his room with black-chalk renderings of "martyrs, hellish tortures and diabolical scene in the manner of Jacques Callot," which the lawyer claims to have seen with his own eyes.[50] If only your talent hadn't been snuffed out, Ledru-Rollin calls out to Breffort, you could have been the Callot of the nineteenth century! Parenthetically he adds a footnote observing that Callot, who had etched his *Desastres de la guerre* in protest against Louis XIII's siege of Nancy, had "specialized purely in grotesques" up to that point, being driven to his work of war reporting by having "almost fallen victim to the atrocities in the War of Lorraine."[51] Could the possibility of becoming the Callot of the nineteenth century, recording the disaster of the barricade in black chalk lithography, have moved Daumier to likewise leave behind caricature for the empathetic enumeration of the dead in *Rue Transnonain*? Daumier's growing reputation as a political artist, one who had already endured a prison term for his activities, could only be taken to contribute to the seriousness of his indictment. Though, as Baudelaire rightly noted, the *Rue Transnonain* is not a caricature, Daumier continued to comment on the legal fallout from the April unrests, caricaturing the government's hypocritical refusal to give defendants their chance in court.[52]

The transnational artist as commemorative practice

I have not treated Daumier at such length instrumentally, because I need him to interpret Ai Weiwei's political art, but intrinsically, because his mode of combining the realist rhetoric of the transparent scene on a subject of political violence is a persistent, living option in public art, one that I want to argue Ai Weiwei fully inhabits. In the *Rue Transnonain*, in any case, Daumier was able to provisionally set aside his own persona and quirks as a comic observer of mores and the political scene and become one, as it were, with the shabby scene of domestic suffering. In the case of Ai Weiwei, on the other hand, the artist's persona has long shadowed, if not overshadowed, his activist projects. Ai Weiwei has been staging his body, biography, and experience as part of his political art for a long time, never against or fully outside the art system, but

publishing a book form of his blog, or enacting his time in prison for alleged tax evasion as a music video (*dumbass*, 2013), with all the awkward erotic undertones that abject bodily domination by the state permits. Submission, pleasure, bodily closeness, and abuse all feed into a six-part sculptural installation of dioramas in minimalist metal cubes (*S.A.C.R.E.D.*), shown most prominently in a Venetian church (Chiesa di Sant' Antonin) during the 2013 Biennale [Fig. 6.5].

In this work, the artist and the guards watching him appeared as fiberglass puppets, shown sleeping, using the toilet, naked in the shower. The diminutive scale is as important here as in the monumentally posed *India Today* shoot. It is the ambivalence that Ai's physique symbolizes, the surprising peril facing his burly body, non-ideal but as recognizable to the art audience as any superhero's, that allows us to enter his discourse of latent violence of the state against individual bodies writ large. Autobiography neatly collapses the personal and the political, but it also requires generalizing, impersonal means to make that privileged access pertinent to others. Ai adopts sometimes unsubtle archetypes for this purpose, chief among them the clown-like poser who has lost his power but cannot quit the stage. This canny orchestration of his (largely European and North American) media presence has made his body the shorthand

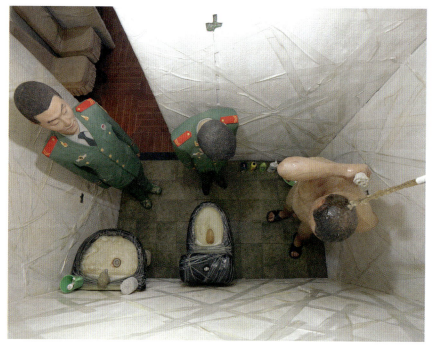

6.5 Ai Weiwei, *S.A.C.R.E.D.*, 2011–13.

representation of political oppression, and at the same time a symbol of resistance, while staying on the top-ten list of global art players, marketing and selling works related more-or-less closely to political action. Social media, and its recuperation in art catalogues and trade publishing (e.g., the printed blog entries) became the public spheres through which Ai Weiwei circulated his art and his protest, in a way that blurs the boundaries between the two, with Twitter accounts being shut down and reopened, and, since the 2010s, an Instagram feed that seems to collapse political agenda, selfie-narcissism, and travel photography in an unsettling exercise of image saturation.[53]

None of this is to say that Ai Weiwei figures in all his art. In particular, his installations incorporating lifejackets collected on the shores of the Mediterranean and arranged in decorous patterns on the façades, or inside, of official architecture—museums, former palaces, or both, as in the case of the Vienna Belvedere—work precisely because the historicity of the material, both that introduced by the artist and that of the venerable piles he is decorating.[54] The feedback loop between humble safety device and the art system that can recycle and valuate everything, including the detritus of mass misery, is stunning and uncomfortable. In the beauty these installations inadvertently stage, they become unsettling and uncanny works of activism. The problem with the Kurdi reenactment is not intrinsically in the aesthetic excess of the photograph, nor in the use of social media and markets for circulating political art as a commodity. The failure, I think, is partly our own: it lies in our recognition of the artist's iconic body as an authenticating instance of pain or resistance, usually his own pain and his own resistance to the contemporary Chinese political system, even if in the last decade Ai has mainly taken on global injustice. Take the telling detail of Ai's legs, carefully posed to resemble Kurdi's with their shod feet. Both bodies end in sneakers—but the sodden little child's shoes, the terrible *punctum* of Demir's image, oft noted, has mutated, jarringly, into Ai Weiwei's massive trainers. Perhaps there is no right way to reenact the contingent presence of consumer goods on dead bodies. In any case, the gesture goes astray, regardless of its sincerity.

It is worth recalling that there is also more than one reenactment photograph: the *India Today* article publishing the action in fact reproduces two, one of them, by editor Gayatri Jayaraman, a color "rehearsal" image of Ai Weiwei lying on a plastic tarp, the seawater just visible at the upper left edge. In contrast, Chawla's much-circulated photo of Ai Weiwei is printed in black and white, recalling the authority of photo-documentation but, even more, given the lyrical deep focus framing trees and distant hillsides, and the vividness with which pebbles and water form graphic textures in the foreground, the formality and artificiality of classic modernist landscape photography.[55]

What if the problem is not a lack of authenticity but indecision about distance? That it is now not dance or live bodily performance but photography,

at least as it appear on social media, that seems too close, too lacking in aesthetic detachment, while the discrepancy of the two bodies—that seen and that referenced—adds a distance we cannot mentally bridge. Another look at the Daumier illuminates this structural difficulty with Ai's chosen mode of reenactment. For we know, and derive the work's political intent from the fact, that the artist only plays dead, that it is his conscious choice to assume this posture. His artist statement insists on this. That is a strategy akin to the posing of legible bodies in history painting, with its meaningful actions and suffering heroes. Daumier, of course, strongly inhabits this tradition. That he has replaced action with destruction, and the active hero with the fallen, if noble, victim, makes the print no less legible as a historical argument. Major history paintings of the preceding two decades, from Géricault's *Raft of the Medusa* to Delacroix's *Greece Expiring on the Ruins of Missolonghi* and *The Massacre of Chios*, depended on stoically suffering rather than nobly acting protagonists. And Paul Delaroche's *L'Assassinat du Duc de Guise*, which is contemporary with the Daumier and has been compared to it, prominently features a dead protagonist.[56] It is significant that these paintings often had topical points of reference: they were founded on real and sometimes, as in the case of Delacroix's paintings about the Greek War of Independence, current events. But Daumier goes further in freeing the suffering body as a monumental marker of injustice from any connection with heroic action. Rather than being constrained or protesting its constraint, Daumier's corpse, imposing in its solidity, is a sign for *us* of the violence and injustice that has left it, and the bodies around it, inanimate. The artist's hand in staging this was intricate, but not so inescapable in the lithograph as Ai Weiwei's in allowing himself to be photographed as Kurdi. Realism, however involved its mechanisms, must at some point stand aside and allow the spectator to meditate on the reality it represents.

The idea animating Ai's realist work is as informed and complicated as Daumier's. But it is an idea dependent on a realization, on history surfacing here as a body. The body remains Ai Weiwei through and through, and there is no way to "free" it after the artist has made it a tool for so many years. The problem of realism today might not lie in metamorphoses of the market or mediation, but in the unstable status of the body in the real world. Is the body a location of knowledge and action or of self-affirmation? Daumier's transposition—which may have put the body of a murdered artist at the center of the political tragedy—left these questions open while cohering as the vision of an impossible (living) eyewitness. Ai, sensitive to these difficulties, plays almost impulsively with the strategy of self-instrumentalization. In May 2017, he repeated the work, or rather its gesture, posing in sandals on a pile of his own porcelain sunflower seeds as protest against a state visit by Donald Trump to the Israel Museum, when some of Ai's works, supposedly

for conservation reasons, but really, the artist suspected, for political motives, were concealed from Trump or at any rate from the museum photo shoot he participated in.[57] The timing was spot-on, but the quick gesture of Ai-as-Kurdi, confronting censorship once again in his own person, sits awkwardly with the finality of the death of the child.

When Courbet published his manifesto on realism in 1861, still smarting from the rejection of his works by the Exposition Universelle six years earlier, he wrote that his goal was not just to "be a painter," but also "to be a human being" creating "living art."[58] Like Ai, Courbet believed that he needed to criticize reality by joining together the artistic with the everyday self. Courbet took himself as subject, even as the guarantor of reality, but the incorporation of one's own body, even mediated through painting, always involves a careful negotiation of closeness and distance. This too Daumier achieved, in a way that has not been surpassed, in his gathering of the scattered real victims into a few concentrated bodies in the *Rue Trasnonain*. It is not the market or circulation as such, but rather the lost distance between artist and work, that prevents realist critique from sticking, by making the artist's persona, the actor who makes the critical speech act, take too central a place in the act's content. Using one's own body for critique is a risk. It closes distances, but also imposes others that might prove insuperable. As long as Ai Weiwei used his life as symbol for the threat to human rights that are also his own, egocentrism might have been justified, even conducive to critique. But there is just so much one body can do.

Notes

1 I cite journalism and art-critical responses below. The scholarly response, though muted, tends to echo the criticisms found in the mass media. See Metter Mortensen, "Constructing, Confirming, and Contesting Icons: the Alan Kurdi Imagery Appropriated by #humanitywashedashore, Ai Weiwei, and *Charlie Hebdo*," Media, Culture and Society, vol. 39, no. 8 (2017), 1142–61; Luísa Santos, "Grafting as a Documentary Tactic in Art," in *Critical Distance in Documentary Media*, ed. Gerda Cammaer, Blake Fitzpatrick, and Bruno Lessard (Cham: Palgrave Macmillan, 2018), 91–107; Suzana Milevska, "Solidarity and the Aporia of 'We': Representation and Participation of Refugees in Contemporary Art," in *Moving Images: Mediating Migration as Crisis*, ed. Krista Lynes, Tyler Morgenstern, and Ian Alan Paul (Bielefeld: transcript, 2020), 245–62; and Ipek A. Çelik Rappas and Diego Benegas Loyo, "In Precarity and Prosperity: Refugee Art Going Beyond the Performance of Crisis," in *Languages of Resistance, Transformation, and Futurity in Mediterranean Crisis-Scapes*, ed. Maria Boletsi, Janna Houwen, and Liesbeth Minnaard (Cham: Palgrave Macmillan, 2020), 63–79. Rappas and Loyo (70) decry the rarity of images of "a pleasure-taking refugee … unless she is a child receiving a cookie from an artist," another well-known Ai image.

2 I will not attempt the equally complex task of disentangling the reception of Demir's photograph, which deserves its own monographic treatment. Among the complexities, one photograph of Kurdi, foreshortened from the feet up, first went viral on Twitter, to be replaced in the later media reception by the more side-on view emulated by Ai. Further, besides 3-year-old Alan, Demir also photographed his drowned 5-year-old brother Galip, though those photos did not get the same exposure. See Maria Mattus, "Too Dead? Image Analyses of Humanitarian Photos of the Kurdi Brothers," *Visual Studies*, vol. 35, no. 1 (March 2020), 51–64. There was a very quickly published 75-page, 15-chapter study of the image's online dissemination by the University of Sheffield's Visual Social Media Lab, *The Iconic Image on Social Media: A Rapid Research Response to the Death of Aylan Kurdi*, ed. Farida Vis and Olga Goriunova (Sheffield: VSML, 2015), focused almost entirely on media reception. A sense of their approach is conveyed by the note to the work's title: "We are aware that his name is Alan and not Aylan. We decided however to consistently use the name Aylan, rather than Alan, as that was the name the image was globally circulated and identified with." https://research.gold.ac.uk/id/eprint/14624/1/KURDI%20REPORT.pdf (accessed November 30, 2021). The child's name was rendered "Aylan" in most of the early reporting; its Kurdish spelling is Alan Kurdî.

3 Gayatri Jayaraman, "Artist Ai Weiwei poses as Aylan Kurdi for India Today magazine," *India Today*, February 1, 2016, http://indiatoday.intoday.in/story/artist-ai-weiwei-poses-as-aylan-kurdi-for-india-today-magazine/1/584804.html (accessed August 20, 2020). Artist and photographer were accompanied for the duration of the visit by *India Today* senior editor Gayatri Jayaraman. This article, and the follow-up special report by Jayaraman on February 3, 2016 ("Artist awash in the land of refugees," www.indiatoday.in/magazine/special-report/story/20160215-ai-weiwei-tribute-to-syrian-refugee-aylan-kurdi-828413–2016–02–03) (accessed August 20, 2020) only appeared on the journal's online portal, *not* in the February 1, 2016 print edition.

4 "Ai's brand of activism is uniquely commercial, and thus uniquely spurious—Ai is gaining both cultural capital and money from the refugee crisis. Rather than placing his work in the public square (why isn't Instagram enough?), Ai turns time and again to the gallery, department store, or art fair." Karen Archey, "e-flux conversations: For photo op, Ai Weiwei poses as dead refugee toddler from iconic image," *e-flux*, https://conversations.e-flux.com/t/for-photo-op-ai-weiwei-poses-as-dead-refugee-toddler-from-iconic-image/3169 (accessed August 20, 2020). The context for the Instagram reference is that in summer 2016 Ai was uploading his Lesbos refugee photographs to his Instagram account.

5 See REDSEA's Artsy profile for Rohit Chawla, *Untitled (Ai Wei Wei)*, www.artsy.net/artwork/rohit-chawla-untitled-ai-wei-wei (accessed August 20, 2020). A story on the 2016 India Art Fair published on February 3, 2016 reports that "[Sandy] Angus, director of the Hong Kong Art Fair and partner of IAF, was the first to scoop up Rohit Chawla's image of Chinese artist Ai Weiwei, for an undisclosed sum." Georgina Maddox, "Balancing Act," *The Hindu Business Line*, www.thehindubusinessline.com/blink/watch/balancing-act/article8194122.ece (accessed August 20, 2020).

6 Jonathan Jones, "Jake Chapman is right to criticize Ai Weiwei's drowned boy art work," *Guardian*, January 13, 2017, www.theguardian.com/artanddesign/jonathanjonesblog/2017/jan/13/jake-chapman-ai-weiwei-refugee-crisis (accessed August 20, 2020).

7 Some critics did take issue with Ai's very successfully promoted self-image as engaged artist. See Nitasha Dhillon, "Ai Weiwei's Photo Reenacting a Child Refugee's Death Should Not Exist," *Hyperallergic* (February 2, 2016), https://hyperallergic.com/272881/ai-weiweis-photo-reenacting-a-child-refugees-death-should-not-exist/ (accessed August 20, 2020), who begins abstractly by asking "what is a refugee?" only to conclude with a large quotation from an earlier article by Dhillon on the state of contemporary art. See also T.J. Demos's brief mention of the work prior to his discussion of Ai's *Human Flow* (2017), which he describes as a "cinema of liberal empathy" in *Beyond the World's End: Arts of Living at the Crossing* (Durham: Duke University Press, 2020), 87. Tom Snow, "Visual politics and the 'refugee' crisis: The images of Alan Kurdi," in *Refuge in a Moving World: Tracing Refugee and Migrant Journeys Across Disciplines*, ed. Elena Fiddian-Qasmiyeh (London: UCL Press, 2020), 168–76, worries about Ai's work drawing attention away from Kurdi and the adverse conditions faced by refugees (172).

8 Some recent art history has contended that artworks can thematize their own circulation and materiality. See Jennifer Roberts, "Copley's Cargo: *Boy with a Squirrel* and the Dilemma of Transit," *American Art*, vol. 21, no. 2 (Summer 2007), 20–41. The relevant claim in Nelson Goodman, *Languages of Art* (Oxford: Oxford University Press, 1968), 230, is that "such properties as weighing ten pounds or being in transit from Boston to New York on a certain day hardly affect the status of a painting in its representational scheme." Against this, Roberts thinks "Copley created [his painting *Boy with a Squirrel*] specifically, and deliberately, to be dispatched" (23). As formulated, it is not clear that Roberts's thesis is incompatible with Goodman's. He had in mind the degree to which one representation is more *diagrammatic* than another, so that certain aspects of its facture do not play a role in representation; his observation is that there is no hard and fast rule, since even for "a representational painting" its weight or travel status *might not* play a role in representation. But then again it might.

9 For the correct title of Daumier's work, see below. It is an effect of its (powerful) reception history that the lithograph is often called *Massacre …*, *Murders …*, or *Murder in the Rue Transnonain*. See, for example, Lorenz Eitner, *An Outline of 19th-Century European Painting* (New York: Harper & Row, 1987), 230, and more recently Casey Harrison, *Paris in Modern Times: From the Old Regime to the Present Day* (London: Bloomsbury, 2019), fig. 4.2.

10 As this text underwent final revisions, Anne Imhof circulated on social media a photograph showing two of her usual supermodel-performers, one painted head to toe in blue and the other in yellow paint. It is hard to imagine a more self-serving response to the Russian invasion of Ukraine.

11 Kanika Anand, "The India Art Fair 2016 scorecard," *Art Radar* (February 3, 2016), www.economist.com/blogs/prospero/2012/01/india-art-fair (accessed August 20, 2020).

12 Gayatri Jayaraman, "Making Art Accessible," *India Today* (February 1, 2016), 46. This article on the *India Today* Art Awards, but none of Jayaraman's reporting on Ai Weiwei, can be found in the print edition of the magazine.

13 There are many problems with a purely deconstructed idea of identity in the current political climate as well. For an intelligent defense of identity politics, see Nizan Shaked, "Is Identity a Method? A Study of Queer Feminist Practice," in *Otherwise: Imagining Queer Feminist Art Histories*, ed. Amelia Jones and Erin Silver (Manchester: Manchester University Press, 2016), 204–25. For interesting criticisms of an unreflective notion of (visual) identity, see Susanne von Falkenhausen, *Jenseits des Spiegels: Das Sehen in Kunstgeschichte und Visual Culture Studies* (Paderborn: Wilhelm Fink Verlag, 2015) translated as *Beyond the Mirror: Seeing in Art History and Visual Culture Studies* (Bielefeld: transcript, 2020), available open access at www.transcript-publishing.com/media/pdf/bd/c8/2a/oa9783839453520.pdf (accessed August 20, 2020).

14 The numbers range between 12 and 14, because some of the heavily injured citizens died several days later. The official statement prepared for the Mairie du 7e Arrondissement of Paris lists twelve people with their names, professions, age, and the nature of their injuries. The document, *Etat nominatif des douze personnes décédées [… des événements d'avril 1834, rue Transnonain* (Ref. N CC 586/d.3) held by the Centre historique des Archives Nationales, can be consulted at: www.histoire-image.org/etudes/rue-transnonain-15-avril-1834 (accessed February 3, 2016). The professions of the inhabitants of the building range from the proprietor of the furniture store on the ground floor and the owner of a theater that operated on floor three and four, to a jeweler, several clerks, a hat maker, a painter, a bronze worker, a gilder, which indicates a mix between proletariat and petty bourgeoisie. Some were themselves members of the National Guard.

15 The graphite preparatory drawing, with traces of white crayon, is owned by the Clark Art Institute in Williamstown, MA; the life-sized oil painting that resulted (221 x 175 cm) is in the Burrell Collection, Glasgow. The *documenta 14* journal, *South* (itself a two-year set of special issues of the Athens journal *South as a State of Mind*) contains an essay by Linda Nochlin, "Representing Misery: Courbet's Beggar Woman," *South*, no. 6 (2015), www.documenta14.de/en/south/3.representing_misery_courbet_s_beggar_woman (accessed August 20, 2020), adapted from Nochlin's last book, *Misère: The Visual Representation of Misery in the 19th Century* (London: Thames & Hudson, 2018), chapter 4. Nochlin argues that Courbet's "unequivocal and unappealing" approach comes in conflict with the irony and formalism of modernists like Manet or Pissarro, which prevented them from enacting in art their revolutionary sympathies; she concludes that "there is more than one way of being of one's time, of being modern." This is true of Ai as well, who taps into the realist-transparent tradition of modernism.

16 Although public opinion demanded a trial of the soldiers responsible, it never took place. On the contrary, starting in April 1835, hundreds of citizens were charged in what came to be known as the "monster trial" (*procès monstre*) for their involvement in the upheavals. Daumier published a famous caricature of a defendant

being gagged and held by the authorities, who sarcastically crow "You have the word, explain yourself, you are free!" (*Vous avez la parole, expliquez-vous, vous êtes libre!*) in *La Caricature* on May 14, 1835, little more than three months before the journal had to cease publication on August 27, 1835. The ultimate source of the reprisals, Louis-Philippe, was forced to step down in the February Revolution of 1848.

17 The uncut print of the (second) most popular of Demir's photos (not the first, foreshortened one first shared on Twitter) has two Turkish police officers in the frame, towering over the body. The cropped view is more effective not just because of the emphatic foregrounding of the body, but because of the sense of its helpless isolation.

18 The shift in location here highlights also the apparent discrepancy between disaster zone and coastal resort, which was grimly resolved when the tourist destination of Lesbos turned into an epicenter of the refugee crisis. The relationship between desire, myth, and construction of islands, and art is historically outlined in Dora Imhof, *Künstliche Inseln: Mythos, Moderne und Tourismus von Watteau bis Manrique* (Berlin: De Gruyter, 2018).

19 Gustave Flaubert, *L'Éducation sentimentale, Histoire d'un jeune homme*. Œuvres complètes de Gustave Flaubert, vol. 3 (Paris: Club de l'honnête homme, 1971), 71. *Sentimental Education*, trans. Robert Baldick, revised with an introduction and notes by Geoffrey Wall (London: Penguin, 2004), 35.

20 Charles Breffort, "A messieurs les membres de la cour de Pairs," in Alexandre Ledru-Rollin, *Mémoire sur les évenements de la Rue Transnonain: dans les journées des 13 et 14 avril 1834* (Paris: Guillaumin, 1834), 5–6. Charles Breffort, described by Ledru-Rollin as a "homme des lettres," was the brother of Jean-François, 58 years old and "fabricant de papiers peints." I am referring to the 3rd edition of 1834.

21 In 1841, Ledru-Rollin was elected to the chamber of deputies and became minister of the interior in the provisional government formed by Alphonse de Lamartine. On his later political career, see Alvin R. Calman, *Ledru-Rollin and the Second French Republic* (New York: Columbia University Press, 1922). The report was written down in July 1834; my reference to the publication in the *National* comes from fn 4, chapter 5, in Jill Harsin, *Barricades. The War of the Streets in Revolutionary Paris, 1830–1848* (New York: Palgrave, 2002), 340. On *Le National* and its editorial direction, see Victor de Nouvion, *Histoire du règne de Louis-Philippe 1er, Roi des Français, 1830–1848* (Paris: Didier, 1857), vol. 1, 104–6.

22 "Vingt saisies, six jugemens, trois condamnations, plus de 6,000 fr. d'amendes, treize mois de prison, des persécutions, au nombre desquelles l'exigence d'un cautionnement de 24,000 fr., tout cela, dans l'espace d'un an, est un preuve incontestable de la profonde haine du pouvoir contre nous" [Charles Philipon]. "Association pour la liberté de la presse," *La Caricature*, no. 90 (26 July 1832), 1.

23 Edwin de T. Bechtel, *Freedom of the Press and L'Association Mensuelle, Philipon versus Louis-Philippe* (New York: The Grolier Club, 1952), 9. Rudolf Zbinden, *Honoré Daumier: Rue Transnonain, le 15 avril 1834: Ereignis-Zeugnis-Exempel* (Frankfurt am Main: Fischer Taschenbuch-Verlag, 1989), 9, calls Philipon's venture a stock corporation.

24 James Cuno, "Charles Philipon and La Maison Aubert: The Business, Politics and Public of Caricature in Paris, 1820–1840" (dissertation, Harvard University, 1985), 266; see also Cuno, "Charles Philipon, La Maison Aubert, and the Business of Caricature in Paris, 1829–41," *Art Journal*, vol. 43, no. 4 (Winter 1983), 350. More detail on Philipon's collaboration with Aubert can be found in David S. Kerr, *Caricature and French Political Culture 1830–1848: Charles Philipon and the Illustrated Press* (Oxford: Oxford University Press, 2000), 58ff.

25 On the occasion of a case brought against him for *lèse-majesté*, Philipon angrily wrote against the authorities in *La Caricature* (24 November 1831): "We will hoot at you, make fun of you. You will no longer be able to show your faces in public, because the people will know them by heart. They will have seen displayed in the boutiques your portraits faithfully rendered. I am condemned. Wait, before rejoicing, until my two hands are paralyzed." Quoted in Robert Justin Goldstein, "The Debate over Censorship of Caricature in Nineteenth-Century France," *Art Journal*, vol. 48, no. 1 (Spring 1989), 14.

26 Lucy Wilkinson, Lisson Gallery, New York, email correspondence, August 18, 2017.

27 David Joselit, *After Art* (Princeton: Princeton University Press, 2012), 3. A preference for the "neoliberals" over the "fundamentalists" has earned Joselit the accusation of writing "neoliberal art history": see Todd Cronan's review in *Radical Philosophy*, no. 180 (July/August 2013), 50–3, reprinted on June 26, 2013 in his online journal *Nonsite*: http://nonsite.org/review/neoliberal-art-history (accessed August 20, 2020). Falkenhausen, *Beyond the Mirror*, 220–5, offers a more even-handed discussion of Joselit's claims in the context of visual culture studies.

28 For one thing, its utility is dubious outside of Joselit's hand-picked examples: the looted contents of the National Museum of Iraq and the Palmyra monuments destroyed by ISIS are alike "documented objects."

29 Julian Stallabrass, *Art Incorporated* (Oxford: Oxford University Press, 2004), 43, reprinted as *Contemporary Art: A Very Short Introduction* (Oxford: Oxford University Press, 2006), 30.

30 It is very unlikely that Stallabrass would endorse this argument in the wake of Brexit, as his recent writings and talks confirm: see, for example, "Are we lost in a forest of Brexit?" talk at RES | FEST 19, Courtauld Institute, April 26, 2019, on YouTube, at https://youtu.be/4Cg8.iNyqxo?list=PLwzRO-e5y3pJeGniXwqApxS6Qbf1ctCnk.

31 Joselit, *After Art*, 94.

32 Kerr, *Caricature and French Political Culture*, 104, notes: "Insisting on the claims of the working classes would have alienated his leisured readership and identified *La Caricature* too closely with the republicans."

33 At the sale of Sarah Bernhardt's library in the Hôtel Druot, a "good impression" of the *Rue Transnonain* sold for 2000 francs, while a collection of *c*.3,000 prints from *Charivari* sold for 3380 francs (and a manuscript by Gabriele D'Annunzio for 2800). See *Le Journal*, July 4, 1923, 2, and *Le Gaulois*, July 4, 1923, 1.

34 Robert Justin Goldstein, *Censorship of Political Caricature in Nineteenth-Century France* (Kent, Ohio and London: Kent State University Press, 1989), 142. A court ruling of 1833, against *Le National*, first established that publications could be

censored *prior* to publication: see Amy Wiese Forbes, *The Satiric Decade: Satire and the Rise of Republicanism, 1830–1840* (Lanham: Lexington Books, 2010), 37.

35 Jürgen Habermas, *The Structural Transformation of the Public Sphere: An Inquiry into a Category of Bourgeois Society* [1962], in particular 57–79. Habermas's critique of the shift in modern publicity toward a preponderance of advertising and corporate decision-making can be found at 181–96. Critics of his supposedly "abstract" definition of the public sphere seem to have missed both the historical detail and the polemic of the book against corporate control of the press, a concern in postwar West Germany, as it is today to a degree scarcely imaginable in 1962.

36 Left critics like Oskar Negt and Alexander Kluge would also add "class consciousness" or class experiences. Oskar Negt and Alexander Kluge, *Public Space and Experience. Analysis of the Bourgeois and Proletarian Public Sphere* [1972] (Minneapolis: University of Minnesota Press, 1993).

37 This may be an oversight of Habermas's ignored by his critics; it is doubtful that he would deny the practical attractions of the coffee-house, though he gives them no theoretical place. On coffee-house culture, see Markman Ellis, *The Coffee-House: A Cultural History* (London: Weidenfeld & Nicolson, 2004), Brian Cowan, *The Social Life of Coffee: The Emergence of the British Coffeehouse* (New Haven: Yale University Press, 2011), and outside of England, *The Thinking Space: The Café as Cultural Institution in Paris, Italy and Vienna*, ed. Leona Rittner, W. Scott Haine, and Jeffrey H. Jackson (London: Routledge, 2013); for even more detail, Ellis, ed. *Eighteenth-Century Coffee House Culture*, 4 vols. (London: Routledge, 2017). Not to neglect tea, there is Markman Ellis, Richard Coulton, and Matthew Mauger, *Empire of Tea* (London: Reaktion, 2015).

38 Subscription publishing has a long and rich history, including the support of revolutionary texts and artworks, itself notably taking off in the eighteenth century. See *The Oxford Companion to the Book*, ed. Michael F. Suarez and H.R. Woudhuysen (Oxford: Oxford University Press, 2010), vol.2, 1186–7.

39 Bechtel, *Freedom of the Press*, 4.

40 Many see this differently, for example, Klaus Schrenk, "Zeitungsgraphiken und Kunsthandel" (doctoral dissertation, Philipps Universität Marburg, 1976), 47–50. On the historical tension between markets and state authority, see "When the Market was 'Left'" the first lecture of Elizabeth Anderson, *Private Government* (Princeton: Princeton University Press, 2016), 1–36 (Tanner Lecture, at https://tannerlectures.utah.edu/Anderson%20manuscript.pdf (accessed August 20, 2020).

41 On Hugo's defense of Shakespeare, the ugly, and the conflicted in his theoretically ambitious prefatory study, see Florence Naugrette, *Le Théâtre romantique: histoire, écriture, mise en scène* (Paris: Seuil, 2001), 132f.

42 A typically cautious statement can be found in James H. Rubin, "Manet's Heroic Corpses and the Politics of their Time," in *Perspectives on Manet*, ed. Therese Dolan (New York: Routledge, 2016), 128: "the modest economic status is suggested by the number of victims who possibly shared the same room."

43 Robert Fohr, "Rue transnonain, le 15 avril 1834," *Histoire par l'image*, March 2016, online journal: www.histoire-image.org/etudes/rue-transnonain-15-avril-1834

 (accessed March 9, 2018). Cf. Robert Fohr, *Daumier sculpteur et peintre* (Paris: A. Biro, 1999), 42.
44 Ledru-Rollin, *Mémoire*, 18. English translation from Louis Blanc, *The History of Ten Years, 1830–1840*, vol.2 (London: Chapman & Hall, 1845), 277, incidentally the first and only English-language source for this material.
45 Ledru-Rollin, *Mémoire*, 39–40. Another woman, Annette Bourgeot, reports that her lover was killed "wearing nothing below," much like Daumier's central figure, who is probably not suffering from an erection, *pace* Albert Boime, *Art in the Age of Counterrevolution, 1815–1848* (Chicago and London: University of Chicago Press, 2004), 331. Louis Breffort was according to another witness *en chemise* (shirt-sleeves) but with "pants sustained by a single suspender" (22), an incongruous bit of comedy that Daumier certainly wanted to avoid in such a serious subject.
46 Ledru-Rollin, *Mémoire*, 18.
47 Bruce Laughton, *Daumier* (New Haven and London: Yale University Press, 1996), 11–12.
48 Ledru-Rollin, *Mémoire*, 48: "le bras fracassé n'est plus qu'un moignon." The right arm had to be amputated, but as Ledru-Rollin never mentions *which* arm, it may be that Daumier didn't know either. See the report on the victims in the official *Journal des débats* for December 8, 1834, 4.
49 The force of Daumier's result is particularly apparent if compared with other images of the massacre, such as the anonymous etching printed by Hadingue of *The Barricades of rue Transnonain*. Here selection and transposition are all on the surface as the artist loads down the façade of 12, rue Transnonain with horror, encasing it between birds of ill omen and a barricade topped by a nude corpse (decorously turned away from the spectator), as well as a decorative frame featuring insurgent banners and soldiers running and shooting. Daumier combines just as freely, but gives a phantasmagoric effect of "being there" to which the anonymous print makes no claim.
50 Ledru-Rollin, *Mémoire*, 47.
51 Ibid., 48, note.
52 "Not precisely a caricature—it is history, reality, both trivial and terrible" ["Ce n'est pas précisément de la caricature, c'est de l'histoire, de la triviale et terrible réalité"]. Charles Baudelaire, "Quelques caricaturistes français," *Curiosités Esthétiques* (Paris: Alphonse Lemerre, 1890), 372. The article first appeared on October 1, 1857, in *Le Present*. It is unlikely that Baudelaire had read *La Caricature* in 1834 (he would have been 13!), but his observations echo Philipon's: "Ce n'est point une caricature, ce n'est pas une charge, c'est une page sanglante de nôtre histoire moderne, page tracée par une main vigoureuse et dictée par une noble indignation." Philipon, *La Caricature* (October 2, 1834), 1. On Baudelaire's reception of Daumier and this print, see Michele Hannoosh, *Baudelaire and Caricature* (University Park: Pennsylvania State University Press, 1992), 137–8.
53 Meiling Cheng, "Ai Weiwei: Acting is Believing," *TDR: The Drama Review*, vol. 55, no. 4 (Winter 2011), 7–13, aptly discussed these twisted combinations of reality and self-promotion, and their appeal to audiences outside China, at a moment of uncertainty, while Ai was being detained by the Chinese government.

54 On his lifeboat and lifejacket installations, see Claire Sutherland, *Reimagining the Nation: Togetherness, Belonging, and Mobility* (Bristol: Policy Press, 2017), chapter 3. Sutherland credits Rupert Friederichsen with a playful suggestion about the symbolism: "perhaps the lifejackets are keeping the European edifice afloat."
55 On some of the factual and aesthetic assumptions attaching to photographed action, in color and monochrome, see my "Process and Authority: Marina Abramović's *Freeing the Horizon* and Documentarity," *Grey Room*, no. 47 (February 2012), 80–97.
56 Art historians, from Jan Bialostocki and Norman Ziff to Albert Boime and Stephen Bann, have noted the affinity between Daumier's dead worker and the murdered Henri I in Delaroche's painting, completed in May 1834 but not shown in the Salon until 1835 (now in the Musée Condé, Chantilly). Preparatory studies of 1832 exist in the Wallace Collection, London, the Musée Fabre, Montpellier and the Boijmans van Beuningen Museum, Rotterdam, but were unlikely to have been seen by Daumier, who spent six months in prison that year for his caricatures. Cf. Elizabeth C. Childs, *Daumier and Exoticism: Satirizing the French and the Foreign* (New York: Peter Lang, 2004), 16: "Daumier's scene reverberates with the martyrdom of a dead Christ, the defeat of a fallen patriarch, and the pathos of the stunted potential of a butchered infant. One may see here a brutalized family or a brutalized France, or both. The specific event provides the arena for the more general statement." The affinity with Delaroche, then, might be fortuitous.
57 Anny Shaw, "Ai Weiwei poses as drowned Syrian refugee toddler once again," *The Art Newspaper*, May 31, 2017, http://theartnewspaper.com/news/ai-weiwei-poses-as-drowned-syrian-refugee-toddler-once-again/ (accessed August 20, 2020).
58 Gustave Courbet, "The Realist Manifesto. An Open Letter" (1861), in Linda Nochlin, *Realism and Tradition in Art, 1848–1900: Sources and Documents* (Upper Saddle River: Prentice Hall, 1966), 33–4.

Caring about monuments: a conclusion

In the course of this book, I have shown how art, in materializing histories in the present, can at least articulate the monumental cares that unite artist and monument-makers with their audiences. In doing so, they help move us from an attitude of helplessness when faced with manifold and monumental "cares" (which has given rise to its own incongruous jargon, such as "doomscrolling") to an ethics of caring more capable of thinking about and, it is to be hoped, acting on considered convictions, or put more informally: what we care about. The theoretical stakes of this project, then, are at the same time practical ones. Considering questions of *how* we set up representation, first raised in the context of post–Second World War commemoration of the Holocaust and genocides in (post-)colonial contexts, as well as paying attention to the material resources used (which encompasses the urban structure around such projects as well as flows of raw materials, people, and labor) and the involvement of audiences in commemoration, allows me to return, in concluding, to the status of monuments. To understand the radical turn facing artists interested in justice and restitution today, it is pertinent to think through conceptual shifts and theoretical models along which I have organized the chapters of this book. The circulation of images, the resurgence of traditions of historical narrative, the reuse of materials and reenactments of events, forms of mediation through glass and screen, are techniques that can clarify or distort, make strange, or complicate these resurfacings of history. These aspects are important for the art historian as much as the artist or concerned citizen confronting public art today; but they should not be read as exhaustive, airtight categories delineating all that is at stake in contemporary commemoration. At their best, these overlapping and incomplete considerations can also help us see what they leave out, new formations and concerns of the memorial landscape.

A recent dramatic example of circulation is a project by Colombian artist Doris Salcedo: she had firearms surrendered by FARC (the Revolutionary Armed Forces of Colombia) melted down and, in collaboration with women who had suffered sexual abuse in the decades-long conflict, hammered them

Caring about monuments: a conclusion 203

into sheet metal, used them to design and line the floor of the memorial space called *Fragmentos* in Bogotá [Fig. 7.1]. The cathartic acts of the women hammering the metal, some of which Salcedo filmed, laughing and crying as they beat the recycled raw material into forms more malleable and more in tune with their own desires for the future, makes the work of memory and commemoration emphatically physical. It also brings in questions about the reuse of materials, extending into virtually every sphere of building activity today [Fig. 7.2].

The context for reuse chosen by Salcedo is particularly telling: in allowing the space lined by these hand-shaped gunmetal sheets to function as a venue for art exhibitions devoted to history and trauma as well as a memorial to the survivors of violence, past, present, and future are brought together in a manner that is subtle and nuanced, and evidently non-competing. One literally *walks* on and through this history beaten into a new shape, attending to what takes place in it, without forgetting its container and the bloody history undergirding it. There is anger, but also care, expended in this project, activism and social bonding, the conflicting interests of those traumatized by the civil war and politicians who want to move forward with a triumphant sign of reconciliation.[1] Salcedo does not solve the difficult historical conundrum, a task no more possible in art than in daily life; rather, she allows the conflicting feelings at work to come to light, in the cathartic production process as well as in the tangible texture of the building. The affective quality of her work, and

Women participating in Doris Salcedo's project, *Fragmentos*, Bogotá, Colombia. 7.1

7.2 Doris Salcedo, *Fragmentos*, 2017, Bogotá, Colombia.

its intricate convolution with the historical and political realities it addresses, has been pointed out by commentators, alongside the startling range of materials and processes, ranging from reconstituted furniture to the monumental crack in the floor of the Tate Modern's Turbine Hall in 2007, called *Shibboleth*.[2] In many ways culminating this trajectory of formal and thematic experimentation, *Fragmentos* is both rigorous in concept and approachable, its intent and message contained as much in acts of cathartic letting go—the hammering film is counterbalanced by interviews with the women about their traumatic experience—as in canny application of recorded footage (from the weapon handoffs to the hammering of the sheet metal) and, above all, in the collaboration with the Colombian women who are Salcedo's co-producers.

One lesson that *Fragmentos* teaches us that might stand for this book as a whole is that, whatever theory of history we might favor (cyclical, evolutionary, fictional-constructive, realist), the way art materializes history most effectively offers real, obdurate objects to confront and to challenge our concepts and smooth digestion of art into political and theoretical discourse about the past. It is, I think, likelier to startle us out of complacency than to confirm casually held opinions, but I won't insist this is always the case, nor its main achievement. More importantly, it forces us to pause in our hurried pace, experience the artwork and reflect on its links to the past (both representational and causal, in this case, through the transformed metal). At its best, it is never content that we stop with a subjective experience of remembering.

Instead, it quiets the hubbub of individual memory and experience, and the ideology and information acquired through schooling and (increasingly) less formal digital mass media, bringing it into some sort of temporary equilibrium around the fulcrum of materialized historical processes.

In coming to care about the past, is it so strange that we may come to care about, and for, the objects that form our interfaces to it? I voiced skepticism against traditional monumental forms, especially when governments and activists hurry to replace one problematic set of colossal victory monuments with equally imposing ones, however fitting these may be.[3] Yet this should not be read as a blanket condemnation of traditional monuments and the kinds of responses they might evoke. I want to acknowledge that sometimes even a conventional or humble memorial object can bring into being political acts at the intersection of activism and care. The Korean *Statue for Peace* is an interesting example of the aesthetically familiar made new and strange politically—by anonymous acts of care.

The first statue by Kim Seo-kyung and Kim Eun-sung [Fig. 7.3] was made on the occasion of the 1,000th occurrence of the so-called Wednesday Demonstration, a weekly protest demanding an apology by the Japanese government, and public acknowledgment of the "comfort system" of the Second World War, in 2011. Called alternately the *Comfort Women Statue* (*wianbusang* 위안부 상) or even just the *"Girl Statue"* (*sonyeosang*, 소녀상),

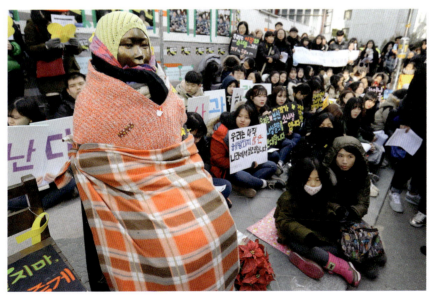

Students gather near *Statue for Peace* by Seo-kyong Kim and Woon-sung Kim, during a rally in front of the Japanese Embassy in Seoul. 7.3

and planted across the street from the Japanese embassy in Seoul, where it complicated war reparation negotiations, with offended Japanese government officials demanding its removal, the statue has also had a quieter effect in its decade of public presence. A graduate student at the School of the Art Institute of Chicago researching the topic first showed me photographs wherein people had given the bronze girl, planted on her bronze chair with her bare feet on the pavement, a coat, scarves, and other warm clothing during the winter.[4] On one hand, this was part of the public success of the monument, in that it allowed for care, for expressions of empathy that had so notoriously been denied survivors of the comfort women system, so that one could start understanding the fraught history the statue commemorated through those small gestures. This was achieved in part thanks to the informed use of participatory strategies by the artists: in Seoul you see a chair next to the girl inviting the audience to sit with the statue, and become part of the work or accompany her on a fraction of her journey, though the effect is muted in the many later versions, such as those in Melbourne and Berlin-Moabit, that place the girl, her chair, and the empty chair to her right on a showy stone platform discouraging interaction. If the "official" function of the sculpture as a performative monument relies on the gambit of getting audience members to "sit with the girl [statue]," it may be doubted whether the procedure is successful very often. The bronze figure itself is idealized: the girl is wearing a ceremonial *hanbok* dress and has a bird on her left shoulder, so that what we see, and sit with, if we do sit, is a sentimental symbol of her pure soul rather than any direct confrontation with pain, which does not contort her facial features, any more than her serenely planted bare feet or the hands quietly forming fists in her lap.

The monument was replicated many times, popping up in Korea via crowdfunding and several activist initiatives, and later in Korean communities in the United States and Europe. It is an impressive tribute—to the subject itself as much as to its unpretentious presentation in sculpture—that the monument became so popular, but there is also at work in the acts of care a tension between the foregrounding of a history of violence the statue strives for and the potentially problematic choice of a traditional commemorative material and language of hieratic seriousness attaching to the girl's posture, which audiences might well sense. The donated clothing may make the imagined girl more comfortable, particularly in the winter when her bare hands and feet strike one as exposed, but they also make her colorful, approachable, and individual, the representation of a human being rather than a goddess of peace descended into victim form. These offerings physically change the statue in a way vandalism cannot do: without irrevocable damage, they make it malleable, or at least hint at a softness and vulnerability that the shining bronze never claimed, despite the rounded contours of Korean

ideal childhood. What I would like to emphasize is how the material, even in its apparent limits (hard, cold, gray) provoked the object's transformation by living people: it is not *just* the image of a girl that elicited these reactions but also its materialization and what that suggested (plopped in front of the Japanese embassy like a sentinel), especially given that the real survivors it is meant to commemorate struggled so long without public sympathy.[5] The care it made possible is productive, and also shows us how intimately activism and monuments have become linked, and not always as activism *against* monuments.

Such activism increasingly relies on social media to bring attention to its objectives, and even to bring people together in the street. While the objects in public space are and are likely to remain at the center of debate, they remind us that history always needs work, even if sometimes the labor is one of removal or transformation.[6] On the other hand, materials and objects must and will change, and be conceived differently, in contemporary society. There is a need for new forms, forms that allow democratic access (the metaphoric or literal empty chair, which so often remains empty in contemporary commemoration), but they should also be forward-looking in terms of material: how the materials relate to our state of the world requires consideration, as does the problematic tradition of heroism adhering to traditional statues. The task for theorists of monumentality today, as much as for monument-makers, is to understand how an ethics of care can meet and interact forcefully with a politics of taking responsibility.[7]

Responsibility, of course, is not an abstract property like equality, but always concrete: the responsibility of specific persons. The scarves and hats on *Statues for Peace* are an act of radical caring, literal and symbolic, for history. Let me ask then, finally: do we still need actual objects in public space in order to commemorate, if these acts are so crucial? Do we even need a physical public space to come together or could all this be achieved in distributed virtual spaces? What does the materiality of monuments mean, the fact that monuments are *made*, that they need labor and materials and indeed money to appear and to endure? Indeed, I believe the form of traditional monuments is historically too entanglement with the law of the strongest to have much of a future in democratic commemoration—at least when it comes to new commissions.[8] This is not due to an essential(ist) problem with the form, but to the long-standing history of the genre, which, ultimately, is to crystalize and focus historical events (or myth) into one coherent message. In this light, the use of extracted materials such as bronze or marble for a new monument, even if form and content are not traditional, is problematic not in some extraneous sense ("sustainability") but in terms of the very power relations which monuments embody and which contribute to resource extraction and climate change.[9] Yet, to conclude from this that we need to let go of public

commemoration is a dangerous position, insofar as the absence of shared physical signs of history pushes active engagement with it out of public view. The monument debate of the last years, I want to claim, shows the *need* not just for public commemoration, but for history, and its appearance in public space—the "obdurate" material I mentioned can be many things, forms and sizes, but its materialization is paramount. History is an essential factor in shaping not just public space in the present, but in allowing access to a functioning public sphere, from the democratic exercise of political rights to acts of social solidarity. It is no accident that spatial relations were discussed prominently at the start of most recent monument activism. The protests that broke out in 2015 around a statue of British colonialist Cecil John Rhodes at the University of Cape Town, Johannesburg, coming to be known as the "Rhodes must fall" movement, sparked those against Confederate monuments in the United States, and later against statues of Columbus and colonization, and ultimately around the world [Fig. 7.4]. Social media contributed to the pace of events. However, it was the spur of local spaces that was decisive. I would want to see here a potential of a multidirectional spatiality, with diverse causes and histories informing each other, even as they act on their own local scales.[10]

I think what the current debate about unwanted monuments and their removal shows above all is the *need* not just for public commemoration, but for public history, and it emphasizes the codependence of real space and a public sphere of debate. As I have shown in this book, the relation of a monument to its site, and its past, is equally important if the goal is access to history in a form meaningful to future acts of care. This has been emphasized by Cameroonian political philosopher Achille Mbembe in his discussion of the Rhodes case in 2015: "What does bringing down the statue of a late 19th century privateer has to do with decolonizing a 21st century university? Or, as many have in fact been asking: Why are we so addicted to the past"?[11] Mbembe's answer concerns public art and commemoration, insofar as they involve the "rearrangement of spatial relations."[12] The main question in this, and many cases around the world, is similar: what markers, such as monuments, can lead audiences to a shared history? I think we need to make sure that this encompasses the right to have many histories represented, but also, more generally, the right to use public space, to keep it public and accessible. Questions of rights are, of course, political questions which we can ask and answer as citizens. Art and public history join the discussion, and deliver to it not just formal means to make history tangible, but a model of history placed and materialized in ways that lend themselves to multiple, noncompeting ways of understanding and inhabiting the world, now and in the future.

7.4 Removal of Cecil John Rhodes statue at the University of Cape Town campus, April 8, 2015.

Notes

1 Anny Shaw, "Doris Salcedo's army of women reshape the meaning of guerrilla weapons," *The Art Newspaper*, December 1, 2018, www.theartnewspaper.com/news/doris-salcedo-s-new-memorial-in-colombia-reshapes-the-meaning-of-guerrilla-weapons (accessed September 27, 2021); Valentina di Liscia, "Colombian Government Exploited Doris Salcedo's Art to Denounce Nationwide Protests," *Hyperallergic*, May 11, 2011, https://hyperallergic.com/645108/colombian-government-exploited-doris-salcedo-art-to-denounce-nationwide-protests/ (accessed September 27, 2001).

2 See Mieke Bal, *Of What One Cannot Speak. Doris Salcedo's Political Art* (Chicago: University of Chicago Press, 2010), and Huyssen, "Doris Salcedo's Memory Sculpture," in *Present Pasts*, chapter 7. Huyssen generously shared with me the lecture he gave at *Fragmentos* in spring 2020. My lecture of September 2020 appeared as "Performative Materials as Activist Commemoration," *Cadernos de Arte Pública*, vol. 2, no. 1 (December 2020), 6–13. The Tate performance is fascinating not only because it required the fabrication of a new layer of concrete; Salcedo's interest in language is evident in the biblical title (the reference to *Judges* 12, "shibboleth" being to a word the pronunciation of which revealed foreign enemies). This links the physical modification of the Tate to metaphoric cracks in façade of racial tolerance in modern democracies.

3 Even here there is a danger of overgeneralization; Kehinde Wiley's *Rumors of War*, a 2019 equestrian statue of a Black man in contemporary dress explicitly modeled on Confederate equestrian monuments commissioned for the Virginia Museum of Fine Arts in Richmond (and first displayed in Times Square, September 26 to December 1, 2019), is not meant as their affirmative counterpart, but as a countermonumental meditation on war monuments: though of course audiences are free to take the statue in a more celebratory manner, an ambivalence Wiley welcomes.

4 Sandra Shim, "From a Monument to a Movement: The Comfort Women Activism and The Statue of Peace as a Protest Monument," MA thesis: School of the Art Institute of Chicago, 2018. For recent discussions, see Rangsook Yoon, "Erecting the 'Comfort Women' Memorials: From Seoul to San Francisco," *de arte*, vol. 53, no. 2–3 (2018), 70–85; Vicki Sung-yeon Kwon, "The Sonyŏsang Phenomenon: Nationalism and Feminism Surrounding the 'Comfort Women' Statue," *Korean Studies*, vol. 43 (2019), 6–39; Dongho Chun, "The Battle of Representations: Gazing at the Peace Monument or Comfort Women Statue," *positions*, vol. 28, no. 2 (May 2020), 363–87.

5 On the larger movement, see Mary M. McCarthy, "The Creation and Utilization of Opportunity Structures for Transnational Activism on World War II Sexual Slavery in Asia," in *Agency in Transnational Memory Politics*, 113–34. The volume incidentally reproduces the scarved, hatted *Statue for Peace* on its cover.

6 We should also be aware that many of the strategies discussed in this book can be coopted by extremists: see, for example, Kim Kelly, "Is the 'QAnon Shaman' From the MAGA Capitol Riot Covered in Neo-Nazi Imagery?," *Rolling Stone*, 8 January

2021, www.rollingstone.com/culture/culture-features/qanon-shaman-maga-capitol-riot-rune-pagan-imagery-tattoo-1111344/ (accessed February 20, 2022) an early meditation on the US Capitol riot that points out the appropriation of Nordic mythic symbols in often monumental ways by far right activists.

7 See Krasny, "Of the Silence of the Dead." Discussions with Krasny were important at different stages of this project. The allocation and the taking of responsibility has been central to modern memory discourse at least since Karl Jaspers, *The Question of German Guilt*, trans. E.B. Ashton (New York: Dial Press, 1947). It assumes new contours as theological and Freudian notions of guilt and reparation give way to more constructive ones, if they do.

8 James E. Young discussed this in the context of Holocaust commemoration decades ago. Among his many publications, see *The Texture of Memory: Holocaust Memorials and Meaning* (New Haven: Yale University Press, 2004).

9 On how the local and global in art involve thinking environmentally, see Ursula K. Heise, *Sense of Place and Sense of Planet: The Environmental Imagination of the Global* (Oxford: Oxford University Press, 2008).

10 Brian Kamanzi, "'Rhodes Must Fall'—Decolonisation Symbolism—What is happening at UCT, South Africa?," *The Post Colonialist*, March 29, 2015, http://postcolonialist.com/civil-discourse/rhodes-must-fall-decolonisation-symbolism-happening-uct-south-africa/ (accessed September 27, 2021).

11 Specifically, in South Africa, "the decolonization of buildings and of public spaces is inseparable from the democratization of access." Achille Mbembe, "Decolonizing Knowledge and the Question of the Archive," lecture given at the Wits Institute for Social and Economic Research (WISER), University of the Witwatersrand, Johannesburg, https://worldpece.org/content/mbembe-achille-2015-%E2%80%9Cdecolonizing-knowledge-and-question-archive%E2%80%9D-africa-country. Mbembe developed some of the same themes in *The Critique of Black Reason*, trans. Laurent Dubois (Durham: Duke University Press, 2017).

12 "Decolonizing the university starts with the de-privatization and rehabilitation of public space—the rearrangement of spatial relations Fanon spoke so eloquently about …" Mbembe, *The Critique of Black Reason*, 3. After protests and defacement, the Rhodes statue was removed from Cape Town University. Mbembe's suggestion on what to do with it: "It might then be that the statue of Rhodes and the statues of countless men of his ilk that are littering the South African landscape properly belong to a museum … A stronger option would therefore be the creation of a new kind of institution, partly a park and partly a graveyard, where statues of people who spent most of their lives defacing everything the name 'black' stood for would be put to rest. Putting them to rest in those new places would in turn allow us to move on and recreate the kind of new public spaces required by our new democratic project." Ibid.

Selected bibliography

Abraham, Florin. *Romania Since the Second World War: A Political, Social, and Economic History*. London: Bloomsbury, 2017.
Adorno, Theodor and Max Horkheimer. *Dialektik der Aufklärung*. Amsterdam: Querido, 1947 (reprinted Frankfurt a.M.: S. Fischer, 1969).
Adorno, Theodor W. *Philosophy of New Music* [1949], translated by Robert Hullot-Kentor. Minneapolis: Minnesota University Press, 2006.
Adorno, Theodor W. *Prismen. Kulturkritik und Gesellschaft*. Munich: Deutscher Taschenbuch Verlag, 1963.
Ai Weiwei, Anthony Pins, eds. *Ai Weiwei. Spatial Matters. Art Architecture and Activism*. Cambridge, MA: MIT Press, 2014.
Allais, Lucia, *Design of Destruction. The Making of Monuments in the Twentieth Century*. Chicago: University of Chicago Press, 2018.
Alloway, Lawrence. "The Public Sculpture Problem." *Studio International* 184, no. 948 (October 1972): 122–5.
Ammon, Stefka and Katharina Lottner, eds. *STEINPLATZ reloaded: Dokumentation und Recherche*. Berlin: EECLECTIC, 2020.
Ana, Ruxandra. "Casa Poporului—un melting pot de mentalități vechi și noi. Dialog cu Ruxandra Balaci." *Observatorul Cultural*, no. 355 (January 18, 2007): 12.
Anderson, Benedict. *Imagined Communities: Reflections on the Origin and Spread of Nationalism*. London and New York: Verso, 1983.
Anderson, Noel W., Andrew Weiner, Tania Bruguera, Tom Burr, Mary Ellen Carroll, Achille Mbembe, et al. "A Questionnaire on Monuments." *October* 165 (August 1, 2018).
Anzaldúa, Gloria. *Borderlands/La Frontera: The New Mestiza*. San Francisco: Aunt Lute, 1987.
Apel, Dora. *Calling Memory into Place*. New Brunswick: Rutgers University Press, 2020.
Araujo, Ana Lucia. *Slavery in the Age of Memory*. London: Bloomsbury, 2020.
Asavei, Maria-Alina. "Rewriting the Canon of Visual Arts in Communist Romania: A Case Study." MA dissertation, Central European University, Budapest, 2007.
Asmus, Sylvia, Jessica Beebone, eds. *Child Emigration from Frankfurt am Main. Stories of Rescue, Loss, and Memory*. Frankfurt am Main: Wallstein, 2021.
Assmann, Aleida. *Cultural Memory and Western Civilization*. Cambridge, UK: Cambridge University Press, 2011.

Assmann, Aleida. *Das neue Unbehagen an der Erinnerungskultur. Eine Intervention.* Beck, München 2013.

Assmann, Aleida. "Der blinde Fleck der deutschen Erinnerungsgeschichte." In *Geschichtsvergessenheit—Geschichtsversessenheit*, edited by Aleida Assmann and Ute Frevert, Stuttgart: Deutsche Verlagsanstalt, 1999.

Assmann, Aleida. *Shadows of Trauma: Memory and the Politics of Postwar Identity*, translated by Sarah Clift. New York: Fordham University Press, 2016.

Assmann, Aleida, and Sebastian Conrad, eds. *Memory in a Global Age: Discourses, Practices and Trajectories.* Houndsmills, Basingstoke and New York: Palgrave Macmillan, 2010.

Augé, Marc. *Non-Places: Introduction to an Anthropology of Supermodernity*, translated by John Howe. London and New York: Verso, 1995.

Auslander, Philip. "On Repetition." *Performance Research* 23, 4–5 (2018): 88–90.

Auslander, Philip. "The Performativity of Performance Documentation." *PAJ. A Journal of Performance and Art* 28, no. 3 (2006): 1–10.

Avram, Horea. "On the Threshold. Conformism, Dissent, and (De)Synchronizations in Romanian Media Art in the 1960s and 1970s." In *New Europe College Stefan Odobleja Program Yearbook*, edited by Irina Vainovski-Mihai, 25–50. Bucharest: New Europe College, 2018.

Babias, Marius and Sabine Hentzsch, eds. *Public Art Bucharest 2007.* Cologne: Walther König, 2008.

Bădică, Simina. "'Forbidden Images'? Visual Memories of Romanian Communism Before and After 1989." In *Remembering Communism. Private and Public Recollections of Lived Experience in Southeast Europe*, edited by Maria Todorova et al., 201–15. Budapest and New York: Central European University Press, 2014.

Baer, Marc David. "Turk and Jew in Berlin: The First Turkish Migration to Germany and the Shoah." *Comparative Studies in Society and History* 55, no. 2 (April 2013): 330–55.

Baker, Alan R.H. *Geography and History: Bridging the Divide.* Cambridge, UK: Cambridge University Press, 2003.

Bal, Mieke. *Of What One Cannot Speak: Doris Salcedo's Political Art.* Chicago: University of Chicago Press, 2010.

Barak, Ami. "Sex, Lies, and Architecture." In *mnac 2004*, edited by Ruxandra Balaci and Raluca Velisar. Bucharest: MNAC, 2004.

Barisione, Maruo and Asimina Michailidou, eds. *Social Media and European Politics: Rethinking Power and Legitimacy in the Digital Era.* London: Palgrave Macmillan, 2017.

Barris, Roann. "Contested Mythologies: The Architectural Deconstruction of a Totalitarian Culture." *Journal of Architectural Education* 54, no. 4 (May 2001): 229–37.

Bartov, Omer and A. Dirk Moses, eds. *Studies in War and Genocide.* 33 vols. New York, Oxford: Berghahn, 1999–2021.

Baudelaire, Charles. "Quelques caricaturistes français." In *Curiosités Esthétiques*, 361–88. Paris: Alphonse Lemerre, 1890.

Bechtel, Edwin de T. *Freedom of the Press and L'Association Mensuelle, Philipon versus Louis-Philippe.* New York: The Grolier Club, 1952.

Beisswanger, Lisa. *Performance on Display. Zur Geschichte lebendiger Kunst im Museum*. Berlin: De Gruyter, 2022.

Bennett, Jane. *Vibrant Matter: A Political Ecology of Things*. Durham: Duke University Press, 2010.

Benz, Wolfgang, ed. *Ein Kampf um Deutungshoheit. Politik, Opferinteressen und historische Forschung. Die Auseinandersetzung um die Gedenk- und Begegnungsstätte Leistikowstraße Potsdam*. Berlin: Metropol, 2013.

Best, Susan. *Reparative Aesthetics. Witnessing in Contemporary Art Photography*. London: Bloomsbury, 2016.

Bindman, David. *Ape to Apollo: Aesthetics and the Idea of Race in the Eighteenth Century*. London: Reaktion/Ithaca: Cornell University Press, 2002.

Birch, Anna, and Joanne Tompkins, eds. *Site-Specific Theatre: Politics, Place and Practice*. New York: Palgrave Macmillan, 2012.

Birchal, Michael. "A History of Socially Engaged Art and the Expanded Field of Public Art Production." In *More Art in the Public Eye*, edited by Micaela Martegani, Jeff Kasper, and Emma Drew. Durham: Duke University Press, 2019.

Bishop, Claire. "Black Box, White Cube, Gray Zone: Dance Exhibitions and Audience Attention." *TDR: Drama Review* 62, no. 2 (2018): 22–42.

Blocker, Jane. *Becoming Past: History in Contemporary Art*. Minneapolis: Minnesota University Press, 2015.

Blocker, Jane. *Where is Ana Mendieta: Identity, Performativity, and Exile*. Durham: Duke University Press, 1999.

Boetzkes, Amanda. *Plastic Capitalism: Contemporary Art and the Drive to Waste*. Cambridge, MA: MIT Press, 2019.

Boia, Lucian. *History and Myth in Romanian Consciousness* [1997], translated by James Christian Brown. Budapest and New York: Central European University Press, 2001.

Bonansinga, Kate. *Curating at the Edge: Artists Respond to the U.S./Mexico Border*. Austin: University of Texas Press, 2014.

Brown, Bill, ed. *Things*. Chicago: University of Chicago Press, 2004.

Bruno, Giuliana. *Surface: Matters of Aesthetics, Materiality, and Media*. Chicago: University of Chicago Press, 2014.

Bryan-Wilson, Julia. "Inside Job: Julia Bryan-Wilson on the Art of Carey Young." *Artforum* 49, no. 2 (October 2010): 240–7.

Bryzgel, Amy. "Against Ephemerality: Performing for the Camera in Central and Eastern Europe." *Journal of Contemporary Central and Eastern Europe* 27, no. 1 (2019): 7–27.

Bryzgel, Amy. *Performance Art in Eastern Europe Since 1960*. Manchester: Manchester University Press, 2017.

Burdekin, Katharine. *Swastika Night*. London: Victor Gollancz, 1937.

Burkhalter, Laura, ed. *Transparencies: Contemporary Art and a History of Glass*. Des Moines: Des Moines Art Center, 2013.

Butler, Judith. *Notes Toward A Performative Theory of Assembly*. Cambridge, MA: Harvard University Press, 2015.

Cameron, Cartiere, and Martin Zebracki. *The Everyday Practice of Public Art. Art, Space and Social Inclusion*. London and New York: Routledge, 2015.

Carlson, Elizabeth. "City of Mirrors: Reflection and Visual Construction in 19th Century Paris." PhD dissertation, University of Minnesota, 2006.

Cârneci, Magda, *Artele plastice în România: 1945–1989. Cu o addenda 1990–2010*, 2nd ed. Bucharest: Polirom, 2013.

Cavalcanti, Maria de Betania. "Totalitarian States and their Influence on City Form: The Case of Bucharest." *Journal of Architectural and Planning Research* 9, no. 4 (Winter 1992): 275–86.

Cheng, Meiling. "Ai Weiwei: Acting is Believing." *TDR: The Drama Review* 55, no. 4 (Winter 2011): 7–13.

Childs, Elizabeth C. *Daumier and Exoticism: Satirizing the French and the Foreign*. New York: Peter Lang, 2004.

Choay, Françoise. *The Invention of the Historic Monument*. Cambridge, UK: Cambridge University Press, 2001.

Christophers, Brett, Rebecca Lave, Jamie Peck, and Marion Werner, eds. *The Doreen Massey Reader*. Newcastle upon Tyne: agenda, 2018.

Chun, Dongho. "The Battle of Representations: Gazing at the Peace Monument or Comfort Women Statue." *Positions: East Asia Cultures Critique* 28.2 (2020): 363–87.

Colomina, Beatriz. "Double Exposure: Alteration to a Suburban House" [2001]. In *Dan Graham*, ed. Alex Kitnick, 163–171. Cambridge, MA: MIT Press and October Files, 2011.

Courbet, Gustave. "The Realist Manifesto. An Open Letter" [1861]. In *Realism and Tradition in Art, 1848–1900: Sources and Documents*, edited by Linda Nochlin, 33–4. Upper Saddle River: Prentice Hall, 1966.

Cowan, Brian. *The Social Life of Coffee: The Emergence of the British Coffeehouse*. New Haven: Yale University Press, 2011.

Cox, Karen L. *Dixie's Daughters*. Gainesville: University Press of Florida, 2003 (rev. ed. 2019).

Cox, Karen L. *No Common Ground: Confederate Monuments and the Ongoing Fight for Racial Justice*. Chapel Hill: University of North Carolina Press, 2021.

Crawford, Romi, ed. *Fleeting Monuments for the Wall of Respect*. Green Lantern Press, 2021.

Croxton, Derek. "The Peace of Westphalia of 1648 and the Origins of Sovereignty." *International History Review* 21, no. 3 (1999): 569–91.

Cuno, James. "Charles Philipon and La Maison Aubert: The Business, Politics and Public of Caricature in Paris, 1820–1840." PhD dissertation, Harvard University, 1985.

Cuno, James. "Charles Philipon, La Maison Aubert, and the Business of Caricature in Paris, 1829–41." *Art Journal* 43, no. 4 (Winter 1983): 347–53.

Danyel, Jürgen, ed. *Die geteilte Vergangenheit: zum Umgang mit Nationalsozialismus und Widerstand in beiden deutschen Staaten*. Berlin: Akademie Verlag, 2014.

Debord, Guy. *Society of the Spectacle* [1967]. New York: Zone Books, 1994.

Demos, T.J. "Rethinking Site-Specificity." *Art Journal* 62, no. 2 (Summer 2003): 98–100.

Demos, T.J. *Against the Anthropocene: Visual Culture and Environment Today*. Berlin: Sternberg Press, 2017.

Demos, T.J. *Beyond the World's End: Arts of Living at the Crossing.* Durham: Duke University Press, 2020.

Deutsche, Rosalyn. *Evictions: Art and Spatial Politics.* Cambridge, MA: MIT Press, 1996.

Dillon, Sarah. *Seeing Renaissance Glass: Art, Optics, and Glass of Early Modern Italy, 1250–1425.* Berlin: Peter Lang, 2018.

Domby, Adam H. *The False Cause: Fraud, Fabrication, and White Supremacy in Confederate Memory*, Charlottesville and London: University of Virginia Press, 2020.

Doss, Erika. *Memoria Mania: Public Feeling in America.* Chicago: University of Chicago Press, 2010.

Doss, Erika. *The Emotional Life of Contemporary Public Memorials: Towards a Theory of Temporary Memorials.* Amsterdam: Amsterdam University Press, 2008.

Doyle, Jennifer, and David Getsy. "Queer Formalisms: Jennifer Doyle and David Getsy in Conversation," *Art Journal* 72, no. 4 (Winter 2013): 58–71.

Dragomir, Elena. "Hotel Intercontinental in Bucharest. Competitive advantage for the socialist tourist industry in Romania." In *Competition in Socialist Society*, edited by Katalin Miklóssy and Melanie Ilic, 89–106. London: Routledge, 2014.

Du Bois, W.E.B. "The Negro and the Warsaw Ghetto," *Jewish Life* 6, no. 7 (May 1952): 14–15.

East, W. Gordon. *The Geography Behind History* [1942]. New York: Norton, 1999.

Ekman, Mattias. "Disputed Spatial Frameworks of Memory." In "Edifices: Architecture and the Spatial Frameworks of Memory," 237–312. PhD dissertation, The Oslo School of Architecture and Design, 2013.

Ekman, Mattias. "Mediation and Preservation." In *Tabula Plena. Forms of Urban Preservation*, edited by Bryony Roberts, 148–56. Zurich: Lars Müller, 2016.

Ekman, Mattias. "The Artwork as Monument after 22 July 2011. Jumana Manna, Pillars from Høyblokka and the Cast as Memorial Art." In *The Government Quarter Study. For Those Who Like the Smell of Burning Tires. Jumana Manna*, edited by Line Ulekleiv, 24–35. Oslo: KORO, 2016.

Elfert, Eberhard. "Denkmalspraxis in Ost- und West-Berlin." In *Erhalten, Zerstören, Verändern? Denkmäler der DDR in Ost-Berlin: Eine dokumentarische Ausstellung.* Berlin: Neue Gesellschaft für Bildende Kunst, 1990.

Ellis, Markman, ed. *Eighteenth-Century Coffee House Culture*, 4 vols. London: Routledge, 2017.

Ellis, Markman. *The Coffee-House: A Cultural History.* London: Weidenfeld & Nicolson, 2004.

Equal Justice Initiative, *Lynching in America: Confronting the Legacy of Racial Terror*, 3rd ed. Montgomery: Equal Justice Initiative, 2017.

Erll, Astrid, and Ann Rigney. "Introduction: Cultural Memory and its Dynamics." In *Mediation, Remediation, and the Dynamics of Cultural Memory*, edited by Astrid Erll and Ann Rigney, 1–14. New York: De Gruyter, 2009.

Falkenhausen, Susanne von. *Beyond the Mirror: Seeing in Art History and Visual Culture Studies.* Bielefeld: transcript-Verlag, 2020.

Farlow, Robert L. "Romania: The Politics of Autonomy," *Current History* 74, no. 436 (1978): 168–86.

Faust, Drew Gilpin. *This Republic of Suffering: Death and the American Civil War*. New York: Knopf, 2008.
Ferdman, Bertie. *Off-Site: Contemporary Performance Beyond Site-Specific*. Carbondale: Southern Illinois University Press, 2018.
Fitz, Angelika and Elke Krasny, *Critical Care. Architecture and Urbanism for a Broken Planet*. Cambridge, MA: MIT Press, 2019.
Foster, Hal. *The Art-Architecture Complex*. London: Verso, 2013.
Fox, William L. "Branding Ice: Contemporary Public Art in the Arctic." In *Future North: The Changing Arctic Landscapes*, edited by Janike Kampevold Larsen and Peter Hemmersam, 165–84. New York: Routledge, 2018.
Frei, Norbert. *Adenauer's Germany and the Nazi Past: The Politics of Amnesty and Integration*, translated by Joel Gelb. New York: Columbia University Press, 2002.
Frei, Norbert. "Auschwitz und Holocaust. Begriff und Historiographie." In *Holocaust: Die Grenzen des Verstehens. Eine Debatte über die Besetzung der Geschichte*, edited by Hanno Loewy, 101–9. Reinbek bei Hamburg: Rowohlt, 1992.
Frei, Norbert. "From Policy to Memory: How the Federal Republic of Germany Dealt with the Nazi Legacy." In *Totalitarian and Authoritarian Regimes in Europe. Legacies and Lessons from the Twentieth Century*, edited by Jerzy W. Borejsza and Klaus Ziemer, 481–9. New York and Oxford: Berghahn, 2006.
Friedlander, Eli. "Some Thoughts on Kitsch." *History and Memory* 9, no. 1/2 (Fall 1997): 376–92.
Gabrielian, Aroussiak, and Alison B. Hirsch. "Prosthetic Landscapes: Place and Placelessness in the Digitization of Memorials." *Future Anterior: Journal of Historic Preservation, History, Theory, and Criticism* 15, no. 2 (2018): 113–31.
Galliera, Izabel. *Socially Engaged Art After Socialism. Art and Civil Society in Central and Eastern Europe*. London: Tauris, 2017.
Gamboni, Dario. *The Destruction of Art. Iconoclasm and Vandalism since the French Revolution*. London: Reaktion Books, 2007.
Gardner, Anthony. *Politically Unbecoming: Postsocialist Art Against Democracy*. Cambridge, MA: MIT Press, 2015.
Geppert, Dominik. *The Postwar Challenge: Cultural, Social, and Political Change in Western Europe, 1945–1958*. Oxford: Oxford University Press, Studies of the German Historical Institute, 2003.
Getachew, Adom. *Worldmaking after Empire: The Rise and Fall of Self-Determination*. Princeton: Princeton University Press, 2020.
Gibbons, Joan. *Contemporary Art and Memory: Images of Recollection and Remembrance*. London: I.B. Tauris, 2007.
Gitler, Inbal Ben-Asher, ed. *Monuments and Site-Specific Sculpture in Urban and Rural Space*. Cambridge, UK: Cambridge Scholars Publishing, 2017.
Gjesdal, Kristen. *Gadamer and the Legacy of German Idealism*. Cambridge, UK: Cambridge University Press, 2009.
Göbel, Ann-Marie. "Krisen-PR im 'Schatten der Mauer': Der 13. August 1961 in der DDR-Zentralorganen." In *Fiktionen für das Volk: DDR-Zeitungen als PR-Instrument*, edited by Anke Fiedler and Michael Meyen, 165–93. Berlin: Lit Verlag, 2011.

Godfrey, Mark. *Abstraction and the Holocaust*. New Haven and London: Yale University Press, 2007.
Godfrey, Mark. "The Artist as Historian." *October* 120 (Spring 2007): 140–72.
Gold, Rochelle. "Reparative Social Media: Resonance and Critical Cosmopolitanism in Digital Art." *Criticism*, vol. 59, no. 1 (Winter 2017): 123–47.
Goldstein, Justin Robert. *Censorship of Political Caricature in Nineteenth-Century France*. Kent, OH and London: Kent State University Press, 1989.
Goldstein, Robert Justin. "The Debate over Censorship of Caricature in Nineteenth-Century France." *Art Journal* 48, no. 1 (Spring 1989): 9–15.
Goodman, Nelson. *Languages of Art*. Oxford: Oxford University Press, 1968.
Greenberg, Clement. "Avant-Garde and Kitsch." In *The Collected Essays and Criticism*, vol. 1, edited by John O'Brian, 5–22. Chicago: The University of Chicago Press, 1986.
Groehler, Olaf. "Der Umgang mit dem Holocaust in der DDR." In *Der Umgang mit dem Holocaust. Europa—USA—Israel*, edited by Rolf Steininger, 233–45. Vienna, Cologne, Weimar: Böhlau, 1994.
Habermas, Jürgen. *The Structural Transformation of the Public Sphere: An Inquiry into a Category of Bourgeois Society* [1962], translated by Thomas Burger (Cambridge, MA: MIT Press, 1991).
Hannoosh, Michele. *Baudelaire and Caricature*. University Park: Pennsylvania State University Press, 1992.
Haraway, Donna. *Staying with the Trouble: Making Kin in the Chthulucene*. Durham: Duke University Press, 2016.
Harsin, Jill. *Barricades. The War of the Streets in Revolutionary Paris, 1830–1848*. New York: Palgrave, 2002.
Hartoonian, Gevork. *Architecture and Spectacle: A Critique*. Farnham: Ashgate, 2012.
Harvey, David. "Space as a key word." In *Spaces of Global Capitalism: A Theory of Uneven Geographical Development*, 117–48. London: Verso, 2019.
Harvey, David. *Rebel Cities: From the Right to the City to the Urban Revolution*. London: Verso, 2012.
Harvey, David. "The Formation of the Projective City." In *The New Spirit of Capitalism*, edited by Luc Boltanski and Ève Chiapello, translated by Gregory Elliott, 103–56. London: Verso, 2005.
Hayden, Dolores. *The Power of Place: Urban Landscapes as Public History*. Cambridge, MA: MIT Press, 1995.
Heise, Ursula K. *Sense of Place and Sense of Planet*. Oxford: Oxford University Press, 2010.
Heller, Ansley. "Breaking Down the Symbols: Reading the Events at Charlottesville through a Postcolonial Lens," *Southeastern Geographer* 58, no. 1 (Spring 2018): 35–8.
Henderson, Julian. *Ancient Glass: An Interdisciplinary Exploration*. Cambridge, UK: Cambridge University Press, 2013.
Hillgruber, Andreas. *Zweierlei Untergang. Die Zerschlagung des Deutschen Reiches und das Ende des europäischen Judentums*. Berlin: Siedler, 1986.
Hock, Oana-Maria. "At Home, in the World, in the Theatre: The Mysterious Geography of University Square, Bucharest." *Performing Arts Journal* 13, no. 2 (1991): 78–89.

Huyssen, Andreas. "Present Pasts: Media, Politics, Amnesia." *Public Culture* 12, no. 1 (2000): 21–38.

Huyssen, Andreas. *Present Pasts: Urban Palimpsests and the Politics of Memory*. Stanford: Stanford University Press, 2003.

Imhof, Dora. *Künstliche Inseln: Mythos, Moderne und Tourismus von Watteau bis Manrique*. Berlin: De Gruyter, 2018.

Ioan, Augustin. "Bucharest's National Museum of Contemporary Art in the Big House." *Art Margins*, April 29, 2008. https://artmargins.com/bucharests-national-museum-of-contemporary-art-in-the-big-house/.

Ioan, Augustin. *Modern Architecture and the Totalitarian Project: A Romanian Case Study*. Bucharest: Institutul Cultural Român, 2009.

Jackson, Matthew Jesse. *The Experimental Group: Ilya Kabakov, Moscow Conceptualism, Soviet Avant-Gardes*. Chicago: University of Chicago Press, 2010.

Jacobi, Fritz. "Trauer als Widerspruch. Leidmetaphern der Kunst in der DDR." In *Kunst in der DDR: Eine Retrospektive der Nationalgalerie*, edited by Eugen Blume and Roland März, 61–71. Berlin: G + H, 2003. Exhibition catalog.

Jameson, Fredric. *Archaeologies of the Future: The Desire Called Utopia and Other Science Fictions*. London: Verso, 2005.

Janney, Caroline E. *Burying the Dead but Not the Past: Ladies' Memorial Associations and the Lost Cause*. Chapel Hill: University of North Carolina Press, 2008.

Jarvis, Bob. "Creating the Image of Bucharest in Art (1850–2017)." *Human Geographies* 12, no. 1 (2018): 5–22.

Jones, Amelia. *Body Art / Performing the Subject*. Minneapolis: University of Minnesota Press, 1998.

Jones, Amelia. "Meaning, Identity, Embodiment: The Uses of Merleau-Ponty's Phenomenology in Art History." In *Art and Thought*, edited by Dana Arnold and Margaret Iversen, 72–90. Oxford: Blackwell, 2003.

Jones, Caroline. "Greenberg's Formalism and Kitsch." In *Kitsch: History, Theory, Practice*, edited by Monica Kjellman-Chapin, 19–41. Cambridge, UK: Cambridge Scholars Publishing, 2013.

Jordheim, Helge. "Mending Shattered Time: 2 July in Norwegian Collective Memory." In *Heritage Ecologies*, edited by Torgeir Rinke Bangstad and Þóra Pétursdóttir. London and New York: Routledge, 2022.

Joselit, David. *After Art*. Princeton: Princeton University Press, 2012.

Joselit, David, Carrie Lambert-Beatty, and Hal Foster, eds. "A Questionnaire on Materialisms." *October* 155 (Winter 2016): 3–110.

Jucan, Iona B., Jussi Parikka, and Rebecca Schneider, eds. *Remain*. Minneapolis: University of Minnesota Press, 2019.

Kartsaki, Eirini. *Repetition in Performance: Returns and Invisible Forces*. London: Palgrave Macmillan, 2017.

Kaspar, Helmut. *Marmor, Stein und Bronze. Berliner Denkmalgeschichten*. Berlin: Edition Berlin, 2003.

Kaufman, Ned. *Place, Race, and Story: Essays on the Past and Future of Historic Preservation*. New York: Routledge, 2009.

Kaufmann, Thomas DaCosta. *Toward a Geography of Art*. Chicago: University of Chicago Press, 2004.

Kaufmann, Thomas DaCosta, and Elizabeth Pilliod, eds. *Time and Place: The Geohistory of Art*. Aldershot: Ashgate, 2005.

Kaye, Nick. *Site-Specific Art: Performance, Place and Documentation*. London and New York: Routledge, 2000.

Kemp-Welch, Klara. *Networking the Bloc: Experimental Art in Eastern Europe, 1965–1981*. Cambridge, MA: MIT Press, 2018.

Kernbauer, Eva. *Art, History, and Anachronic Interventions Since 1990*. London: Routledge, 2021.

Kerr, David S. *Caricature and French Political Culture 1830–1848: Charles Philipon and the Illustrated Press*. Oxford: Oxford University Press, 2000.

Kessler, Erwin. "MNAC: un kitsch istoric și politic." *Revista 22*, supplement no. 780 (2005). https://nettime.org/Lists-Archives/nettime-ro-0502/msg00126.html.

Kiedaisch, Petra, ed. *Lyrik nach Auschwitz: Adorno und die Dichter*. Stuttgart: Reclam, 1995.

King, Katie. *Networked Reenactments: Stories Transdisciplinary Knowledges Tell*. Durham: Duke University Press, 2011.

Klocker, Hubert, ed. *Ion Grigorescu: Horse/Men Market*. Köln: König, 2012. Exhibition catalog.

Koolhaas, Rem. "Junkspace." *October* 102 (Spring 2002): 175–90.

Koolhaas, Rem, and Hal Foster, *Junkspace with Running Room*. New York: New York Review of Books, 2016.

Koselleck, Reinhart. *Futures Past: On the Semantics of Historical Time*. New York: Columbia University Press, 2004.

Koselleck, Reinhart. *Sediments of Time: On Possible Histories*, translated and edited by Sean Franzel and Stefan-Ludwig Hoffmann. Stanford: Stanford University Press, 2018.

Krajewsky, Markus. *Bauformen des Gewissens. Über Fassaden deutscher Nachkriegsarchitektur*. Stuttgart: Alfred Kröner, 2016.

Krasny, Elke. "Vom Schweigen der Toten. Of the Silence of the Dead." In *The Future of Remembrance. Jewish Museums and the Shoah in the 21st Century*, edited by Danielle Spera and Astrid Peterle. *Vienna Yearbook for Jewish History, Culture and Museums* 12 (2020): 88–97.

Kreuger, Anders. "Ion Grigorescu: My Vocation is Classical, even Bucolic." *Afterall* 41 (Spring/Summer 2016): 22–37.

Kwon, Miwon. "One Place after Another: Notes on Site Specificity." *October* 80 (Spring 1997): 85–110.

Kwon, Miwon. *One Place After Another: Site-Specific Art and Locational Identity*. Cambridge, MA: MIT Press, 2002.

Kwon, Vicki Sung-yeon. "The Sonyŏsang Phenomenon: Nationalism and Feminism Surrounding the 'Comfort Women' Statue," *Korean Studies*, vol. 43 (2019): 6–39.

Ladd, Brian. *The Ghosts of Berlin: Confronting German History in the Urban Landscape*. Chicago: University of Chicago Press, 2018.

Landsberg, Alison. *Prosthetic Memory: The Transformation of American Remembrance in the Age of Mass Culture*. New York: Columbia University Press, 2004.

Larsen, Janike Kampevold. "Global Tourism Practices as Living Heritage: Viewing the Norwegian Tourist Route Project." *Future Anterior*, vol. 9, no.1 (Summer 2012): 67–87.

Laughton, Bruce. *Honoré Daumier*. New Haven and London: Yale University Press, 1996.

Ledru-Rollin, Alexandre. *Mémoire sur les évenements de la Rue Transnonain: dans les journées des 13 et 14 avril 1834*. Paris: Guillaumin, 1834.

Lefebvre, Henri. *The Production of Space* [1974], translated by Donald Nicholson-Smith. Oxford: Blackwell, 1991.

Levy, Daniel, and Natan Sznaider. *The Holocaust and Memory in a Global Age*. Philadelphia: Temple University Press, 2005.

Lippard, Lucy. "Art Outdoors. In and Out of the Public Domain." *Studio International* 193, no. 986 (March–April 1977): 83–90.

Lippard, Lucy. *Six Years: Dematerialization of the Art Object 1966–1972*. London: Studio Vista, 1973.

Lippard, Lucy. *Undermining: A Wild Ride Through Land Use, Politics and Art in the Changing West*. New York and London: The New Press, 2014.

Lippard, Lucy. *The Lure of the Local*. New York: New Press, 1997.

Lipsitz, George. *How Racism Takes Place*. Philadelphia: Temple University Press, 2011.

Lock, Charles. "Glass Glimpsed: In, On, Through and Beyond." In *Invisibility Studies: Surveillance, Transparency and the Hidden in Contemporary Culture*, edited by Henriette Steiner and Kristin Veel, 5–24. Oxford: Peter Lang, 2015.

Lupaș, Ioan. "Toate plugirile umblă." *Țara noastră*, no. 14 (April 1, 1907).

Lupaș, Ioan. *Paralelism istoric*. Bucharest: Tipografia ziarului "Universul," 1928.

Lütticken, Sven. "Gestural Study." *Grey Room* no. 74 (Winter 2019): 86–111.

Marcuse, Harold. "Holocaust Memorials: The Emergence of a Genre." *American Historical Review* 115, no. 1 (February 2010): 53–89.

Martin, Reinhold. *The Organizational Complex: Architecture, Media, and Corporate Space*. Cambridge, MA: MIT Press, 2003.

Martin, Reinhold. *Utopia's Ghost: Architecture and Postmodernism, Again*. Minneapolis: University of Minnesota Press, 2010.

Massey, Doreen, and John Allen, eds. *Geography Matters! A Reader*. Cambridge, UK: Cambridge University Press in association with the Open University, 1984.

Massey, Doreen. "Geographies of Responsibility." *Geografiska Annaler*, Series B, Human Geography 86, no. 1 (2004): 5–18.

Massey, Doreen. *Space, Place and Gender*. Minneapolis: University of Minnesota Press, 1994.

Massey, Doreen. *For Space*. London: Sage, 2005.

Maxim, Juliana. *The Socialist Life of Modernist Architecture: Bucharest, 1949–1964*. New York: Routledge, 2019.

Mbembe, Achille. *Critique of Black Reason*, translated by Laurent Dubois. Durham: Duke University Press, 2017.

Meng, Michael. *Shattered Spaces: Encountering Jewish Ruins in Postwar Germany and Poland*. Cambridge, MA: Harvard University Press, 2011.
Merrill, Samuel, Emily Keightley, and Priska Daphi, eds. *Social Movements, Cultural Memory and Digital Media: Mobilising Mediated Remembrance*. Cham: Springer, 2020.
Meyer, James. "The Functional Site." *Documents*, no. 7 (Fall 1996): 20–9.
Milevska, Suzana. "Solidarity and the Aporia of 'We': Representation and Participation of Refugees in Contemporary Art." In *Moving Images: Mediating Migration as Crisis*, edited by Krista Lynes, Tyler Morgenstern and Ian Alan Paul, 245–62. Bielefeld: transcript, 2020.
Mirzoeff, Nicholas, ed. *Diaspora and Visual Culture: Representing Africans and Jews*. London: Routledge, 1999.
Mitscherlich, Alexander and Margarete. *The Inability to Mourn: Principles of Collective Behavior* [1967], translated by Beverley R. Placzek. New York: Grove, 1975.
Morelli, Didier. "Form Follows Action: Performance in/against the City, New York and Los Angeles (1970–85)." PhD dissertation, Northwestern University, 2021.
Morozov, Evgeny. *The Net Delusion: The Dark Side of the Internet Freedom*. New York: Public Affairs, 2011.
Morrissey, Katherine G. and John-Michael H. Warner, eds. *Border Spaces: Visualizing the U.S.-Mexico Frontera*. Tucson: University of Arizona Press, 2018.
Morton, Timothy. *The Ecological Thought*. Cambridge, MA: Harvard University Press, 2010.
Moses, A. Dirk, ed. *Empire, Colony, Genocide: Conquest, Occupation, and Subaltern Resistance in World History*. New York and Oxford: Berghahn, 2008.
Murphey, Rhoads. *The Scope of Geography*. Chicago: Rands McNally, 1966.
Murphy, Kevin D., and Sally O'Driscoll, eds. *Public Space/Contested Space. Imagination and Occupation*. London and New York: Routledge, 2021.
Nae, Cristian. "Basements, Attics, Streets and Courtyards: The Reinvention of Marginal Art Spaces in Romania During Socialism." In *Performance Art in the Second Public Sphere: Event-based Art in Late Socialist Europe*, edited by Katalin Cseh-Varga and Adam Czirak, 89–101. New York: Routledge, 2018.
Negt, Oskar, and Alexander Kluge. *Public Space and Experience. Analysis of the Bourgeois and Proletarian Public Sphere*. Minneapolis: University of Minnesota Press, 1993 [German 1972].
Nesbit, Molly. "Ready-Made Originals." *October* 37 (Summer 1986): 53–64.
Nesbit, Molly. *Their Common Sense*. London: Black Dog, 2000.
Nielsen, Kristine. "Whatever Happened to Ernest Barlach? East German Political Monuments and the Art of Resistance." In *Totalitarian Art and Modernity*, edited by Mikkel Bolt Rasmussen and Jacob Wamberg, 147–69. Aarhus: Aarhus University Press, 2010.
Nienass, Benjamin. "Postnational Relations to the Past: A 'European Ethics of Memory'?" *International Journal of Politics, Culture, and Society* 26, no. 1 (2013): 41–55.
Nolte, Ernst. "Die Vergangenheit, die nicht vergehen will," *Frankfurter Allgemeine Zeitung*, June 6, 1986.

Nora, Pierre, ed. *Rethinking France: Les Lieux de Mémoire* [1983], 4 vols. Chicago: University of Chicago Press, 2001.

Ockman, Joan. "Toward a Theory of Normative Architecture." In *Architecture of the Everyday*, edited by Steven Harris and Deborah Berke, 122–52. Princeton: Princeton Architectural Press, 1998.

Osborne, James. "Counter-monumentality and the vulnerability of memory," *Journal of Social Archaeology* 17, no. 2 (2017): 163–87.

Paglen, Trevor. "Experimental Geography: From Cultural Production to the Production of Space." In *Critical Landscapes: Art, Space, Politics*, edited by Emily Eliza Scott and Kirsten Swenson, 34–42. Berkeley and Los Angeles: University of California Press, 2015.

Pandele, Andrei. *Bucureștiul Mutilat*. Bucharest: Humanitas, 2018.

Pandele, Andrei. *Casa Poporului. Un sfârșit în marmură*. Bucharest: Compania, 2009.

Papararo, Jenifer. "The Modernist: Catherine Opie." Winnipeg: Plug In: ICA, 2020. https://plugin.org/wp-content/uploads/2020/08/Opie-Exhibition-Essay.pdf (accessed September 8, 2020).

Parvu, Ileana. "Reenactment, Repetition, Return. Ion Grigorescu's Two Dialogues with Ceaușescu." *ARTMargins Online*, January 26, 2018. https://artmargins.com/reenactment-repetition-return/#ftnlink_artnotes1.17.

Patrizio, Andrew. *The Ecological Eye: Assembling an Ecocritical Art History*. Manchester: Manchester University Press, 2018.

Pearson, Mark. *Site-Specific Performance*. New York: Palgrave Macmillan, 2010.

Perjovschi, Dan. "Critic. Critică. Artist. Artă." *Revista* 22, May 29, 2018. https://revista22.ro/70271469/critic-critic-artist-art.html.

Perry, Rachel E. "The Holocaust is present: reenacting the Holocaust, then and now." *Holocaust Studies* 26, no. 2 (2020): 152–80.

Pickford, Henry W. *The Sense of Semblance: Philosophical Analyses of Holocaust Art*. New York: Fordham University Press, 2013.

Pintilie, Ileana. *Actionism in Romania During the Communist Era*, translated by Silviu Pepelea. Cluj: Idea Design & Print, 2002.

Pintilie, Ileana. "Questioning the East: Artistic Practices and Social Context on the Edge." In *Performance Art in the Second Public Sphere. Event-Based Art in Late Socialist Europe*, edited by Katalin Cseh-Varga and Adam Czirak, 60–72. London and New York: Routledge, 2018.

Piotrowski, Piotr. "New Museums in East Central Europe." In *1968–1989: Political Upheaval and Artistic Change*, edited by Claire Bishop and Marta Dziewanska, 149–66. Warsaw: Museum of Modern Art, 2008.

Popescu, Diana I. and Tanja Schult, eds. *Revisiting Holocaust Representation in the Post-Witness Era*. New York: Palgrave Macmillan, 2015.

Preda, Caterina. "'Project 1990' as Anti-Monument in Bucharest and the Aestheticisation of Memory." *Südosteuropa*, 64, no. 3 (2016): 307–24.

Preda, Caterina. *Art and Politics Under Modern Dictatorships: A Comparison of Chile and Romania*. New York: Palgrave Macmillan, 2017.

Prochaska, David, and Jordana Mendelson, eds. *Postcards: Ephemeral Histories of Modernity*. University Park: Penn State University Press, 2010.

Rappas, Ipek A. Çelik, and Diego Benegas Loyo. "In Precarity and Prosperity: Refugee Art Going Beyond the Performance of Crisis." In *Languages of Resistance, Transformation, and Futurity in Mediterranean Crisis-Scapes*, edited by Maria Boletsi, Janna Houwen, and Liesbeth Minnaard, 63–79. Cham: Palgrave Macmillan, 2020.

Reading, Anna. *Gender and Memory in the Global Age*. New York: Palgrave Macmillan, 2016.

Riegl, Alois. "The Modern Cult of Monuments: Its Character and Its Origin" [1903], translated by Kurt W. Forster and Diane Ghirardo, *Oppositions* 25 (1982): 21–51.

Roberts, Bryony, ed. *Tabula Plena: Forms of Urban Preservation*. Zurich: Lars Müller Publishers, 2016.

Röder, Kornelia. *Topologie und Funktionsweise des Netzwerks der Mail Art. Seine spezifische Bedeutung für Osteuropa von 1960 bis 1989*. Bremen: Salon Verlag, 2008.

Rogoff, Irit. *Terra Infirma: Geography's Visual Culture*. New York: Routledge, 2000.

Rojas, Emilio. "Naturalized Borders (An Open Wound in the Land, An Open Wound in the Body)." In *Where No Wall Remains: Projects on Borders and Performance*, special issue of *Theater* (Yale School of Drama/Yale Repertory Theatre), edited by Tania El Khoury and Tom Sellar, vol. 51, no. 1 (2021): 62–79.

Ross, Christine. *The Past is the Present; It's the Future Too: The Temporal Turn in Contemporary Art*. London and New York: Continuum, 2012.

Rothberg, Michael and Jürgen Zimmerer. "Enttabuisiert den Vergleich! Die Geschichtsschreibung globalisieren, das Gedenken pluralisieren: Warum sich die deutsche Erinnerungslandschaft verändern muss." *Zeit Online*, March 30, 2021.

Rothberg, Michael. "From Gaza to Warsaw: Mapping Multidirectional Memory." *Criticism* 53, no. 4 (Fall 2011): 523–48.

Rothberg, Michael. "Holocaust Memory after the Multidirectional Turn," *Berliner Zeitung*, February 21, 2021. www.berliner-zeitung.de/open-source/gegen-opfer konkurrenz-es-gibt-auch-in-deutschland-kein-isoliertes-gedenken-li.141816 (accessed September 8, 2021).

Rothberg, Michael. *Multidirectional Memory: Remembering the Holocaust in the Age of Decolonization*. Stanford: Stanford University Press, 2009.

Rothberg, Michael. *The Implicated Subject. Beyond Victims and Perpetrators*. Stanford: Stanford University Press, 2019.

Rowe, Colin and Robert Slotzky. "Transparency: Literal and Phenomenal." *Perspecta*, vol. 8 (1963): 45–54.

Sándor, Katalin. "Filming the Camera: Reflexivity and Reenactment in *Reconstruction* and *Niki and Flo*." In *The New Romanian Cinema*, edited by Christina Stojanova with Dana Duma, 80–92. Edinburgh: Edinburgh University Press, 2019.

Sarrazin, Thilo. *Deutschland schafft sich ab. Wie wir unser Land aufs Spiel setzen*. Munich: Deutsche Verlags-Anstalt, 2010.

Sassen, Saskia. *The Global City: New York, London, Tokyo*. Princeton: Princeton University Press, 1992.

Sassen, Saskia. *Guests and Aliens*. New York: New Press, 1999.

Saunders, Anna. *Memorializing the GDR: Memorials and Memory after 1989*. New York and Oxford: Berghahn, 2019.

Savage, Kirk. *Monument Wars: Washington, DC, the National Mall, and the Transformation of the Memorial Landscape*. Berkeley and Los Angeles: University of California Press, 2009.

Savage, Kirk. *Standing Soldiers, Kneeling Slaves: Race, War, and Monument in Nineteenth Century America*, 2nd ed. Princeton: Princeton University Press, 2018.

Schlereth, Thomas J. "Columbia, Columbus, and Columbianism," *Journal of American History* 79, no. 3 (December 1992): 937–68.

Schmid, Thomas. "Der Holocaust war kein Kolonialverbrechen. Eine Erwiderung auf Michael Rothbergs und Jürgen Zimmerers 'Enttabuisiert den Vergleich!'" *Zeit Online*, April 8, 2021.

Schneider, Rebecca. "That the Past May Yet Have Another Future: Gesture in the Times of Hands Up." *Theatre Journal* 70, no. 3 (September 2018): 285–306.

Schneider, Rebecca. *Performing Remains: Art and War in Times of Theatrical Reenactment*. London and New York: Routledge, 2011.

Schrenk, Klaus. "Zeitungsgraphiken und Kunsthandel." PhD dissertation, Philipps Universität Marburg, 1976.

Schwarzer, Alice. "Im Namen einer falschen Toleranz," *Die Zeit*, July 25, 2019.

Senie, Harriet F. *Memorials to Shattered Myths: Vietnam to 9/11*. New York: Oxford University Press, 2016.

Sennett, Richard. *The Fall of Public Man*. Cambridge, UK: Cambridge University Press, 1977.

Șerban, Alina. "Ana Lupaș." Archive of Women Artists Research & Exhibitions (AWARE), 2013.

Shaked, Nizan. "Is Identity a Method? A Study of Queer Feminist Practice." In *Otherwise. Imagining Queer Feminist Art Histories*, edited by Amelia Jones and Erin Silver, 204–25. Manchester: Manchester University Press, 2016.

Shanken, Andrew. *The Everyday Life of Memorials*. New York: Zone Books, 2022.

Shanahan, Marie. *Journalism, Online Comments, and the Future of Public Discourse*. New York: Routledge, 2018.

Shaw, Lytle. *Fieldworks: From Place to Site in Postwar Poetics*. Tuscaloosa: University of Alabama Press, 2012.

Sheren, Ila Nicole. *Portable Borders: Performance Art and Politics on the U.S. Frontera since 1984*. Austin: University of Texas Press, 2015.

Shen, Lynette. "A Body in Places: Performative Monumentality in Eiko Otake's Spectral Performance." MA thesis, School of the Art Institute of Chicago, 2021.

Shim, Sandra. "From a Monument to a Movement: The Comfort Women Activism and The Statue of Peace as a Protest Monument." MA dissertation, School of the Art Institute of Chicago, 2018.

Skylar, Morty, Cinda Kornblum, and Dave Morice, eds. *The Ultimate Actualist Convention*. New York: The Spirit That Moves Us Press, 2017.

Slevogt, Esther. *Aufgebaut werden durch Dich die Trümmer der Vergangenheit: Das jüdische Gemeindehaus in der Fasanenstrasse*. Berlin: Hentrich & Hentrich, 2009.

Smith, Linda Tuhiwai. *Decolonizing Methodologies: Research and Indigenous Peoples*. 2nd ed. London: Zed Books, 2012.

Spera, Danielle. "An Altered Approach to the Holocaust. Interview with Professor Ido Bruno, Director of the Israel Museum Jerusalem." In *The Future of Remembrance. Jewish Museums and the Shoah in the 21st Century*, edited by Danielle Spera and Astrid Peterle. *Vienna Yearbook for Jewish History, Culture and Museums* 12 (2020): 98–113.

Spirescu, Adrian. *Architectures Pages: Interferences and Anxieties*. Bucharest: Iglooprofil, 2013.

Stallabrass, Julian. *Art Incorporated: The Story of Contemporary Art*. Oxford: Oxford University Press, 2004.

Starobinski, Jean. *Transparency and Obstruction* [1958], translated by Arthur Goldhammer. Chicago: University of Chicago Press, 1988.

Sternfeld, Nora. "Memorial Sites as Contact Zones. Cultures of Memory in a Shared/Divided Present." *EICCP. European Institute for Progressive Cultural Policies*.

Stevens, Quentin, Karen Franck, and Ruth Fazakerley. "Counter-monuments: The Antimonumental and the Dialogic," *The Journal of Architecture* 23 (2018): 718–39.

Stierli, Martino. *Montage and the Metropolis: Architecture, Modernity, and the Representation of Space*. Princeton: Princeton University Press, 2018.

Stiles, Kristine. *States of Mind: Dan and Lia Perjovschi*. Nasher Museum of Art at Duke University. Durham: Nasher Museum of Art, 2007. Exhibition catalog.

Sturken, Marita. *Tangled Memories: The Vietnam War, the AIDS Epidemic, and the Politics of Remembering*. Berkeley and Los Angeles: University of California Press, 1997.

Sturken, Marita. "The Wall, the Screen, and the Image: The Vietnam Veterans Memorial." *Representations*, no. 35 (Summer 1991): 118–42.

Suderburg, Erika, ed. *Space, Site, Intervention: Situating Installation Art*. Minneapolis: Minnesota University Press, 2000.

Tang, Yu-Ting, and C. Paul Nathanail. "Sticks and Stones: The Impact of the Definitions of the Brownfield in Policies on Socio-Economic Sustainability." *Sustainability* 4, no. 5 (2012): 840–62.

Taylor, Diana. "Saving the 'Live'? Re-Performance and Intangible Cultural Heritage." *Etudes Anglaises* 69 no. 2 (2016): 149–60.

Thomas, Erin L. *Smashing Statues. The Rise and Fall of America's Public Monuments*. New York: W.W. Norton & Company, 2022.

Tibi, Bassam. *Europa ohne Identität, Die Krise der multikulturellen Gesellschaft*. Munich: Bertelsmann, 1998.

Țichindeleanu, Ovidiu. "Ion Grigorescu: A Political Reinvention of the Socialist Man." *Afterall* 41, no. 1 (2016): 10–21.

Titu, Alexandra. *Experiment în Arta Românească după 1960*. Bucharest: Soros Center for Contemporary Art, 1997.

Tugendhaft, Aaron. *The Idols of ISIS: From Assyria to the Internet*. Chicago: University of Chicago Press, 2020.

Tureanu, Ileana. *București 2000: Concurs internațional de urbanism = Concours international d'urbanisme = International Urban Planning Competition*. Bucharest: Simetria, 1997.

Vidler, Anthony. *The Architectural Uncanny: Essays in the Modern Unhomely.* Cambridge, MA: MIT Press, 1992.

Wall, Jeff. "Dan Graham's Kammerspiel" [1985]. In *Real Life Magazine: Selected Writings and Projects, 1979–1994,* ed. Miriam Katzeff, Thomas Lawson, and Susan Morgan, 194–217. New York: Primary Information, 2006.

Walton, Kendall. "Transparent Pictures: On the Nature of Photographic Realism." *Critical Inquiry* 11, no. 2 (December 1984): 246–77.

Weibel, Pieter, ed. *Stellvertreter/Representatives/Representanti: Andrea Fraser, Christian Philipp Müller, Gerwald Rockenschaub: Österreichs Beitrag zur 45. Biennale von Venedig 1993.* Vienna: Bundesministerium für Unterricht und Kunst, 1993. Exhibition catalog.

Widrich, Mechtild. "From Rags to Monuments. Ana Lupaș's Humid Installation," *ArtMargins Online* (November 1, 2021). https://artmargins.com/from-rags-to-monuments-ana-lupass-humid-installation/.

Widrich, Mechtild and Jorge Otero Pailos. "Ex Situ, On Moving Monuments." *Future Anterior: Journal of Historic Preservation, History, Theory, and Criticism* 15, no. 2 (2018): iii–vii.

Widrich, Mechtild. "Can Photographs Make It So? Repeated Outbreaks of VALIE EXPORT's *Genital Panic.*" In *Perform, Repeat, Record,* edited by Amelia Jones and Adrian Heathfield, 89–103. Bristol: Intellect, 2012.

Widrich, Mechtild. "Collecting 'History in the Making': The Privatization of Propaganda in National Socialist Cigarette Cards." In *Contemporary Collecting: Objects, Practices, and the Fate of Things,* edited by Kevin Moist and David Banash, 151–72. Lanham/Toronto/Plymouth, UK: Scarecrow Press, 2013.

Widrich, Mechtild. "Natur-Gewalt. Über Jonas Dahlbergs Entwurf für das Utøya-Mahnmal in Norwegen." *Texte zur Kunst,* no. 95 (September 2014): 266–93.

Widrich, Mechtild. "Performative Materials and Activist Commemoration," *Cadernos de Arte Pública,* vol. 2, no. 1 (December 2020): 6–13.

Widrich, Mechtild. *Performative Monuments. The Rematerialisation of Public Art.* Manchester and New York: Manchester University Press, 2014.

Wiesenthal, Simon, ed. *Projekt: Judenplatz Wien.* Vienna: Zsolnay, 2000.

Winter, Jay. *Sites of Memory, Sites of Mourning: The Great War in European Cultural History.* Cambridge, UK: Cambridge University Press, 1995.

Wollheim, Richard. *Art and Its Objects: An Introduction to Aesthetics.* New York: Harper & Row, 1968.

Wollheim, Richard. "In Defense of Seeing-In." In *Looking into Pictures: An Interdisciplinary Approach to Pictorial Space,* ed. Heiko Hecht, Robert Schwartz, and Margaret Atherton, 3–15. Cambridge, MA: MIT Press, 2003.

Wu, Hung. "Tiananmen Square: A Political History of Monuments." *Representations,* no.35, Special Issue: Monumental Histories (Summer 1991): 84–117.

Wüstenberg, Jenny, and Aline Sierp, eds. *Agency in Transnational Memory Politics.* New York: Berghahn, 2020.

Wüstenberg, Jenny. *Civil Society and Memory in Postwar Germany.* Cambridge, UK: Cambridge University Press, 2017.

Wüstenberg, Jenny. "Locating Transnational Memory." *International Journal of Politics, Culture, and Society* 32, no. 4 (December 2019): 371–82.

Yoon, Rangsook. "Erecting the 'Comfort Women' Memorials: From Seoul to San Francisco," *de arte* 53 (2018): 2–3, 70–85.

Young, Craig and Duncan Light. "Multiple and Contested Geographies of Memory: Remembering the 1989 Romanian 'Revolution.'" In *Memory, Place, and Identity: Commemoration and Remembrance of War and Conflict*, edited by Daniella Drozdzewski, Sarah De Nardi, and Emma Waterton, 56–73. New York: Routledge, 2016.

Young, James E. *At Memory's Edge*. New Haven and London: Yale University Press, 2000.

Young, James E. *The Texture of Memory: Holocaust Memorials and Meaning*. New Haven: Yale University Press, 1993.

Yusoff, Kathryn. *A Billion Black Anthropocenes or None*. Minneapolis: University of Minnesota Press, 2018.

Zalewska, Maria. "Selfies from Auschwitz. Rethinking the Relationship Between Spaces of Memory and Places of Commemoration in the Digital Age." *Studies in Russian, Eurasian and Central European New Media*, no. 18 (2017): 95–116.

Zebracki, Martin. "A Cybergeography of Public Art Encounter: The Case of *Rubber Duck*." In *Public Art Encounters*, edited by Martin Zebracki and Joni M. Palmer, 198–216. New York: Routledge, 2018.

Zebracki, Martin and Jason Luger. "Digital Geographies of Public Art: New Global Politics." *Progress in Human Geography* 43, no. 5 (2018): 890–909.

Ziesemer, Nina. *Denkmalbestand im Wandel: Denkmale der DDR nach 1989*. Baden-Baden: Tectum, 2019.

Index

abstraction (in art) 46, 51n21, 52n37, 59–60, 76
Adenauer, Konrad 62, 79n9
Adorno, Theodor 60, 80n16, 82n28, 169n15
aesthetic(s) 4–5, 12–14, 36, 69–71, 119, 171n31, 178, 187–8
 autonomy 176, 187, 192–3
 distance 37, 67, 129–31, 148, 154, 191–3
 see also realism; sublime; transparency
Ai Weiwei 97–9, *98*, 110n31–3, 111n36, *166*, 167, 175–8, *176*, 183–6, 189–95, *190*, 196n12, 200n53, 201n54
Alberro, Alexander 49n14
Alexander, Elizabeth 48n5
allegory 161, 164, 167, 172n37, 174n47, 182
Altun, Cemal Kemal 69, *70*, 85n47
Ammon, Stefka *see* mmtt
Anderson, Benedict 31, 49n8
Anderson, Elizabeth 199n40
anti-Semitism 2, 59, 72, 76, 82n24
Anthropocene 10–11, 19, 91, 97, 102, 107n12
Anzaldúa, Gloria 54n45
Apel, Dora 10, 23n19, 24n38, 53n42, 108n16
architecture 42, 89–90, 99–105, 128–9
 modernist 150–7, 161, 163–6, 169n14–16, 170, 171n29–30, 173n40
art market 175–8, 184–6, 198n33, 199n40
Assmann, Aleida 23n19, 50n16, 64, 66, 82n29, 83n36, 108n13

audience(s) 33, 105, 131–2, 154, 158–9, 171n33, 175–6, 188–9, 206
 global 59, 62, 65–6, 75, 200n53
 live 6–10, 29, 35–7, 42–3, 51n24–5
Auschwitz 63, 68, 71–2, *73*, 82n28, 86n54
 'poetry after' 60, 80n16
Auslander, Philip 166n1
Austria 2, 20n6, 49n14, 59, 98–9, 110n33
authenticity 9, 12, 26, 42, 69, 74, 102, 150–1, 158–9, 177–8, 191

Babias, Marius 116, 138n4
Balaci, Ruxandra 52n29, 128, 140n18, 142n34
Ballard, J.G. 83n31
Barak, Ami 143n40
Bartana, Yael 74–7, *77*
Baudelaire, Charles 189, 200n52
Behkalam, Akbar *70*, 85n48
Belvedere (Vienna) 97–9, *98*, 105, 111n33
Benjamin, Walter 150, 169n11, 174n47, 178
 concept of 'aura' 29, 172n36
Bennett, Jane 22n18
Berlin 56, *57*, *58*, 62–5, *63*, *64*, 68–71, *70*, 76, 84n42, 85n43, 111n36, 116, 123, 138n4, 206
 Berlin Wall 36, 62–5, 83n32
 memorials 48n6, 55–9, 75, 78n4–5, 79n6
Best, Susan 81n22
Beyoncé 50n19
Biden, Joseph 82n23

Bishop, Claire 51n25, 142n29
Bitzan, Ion 131, 143n42
Blocker, Jane 12, 23n28, 24n29–31, 172n35
body 77, 154, 172n35, 189–93, 197n17
　in performance 31, 35–7, 43–7, 53n41, 87–91, 148, 159–61, 177, 183
Boetzkes, Amanda 91, 107n11
Boime, Albert 200n45, 201n56
Bonvicini, Monica *152*–5, 170n19, 170n22
border(s) 32, 44–7, 49n14, 54n43, 54n45, 83n32, 185
Bourgeois, Louise, 93, *94*
bourgeoisie 150, 183, 186–7, 196n14, 198n32
Bourriaud, Nicolas 128, 142n29
Brancusi, Constantin 115
Brandenburg Gate 63, *63*, 82n27
Brandt, Willy 62, 67
Brătescu, Geta 142n34
Breffort family 183, 188–9, 197n20, 200n45
Breivik, Anders Behring 100–2, 104
bronze *8*, 20n4, 75, *75*, 86n57, 98–9, *205*, 206
brownfield land 90, 107n9
Bruno, Giuliana 10–11, 23n22, 171n29
Bryan-Wilson, Julia 23n23, 106n4
Bryzgel, Amy 53n37, 143n43, 144n49, 145n54
Bucharest (Bucureşti) 38–42, *38*, *40*, 50n19, 53n40, 114–32, *115*, *121*, *122*, *126*, 138n4, 139n7, 144n48
　1977 earthquake 125–6, 132, 141n24
　Bucharest 2000 call 123–5, *124*, 140n19
　demolished by Ceauşescu 125–9, 131–3
Bundesverfassungsgericht (Karlsruhe) 150–1, *151*, 169n14–15
Butler, Judith 4, 21n9

Cai Guo-Qiang 5–7, *6*, *7*, 22n13–14
Callot, Jacques 189
Cantor, Mircea 129, *130*, 138n4
cardboard *38*, 39–40, 129
care 4–5, 10, 17–19, 21n11, 77, 103–4, 176, 189, 202, 205, 207

caricature 184, 186, 189, 196n16, 198n24–5
　La Caricature 179, *181*, 184, 186, 197n16, 198n25, 198n32, 200n52
　Le Charivari 184, 186, 198n33
Casa Poporului *see* People's House
Ceauşescu, Elena 38, 110, 119, 140n22
Ceauşescu, Nicolae 35, 38, 115, 119–20, 125–7, 141n23
　fall and death of 39, 42, 53n39, 135
　images of 132–4, *134*, 144n47, 145n51
　North Korean influence on 125, 140n22
censorship 33–4, 42, 50n18, 72, 119, 144n48, 186–7, 193, 198n25, 198n34
Charlottenburg *see* Steinplatz
Chawla, Rohit 175–9, *176*, 186, 191, 194n5
Cheng, Meiling 200n53
Chicago 5–6, *8*, *9*, 14, 22n16, 44, 108n14
Childs, Elizabeth 201n56
Choay, Françoise 47n1, 85n46, 102
circulation (of images) 5, 26, 37, 43, 105, 177–8, 185–6, 191–3, 194n2, 195n8, 195n10, 202–3
Civil War (US) 26, *27*, 29, *30*, 47n2, 65, 83n35
climate 5, 55, 95, 97, 103, 109n19, 110n29, 207
cloth, clothing 46–7, 121, *122*, 140n16, 206
Cold War 36, 50n14, 120, 155
　in Germany 55, *57*, 61–3, *63*
collaboration(s) 9, 35–8, 116, 121, 135, 137, 158, 164, 168n6, 198n24, 202–4
collecting, collectors 42, 52n36, 98, 110n31
Colomina, Beatriz 170n23, 172n37
colonialism 1, 12–15, 44, 47, 60–1, 80n14, 93, 97, 163, 202, 208
commemoration 6, 10, 35–6, 47n2, 92–4, 207
　Cold War 56–65, *57*, *58*
　Holocaust 10, 13, 23n19, 55, 59–63, 72–4, 79n12, 81n20, 82n24, 85n49
　singularity of 61, 81n21
　unrepresentable 60, 80n16, 81n17, 92

pluralist 16, 28, 56, 59–62, 66, 67–9, 72–4, 76, 100, 207
commodities, commodification 51n21, 53n40, 71, 146, 154, 160–1, 168n6, 176, 184–7, 191, 194n4, 199n35–37
concrete (material) 69, 87–91, 103, 123, 150, 164, 210n2
consumption *see* commodification
context 123, 129, 132, 146, 152, 157, 159, 162
Cosgrove, Denis 109n19, 110n29
cosmopolitanism 31, 50, 84n39, 91–2, 128, 178
Courbet, Gustave 181, *182*, 193, 196n15
Cseh-Varga, Katalin 53n37

Dahlberg, Jonas 100–5, *100*, 111n37–9, 113n45
Dağçinar, Argun 99, 111n34
Dan, Călin 142n32
dance 9, 35–41, 50n19, 51n25, 52n27, 52n30
Daumier, Honoré 179–84, *180*, 186–9, 192–3, 195n9, 196n16, 200n45, 200n48–9, 200n52, 201n56
Debord, Guy 168n3
decolonizing 1, 12–13, 163, 208, 211n11–12
Delaroche, Paul 192, 201n56
Deller, Jeremy 116
Demir, Nilüfer 175, 191, 194n2, 197n17
Demos, T.J. 31, 49n10, 108n12, 195n7
Derrida, Jacques 24n29, 161, 172n36
Deutsche, Rosalyn 96, 106n1
diaspora(s) 13, 24n37, 60, 80n14
Diller + Scofidio (architects) 168n6
discomfort 152–7, 169n17, 171n29, 177–9, 191
documenta (Kassel) 110n30, 181, 186, 196n15
documentation, documentary 10, 28, 37, 42, 68, 118–19, 146, 152, 161, 164–6, 166n1, 191, 201n55
Doss, Erika 20n3
Dubai 88, *88*, 107n10
Du Bois, W.E.B. 60, 80n14
Duchamp, Marcel 147–9, *148*, 151, 162, 168n5–6, 168n9

East Germany (*DDR*) 64–5, 78n5, 83n32–4
ecology *see* environmentalism
education (museum) 65–6, 71, 80n16
Eisenman, Peter 59, 71–2, 86n54, 161, 170n26
Ekman, Mattias 104–5, 112n41–3, 113n45–6
Elshahed, Mohamed 47n3
empire(s) 55, 80n14, 81n22, 98–9, 110n33
Enlightenment 82n28, 95, 150
environmentalism 5, 9, 15, 22n18, 44–7, 90–2, 95, 100–5, 108n12, 207, 211n9
experience(s) 35–7, 64–7, 74–7, 99, 101, 189–90, 199n36, 205
EXPORT, VALIE 20n6, 88–92, 106n7, 155, *156*

fabric *see* cloth
Falkenhausen, Susanne von 196n13, 198n27
family 65, 67, 76 –7, 181–3, 188, 201n56
Federal Republic of Germany 56, 61–3, 82n29, 85n47, 150, 169n15
feminism 21n11, 68, 78n1, 89, 91, 95, 106n7, 147–8, 159, 168n8, 196n13
fiction 12, 26, 35, 118, 146, 166n1, 175, 188–9
film 119, *120*, 129, 131–2, 144n44–7, *166*, 167, 203–4
Flaubert, Gustave 183, 197n19
Fohr, Robert 188, 199n43
Foster, Hal 107n9, 146
Frank, Anne 64, 66
Frankfurt am Main 74, 76, *77*
Fraser, Nancy 21n8
Frei, Norbert 79n9, 82n28–9, 83n34
Freud, Sigmund 107n9, 153, 170n24, 211n7
Fried, Michael 170n21
future 1–5, 11, 14, 34, 41, 93, 108n15, 146, 208

Gadamer, Hans-Georg 22n17
Gardner, Anthony 52n29, 52n34, 128, 142n31, 143n41
gender 21n11, 36, 43, 147, 155, 161, 170n22, 172n35
genocide(s) 13, 60–1, 81n22, 202
 comparisons of 59, 61, 81n21
geography 87, 95–7, 105, 108n18, 115
 art 95, 106n1, 107n9, 109n19, 110n25
 Radical 95–6, 109n20–3, 110n29
Gerkan, Meinhard von 123, *124*, 125, 140n19
Gerz, Jochen 72, 86n56
Getachew, Adom 80n14
Getsy, David 43, 53n41
Gheorgiu-Dej, Gheorgie 125, 141n22–3
Gilligan, Carol 21n11
glass (in art) 46, 84n42, 93, 112n41–2, 127–31, 146–57, 160–6, 169n12, 173n41
 enclosure 141n28, 158, 163, 173n42
 stained 29, *30*, 31, 48n5, 173n41
global, the 17, 23n25, 31, 35–6, 43–4, 59, 72, 76, 105, 109n19, 175, 178, 211n9
 globalization 88–90, 96, 105, 185
Godfrey, Mark 24n28, 81n17
gold 99, 127, *127*, 129
Gold, Rochelle 84n39
Gómez Platero, Martin *18*, 19
Goodman, Nelson 195n8
Graham, Dan 154–5, 158–60, *158*, 163, 170n23, 170n25, 171n30, 172n37
grass 44–6, *45*, 106n5
Greenaway, Peter 52n32
Grigorescu, Ion 131–5, *133*, *134*, 144, 145n51
guilt, collective 64, 65, 211n7
Guy, Georgina 35, 51n21

Haacke, Hans 46
Habermas, Jürgen 81n18, 86n58, 186, 199n35–7
Halbwachs, Maurice 113n46
Hanak, Werner 84n38
Haraway, Donna 97, 107n12

Harvey, David 51n26, 106n1, 109n22, 171n30
hashtags 29, 33, 71–2, *73*
Hayden, Dolores 96, 110n27
Heizer, Michael 102
Hirschhorn, Thomas 154
Historikerstreit (Historians' Dispute) 61–2, 81n18–19
history, the historical 1–6, 29, 61, 204
 construction of 9, 12, 17, 26, 62–3, 146
 materiality of 9–15, 19, 66, 92, 96–7, 105, 161, 191, 203, 208
 myth, and 1–2, 20n3, 63–5, 69, 79n10, 79n12, 83n33, 150, 207, 210n6
 teaching of 26–28, 60, 65–6, 84n37–8
history painting 20n4, 192–3, 196n15, 201n56
Hoffmann, E.T.A. 153
Holocaust *see* commemoration
Hong Kong 33, *34*, 50n18, 194n5
Hugo, Victor 187, 199n41
Huizinga, Johan 76, 86n59
Husserl, Edmund 169n18
Huyssen, Andreas 11, 23n24–5, 24n38, 210n2

identity 43, 66, 85n47, 172n35, 178, 196n13
Iliescu, Ion 115–17, 138n2
Imhof, Anne 51n25, 195n10
Imhof, Dora 197n18
India Art Fair 175–6, *176*, 178, 194n5, 195n11
India Today 175–8, 191, 194n3, 196n12
indigeneity, indigenous people 13, 44–6, 93
individual(s) 17, 28, 35, 42–3, 51n25, 59, 64, 71, 74, 76, 169n18, 190, 205–6
Intercontinental Hotel 119–21, *121*, 139n12–13
Ioan, Augustin 127–8, 141n28, 142n36, 143n37
Israel Museum Jerusalem 81n20, 192–3

Jackson, Matthew Jesse 53n38
Jaar, Alfredo 185

Jaspers, Karl 211n7
Jayaraman, Gayatri 191, 194n3, 196n12
Jewish Museum Frankfurt 66, 84n38
Jewish Museum Vienna 81n20, 84n37
Jewish community (Berlin) 56–7, *58*, 61, 65
 see also Kindertransport
Johnson, Philip 152, 172n37
Jones, Amelia 168n8
Joselit, David 185–6, 198n27–8

Kant, Immanuel 95, 159, 171–2n34
Kaufmann, Thomas DaCosta 106n1, 109n19
Kemp-Welch, Klara 53n37
Kent, Flor 86n57
Kindertransport(e) 74–7, *75*, *77*
King, Katie 50n15
Knorr, Daniel 116–17, 138n4–6
Koolhaas, Rem 107n9, 151, 171n29
Korea 205–7, *205*, 210n4–5
KORO (Public Art Norway) 101, 111n39
Koselleck, Reinhard 23n19
Krasny, Elke 21n11, 85n50, 211n7
Krauss, Rosalind 147, 168n4, 168n6
Kula, Manthey 104, *104*
Kurdi, Alan 175, 183, 191, 193n1, 194n2, 195n7
Kwon, Miwon 16, 31, *32*, 49, 90, 96

labor 44, 89, 91–2, 108n14, 108n17, 126, 140n15, 202, 207
land art 44–6, 88–9, 102, 106n1, 110n25
 see also place; site
Lautner, John 164, *165*, 173n45
Ledru-Rollin, Alexandre 183–4, 188–9, 197n20–1, 200n44–5, 200n48
Lee, Pamela M. 170–1n26
Lefebvre, Henri 14, 24n39, 107n8, 109n20
Lenssen, Anneka 47n3
Lesbos 98–9, 175, 177, 183, 194n4, 197n18
lifejackets *98*–9, 111n34–6, 191, 201n54
Lin, Maya 60, 80n13, 102
Lippard, Lucy 23n20, 106n1, 108n17

live/mediated duality 6, 19, 29, 33–4, 43–4, 66
lithography 179, *180*, 181, 183–4, 187, 189
local/global link 89–91, 98–9, 104–5, 116–17
Long, Richard 88–9, 106n5–6
Loos, Adolf 172n36
Los Angeles 96, 110n25, 164–6, *165*, 173n45
Lottner, Katharina *see* mmtt
Louis-Philippe 179, 183, 187, 197n16, 198n25
Lueger, Karl 1–2, *3*, 20n5–6
Lütticken, Sven 51n21, 51n24
Lupaș, Ana 121, *122*, 135, 139n15, 140n16
lynching memorials 93, 108n16

mail art 42, 53n37, 179, 187
marble 123, *126*–*127*, 207
Marcoci, Roxana 145n55
Marker, Chris 164
Marshall, Kerry James 48n5
Martin, Reinhold 157, 162, 170n25, 171n30
martyr(dom) 37, 83n33, 175, 189, 201n56, 206
Massey, Doreen 95–6, 109n20–3, 110n24
materiality/materialization 4, 13–15, 19, 47, 92–3, 106n8, 129, 146, 157, 205–8
 'New Materialism' 22n18, 23n23
 of memory 9–10, 13, 23n19, 76, 203
 monuments 59–60, 76, 121, 127–8, 207
 morality of 150–5, 161–2, 191
Matta-Clark, Gordon 155, 170–1n26
Mbembe, Achille 25n40, 208, 211n11–12
media(tion) 4–6, 10–13, 17, 28, 33, 42–4, 137, 146, 151, 157, 192, 202
 across technologies 50n15, 71, 118, 132
 digital 27, 50n16, 51n24, 67, 72, *73*, 167, 173n43
 social 6, 10, 11, 33–4, 37, 50n17, 51n25, 66–7, 71–4, 84n39, 86n53, 131, 145n55, 173n40, 175–8, 191, 194n2, 194n4, 207

media(tion) (*cont.*)
 subscription, by 179, 184, 186–7, 199n38
 transparency and 149–51, 157, 159–66
medium 10, 41, 43, 99, 132, 147, 158, 160, 164
Meisler, Frank 75, *75*, 86n57
memorial(s) *see* monuments
memory (studies) 10–12, 23n24, 50n16, 80n12, 85n49, 111n34, 113n46
 competitive 62, 65, 81n21, 82n25, 192–3
 multidirectional 13–14, 43, 55, 60, 79n12
 noncompeting 13–14, 24n38, 53n42, 203
 transnational 65, 72, 74, 80n14, 84n36
Mendieta, Ana *160*–162, 172n35
Meyer, James 31, 49n11, 49n14
Mies van der Rohe, Ludwig 152, 155, 172n37
Miéville, China 35
migration 5, 16, 47, 49n14, 55–6, 60–2, 66, 71, 79n12, 96, 99, 105, 185, 193n1
Mihuleac, Wanda 42
mineriad(s) 115–17, 121, 135, 137n1, 138n4
minimalism 31, 59, 154
mirror(s) 150, 152–5, 157–63, 169n10, 169n18, 171n30, 172n37, 173n43
Mitscherlich, Alexander, Margarete 60, 80n15
mmtt (artist team) 67–8, *68*, 84n42, 85n45
modernism 43, 89, 148–9, 168n5, 175, 196n15
 architectural 39, 46, 56, 93, 101, 119, 127–9, 141n28, 150–9, 163
The Modernist 164–6, 173n45, 174n46
monument(s)
 activism 4–6, 9, 20n6, 22n14–16, 44, 72, 135–7, 205–8
 Bismarck, Otto von 29, 48n6
 Columbus, Christopher 20n3, 208
 Confederate 1, 2, 20n3, 21n7, 29–31, *30*, 48n5, 208
 contemporary concerns, to 2–5, 19, 20n6, 92–4, 99, 135–7, 206–7
 counter-monuments 18n2, 35, 39, 44, 72, 86n56, 100, 121, 124, 210n3
 debate(s) about 1–6, 20n3–6, 39, 59–60, 71, 100–4, 128, 206–8
 destruction of 21n7, 25n40, 58, 81n23, 97, 102, 164, 198n28, 211n12
 distributed 4, 9, 29, 39, 72, 91–2, 99, 102, 116–18, 187
 equestrian 2, 20n4, 39, *41*, 210n3
 inscriptions 48n5, 56, 72, 77, 78n3, 79n6, 93, 99, 101–2, 135–7, 139n7, 145n52
 interactions with 72, 76–7, *77*, 206
 misuse of 71–2, 85n49, 86n53–4
 monumentality 1, 10, 14, 17, 41–2, 60, 123–5, 190, 192, 205
 symbolism 19, 56–8, 75–6, 78n3, 93–4, 102, 111n38, 112n42, 116–17, 134–7, 161, 206
 traditional materials and 10, 75, 99, 129, 140n16, 205–7
 ruins as 56, 60, 78n4, 79n5, 131
 victims, to 56–9, 62–5, 76–7, 79n10, 93–4, 100–5, 108n16, 179–93, 205–6
 see also commemoration
Monument Lab 18n1
Moore, Henry 5, *7*, *8*, 9
Morelli, Didier 107n8
mourning 12, 60, 83n33, 121, 179
Müller, Christian Philipp 31–2, *32*, 46, 49n14, 54n43
multidirectionality 13–17, 33–7, 44, 125, 208
Münster 35–7, *36*, 51n22
museum(s) 38–41, 52n29, 65–7, 71, 81n20, 84n37–8, 123, 128, 131, 141n28, 142n32, 147–8, 173n42, 192–3
Musil, Robert 29, 48n6
Musqueam First Nation 44–7, 54n44

Nae, Cristian 144n48
narcissism 31, 71, 74, 159, 168n8, 191

Index

nationalism 31, 72–4, 129, 137n1, 185, 198n30
National Cathedral (Washington) 29–31, 48n5
National Dance Center Bucharest (CNDB) 38–9, 52n27, 52n29–30
National Museum of Contemporary Art, Bucharest (MNAC) 38–9, *40*, 52n29, 52n34, 123, 127–31, 140n18, 142n29, 142n34, 143n39–42, 145n55
National Socialism 52n36, 55, 64–5, 150, 169n15
National Theatre (Bucharest) 39, 52n30, *115*, 119, 121, *121*
Native Americans (First Nations) 44–7, 54n44
nature 47, 82n28, 91, 102, 107n9, 111n38
Nesbit, Molly 168n6
Nixon, Richard 141n22
Nochlin, Linda 196n15, 201n58
Nolte, Ernst 61, 81n18
nonsite, non-place 90, 106n6, 107n9
Nora, Pierre 47n1, 102, 112n44
nuclear imagery 5–7, 21n12

Obama Presidential Center 108n14
occlusion 69, 149–51, 155, 162–3, 169n10
Ockman, Joan 154–5, 170n25
Opie, Catherine 164–6, *165*, 173n45, 174n46
Opium Wars 98, 110n33
Osborne, James 21n7
Oslo 100–5, *103*, 111n37, 111n39, 112–13
Otake, Eiko *8*, 9, 22n16
Otero-Pailos, Jorge 18n1

pain 37, 76–7, 98, 102, 178, 191, 206
Pandele, Andrei *126*–9, 141n25, 143n38, 144n45
pandemic(s) *18*, 19, 118, 135–7, 138n2, 145n53, *166*, 167
Papararo, Jenifer 164, 174n45
Paris *see* Rue Transnonain massacre
Parvu, Ileana 144n46

People's House 38–42, *38*, *40*, 123–31, *124*, *126*, *127*, *130*, 140n17–19, 142n36, 143n42
critique of 39, 127–9, 140n19, 143n39
kitsch and 127, 129, 140n18, 143n37
right to photograph 53n40, 141n25
perception 89, 92, 99, 101, 105, 161–3, 169n18
performance (for the camera) 9–10, 35, 39, 44–7, 51n21, 87–91, 97, 131–2, 144, 148–9, 158–62, 175–8, 191–3
sites 39, 41, 87–91, 107n8, 115–19, 183
performative(s) 10, 14, 41, 59, 61, 105, 118–19, 193, 206–7
Perjovschi, Dan 114–19, *115*, 123, 131, 135–7, *136*, 138n3–4, 139n9, 143n41–2, 145n53–5
Perjovschi, Lia 116–*17*, 131, 138n4, 143n41
Petrescu, Anca 42, 52n28, 53n40, 126–8
Philipon, Charles 179, 184, 186, 188, 197n22–3, 198n24–5, 200n52
photography 5, 26, 32, 36–7, 88–91, 106n6, 107n10, 118, 191
photojournalism 175–7, 194n2, 197n17
monuments and 108n16, 141n25, 164–6
Picasso, Pablo 103, *103*
Pintilie, Ileana 53n37, 144n45
Pintilie, Lucian 119, *120*, 139n10–11
Piotrowski, Piotr 128, 142n32–3
Piper, Adrian *159*–62, 171n34, 172n35
Pirici, Alexandra 35–43, *36*, *38*, *41*, 50n19, 51n21, 51n24, 53n40, *115*, 116, 129–31
place 20n2, 26–9, 50n17, 95–7, 106n1, 108n17
plastics 67, 69, 91, 107n11
play 37, 71, 72, 76–7, 86n59
politics, political 4, 9, 13, 32–3, 62–3, 183, 208
activism 5–6, 135, 177–8, 191–2, 203–7
codes 33–4, *34*, 50n18, 64–5, 79n7, 132
persecution 184, 190, 196n16, 198n25
power 4, 12, 36, 42, 54n43, 125–31, 155
prisoners 56, 62, 79n7, 189–*190*, 200n53

politics, political (*cont.*)
 propaganda 52n35–7, 62–5, 83n32, 132–3, 144n45–8
 right-wing 1, 29, 48n5, 59, 62, 100, 111n39, 211n6
 see also censorship; public sphere
popular culture 33–4, 50n19, 72, 182
populism 2, 55, 59, 62, 78n1, 81–2n23, 99
postcard(s) 39–42, *41*, 52n31–2, 53n40
post-communism 35, 38, 41, 128, 145n54
postmodernism 17, 26, 148–52, 157, 162–3
poverty 155, 171n26, 172n36, *182*, 196n15
Preda, Caterina 52n37, 144n45
press 84n39, 183–4, 197n21–3, 198n32, 199n35
proletariat (French) 179, 183, 187, 196, 198n32
prosthesis, prosthetic 12, 24n29–30
protest *see* political activism, monument activism
public/private duality 41–3, 64, 116, 152–5, 161, 181–3
public sphere 33, 42, 61–2, 66, 74, 84n39, 94, 131, 153, 178–9, 186–7, 191, 199n35, 208
public transport 33, *34*, 116–17, 135, 138n5–6

queer theory 43, 44, 53n41, 196n13

race, racism 31, 48n5, 48n7, 92–5, 97, 109n19, 160–1, 172n35
Radu, Magda 144n47, 145n51
Rancière, Jacques 171n33
realism (aesthetic) 17, 119, 163–6, 173n44, 175–81, 187–9, 192–3, 196n15
reality 4, 11–12, 26, 34, 72, 119, 173n39, 192–3, 200n52–3
reenactment 37, 53n39, 76, 115–16, 119–20, 138n4, 144n46, 177, 183, 192–3
refugees 69–71, 85n47, 97–9, 111n35, 175, 177, 183, 193n1, 195n7, 197n18
relation(s) 10–11, 33, 51n26, 78, 95–6, 109n21

reperformance 35–6, 51n24, 88–91, 106, 192–3
Repin, Ilya 20n4
representation 11, 17–19, 24n31, 42–4, 60, 80n16, 147, 162–4, 171n31, 173n38–9, 173n44, 195n8
representation (political) 2–6, 28, 50n18, 69, 100, 116, 179, 202, 208
resource extraction 16, 19, 87–88, 91, 97, 100, 102–3, 110n29, 202, 207
reuse, recycling 99, 102, 105, 111n35, 202–4
'Rhodes must fall' movement 207, *208*
Riegl, Alois 20n7
Roberts, Bryony 112n41
Roberts, Jennifer 195n8
Rogoff, Irit 90, 96, 106n1, 107n9
Rojas, Emilio 44–7, *45*, 54n43, 54n45, 91
romanticism 89, 95, 101, 173n44, 187, 199n41
Ross, Christine 24n28
Rothberg, Michael 13–14, 24n37–8, 43, 53n42, 60–1, 80n14, 81n21, 82n25
Rowe, Colin 169n16, 170n26, 173n40
Rue Transnonain massacre 179–84, 187–9, 196n14, 200n45, 200n49

Salcedo, Doris 202–4, *203*, *204*, 210n2
Salomon, Charlotte 68
Sassen, Saskia 49n13
Savage, Kirk 20n3, 80n13
Scheerbart, Paul 150, 172n36
Schneider, Rebecca 23n28, 51n23
School of the Art Institute 9, 22n16, 84n37, 206
Schwarzer, Alice 78n1
screen 10, 146–9, 157, 161, 164, 173n44, 177, 188
Scriba, Decebal 144n48
sculpture 43, 53n41, 116, 138n4, 154, 206
seeing-in 157, 162, 171n31, 173n38
seeing-through 41, 161–3, 166
self, subject 66, 74, 159–60, 169n18, 171n34, 189–93, 206

selfie 71–2, 85n49, 86n54, 131, 143n42, 159–60
Senie, Harriet 20n3, 79n10, 80n13
Sennett, Richard 170n19
Shaked, Nizan 196n13
Shapira, Shahak 72, 86n53–5
Shaw, Lytle 49n10
Shim, Sandra 206, 210n4
Sibiu (Romania) 116, *117*, 135, *136*
silence 64, 79n5, 85n50, 118, *130*, 211n7
Singapore 163, 173n42, 176
site: historicity 26–28, 43–4, 105, 114, 118, 137
 imagined 42, 46, 65–6, 76, 129
 specificity 28–31, 34–7, 42, 47, 107n8
 discursive 31–2, 37, 49n9–10, 53n42, 96, 137
slavery 13, 84n36, 97, 161, 210n5
smartphone(s) 5–6, 19, 36–7, 66, 85n49, 135–7, *136*, 145n54, 154, 167, 173n43
Smith, Linda Tuhiwai 12–13
Smithson, Robert 106n6, 107n8
social media *see* mediation
space, spatiality 10–14, 49n9, 51n26, 95–6, 105, 109n21, 149–57, 207–8
Sparrow, Brent 54n44
spectacle 5, 146, 166n2, 168n3, 171n30
speech acts *see* performatives
Spirescu, Adrian 39, *40*, 127, 129, 143n39
Stalin(ism) 57, 58, 61, 82n24, 125, 141n22
Stallabrass, Julian 185, 198n30
Starobinski, Jean 169n10
Staudte, Wolfgang 64, *64*
Steilneset (Norway) 93–4, *94*, 108n17
Stein, Karl vom 67, 85n43
Steinplatz 56, *57*, 60–3, 67–71, 79n5–6, 82n24
 reloaded 67–71, *68*, 84n42, 85n45
Stenzel, Hans-Christof 168n9
Sternfeld, Nora 59, 79n11
Stiles, Kristine 143n41–2
Stierli, Martino 169n14
sublime, sublimity 60, 89, 91, 155

surface(s) 10, 152, 157, 161–2, 171n29, 171n31
surveillance 71, 118, 132, 152–3, 159, *190*

Tahrir Square (Cairo) 28, 47n3
Tate Modern 51n21, 204, 210n2
Taut, Bruno 150, 155
television 11, 23n27, 36, 42, 50n15, 51n25, 132
Thirty Years War 36, 51n22
Tibi, Bassam 78n1, 81n23
tile (as material) 56, *58*, 78n4
time, temporality 10–11, 23n28, 24n31, 25n40
 belatedness, delay 40, 42, 118, 132, 162
 strata, sedimentation 23n19, 28, 39, 92
 space and 95–6, 110n24, 149
Tismaneanu, Vladimir 140–1n22
Touloumi, Olga 170n24
tourism 28, 39–42, 139n12, 183, 186, 197n18
 monument 1, 59, 71–2, 101–4, 108n17, 128, 143n42
transparency 15, 128–31, 146–58, 160–6, 169n16, 173n39, 189
trif(r)ons (three-faced God) 134, 145n51
Trump, Donald 4, 62, 81n23, 192–3
Turks (German) 58, 66, 69–70, 78n1, 79n12

Ukraine 195n10
uncanny, the 107n1, 150–3, 170n24, 191
United Daughters of the Confederacy 29–31, 48n5, 48n7
University of the Arts (Berlin) 67–8, 84n42
University of British Columbia 46–7, 54n44
University of Cape Town 207, *208*
University of Chicago 5–9, *6*, *7*, *8*, 22n14
University Square (Bucharest) *115*, 116, 118–21, *121*, *122*, 123, 135, 137n1, 138n4–6, 139n7, 140n16
urbanism 88–91, 96–7, 100–5, 112–15, 124, 154, 157, 162, 170–1n26

Utopia(nism) 11, 19, 155, 157, 187
Utøya 100–4, *101*, *104*, 111n38, 112n42, 113n45

Vancouver 45–7, *46*
Venice (Biennial) 49n14, 51n25, 99, 108n15, 111n34, 190, *190*
video 39, 50n19, 66, 160, 173n43
Vidler, Anthony 150, 153, 169n11–12, 170n24, 171n26, 171n29, 173n40
Vienna 2, 3, 20n6, 38, 59, 86n57, 89, 97, *98*, 155, *156*, 191
violence 155, 171n26, 174n46, 181–3, 192
 political 89, 100, 115–18, 137n1, 179, 188–90, 203, 205–6
 racial/ethnic 59, 93, 97, 108n16, 137n1
Visual Social Media Lab (Sheffield) 194n2
Voinea, Raluca 138n4, 139n9
vulnerability 118, 151–7, 181–3, 190, 206

Wagner, Anne 173n43
Wall, Jeff 162, 170n23, 172–3n37
Walton, Kendall 173n39
Washington, D.C. 29–31, *30*, 48n5, 60, 141

West Germany *see* Federal Republic
Whiteread, Rachel 59, 80n13
Widrich, Mechtild: on exhibition spaces 84n37, 171n28, 172n42–3, 210n2
 on monuments 22n13, 22n15, 23n20, 35, 80n13, 86n56 111n39, 139n15
 on performance 35, 106–7n8, 118, 146, 168n6, 201n55
Wiley, Kehinde 210n3
Wilke, Hannah 148–9, *149*, 162, 168n7–9
Wollheim, Richard 157, 162–3, 171n31, 173n38
wound(s) 36, 54n45, 102, 111n38, 179, 188–9
Wüstenberg, Jenny 79n5, 80n14, 83n24

Yap, Chin-Chin 110n31
Young, Carey 87–92, *88*, *90*, 96, 106n2–7
Young, James E. 85n49, 86n56, 211n8
Yusoff, Kathryn 97, 110n29

Zalewska, Maria 71–2
Zola, Émile 164, 173n44
Zumthor, Peter 93, *94*